The Art of
Carnival Glass

Glen & Stephen Thistlewood

Schiffer Publishing Ltd ®

4880 Lower Valley Road, Atglen, PA 19310 USA

Dedication

For Angie and Andrew

A thing of beauty is a joy forever:
Its loveliness increases; it will never
Pass into nothingness.
—John Keats (1795-1821) British poet.

Library of Congress Cataloging-in-Publication Data

Thistlewood, Glen.
 The art of carnival glass / by Glen and Stephen
Thistlewood.
 p. cm.
 Includes bibliographical references.
 ISBN 0-7643-1963-9 (large print)
1. Carnival glass--Collectors and collecting. I. Thistlewood,
Stephen. II. Title.
NK5439.C35 T54 2004
748.2'075--dc22

2003018887

Designed by Mark David Bowyer
Type set in Dauphin/Korinna BT

ISBN: 0-7643-1963-9
Printed in China
1 2 3 4

Published by Schiffer Publishing Ltd.
4880 Lower Valley Road
Atglen, PA 19310
Phone: (610) 593-1777; Fax: (610) 593-2002
E-mail: Info@schifferbooks.com
Please visit our web site catalog at **www.schifferbooks.com**
We are always looking for people to write books on new and
related subjects. If you have an idea for a book, please
contact us at the above address.

This book may be purchased from the publisher.
Include $3.95 for shipping.
Please try your bookstore first.
You may write for a free catalog.

In Europe, Schiffer books are distributed by
Bushwood Books
6 Marksbury Avenue
Kew Gardens
Surrey TW9 4JF England
Phone: 44 (0) 20 8392 8585
Fax: 44 (0) 20 8392 9876
E-mail: Bushwd@aol.com
Free postage in the UK. Europe: air mail at cost.

Contents

Acknowledgments

Special thanks go to **Joan Doty, Janet & Alan Mollison,** and **Bob Smith** for their constant help and support in so very many ways.

Many people have allowed their glass to be photographed for this book—particular thanks, however, go to Randy and Jackie Poucher for the photographs of special items from their wonderful collection.

As always, our family and friends have been there when we needed them for advice, technical information and extra bits of proof reading.

We also wish to thank

Val and Bob Appleton
Phyllis Atkinson
Stephen and Trudy Auty
Dick & Sherry Betker
Carl and Eunice Booker
Ann & David Brown
Dave Doty
Jorge Duhalde
Gale Eichhorst
Frank M. Fenton
Rita & Les Glennon
Kaisa Koivisto
Jeri Sue Lucas
Dale Matheny
David McKinley

Pam & Mike Mills
Charles & Eleanor Mochel
Connie Moore
Tom & Sharon Mordini
Jim Nicholls
Ed & Virginia Perva
Jorge Perri
Brian Pitman
The late Miss Elizabeth (Betty) Robb
Howard Seufer
Marty Seufer
Carol & Derek Sumpter
George Thomas
Rick Wilkins

Last, but by no means least, we wish to thank our publisher, Peter Schiffer and our editors, Donna Baker and Ginny Parfitt. Their friendship and support has been outstanding.

Photography for the book (with the exception of those noted in the captions) is by Stephen Thistlewood. Equipment used was a Canon EOS 500N camera and Sigma Macro lens, using three 500 watts tungsten floodlights and an 80B filter. Film used was Fujichrome Sensia ISO 200 and 400.

Price Disclaimer

Throughout the book, value ranges are given for all photographed items where appropriate. Value is assessed for items with excellent iridescence and no damage, and in the color and shape photographed only. Values are based on both auction prices and private sales in the United States of America. Lower values would naturally be attributed to items with damage. Condition, color, iridescence, availability, and indeed subjective judgment all play a major part in determining value. The reader is referred to David Doty's *A Field Guide to Carnival Glass*, Tom and Sharon Mordini's *Carnival Glass Auction Prices* and similar guides to gain further pricing information. Please note that a number of the items shown in this book have never or have only rarely appeared at public auction, therefore price assessment is not easy. Furthermore, a number of patterns are being named and attributed for the first time in this book therefore, although they may have been sold at auction in the past, they have been sold un-identified. For some exceptionally rare and unusual items, no price (NP) is shown. This is because the item concerned has not, to our knowledge, changed hands either at auction or in a private sale, for many years—indeed it may never have changed hands. A speculative price category (SP) has been used purely as a guide, where the value has been assessed based on similar, though not necessarily identical, items. Neither the authors nor the publishers can be liable for any losses incurred when using the values attributed within this book, as the basis for any transaction.

Introduction
Carnival Glass as Art?

History has remembered the kings and warriors, because they destroyed. Art has remembered the people, because they created.
—William Morris, 1834-96. British designer, artist and poet

What is "art?" There are many definitions of the term, the only constant seems to be its multi-faceted nature. Two key notions are essential for the authors' interpretation of the concept within the realm of this book. Firstly, "art" is the product of human creativity through the application of skill. Secondly, in its most fundamental form, "art" is the creation of beautiful or significant things. The perception of beauty may be subjective, thus the inclusion of the phrase "significant things"—implying a collective acceptance of such items. The purpose of this book is to explore the intrinsic beauty of Carnival Glass through a consideration of its form, patterns, color, and decoration.

But first, what exactly is Carnival Glass? Before we proceed any further, a definition is required. Carnival Glass is generally considered to be press moulded, iridized glass with a pattern created by a mould. Carnival was originally produced in the United States of America from about 1907 to around 1925. That is the era of the first mass production of Carnival, and the authors refer to it throughout the book as Classic Carnival. Following on from that initial output, many countries around the world such as Australia, England, and Finland, also began to produce their own Carnival, which the authors refer to as Australian Carnival, English Carnival and so on—or by the specific manufacturer, where known. Virtually all the aforementioned Carnival was hand pressed, shaped and iridized. A change came in the United States, however, during the 1930s, when machine made Carnival (now known as Late Carnival) with a factory finish was mass produced. From the 1960s to date, several companies (including some of the original producers of Classic Carnival) began to re-issue Carnival again—this is currently known as Contemporary Carnival.

The name Carnival Glass is actually a recent term. When Carnival was first produced in the United States during the early 1900s, a variety of descriptive names (such as Baking Powder Glass, Venetian Art Glass and Poor Man's Tiffany) were used to advertise it. Stock was sold through mail order catalogs, in dime stores and in department stores where it cost just a few cents a piece. Some was even given away as premiums with sales catalogs. Later on, possibly due to unsold stocks, or maybe due to poorer quality items swamping the market, some of the iridized glass began to be given away at carnivals and county fairs—hence its colorful sobriquet—**Carnival Glass.**

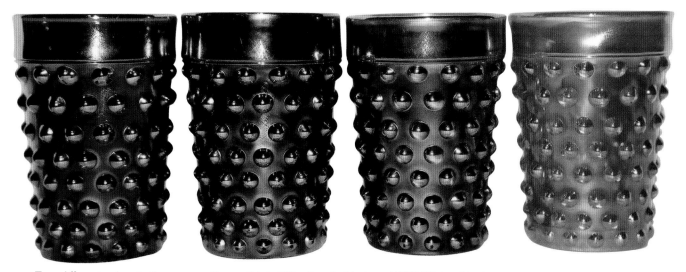

Four different colors in the same pattern—this is Millersburg's fabulous *HOBNAIL* tumbler in (from the left) amethyst, blue, green, and marigold. The simple yet effective pattern is emphasized and enhanced by the combination of color and iridescence—sheer simplicity, sheer beauty. *Courtesy of Bob Smith.* These scarce items rarely sell at auction, SP amethyst $700-1000; blue $1300-1600; green $1800-2000; marigold $1500-2000.

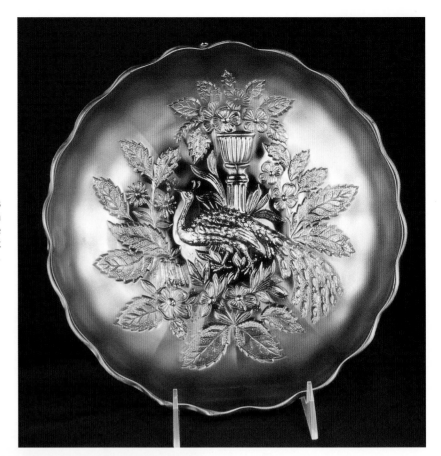

The beauty and art of Carnival Glass are captured in this magnificent, green Millersburg *PEACOCK AND URN* large ice cream shaped bowl with a vibrant satin iridescence. $800-1200.

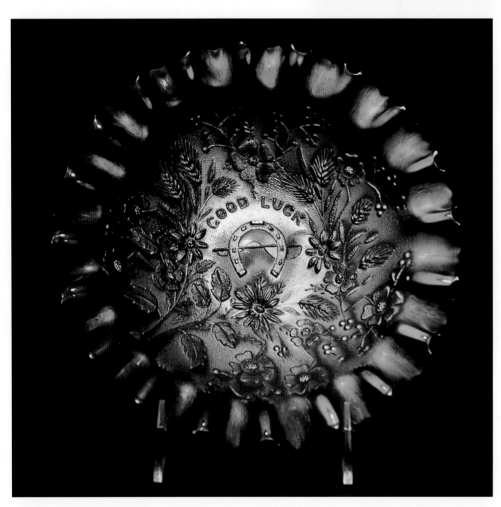

The breathtaking, electric iridescence on this cobalt blue *GOOD LUCK* bowl from Northwood is enhanced by the fine stippling all over the surface of the glass. The delicately crimped "pie crust edge" enhances its beauty. $700-1000.

Part One
Carnival Glass and its Inspirations

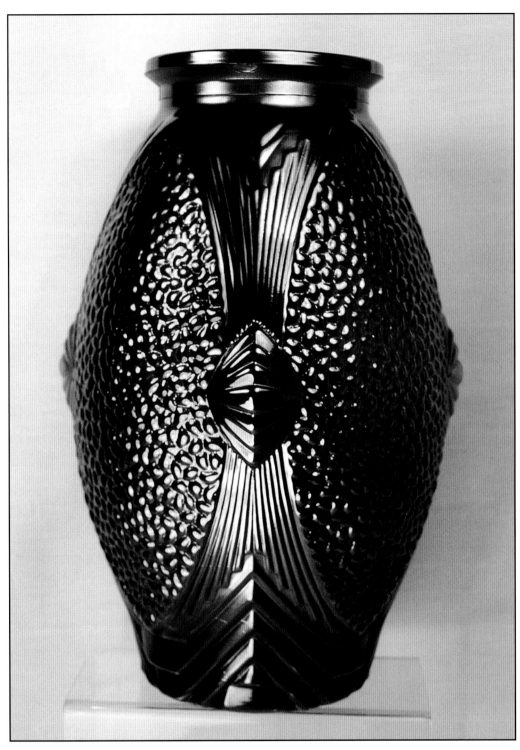

The Art Deco influence is clearly evident in the shape and style of this massive, bulbous, blue *PEBBLE AND FAN* vase, made in Czechoslovakia. SP $750-1250.

Chapter One
Inspirations

Carnival Glass embodies a blend of design styles that echoed popular taste. It represents the meeting of "art" with the ordinary things; the familiar, everyday items that entered a multitude of homes and brightened up many working lives. The entire concept of using iridescence, as we shall see, has its roots in history. Many Carnival patterns and shapes show the influences of artistic movements such as Art Nouveau, the Aesthetic, and Arts & Crafts movements, and—on some Carnival made through the 1920s and 1930s—the Art Deco influence. There are also patterns such as Fenton's *ORANGE TREE* that clearly have their inspirations in the work of specific designers such as William Morris. In Part One we take a look at the background and inspirations that have helped to shape Carnival as well as the passions that personify it. We then move on to consider the beauty and art of Carnival through an understanding of the manufacturing and decorating processes involved in its creation.

Fenton's *ORANGE TREE* pattern was undoubtedly inspired by William Morris's decorative designs. He and several others formed a home furnishings company called Morris, Marshall, Faulkner & Co. Their ideas and concepts of good taste made the international "rounds" at the end of the 19th century in the form of wallpaper and textiles. Morris's "Orchard" wallpaper (designed in conjunction with Henry Dearle) was surely the inspiration behind the Fenton *ORANGE TREE* pattern. Shown here is a covered sugar (part of a four piece table set) in cobalt blue. $125-175.

A visually striking vase, this is *DECO LEAVES* in vibrant marigold, from the Czech manufacturer, Rindskopf. The line, the shape, the overall concept—they are all highly evocative of Art Deco design. SP $500-800.

Iridescence

Early advertisements for Carnival in the Butler Brother's catalogs described the glass as *Pompeiian*—so what's the link to that ancient Italian city tragically buried by volcanic ash? It stems right back to the discoveries of iridized glass in the ruins of Pompeii and also to the finding of iridized glass buried in ancient tombs. The iridescence on the surface of these items was not a deliberate effect produced by the original glass makers, it was instead brought about by a natural process known as "devitrification" (the breaking down or chemical decomposition of the glass) caused by being buried for such great lengths of time in moist and often acidic soils. But this was iridescent glass by accident—the production of iridescent glass by design was to come many centuries later.

During the 1800s, European glassmakers were constantly striving for innovation. Manufactured iridized glass was first made in Bohemia and then in England—during the 1870s, the iridized glass

was exhibited at international fairs in both Vienna and Paris. Some of the items had patterns—Thomas Webb's "Brain" glass for example, had a crackle effect—but the patterns were not press moulded like Carnival. This early iridized glass was blow moulded and the patterns were made with applied decoration. In the case of Webb's "Brain" glass, the pattern was achieved through plunging the glass into cold water to get the crackle, then re-heating, blowing and iridizing.

A quote from an 1879 American trade journal that was used by Revi in his book *Nineteenth Century Glass*[1] helps to further illustrate the links and sources of inspiration. An importer and wholesaler dealing in Bohemian glass products reported that they had "just received from Bohemia the finest selection of iridescent glass and Bronze glass ever assembled under one roof…. In the bronze glass the Pompeiian and antique styles prevail. These are interesting as well as beautiful, specially so as being exact copies of relics rescued from the ruins of the buried city. The iridescent glass goods are of the most perfect finish and graceful shapes, and glitter in the light with all the hues of the rainbow."

Later in the 1880s and early 1900s, various makers took the art of iridized glass to new levels. Among the most renowned of these manufacturers were Lobmeyer, Pallme-Konig and Loetz in Bohemia, Stephens & Williams and Thomas Webb in England and Louis Comfort Tiffany in the USA. Tiffany had been inspired by the natural iridescence seen on some ancient glass—in particular Roman glass. During his travels throughout Europe he had observed many classical styles and effects. Tiffany patented his first glass-lustering technique in 1881 and his iridescent glass—known as "Favrile"—followed in 1894. In the method of manufacture of Tiffany's Favrile, salts of rare metals were dissolved in the molten glass and through various stages of re-heating, were brought to the surface to give a distinctive effect. Added to this, Tiffany's glass was then sprayed to give an iridescent effect (usually with various chlorides—different metals gave different color effects). It was hugely popular with specialties like the peacock feather motif and the jack-in-the-pulpit vase. Other American manufacturers followed in his footsteps: Steuben, Quezal, and Durand. But their iridized art glass had one major drawback for the ordinary man and woman—it was expensive!

When Classic Carnival Glass was first made in the USA around 1907, it was imitating the iridized art glass that had been made previously by those famous manufacturers such as Loetz and Tiffany. The ads that appeared in the Butler Brothers' catalogs suggested not only these sources of inspiration, but also the links to the recent archeological discoveries. In 1909 and 1910, early Northwood ads described the groups of iridized glass as *Pompeiian Iridescent Assortments*. In the body of these ads (which included such familiar items as the *FINE CUT AND ROSES* rose bowl) the description of the goods stated: "such effective designs heretofore produced only in the expensive imported goods." Another Northwood ad in 1909 described their iridized range as *Bohemian Iridescent*—confirming the source of inspiration to be Bohemia, an area formerly part of Czechoslovakia and now part of the Czech Republic.

Fundamentally, however, when Carnival Glass came on the scene it was as a response to the times. Machine technology had been advanced, mass production was the watchword of the era. The processes involved in iridizing glass were well known and the materials were available. But the real key to it all was to be found in the public taste—in what the people wanted. They'd seen the incredibly expensive Tiffany glass and they loved it. They were attracted to its gorgeous, rich patterns and its fabulous iridescence. But they wanted it cheap. They wanted it affordable. Whereas Tiffany's iridized glass adorned the homes of the well-to-do few, the cheaper, mass produced Carnival from manufacturers such as Fenton, Northwood, Dugan, Imperial, and Millersburg, reached a far greater buying public. Being rich is not a pre-requisite for the appreciation of beauty. The widespread availability of reasonably priced iridized Carnival Glass gave ordinary people the rare opportunity to grace their homes with decorative objects. Though the glass was mass produced, much of it was also hand finished. In fact, so much individuality was applied to each piece of glass in terms of its color, iridescence, or hand finishing, that it is really very difficult to find two pieces exactly the same in all respects. Bowls, plates, and other exotic shapes, adorned with peacocks, flowers, butterflies, fruits and dragons—and all in vibrant, shimmering iridescence. This was Art for Everyone.

Advertisements featuring rose bowls like the one illustrated here, were shown in the 1909 and 1910 Butler Brothers' catalogs. It is, of course, Northwood's *FINE CUT AND ROSES* rose bowl and in purple (as shown here) is valued between $100-150.

A tiny cream jug in "Queen's Ivory Ware" from Sowerby of England circa 1880. The pattern features peacock and floral motifs. The peacock was not only the trademark of Sowerby's, it was also a very popular motif of the era.

A close-up detail of the pattern on the Northwood *PEACOCK AT THE FOUNTAIN* sugar at left.

Look at the similarities between the peacock design on this covered sugar in Northwood's *PEACOCK AT THE FOUNTAIN* design and the peacock pattern on the Sowerby creamer on the previous page. Northwood was born and raised in Stourbridge, England. He studied design there for several years before emigrating to the United States. It's likely that he saw the little creamer in the United Kingdom and translated the design across to his Carnival patterns some years later. Value range for this purple covered sugar, $200-300.

A slightly different aspect in close-up of the pattern on the Northwood *PEACOCK AT THE FOUNTAIN* sugar above.

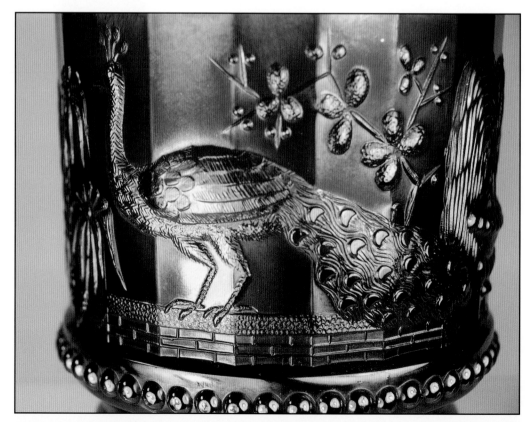

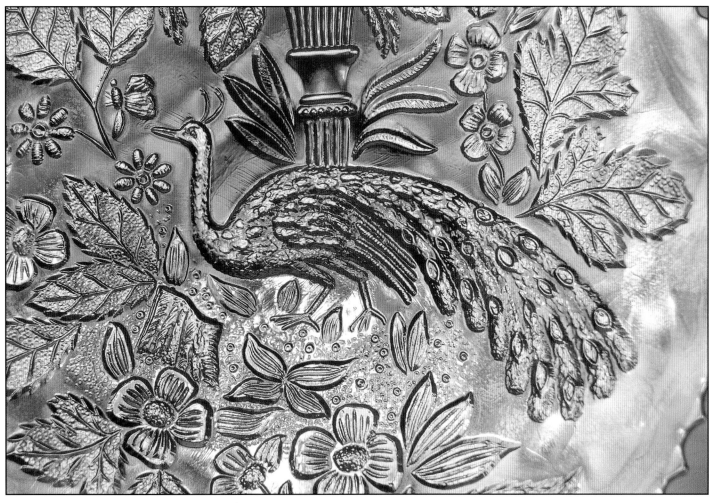

Fenton's *PEACOCK AND URN* design is shown here in close-up. Peacock patterns were very popular in Classic Carnival Glass. The peacock was a favorite motif in Japanese design dating back to the eighth century. As the Japanese style began to inspire the Arts and Crafts, Aesthetic, and Art Nouveau Movements of the late nineteenth-century, the peacock motif entered their repertoires. Peacocks (and their feathers) were everywhere. Most Carnival Glass manufacturers made patterns featuring the peacock or a motif representing its feathers—here is one of Fenton's naturalistic interpretations of the peacock. It is a masterpiece of flowing design and balanced composition.

More peacocks, here from Northwood. This is a detail from the famous *PEACOCKS (ON THE FENCE)* pattern. For many, this pattern is the true essence of Carnival Glass. It is a harmonious and elegant composition featuring two peacocks, one with a fanned out tail, upon a fence. The mould detail seen on the peacock feathers, the lattice work, and the flowers is superb. The background may be stippled (as shown here)—this adds to the iridescent effect and therefore, the value. These Northwood items usually have excellent iridescence, the multi colors of which suggest the natural brilliant hues of the peacock. The exterior is usually ribbed but may sometimes be found with Northwood's *BASKETWEAVE* pattern. Ads for Northwood's *PEACOCKS* first appeared in the Butler Brothers catalogs in 1912. A blue, stippled Northwood *PEACOCKS* plate with excellent iridescence is valued circa $900-1400.

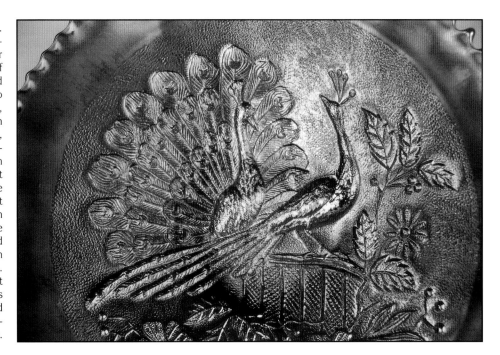

Luscious grapes and other fruits were also popular motifs of the Classical Carnival era. These delicious looking grapes are the main motif on Imperial's *HEAVY GRAPE* pattern, and are seen here on an amber plate. $200-300.

The sunflower motif in Carnival was inspired by the craze for things Oriental. This close-up of Northwood's *SUN-FLOWER* pattern shows the astonishingly detailed rendition of the flower, with every petal being finely stippled. The sunflower motif is the entire pattern —a huge and intricate flower head, like a sunburst. The petals are regular, almost regimented; the effect is one of harmony. Value range for this cobalt blue bowl $500-700.

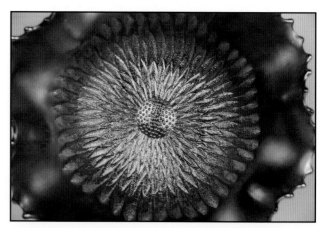

Shapes and Patterns

It is impossible to point to one single source of inspiration for the multitude of shapes and patterns that began to be produced in Classic Carnival Glass from around 1907 onward. The mid to late 1800s had been a period when regional styles, decorative detail, and hand craftsmanship had flourished. Many social and cultural changes had also taken place as the Aesthetic Movement (and other varied but related styles) swept through North America and Europe. Although a somewhat contrived, artistic trend, the Aesthetic Movement was characterized by a desire for beautiful surroundings and a regard for the quality of one's life. Beautiful and decorative objects were championed as fit for everybody and not just for the privileged elite. The Movement's emphasis was on interiors and artifacts that would improve the everyday quality of life through their sheer beauty. The Aesthetic Movement reflected an attitude, a new freedom and revitalization and it touched every sphere of the fine and decorative arts, often elevating them to a new status.

In the mid to late 1800s, travel had become much easier and advances in printing had made the written (and illustrated) word far more widely available. The opening up of Japan to foreigners led to exotic goods from the Far East appearing in the western world, immediately entrancing artists and designers. Indeed, a phenomenon called "Japonisme"— a taste for things Japanese—took hold and their favorite motifs (including the peacock and the butterfly) were soon to be seen on all forms of the decorative arts.

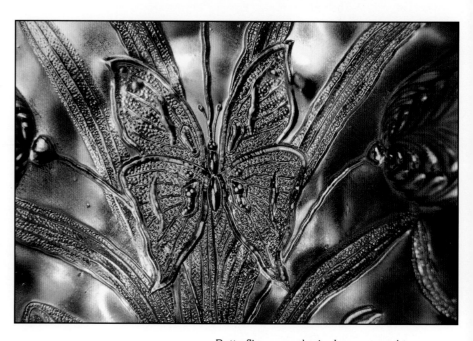

Butterflies—popular in Japan—caught on in the western world too, as part of the general trend for Oriental design. Most of the Classic Carnival designs represent butterflies in a somewhat stylized manner. Here we have a close-up detail from Dugan/Diamond's *BUTTERFLY AND TULIP.* This massive bowl in purple $2000-2500.

By the mid 1880s, the Arts & Crafts Movement (a design style that grew out of the disillusionment many designers felt with the changes brought on by the Industrial Revolution) had already taken hold. At its most fundamental, it was a celebration of individual crafts- manship and design, and it was spearheaded by William Morris who was especially renowned for his memorable textiles, wallpapers, and home furnishings. Somewhat rooted in the Arts & Crafts Movement was another great design style of the era—the Art Nouveau Move- ment. An international style of decoration and architecture, Art Nouveau developed in the 1880s and 1890s and is generally typified in visual terms by curving, organic lines and writhing plant forms as well as an emphasis on decoration and artistic unity. In the USA, the renowned glassmaker Louis Comfort Tiffany was a leading practitio- ner of the Movement.

Art Nouveau itself was also influenced by other forms of art—in particular that of the Orient and Japan. Motifs frequently used by designers of the era were peacocks, irises, sunflowers, waterlilies, dandelions, and vines—the same motifs that appear again and again in Carnival Glass patterns. Design ideas were spread and imitated; style books or pattern books helped their spread whilst International exhibitions and trade fairs also played a major part. In 1876, for ex- ample, the Philadelphia Centennial Exposition was held, displaying many Oriental themes as well as work from major international de- signers such as William Morris. Oriental artifacts and peacock feath- ers were very popular items for decorating the house around the late 1800s and early 1900s. This was one late nineteenth-century fashion fad that later found favor with the Carnival Glass manufacturers, for the peacock in particular, was chosen for many Carnival patterns and indeed, today, has come to represent the essence of Classic Carnival design.

The Carnival Glass patterns and forms that emerged in the early 1900s represented a harmony of styles, inspired by a blend of popu- lar motifs and ideas. Japonisme, the Arts & Crafts and Aesthetic Move- ments, Art Nouveau, and more. The elaborate ornamentation of the 18th century Rococo Revival and the fashion for pattern glass and cut glass also inspired the Carnival designers and mould makers. Fur- ther, the Great Exhibitions that focused on the importance of design within industry also helped to foster the commercial climate into which Carnival Glass was born.

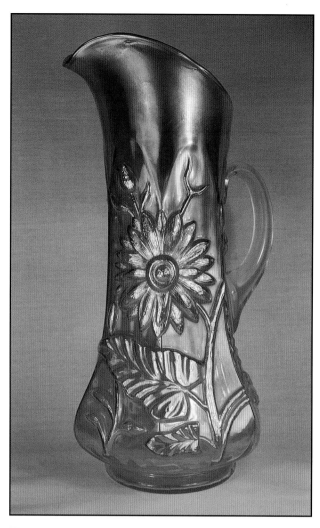

The pattern on this marigold tankard water pitcher from Northwood is called *DANDELION*, but when it was first made and advertised in the Butler Brothers catalog of February 1912, the flower was actually called "Sunflower." At the time, however, it was an apt choice, for that's what the flower almost certainly was supposed to be. The Sunflower was a much loved graphic symbol of the Aesthetic and Art Nouveau movements. Value range for this marigold water pitcher $300-500.

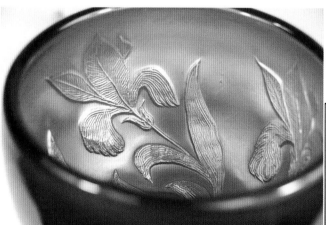

The iris was a popular motif of Art Nouveau style that was also used in Carnival Glass. Fenton's interpreta- tion of the iris motif, seen here on the interior of their *IRIS* compote, illustrates the way in which the Carnival design echoed the earlier Art Nouveau style. In green, as shown here, the *IRIS* "buttermilk" goblet is valued in a range from $50-100.

This close-up of the floral motif on the *DANDELION* pitcher shows its likeness to a sunflower.

13

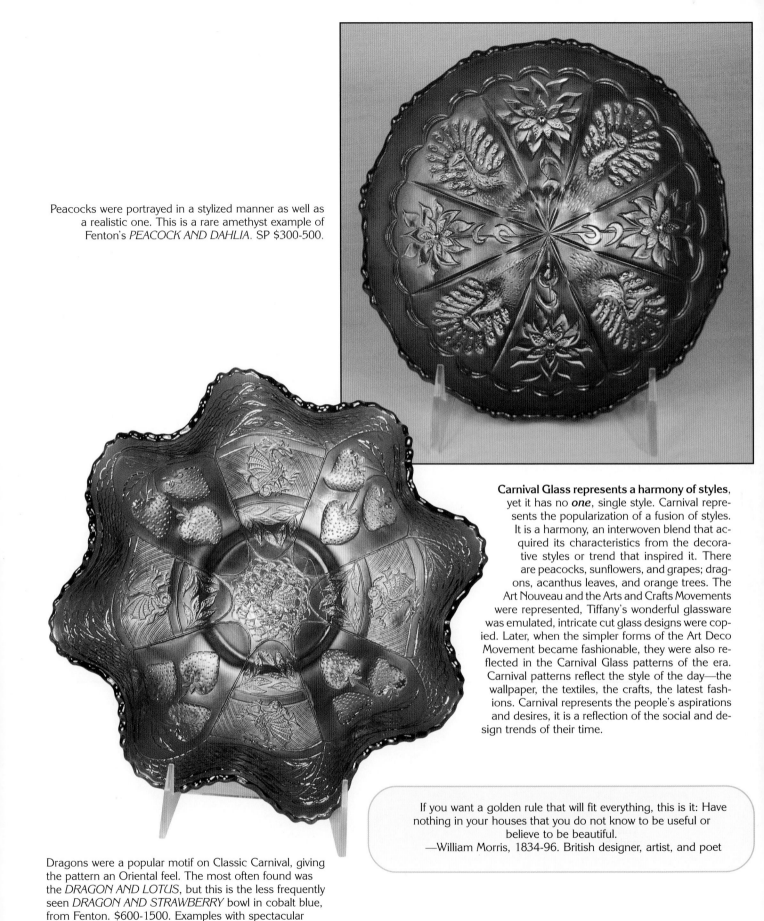

Peacocks were portrayed in a stylized manner as well as a realistic one. This is a rare amethyst example of Fenton's *PEACOCK AND DAHLIA*. SP $300-500.

Carnival Glass represents a harmony of styles, yet it has no *one*, single style. Carnival represents the popularization of a fusion of styles. It is a harmony, an interwoven blend that acquired its characteristics from the decorative styles or trend that inspired it. There are peacocks, sunflowers, and grapes; dragons, acanthus leaves, and orange trees. The Art Nouveau and the Arts and Crafts Movements were represented, Tiffany's wonderful glassware was emulated, intricate cut glass designs were copied. Later, when the simpler forms of the Art Deco Movement became fashionable, they were also reflected in the Carnival Glass patterns of the era. Carnival patterns reflect the style of the day—the wallpaper, the textiles, the crafts, the latest fashions. Carnival represents the people's aspirations and desires, it is a reflection of the social and design trends of their time.

If you want a golden rule that will fit everything, this is it: Have nothing in your houses that you do not know to be useful or believe to be beautiful.
—William Morris, 1834-96. British designer, artist, and poet

Dragons were a popular motif on Classic Carnival, giving the pattern an Oriental feel. The most often found was the *DRAGON AND LOTUS*, but this is the less frequently seen *DRAGON AND STRAWBERRY* bowl in cobalt blue, from Fenton. $600-1500. Examples with spectacular color have sold for $2200 (1999) and $1700 (2001).

[1]Revi, Albert Christian. *Nineteenth Century Glass: Its Genesis and Development*. Atglen, Pennsylvania: Schiffer Publishing Ltd., 1967.

Chapter Two
Background: Passion or Obsession?

If you follow your bliss, doors will open for you that wouldn't have opened for anyone else.
—Joseph Campbell, 1904-1987. US author

What is it about Carnival Glass that attracts and inspires? It's likely that you, reader, are one of those whom Carnival has captivated. There are collectors all over the world, from coast to coast and continent to continent. There are international associations and small local clubs; there are collectors who "go it alone," collecting in splendid isolation and there are those who belong to just about every club in existence. There is even a "virtual" internet-based, international Carnival association. The one common link is, of course, "poor man's Tiffany"—iridized, pressed glass—Carnival Glass.

Carnival Glass collecting is international, and collectors are to be found in all corners of the world. This view is of an antique show in southern Sweden where *lysterglas* (Carnival) made by Eda Glasbruks, can sometimes be found.

Many collectors inherited a piece of Carnival Glass from a relative; its sentimental value ensuring that it would be kept in the family. Soon, perhaps, they began to inquire a little and wanted to find out what exactly that pretty bowl of Grandma's was. Others simply went antiquing one day and got "hooked" when they came across an attractive piece of Carnival. They bought it and then perhaps another, and before too long they had become collectors. When Carnival was first made, of course, it was meant to be used. Essentially functional in shape and form, yet beautiful enough to simply be placed on the mantle and admired, Carnival Glass was undoubtedly "collected" by many of its early purchasers who could not bear to see it sullied or damaged by use. Nevertheless, its primary purpose was to be used, and contemporary advertising emphasized that fact. There were bowls for every imaginable purpose, plates, drinking utensils, tableware, vases, and more.

By the 1950s, Carnival began to be seen as a collectible in its own right, although it wasn't always collected openly. In a fascinating article in the Fall 1968 edition of O. Joe Olson's *Carnival Glass News and Views* journal, Phil Garrison, a collector and antique dealer, explained how Carnival Glass was often brought out "from a box under the counter or from the back room" when he visited antique shops in the eastern states. Prices were low, ten cents apiece or three for twenty-five cents. Garrison explained:

"In those days a person bought it by the box or the bushel basket! I remember many times when we were <u>forced</u> to take a box or bushel basket of carnival in order to get one piece of pressed glass which was popular in the early 1950s. We would select what we considered were the pretty pieces of carnival and then 'junk' the remainder. We always had ten to twelve bushels of Carnival in the cellar."

"I remember one sale clearly …. One hundred pieces of 'yellow' marigold for seven dollars! Later on we got as much as fifty cents for the dark bowls—any of them. I had a fine seven piece Carnival water set with birds in the pattern …. I sold it for $2 because I had gotten the set, among other items, in two boxes of stuff that cost me fifty cents a box. In those days I think water sets—dark and light—were more in demand than any other pieces regardless of beauty, pattern or scarcity. By 1956, we started to get as much as $4 for water sets. They were popular among the farmers who were not particular about the color. They wanted to use them to serve milk or cider. There appeared to be a gradually growing interest and fairly good prices. It was all just Carnival at that time—no fancy names, only dark and light."

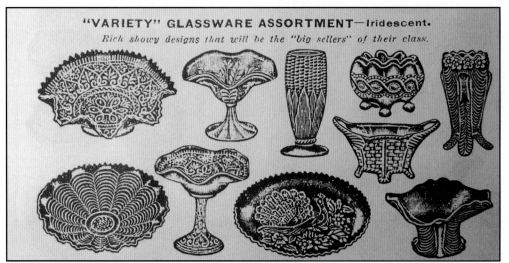

This 1912 Fenton ad from a Butler Brother's catalog shows the many uses that were ascribed to the new iridized glass we now call Carnival. Bowls, bonbons, nut bowls, grape dishes, salad bowls, and more were on offer. Note that this ad referred to them as "practical pieces"—this was glass that was intended for use. It was also glass that brought beauty into everyday lives. The patterns shown include *ORANGE TREE, PEACOCK AND URN, PERSIAN MEDALLION, POND LILY, AND RUSTIC.*

Another ad from 1912, this time from Northwood. The shapes here were listed as nut bowl, nappy, jelly dish, bonbon, and of course, the ubiquitous bowl. The patterns shown are (left to right) top row: *HEARTS AND FLOWERS, FERN* compote, *CORN* vase, *BEADED CABLE, BUSHEL BASKET, DAISY AND DRAPE* vase. Bottom row: *NIPPON, HEARTS AND FLOWERS* compote, *PEACOCKS, DRAPERY.*

16

One wonders what that seven piece water set "with birds in the pattern" that sold for $2 might have been. Maybe Northwood's *SINGING BIRDS*? Now, in marigold, that would sell for around $400-600 or so, maybe more; in green, upwards of $1000. How many of today's collectors read the previous paragraphs whispering "if only" to themselves?

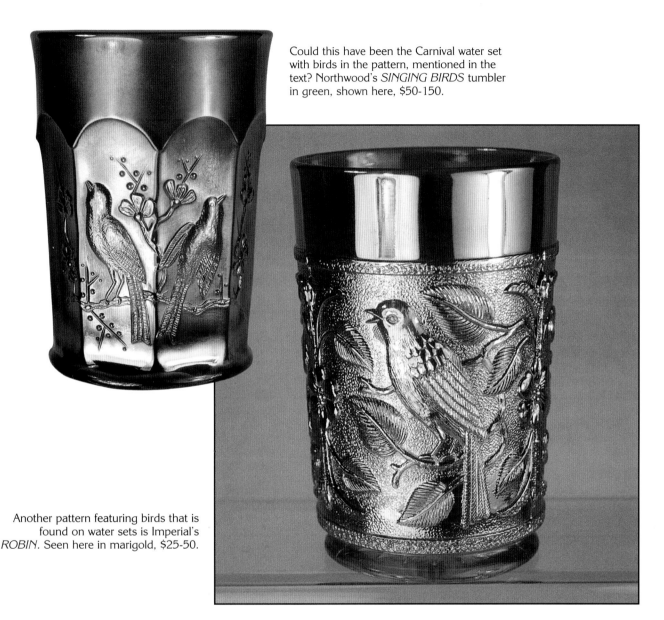

Could this have been the Carnival water set with birds in the pattern, mentioned in the text? Northwood's *SINGING BIRDS* tumbler in green, shown here, $50-150.

Another pattern featuring birds that is found on water sets is Imperial's *ROBIN*. Seen here in marigold, $25-50.

It wasn't long, though, before Carnival began to acquire a clear identity. During the 1960s, through the writings of Marion T. Hartung and Rose M. Presznick, Carnival collecting began to take off and in 1964 O. Joe Olson established the first Carnival collector's club, the Society of Carnival Glass Collectors (SCGC). As more people began to look for Carnival and join clubs that might help them in their quest, more research and writing was soon undertaken on the subject. One of the notable collectors and writers on Carnival in the 1970s and 1980s was the late Don Moore. Don's wife, Connie, told the authors many of her recollections of collecting Carnival with Don. Here's one of her reminiscences from the 1970s.

Back in the seventies, when Don and Connie were living in Alameda, California, people would often call up offering glass for sale. One day Don took a call from

a lady in San Jose who had some Carnival she had finally decided to part with. Not a large collection, mind you—just a single GRAPE AND CABLE punch set. Don made all the necessary arrangements and he and Connie set off, arriving shortly at the lady's condo' in a delightful little residential complex. As they walked inside they were greeted by the sight of a stunning, purple, master GRAPE AND CABLE punch set complete with all twelve cups, sitting resplendently on a table.

The history that the Moores were to learn about the set was extraordinary. The owner explained that it had been in her family for as long as she could remember. As a little girl, she and her sister had lived in New York, where her parents had a bakery store. In the shop, on either side of the entrance door, was a window—and

*majestically displayed within each window alcove was a Northwood master GRAPE AND CABLE punch set—one of which was purple, the other marigold. Every morning, the girls' parents would fill the two punch bowls with delicious cookies—a different kind for each set. When their regular shoppers made their (usually weekly) visits to buy bread, the customers' children would be allowed to go to the punch sets and take a cookie—one from the purple set and one from the marigold set. Throughout the long years that the punch sets remained in the shop, delighting many children, not one chip or bruise ever marred their surface. The children had treated the glass with respect and care (then, of course, it **did** provide them with tasty cookies).*

A magnificent, white, Northwood *GRAPE AND CABLE* punch set. This is the splendid banquet or master size (see Part Two, Chapter Four, "Drinking Vessels") for more details on punch sets. It would have been a set in this size that is referred to in the story told by Connie Moore (see text, this chapter). In white Carnival, this is a rare item that seldom comes up for sale—lucky is the individual who manages to own such a set. In 1995 a nine piece set sold for $8000. In 1997 a fourteen piece set sold for $6500. In 2002 at private sale a thirteen piece set sold for $8500. *Courtesy of Charles and Eleanor Mochel.*

Years later, when the sisters had grown up and moved away, each agreed to take a punch set. Don and Connie were offered the purple one from one of the sisters and naturally, they bought it without hesitation. Connie explained that she and Don treasured it and looked after it for many years (sometimes wondering about the little hands that used to reach inside it to take out a cookie). It was one of the very last pieces that Connie ever sold.

There are Carnival collectors all over the world. Jorge Perri from Buenos Aires, Argentina has also been collecting and dealing in Carnival for many years. He shared with us the story of how it all began for him.

"I am going to tell you how it was that I came into the carnival world. My grandmother had in one of her cabinets a blue carnival centerpiece. I was in that time only five years old and was very interested in that gorgeous glass, so I asked her to give it to me as a present. She answered me: 'You'll inherit it when I am not here anymore.' When I was six years old, my grandmother died and her daughter, my aunt, never gave me the promised piece. Years later, in the quarter in which I live, San Telmo, celebrating the week of Buenos Aires, a flea market was inaugurated. I and a friend of mine installed a stand in that place. It was 1970 and a year later we began with an antique shop just in front of the square in which, every Sunday, was a flea market very well known all around the world. By chance, one of those Sundays, in one of the stands, I discovered a carnival centerpiece exactly like the one my grandmother used to have. I immediately bought it and that was our first important piece of carnival that introduced me into this magical world. During our first years we only bought blue items of carnival and many years later adopted also the marigold color pieces."

Carnival is collected avidly in the United Kingdom and Australia, where there are several organized clubs and associations. In Sweden, *lysterglas* (as Carnival is known there) is collected and displayed at the Eda Glass Museum at Eda Glasbruks in the Varmlands. In Finland, the Finnish Glass Museum has a splendid array of Carnival (*lister lasi*) mainly from Riihimaki, with some also from Karhula-Iittala. Go further afield to India, and you will also find collectors—for the output from Jain, as well as a variety of other makers, is avidly sought (often eventually finding its way into collections in the United States, Australia, and the United Kingdom).

The magic of Carnival Glass collecting has caught people all over the world in its spell. For many, it is Carnival's sheer beauty that enthralls; for some others it is simply seen as a sound investment, while for growing numbers, it is also the historical and social aspects that fascinate too. Above all though, the multitude of patterns, the fascinating array of form, shape, and function, coupled with the crowning glory of iridescence, are together, the Art of Carnival Glass.

Left to right: Brockwitz *SQUARE DIAMOND* (aka *COLUMN FLOWER*) blue vase; Millersburg amethyst *FEATHER AND HEART* tumbler; Millersburg blue *BERNHEIMER BROTHERS* ruffled bowl; Riihimaki blue *STARBURST* tumbler; Karhula *SPINNING STAR* blue vase.

Chapter Three
How Carnival Glass was Made
Moulding the Glass

At its simplest, the equipment used to make press moulded glass consists of a *mould,* a *base* or *bottom plate,* a *top ring,* and a *plunger.* The mould may have two, three, or more moveable or hinged parts, which can be opened to allow the glass item to be removed once it has been pressed. Where these parts join, they cause seam lines in the glass item unless they are later fire polished to remove them. The basic process to make press-moulded glass is that an amount of molten glass (called *hot metal*) is taken from a glass furnace on a *gathering rod* (which is hand-turned in the hot metal to gather it up at one end). The quantity of hot metal gathered up is known as the *gather.* The hot metal is viscous, and it is allowed to drop from the gathering rod into the mould—a worker uses metal shears to cut off the correct amount of hot metal that is judged sufficient to make the finished item. The plunger is pressed down into the mould, forcing the molten glass into it, whilst the base plate and the top ring stop the molten glass being squeezed out. The combination of the mould and the plunger create the basic shape of the glass object as it is taken from the mould (for example a bowl or a tumbler). The mould and the plunger also create the pattern on the exterior and interior, respectively, of the glass item.

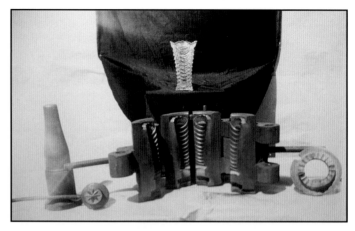

A cast iron mould in the *YORK* pattern, on display at the Magnor Glass factory in Norway. Magnor was a "sister" factory to Eda Glasbruks, the Carnival manufacturer. (Eda almost certainly used this mould back in the 1920s). A crystal vase can be seen on top of the mould. On the left of the photograph is the tall, thin plunger; next left can be seen the small round base plate with a star pattern; in the center is the main mould itself—opened wide; and on the right is the ring that fits on the top.

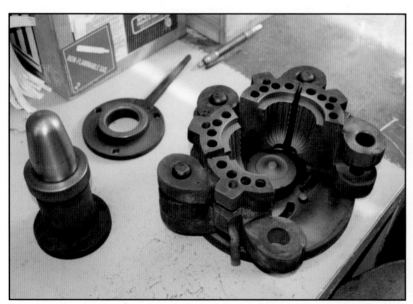

This is a three part, cast iron mould. On the left is the plunger, in the middle can be seen the top ring and on the right, the mould itself.

A marigold Carnival version of the *YORK* vase from Eda Glasbruks. Note this is a slight variant of the one shown in the previous photograph, as this vase has a pedestal base. SP $200-250.

Any design that is cut into the surface of the mould (or the plunger) will appear as the finished pattern in relief (raised up) on the surface of the glass item. This is known as **cameo**. Conversely, where a design is created by cutting away unwanted areas of the mould and thus leaving the desired design raised up from its surface, the resulting pattern will be incised, or cut into the surface of the glass (as in many geometric designs). This is known as **intaglio**.

A blue *ROSE SHOW* plate (Northwood). The pattern is cameo, but note that it is raised up more than the *ROSE SHOW VARIANT* bowl shown on the following page. $600-1000.

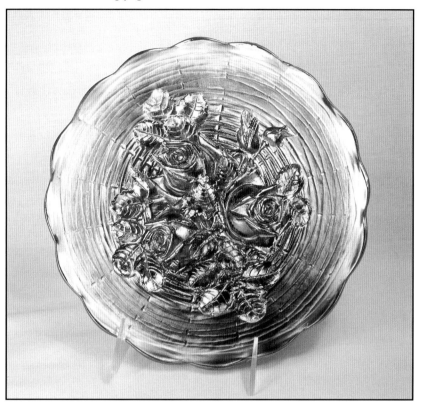

Close-up detail of the roses on the *ROSE SHOW* plate. The depth of mould work is astonishing. The roses are raised up off the surface of the plate in almost sculptural detail. This cameo pattern is surely a masterpiece of the mould maker's craft.

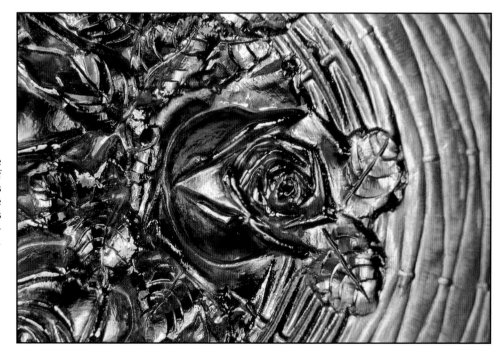

21

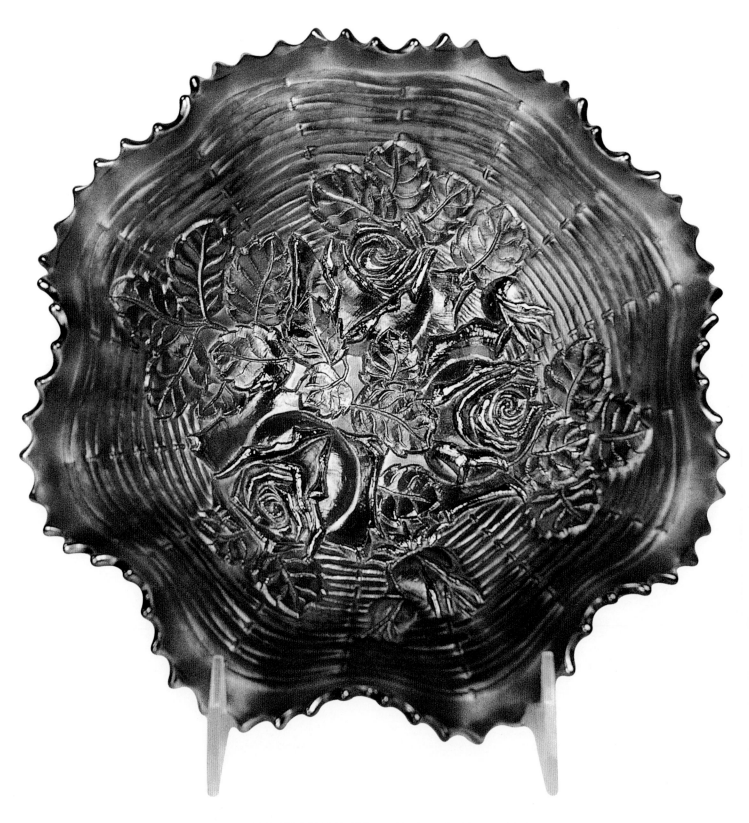

A blue *ROSE SHOW VARIANT* bowl (Northwood). The moulded floral pattern is in relief—**cameo**. $700-1200.

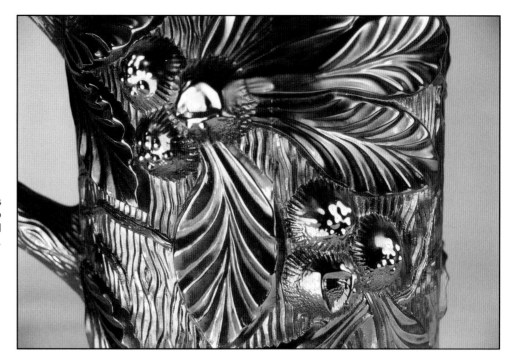

Northwood's *ACORN BURRS* is another cameo pattern. This close-up detail shows the amazing depth and detail of the mould work.

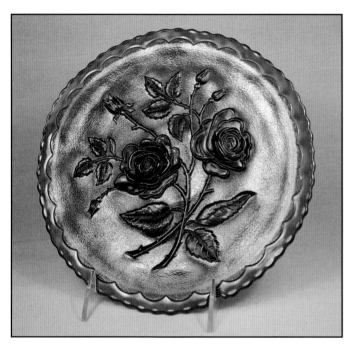

Another rose pattern, this time from Imperial—this is their *OPEN ROSE* plate in rich, vibrant purple. The design is cameo. This pattern is rarely offered for sale in the purple plate shape, but can reach around $2000 in perfect condition. The color makes a big difference to the availability and of course, the price. Marigold, helios, and amber examples are seen more often and their value ranges from $100-200.

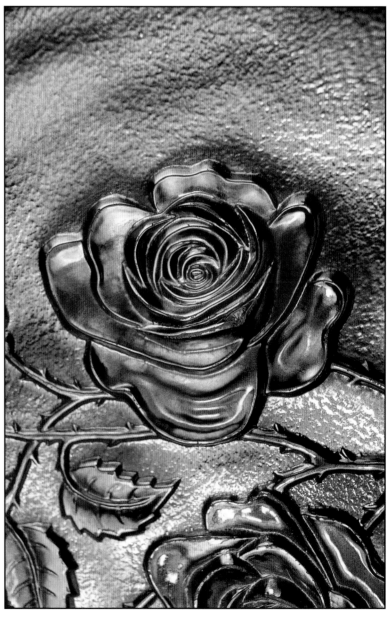

Close-up detail of the roses on the *OPEN ROSE* plate.

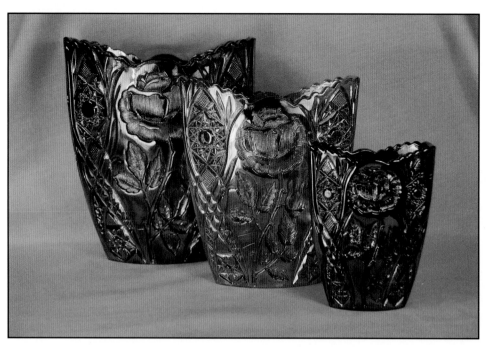

Both Brockwitz (Germany) and Eda Glasbruks (Sweden) made these unusual oval shaped vases in the *ROSE GARDEN* pattern. The beautiful floral and geometric pattern is intaglio on the surface of the glass. SP large size, $5000-6000; mid size, $3000-4000; small size, $1000-2000. It is interesting to note that Riihimaki of Finland made a cut crystal (not pressed) version of the oval *ROSE GARDEN* vase. Shown in Riihimaki's 1930 Catalog A (Cut Crystal) this cut glass vase was given the pattern name "Kaisa 2." The cut crystal version was very similar to the pressed glass version, but there are many significant differences in execution and interpretation. Another cut crystal vase in the same oval shape—"Kaisa 1"—was also shown. It features a different stylized flower that is slightly similar to the Brockwitz *ASTERS* pattern.

Close-up detail of the superb intaglio rose design on the *ROSE GARDEN* vase.

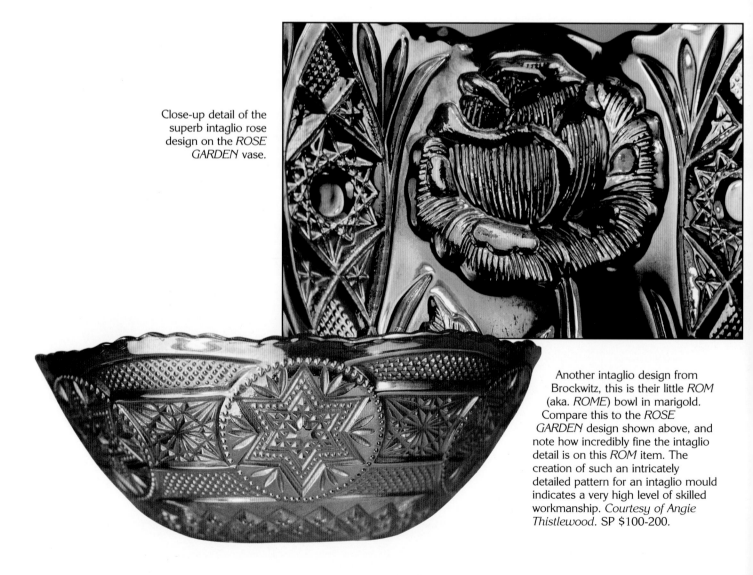

Another intaglio design from Brockwitz, this is their little *ROM* (aka. *ROME*) bowl in marigold. Compare this to the *ROSE GARDEN* design shown above, and note how incredibly fine the intaglio detail is on this *ROM* item. The creation of such an intricately detailed pattern for an intaglio mould indicates a very high level of skilled workmanship. *Courtesy of Angie Thistlewood.* SP $100-200.

The base plate could also have a design, for example, a multi-rayed star, which would then appear on the underside of the marie (collar base) of the glass item. Plungers, moulds, and base plates could be interchanged—thus giving rise to many and varied permutations of the patterns.

Moulded Trademarks

Occasionally, manufacturer's trademarks may be found moulded into the glass. The most well known example of this is, of course, the famous Northwood N mark, that is often seen on the marie of a fair proportion of Northwood's Classic Carnival Glass. (Note that Mosser and L.G Wright used a similar looking trademark for a short while in the 1970s—for details, see the main section on Contemporary Carnival Glass in *A Century of Carnival Glass*[1]. See also the section on Fakes, for Taiwanese use of the N mark). NORTHWOOD in script can also be seen on some scarce examples of Dugan's Carnival. This apparent contradiction came about owing to the fact that Dugan had used some old Northwood moulds (previously used for crystal and opalescent glass) for Carnival production, some of which bore the Northwood script signature. These moulds were acquired by Dugan when he took over the Indiana, Pennsylvania, glass plant from his cousin Harry Northwood.

Northwood's N in a circle underlined.

Several non United States manufacturers also used moulded trademarks. In the 1920s and 1930s, Sowerby in England used a peacock head trademark on some of their Carnival. In Finland, Riihimaki occasionally marked their Carnival with a raised letter R or the full name RIIHIMAKI. They also used a rare moulded trademark showing the outline of a lynx (a trademark of the company). The other Finnish Carnival manufacturer, the Karhula-Iittala combine, also sometimes trademarked their Carnival in a similar fashion, using the raised letters IITTALA or KARHULA, which may be found prominently on the inside or upper face of the glass item. Such markings can be a great help to the researcher when faced with an unreported pattern. The answer to the question "who made it?" is apparently easy to answer when the manufacturer's name is moulded onto the mystery item!

Sowerby's peacock head trademark (left) is sometimes seen moulded into the glass. On the right is a sketch of the seldom seen paper label that was sometimes used by Sowerby.

In the very center of the marie of this item can be seen the moulded Sowerby peacock head trademark. The pattern on the exterior of this small Sowerby bonbon dish is *JEWELLED PEACOCK*. The name actually refers to the peacock head trademark that is usually found in the center of this design. First introduced in the late 1800s, it had the Sowerby pattern #8005. The *SCROLL EMBOSSED* interior (see following illustration) was added in the 1920s when the Carnival versions were made. Sowerby undoubtedly plagiarized the *SCROLL EMBOSSED* pattern from Imperial.

Sowerby's *SCROLL EMBOSSED* bonbon (see previous illustration for more detail)—the four open-work handles are a distinctive feature of this item. $30-50.

25

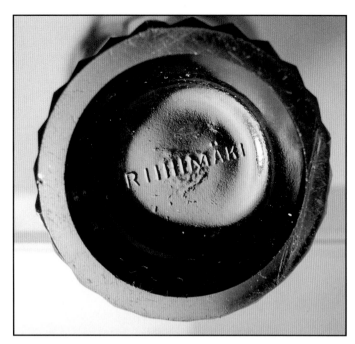

The word RIIHIMAKI is clearly moulded into the base of several examples of the *BISHOP'S MITRE* vase. This is an especially crisp and clear example on blue base glass. Riihimaki was a Finnish Carnival manufacturer.

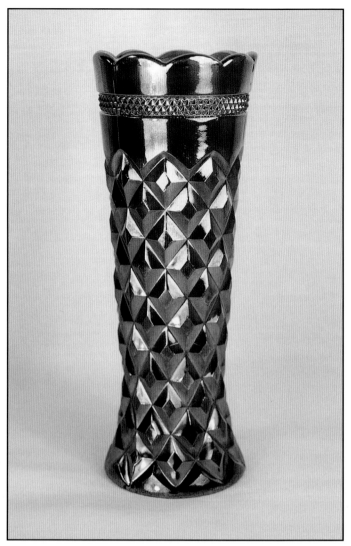

Currently, this is the only known example of Riihimaki's *KAARO* vase (the name given to the pattern in Riihimaki's 1935 catalog; it had the pattern number 5910). This blue example has a splendid, multicolored iridescence that is highlighted by the faceted diamond pattern—simple yet very effective. On the base of the vase is the moulded trademark RIIHIMAKI.

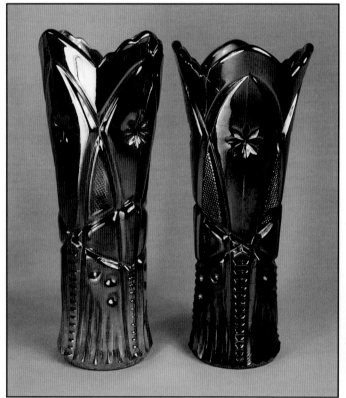

Riihimaki's *BISHOP'S MITRE* vases in marigold (left) and blue. SP marigold $300-500: blue $500-750

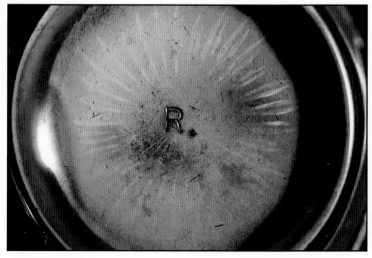

In the center of this ashtray is a letter R followed by a period (full stop). This stands for Riihimaki, the Finnish manufacturer.

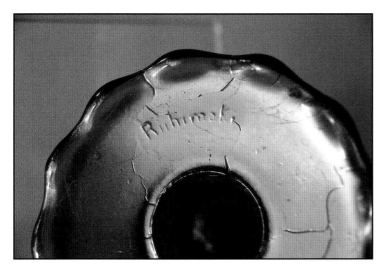

Another moulded trademark for Riihimaki—note the different style of lettering on this one. It appears on the top of some examples of the *FIREFLY* (aka *MOTH*) candlesticks.

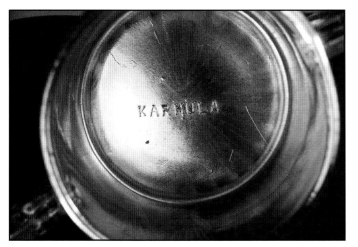

Karhula, another Finnish Carnival manufacturer, also used a moulded trademark on some of their Carnival. The example illustrated here is inside the handled sugar bowl of a rare *KARHULA FOUNTAINS* item (Karhula's #4524 in their 1934 catalog) shown in the following illustration.

Sometimes, however, the story is a little more complex and trademarks can lead to further revelations, as was the case when the authors came across a blue Carnival bowl with the word KAUKLAHTI moulded into the inside. The pattern (named *ALBIAN* by fellow collectors John and Frances Hodgson) was illustrated in the 1939 Riihimaki catalog, so the question was posed—who made the piece, Kauklahti or Riihimaki? The curator at the Finnish Glass Museum at Riihimaki, Kaisa Koivisto, helped us find the answer to the puzzle. Kauklahti was a glass works outside Helsinki that was bought by Riihimaki from Claes Norstedt in 1927. Two Riihimaki catalogs have recently come to light that feature items which were almost certainly made from moulds that originally belonged to Kauklahti—further research carried out by the museum in Espoo, Helsinki, confirms a number of interesting patterns as Kauklahti originals. These pieces would have been made in Carnival, possibly at the Kauklahti factory after it came into Riihimaki's ownership. The patterns make for interesting study, as the seldom seen *ALBIAN* bowl was not the only one that was made using original Kauklahti moulds, a whole range of well known Carnival patterns was also originally from Kauklahti moulds. *WESTERN THISTLE, TIGER LILY, GRAND THISTLE, STARBURST,* and the European version of *FOUR FLOWERS* are familiar designs whose origins are now clearer. Better still, a mystery can now be solved—although long suspected to be Riihimaki, but never with clear catalog proof, the *FIR CONES* pitchers and tumblers can now be confirmed with certainty. *FIR CONES* water pitchers, tumblers, and a range of bowls were illustrated in the 1927 Riihimaki catalog that features moulds acquired through the Kauklahti merger. For more on this line of research, see Part One, Chapter Five, "A Closer Look at How Designs Take Shape."

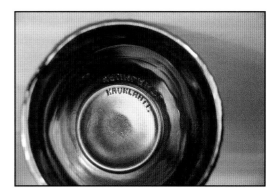

The interior of this blue *ALBIAN* bowl clearly shows the moulded KAUKLAHTI trademark.

KARHULA FOUNTAINS handled sugar and creamer in marigold— currently the only reported examples. SP $90-125 each.

The *ALBIAN* bowl by Kauklahti. SP $100-150.

Probably the lengthiest moulded trademark was employed occasionally by Piccardo of Argentina, as the illustration on the base of the scarce *BAND OF ROSES* goblet shows. Another Argentinean manufacturer, Cristallerias Rigolleau, sometimes used the full company name and address on their glass products. This can be seen on their rare *BEETLE* ashtray and the *CR ASHTRAY*.

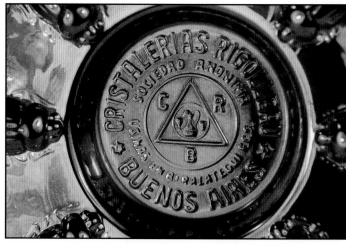

The moulded trademark and lettering on Cristaleria Rigolleau's *BEETLE* ashtray form the pattern itself. The words "Cristalerias Rigolleau. Buenos Aires" surround the very center, where the words "Sociedad Anonima Usinas En Berazategui F.G.S." are written. All the words are moulded into the glass.

A variety of trademarks were used on Indian Carnival. The Jain Company's logo (JAIN in lettering or script) has been familiar to Carnival collectors for several decades, but there are others: Paliwal, CB, SASNI, WEST, PGW, KP, UMM, BM and AVM are all marks that have been found on Indian Carnival Glass. Recent research by Bob Smith and the authors has uncovered a range of small glass companies in the Firozabad and Shikohabad areas of India that were responsible for producing some Carnival Glass. These include the Khandelwal Glass Works of Sasni that was established in 1932, and whose trademark is SASNI, and the Paliwal Glass Works that was established in 1922 in Shikohabad. The other makers include Advance Glass Works, AVM Glass Industries, BM Glass Works, KP Glass Industries, Om Glass Works and West Glass Works. Further details for these glass works can be seen in Appendix One.

Sometimes markings on the glass can prove initially deceptive. Finding a British Registered Design number on an item might suggest the piece was made in the United Kingdom, but this wasn't always the case. Some overseas manufacturers (for example Josef Inwald from Czechoslovakia) occasionally had their designs registered by agents in the UK yet the glass was actually manufactured elsewhere.

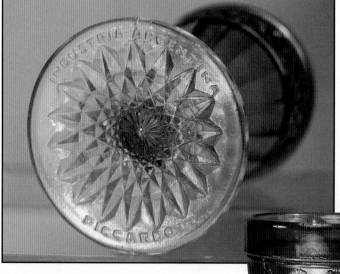

On the base of this rare (so far this is the only reported example) *BAND OF ROSES* goblet are the moulded words INDUSTRIA ARGENTINA and PICCARDO. SP $200-300.

Piccardo's *BAND OF ROSES* goblet. SP $200-300.

Three Indian tumblers, each with a different moulded trademark on its base. From the left: *DIAMONDS AND GRAPES, CALCUTTA DIAMONDS,* and *GRAPEVINE AND SPIKES* (aka *GRAPE AND PALISADES*). Value is hard to assess for Indian items owing to a recent influx of items from the sub-continent. The range varies widely from around $30-150.

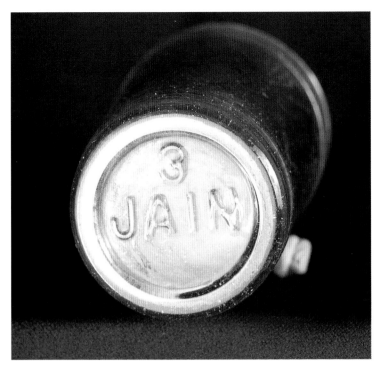

This is the JAIN trademark with a number 3 above it, as seen on the base of the *DIAMONDS AND GRAPES* marigold tumbler.

These two Indian tumblers are both made from very thin glass and have delicate and rather intricate designs. Both have the moulded word "Paliwal" on their base, in different lettering. On the left, the tall *STARS OVER INDIA VARIANT (FLOWER BAND)* tumbler has PALIWAL written very faintly in block letters. On the right, the delicate *GANGES GARDEN* tumbler in rich pumpkin marigold has Paliwal written in script (see following photograph). Both of these were trademarks of the Paliwal Glass Works (Shikohabad, India). Either tumbler $75-150.

CALCUTTA DIAMONDS has the moulded letters AVM on the base. This was the trademark of AVM Glass Industries of Firozabad, India.

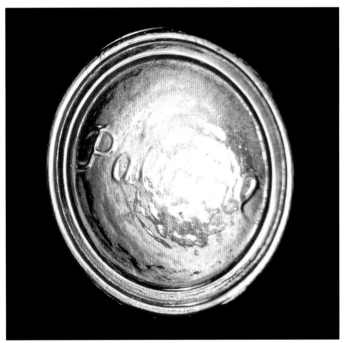

"Paliwal" in script is written on the base of the *GANGES GARDEN* tumbler.

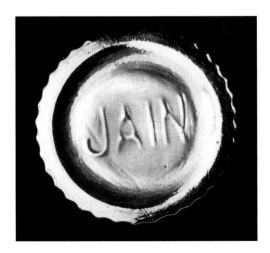

The moulded JAIN trademark on the base of the *GRAPEVINE AND SPIKES* (aka *GRAPE AND PALISADES*) tumbler.

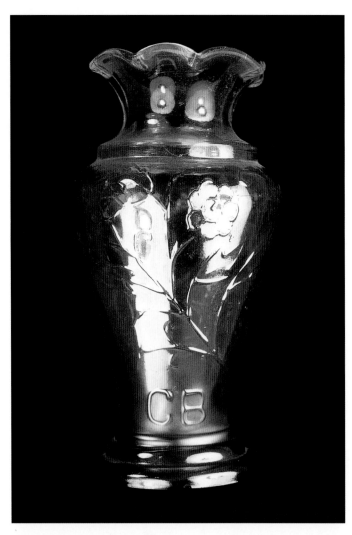

CB moulded in large capital letters can be seen on this vase, indeed almost appears to be part of the design. Its prominence led collectors to name this vase the *CB VASE*. $70-100.

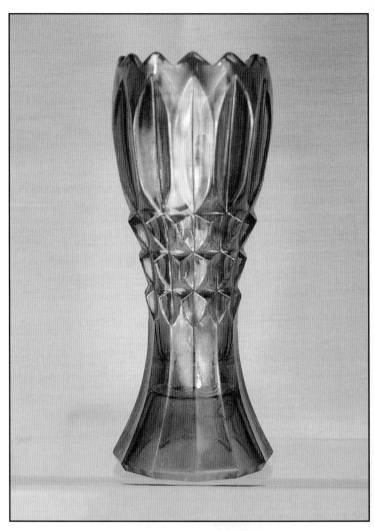

This rare, 6 inch high, Inwald vase has a magnificent, pumpkin iridescence (typical of the high quality workmanship of this Czech manufacturer)—it was named *PRINCETON* in the 1990s, but shortly afterwards the authors came across the original, contemporary name for it: *CORONET*. $550-650.

The same two letters—CB—are also found on some of the *ELEPHANT* vases, causing speculation that maybe CB is the name of an Indian glass manufacturer. The vase on the right, however, has the word JAIN moulded in it. Either *ELEPHANT* vase $50-150. Note that a few years ago (before the current dilution of the market by the influx of imported goods) these vases were selling in the $500-800 range.

On the side of the base of the *PRINCETON* aka *CORONET* vase is the moulded lettering: Regd. No. 735621. This is a British registration number, not surprising as Inwald registered a number of their designs in the UK—seems it gave a certain *cachet* to the glass to be thus numbered.

In more recent times, moulded trademarks have been employed on Carnival issued by Fenton and Imperial, amongst others. Introduced from the 1960s onward, such marks denote Contemporary production by those companies. This helps to differentiate, for example, the old Classic Fenton output (unmarked) from the modern output (trade marked). For further details on trademarks, see *A Century of Carnival Glass*[1].

The Fenton name is clearly moulded on the back of this *CRAFTSMAN* plate from Fenton, dating from the early 1980s. Fenton began to use this oval trademark in the 1970s.

The Fenton logo as seen on the paper sticker on the *GARDEN OF EDEN* plate.

The IG trademark (for Imperial Glass) can clearly be seen moulded onto the base of the *SWAN* salt. This was used from the mid 1960s until 1972, when they made a deal with Lennox to become a wholly owned subsidiary of Lennox Inc. The trademark was changed to LIG (Lennox Imperial Glass).

31

When Arthur Lorch took over the Imperial company in 1981, the trademark was re-cut to read ALIG (Arthur Lorch Imperial Glass).

Northwood in script is moulded into the base of items from the new Northwood Art Glass Company (owned by David McKinley, the great nephew of Harry Northwood). The item on which this caption appears is the *DOLPHIN* footed compote in cobalt blue, made in 1999.

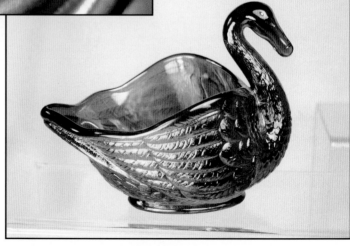

Imperial's amber *SWAN* salt, produced during the early 1970s. $30-50.

These two lovely items from the new Northwood Art Glass Company (made for them by Fenton) show the regular *DOLPHIN* compote (left) in cobalt blue and the whimsy rose bowl shape in lavender. Blue compote $75-100. Lavender whimsy $100-150.

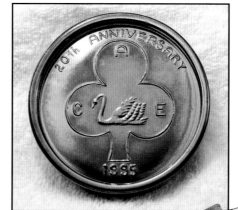

A souvenir commemorative made by Fenton for the Australian Carnival Enthusiasts (ACE) 20th anniversary in 1995. This item is in black amethyst and features the Australian Swan. $20-40.

A paper label that has survived many decades— this is the trademark of the Elme Glass Company, a Swedish glass manufacturer. Elme made a small amount of Carnival Glass in the 1920s and 1930s, several examples of which have been found with paper labels still intact.

Coloring the Glass

When you look at a piece of Carnival Glass, the color that you see is usually a combination of two things: the base color of the glass and the effects of the iridescence. To determine the base color, hold the item up to a good source of light and try to look at the glass at a point where there is no iridescence, such as a collar base or foot. The base color will determine what the Carnival Glass color will be categorized as (for example, blue, purple, and so on). The most notable exception to this rule is marigold, which is a surface treatment applied to clear glass. Do note, however, the color of any glass object may be altered owing to the light source used to view it. Daylight is the best way to view glass for consistency, since fluorescent light can change the visual appearance of the color of glass quite markedly.

Marigold is the most frequently found Carnival color, and is possibly the one most associated with Carnival Glass. The orange coloring comes from the metallic salts in the iridescence and not the base glass, which is actually clear. The stem on this marigold *STREAM OF HEARTS* compote (Fenton) can be seen to be clear glass (and is not iridized). $100-200.

33

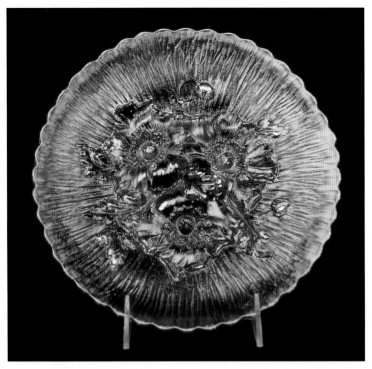

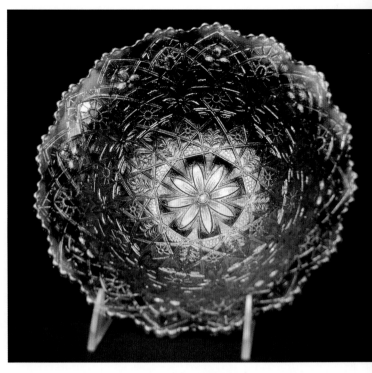

Marigold has many "moods." It can be pale and silvery, pastel and full of colored highlights, or glowing with pink tones. One of the most sought after marigold effects is pumpkin marigold. This is characterized by deep and intense pink, red, and purple overtones in the iridescence—it's a rich and magnificent effect that nudges up the value. Here's a Northwood pumpkin marigold *POPPY SHOW* plate. In November 2002 a dark pumpkin plate like this one pictured sold for $2800.

Smoke is usually on clear base glass too (there are exceptions, as smoky iridescence can be found on grey or grey-blue base glass too). This is Imperial's *HATTIE* bowl in smoke. It's an interesting design, as the exterior pattern is identical to the main interior design (usually in perfect register). $80-120.

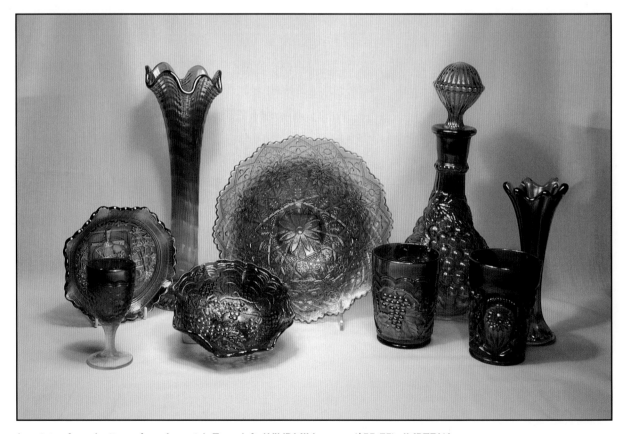

A variety of smoke items from Imperial. From left: *WINDMILL* sauce ($55-75); *IMPERIAL GRAPE* wine glass ($45-65); *RIPPLE* swung vase ($150-250); *IMPERIAL GRAPE* sauce ($45-65); *HATTIE* bowl ($80-100); *IMPERIAL GRAPE* tumbler ($80-120); *IMPERIAL GRAPE* decanter ($250-350); *FASHION* tumbler ($80-120) and *MORNING GLORY* small size vase ($80-120).

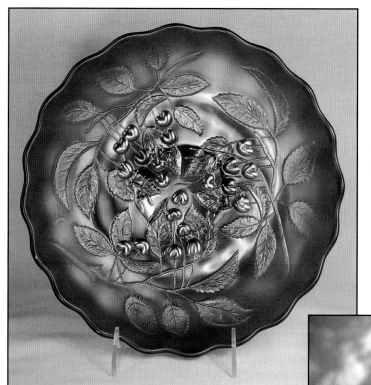

Millersburg's *HANGING CHERRIES* aka *CHERRIES* large ice cream bowl in green with a satin iridescence with lots of blue and purple highlights. $300-500.

Hold your Carnival Glass to a good source of light to determine its base color. This is the same Millersburg *HANGING CHERRIES* aka *CHERRIES* large ice cream bowl as shown in the previous photograph—note the green base color.

This is red—and there's no mistaking it. A bright, "stop light" red when held to the light (this sunny day was perfect, but be careful never to look directly at the sun when you view your glass this way). This is Fenton's 7 inch *PEACOCK TAIL* bowl. SP $2500-3000.

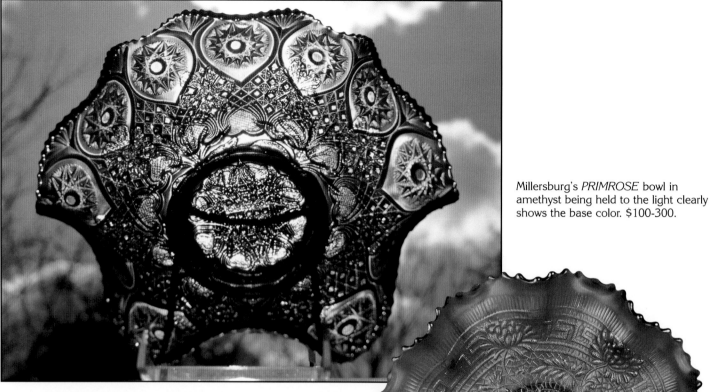

Millersburg's *PRIMROSE* bowl in amethyst being held to the light clearly shows the base color. $100-300.

The intensity of the perceived color also depends on the thickness of the glass and the concentration of colorant in the glass. Thick colored glass will appear darker or more strongly colored than thin glass of exactly the same composition. Perception may also play a significant part in determining base color—Riihimaki's pink, for example, is very close to paler shades of their amber color (selenium was the coloring agent used). The final choice—pink or pale amber—is in the eyes of the beholder.

The basic constituents of all glass are silica sand, soda ash, and lime, which are mixed together to produce the glass batch. These raw materials plus various other substances such as glass cullet (broken glass) or various chemicals (usually metal oxides) are mixed together and then heated in the furnace to a very high temperature—about 2500 degrees Fahrenheit—causing it to become a workable, molten, viscous fluid—sticky like hot taffy. This is the hot metal referred to above.

The color of the glass is a product of its chemical composition. This is determined by the elements (usually transition metals) that have been added to the glass batch. Here are some of the means by which the basic colors can be achieved (note, unless otherwise stated, the metal compounds added are usually used in the form of metal oxides).

Blue is made by the addition of either cobalt, iron, copper, or vanadium.

Blue-green shades are made by the addition of copper.

Green is made by the addition of either chromium, copper, iron or vanadium, or rare-earth metals such as praseodymium.

Purple is made by the addition of either manganese, nickel, or the rare-earth metal neodymium.

Northwood's cobalt blue is a rich and vivid base color. Here it is seen on an *EMBROIDERED MUMS* ruffled bowl. $300-700.

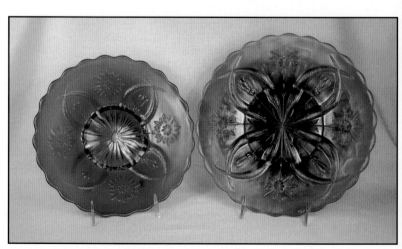

The mysterious *FOUR FLOWERS VARIANT*—(the maker is still not determined, although the authors believe that Sowerby is a possibility). Some interesting base colors are known in this pattern: here are two plates—on the left, a 9 inch plate in a jade or teal green—on the right, a rare 11 inch chop plate in emerald green, loaded with blue and green highlights. Teal 9 inch plate $350-500. SP Emerald green chop plate $1000-2000.

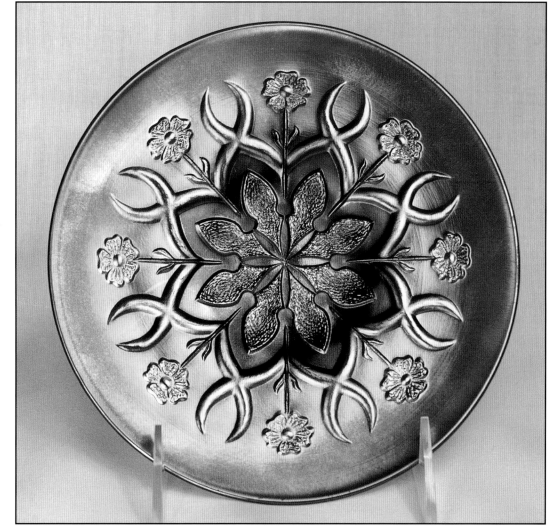

This pretty *WISHBONE AND SPADES* (Dugan/Diamond) small, smooth edged plate is amethyst. The base color of amethyst is actually a light pinkish purple. $400-600. Note, a similar plate sold in 2002 for $875.

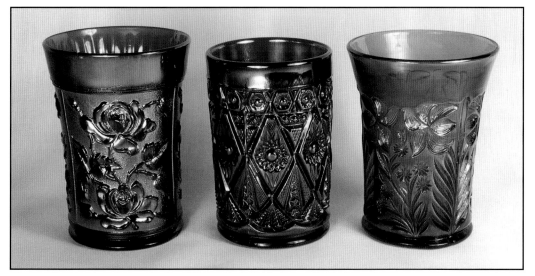

Three tumblers from Imperial that all come under the generic group of purple, yet the base color and iridescent effect varies tremendously on them. On the left, a delicate amethyst base glass with an electric green-blue iridescence on a *LUSTRE ROSE* tumbler. $50-150. Center, a rich purple base color and vivid purple-blue iridescence on a *DIAMOND LACE* tumbler. $50-80. Right, a delicate lavender base color and blue-lavender iridescence on this pretty *TIGER LILY* tumbler. $200-300.

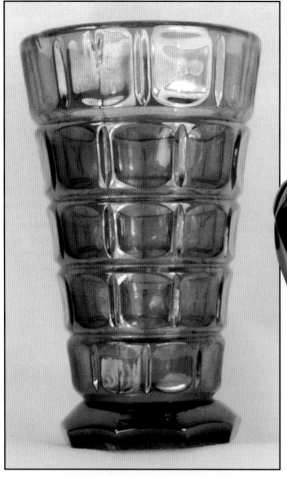

A common misconception is that Carnival from Europe was only made in two colors—marigold and blue. Not so! Here's a delicate purple vase from the Swedish manufacturer Eda Glasbruks. The pattern is *REX* and this vase stands 5 inches high. SP $600-800.

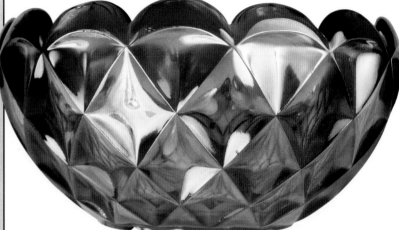

Here's another piece from Eda, this is the *SVEA* bowl in rich purple with a magnificent purple-blue iridescence. Eda's purple is generally very impressive and loaded with color effects in its iridescence. SP $300-500.

Red is made by the addition of the non-metal selenium (note this is for press moulded red) and cadmium sulfide. Red can also be produced by the addition of gold.
 Vaseline (yellow-green) is made by the addition of uranium.
 Brown and **Amber** are made by the addition of manganese with iron or titanium. Other colorants are the non-metal sulfur and carbon or iron with sulfur or selenium. Titanium and cerium give yellow-browns.

Two red items made by Fenton. On the left, a ruffled *HOLLY* hat shape, $250-650. On the right, a *HOLLY* compote in red that shows the typical shading to amberina on the stem. $600-1000.

This *IMPERIAL GRAPE* tumbler in amber from Imperial has a wonderful purple iridescence. $250-500.

The Czech manufacturer Rindskopf also used amber as a base glass, as this *STIPPLED DIAMOND SWAG* stemmed sugar bowl proves. SP $100-150.

The *LIGHTNING STARS* tumbler in amber from the Finnish maker, Riihimaki (note, this tumbler, and the *FLASHING STARS* tumbler, both match up with the *FLASHING STARS* pitcher). Amber was used by Riihimaki fairly frequently—the iridescence varies from a typical marigold effect to a superlative, electric purple-amber effect. SP $200-400.

Pink is made by the addition of the non-metal selenium or the rare-earth metal neodymium—in Scandinavia, selenium and cadmium sulfide were used together in the batch to produce pink.

Yellow is made by the addition of sulfur, nickel, cadmium sulfide, chromium, or iron.

Black is made by the addition of cobalt with copper, or manganese—or simply by adding a lot of colorants together.

Opaque (white) milk glass is ordinary glass with the mineral feldspar added to it, which is an aluminum silicate.

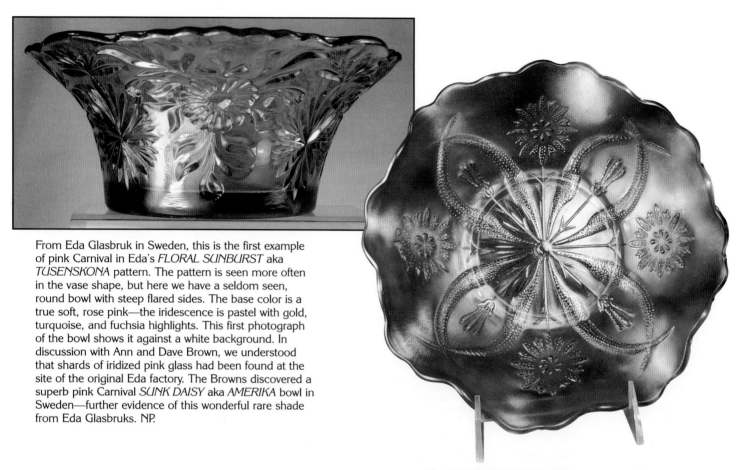

From Eda Glasbruk in Sweden, this is the first example of pink Carnival in Eda's *FLORAL SUNBURST* aka *TUSENSKONA* pattern. The pattern is seen more often in the vase shape, but here we have a seldom seen, round bowl with steep flared sides. The base color is a true soft, rose pink—the iridescence is pastel with gold, turquoise, and fuchsia highlights. This first photograph of the bowl shows it against a white background. In discussion with Ann and Dave Brown, we understood that shards of iridized pink glass had been found at the site of the original Eda factory. The Browns discovered a superb pink Carnival *SUNK DAISY* aka *AMERIKA* bowl in Sweden—further evidence of this wonderful rare shade from Eda Glasbruks. NP.

The *FOUR FLOWERS VARIANT* is also found in this rare yellow base glass—the iridescence is pastel and has an almost frosty appearance. SP $200-400.

Eda's *FLORAL SUNBURST* aka *TUSENSKONA* bowl in pink is seen here against a black background. NP.

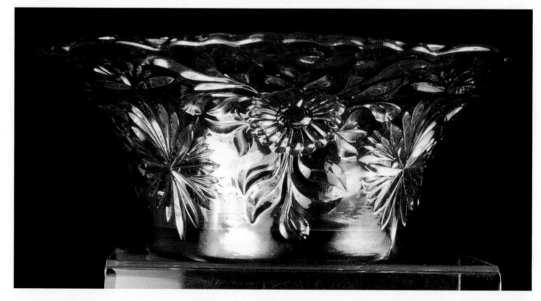

True black is a seldom-seen base glass color, but this example is from Sowerby. When this item is held to a bright light source, a dense black is observed with no trace of purple. The pattern is *PINWHEEL* and the unusual shape is actually a sugar bowl.

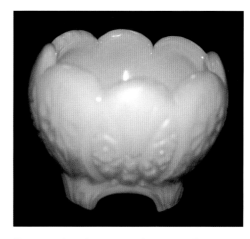

Opaque white (as opposed to clear glass with a frosty iridescence) is rare. This example is from Eda Glasbruks and is the color the Swedes term *parlemorlystrad*. The pattern is *SUNK DAISY* aka *AMERIKA*. NP.

Persian blue is a rare and beautiful base glass color. This *PEACOCK AND URN* bowl from Fenton is an excellent example of the color—the semi-translucent, light blue glass can be seen on the collar base. The iridescence has a bronze effect. $1000-2000.

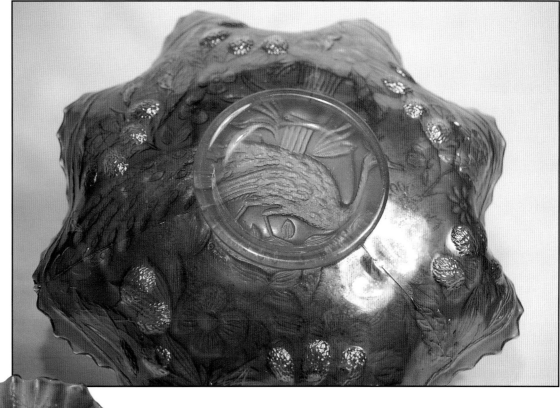

A *HOLLY* 3 in 1 edge bowl from Fenton in a very rare color for this item, marigold over milk glass. The base glass is opaque white milk glass, the rich marigold iridescence almost masks it, but look at the edges. Only two bowls are known in this color, with this edge treatment. SP $2000-2250. *Photo courtesy of Randy and Jackie Poucher.*

41

Striking

Striking is a fascinating technique used to achieve a special color effect. It relies on the introduction of chemicals to the glass batch that will ultimately change the color of part or all of a glass item, when that portion of the item is reheated. The process was named "striking to another color," or "striking" for short. Technically, striking is when the crystalline structure of the coloring agent alters upon controlled re-heating.

A good example of how striking affects the color of glass is in the highly sought after Carnival color, red. Shades of cranberry and ruby red can be made by the addition of gold, however, a breakthrough came with the addition of selenium to the batch in the 1920s that produced a bright cherry red color when the temperature control was exactly right.

Pressed red is a difficult color to achieve with absolute uniformity as it is notoriously difficult to strike. When selenium red is taken from the hot glass batch it is red. However, when it is then pressed in a mould, its color becomes yellow. Subsequent re-heating causes the yellow color to change back to red—technically, what happens is that the crystals within the glass are made smaller by pressing—this causes the color change to yellow. They are then made larger by controlled re-heating, which in turn causes the yellow color to become darker and go back to red (strike).

It's not unusual to find a yellow shading on red Carnival Glass where the heat has not been great enough on that portion of the item being made. The shading into yellow is called amberina. Standard amberina is where the outer edges of the piece are red but as you look toward the center of the item you see an increasing amount of yellow. Reverse amberina is the opposite way round—the yellow tones are to the outer edge of the piece.

Fluorescence

Fluorescence on Carnival is an interesting topic. Some Carnival will glow when an ultra violet (UV or "black") light is shone onto the glass. (This can be seen to great dramatic effect in the dark). Vaseline glass, characterized by a yellow-green base color, is colored by uranium oxide—a very low level radio-active substance. The iridescence is usually marigold, which tends to mask the yellow-green effect of the base color. Rarely, the iridescence is a light pastel effect (usually from Northwood and Millersburg) that allows the base color to be seen readily. When a UV light is shone onto vaseline glass (pick the least iridized part of the glass and go somewhere away from bright lights, ideally total darkness for the best effect) it glows a vivid, transparent yellow-green. When you first see the effect, it can be a surprise, as it is so bright.

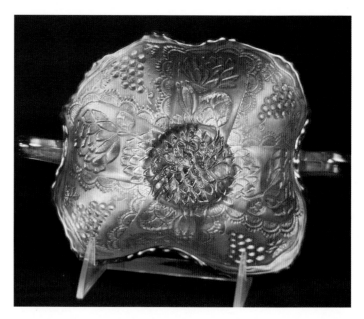

Fenton's *LOTUS AND GRAPE* handled bonbon in vaseline Carnival. It's virtually impossible to discern the light yellow-green base glass color from this frontal view because the heavy, bronze-marigold iridescence masks it. $150-250.

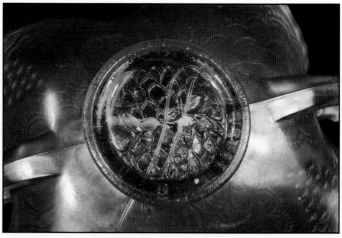

The collar base of the vaseline *LOTUS AND GRAPE* bonbon shows the characteristic light green coloring.

A dramatic illustration of vaseline Carnival Glass taken in the dark, under ultra violet ("black") light. This is Northwood's *CONCAVE DIAMONDS* tumbler in vaseline. $125-150.

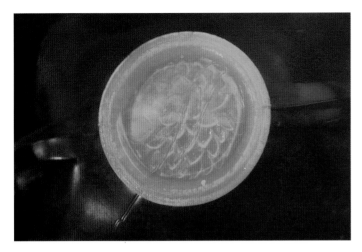

When the room is darkened and an ultra violet light is shone onto the collar base of the vaseline *LOTUS AND GRAPE* bonbon, it glows vividly.

Some Carnival may have an orange glow under UV light. The main coloring agent that causes this is cadmium, usually in the form of cadmium sulfide. The fluorescence can vary from a citron yellow through to a dark red. Cadmium was often added to the batch along with selenium to create red glass. You may note how the amberina sections of amberina/red glass glow. Why? Red glass is re-heated to strike the color—until the moment of striking the selenium/cadmium red glass will react with UV light and glow. But as soon as the red color appears, the fluorescence vanishes.

Opalescence

The addition of bone ash to the glass batch produced opalescence. When this was re-heated in the glory hole, the glass took on a white pearl-like effect on the outer edges and sometimes also on thicker or protruding parts of the pattern. The opal effect can vary from a delicate and fine hint of opal (as seen on some of the rare Fenton examples) to a denser, broader effect (as seen on most Dugan/Diamond examples). These contrasts were probably caused by the different methods of re-heating employed by the various Carnival manufacturers. When the opal effect occurs on clear glass with marigold iridescence it is known as peach opal; when it occurs on light blue-green glass it is known as aqua opal. These are the two main examples of opalescent finishes, but there are other rarer opalescent colors such as amethyst opal.

Seldom seen, this ruffled Fenton *THISTLE* bowl has a strong vaseline base glass. $200-400.

Two peach opalescent (opal) items: on the left is a banana boat shape from Dugan/Diamond in the *SKI STAR* pattern with *COMPASS* exterior $100-200; on the right is a ruffled bowl from Fenton in the *PEACOCK AND GRAPE* pattern $400-500. Note that a pumpkin marigold peach opal *PEACOCK AND GRAPE* bowl sold for $1000 in 2000.

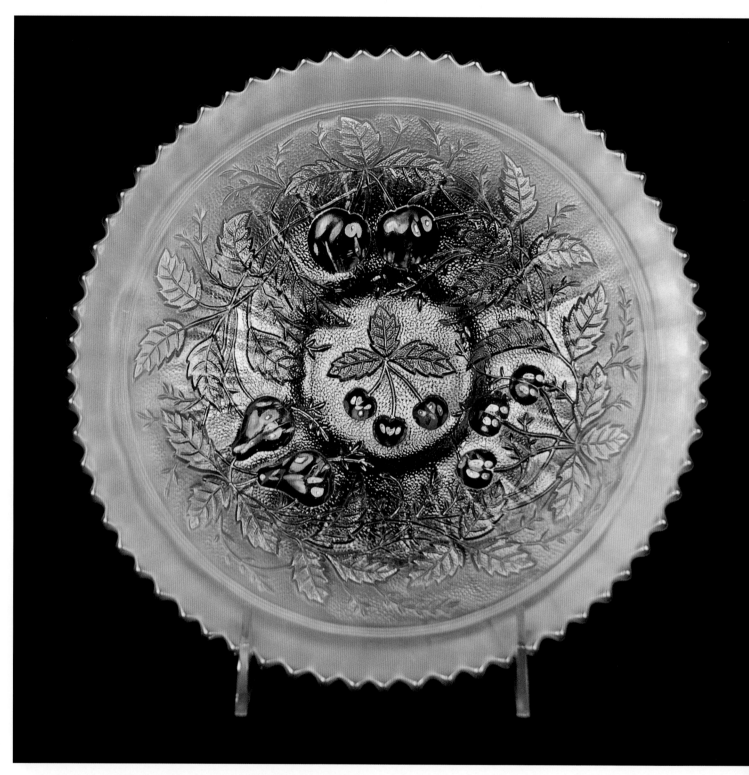

Northwood's *THREE FRUITS* plate in aqua opal with a wonderful,
pastel iridescence that is enhanced by the stippling on the pattern.
A truly beautiful and sought after item. $4000-8000.

Two very different vases from Dugan/Diamond in peach opal. On the left, a *THIN PANEL* vase with a splendidly ostentatious, tightly crimped, jack-in-the-pulpit mouth. $100-150. On the right a slightly swung *LINED LATTICE* vase. Note how the white opalescent tips accentuate the peaks on the pattern. $250-500.

Northwood was the master of aqua opalescent Carnival—this is the *ROSE SHOW* ruffled bowl in aqua opal with a butterscotch iridescence. $800-1500.

Fenton also made aqua opal in recent decades. This is their contemporary production of aqua opal seen on a *BUTTERFLY AND BERRY* ruffled edge vase. $50-75.

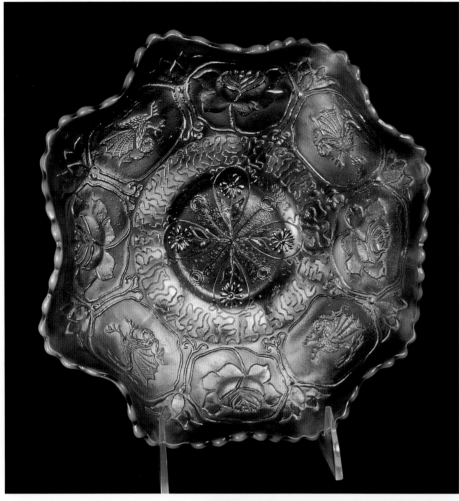

Fenton also made some aqua opal Carnival, but it was scarce and usually only had a gentle hint of opalescence around the edges. This rare *DRAGON AND LOTUS* ruffled bowl has an aqua opal base glass and a bronze-green iridescence—the opal edge is clear and defined. $2000-4000.

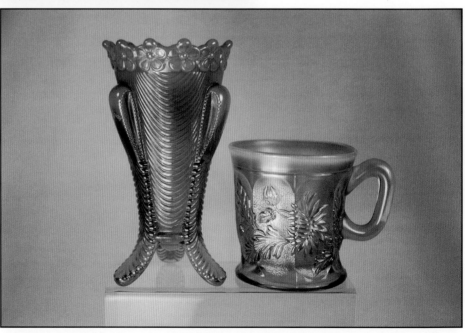

A *DAISY AND DRAPE* vase and a *DANDELION* mug, both in aqua opal, from Northwood. $500-800 for the vase, $300-800 for the mug.

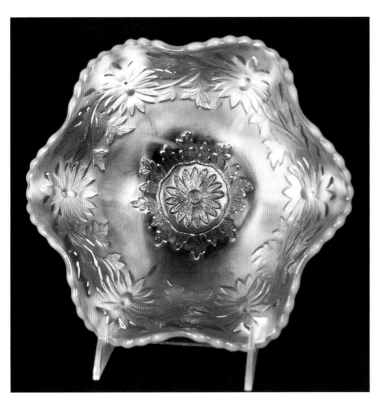

Westmoreland's blue opal *DAISY WREATH* bowl. $200-400.

Multicolored base glass—Slag Glass

Slag glass is an unusual type of glass, made by mixing two different colors in the hot glass batch (one being opaque white). In the glass making region of the north east of England, back in the 1800s, slag (a waste product from iron works) was sometimes added to the glass mix. However, the end result was not what we refer to as slag glass today—it was something entirely different. To illustrate, here's a quote from Sowerby's "Recipe Book 1802 - 1832" that will explain. On 28th December 1805 Sowerby's Recipe Book stated that "Slag from Iron Foundry" was introduced into a "Red Opake" glass mix. Sowerby's own advertisements make it clear that their slag glass was a separate color that actually looked black, but was in fact made from a dark bottle green or deep purple glass with the addition of slag waste. They would mix iron slag with the other raw materials in the batch—but this was not common, nor did they use that method of coloring their glass for very long. The pressed glass companies were situated in the north east of England, around Newcastle-upon-Tyne which was—and is—a very industrialized area with plenty of iron works around.

However, this slag glass was not what we mean today by the term. Over the years it was corrupted to mean the type of glass that Sowerby's originally called "Malachite." (Malachite is a stone which is usually found featuring bands of black through its beautiful green background—it gets its name from the Greek word *Malake* meaning "mallow" which refers to its low hardness as a stone). In glass terminology it refers to a range of variegated colored ware e.g. brown, green, blue, black, grey glass that was made by mixing one of those colors of glass with white glass. Sowerby's own differentiation between the terms is shown in this 1885 Sowerby ad for "Vitro-porcelain, Patent Queen's Ware, Green and Blue Malachite, Blanc de Lait, Tortoiseshell, Slag Glass etc." So, what we call slag glass today, was that marbled and variegated glass which Sowerby's originally referred to as Malachite.[2]

Rare examples of iridized slag glass are known in the United States. Northwood produced very scarce examples of iridized blue slag known as "Sorbini"—pieces known in this color are the *PEACH* water pitcher, the *TREE TRUNK* vase, and the *PEACOCKS* bowl. Purple slag is also known in the *ACORN BURRS* water pitcher pattern (as a

point of interest, noted collectors Lynda and Don Grizzle who have owned the aforementioned slag pitchers point out that both were marked with a double circled N mark). Fenton made a very few examples of red slag, a cherry red color with swirls of darker shades of glass, which has been found in such patterns as *PEACOCK AND GRAPE* and *HOLLY*.

In April 2002, the first example of iridized slag glass made by a manufacturer outside the United States was discovered. Found in Finland, the item is a *STARBURST* nut bowl or sugar bowl, made by Riihimaki. The iridescence on the bowl is a rich butterscotch, loaded with pinks and golds. The base color is an astonishing mixture of opaque white and grey-brown swirls. Possibly an experimental item, this is currently the only example known. Examples of purple and white slag (not iridized) by Riihimaki are on display at the Finnish Glass Museum.

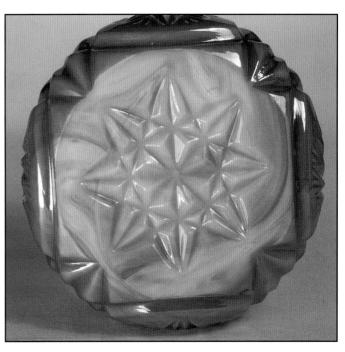

The base glass color of this Riihimaki *STARBURST* incurved sugar or nut bowl is the only reported example of iridized slag glass produced outside the United States. This illustration of the uniridized bottom of the bowl clearly shows the opaque creamy white color of the glass, and the brown marbled swirls that run throughout it. In discussion with Kaisa Koivisto, the curator of the Finnish Glass Museum at Riihimaki, we believed that it was possibly an experimental product. (Riihimaki are known to have produced un-iridized purple slag glass). NP.

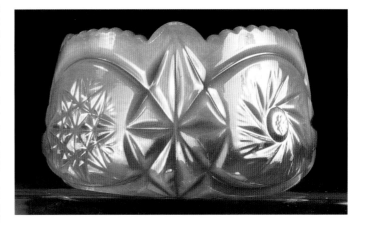

The iridescence on the iridized slag *STARBURST* sugar or nut bowl from Riihimaki is a rich butterscotch. NP.

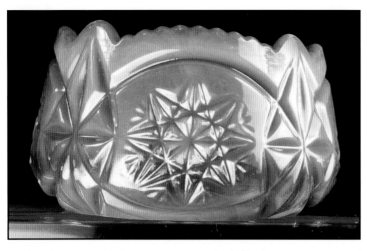

Another aspect of the star pattern on the iridized slag *STARBURST* sugar or nut bowl. NP.

Iridizing the Glass

The essence of Carnival—iridescence! An ever-changing, shimmering play of color—a dancing rainbow of light—encasing the beauty of the glass. So, how is this characteristic iridescence created? Simply put—hot glass is sprayed with a liquid solution of various metallic salts. These solutions are called "dope" by the glassmakers, and the process is known as "doping." The liquid evaporates to leave a finely ridged, metallic film on the surface of the glass that can split ordinary daylight into the spectrum of colors in a rainbow effect. This iridescence is what distinguishes Carnival Glass from other press moulded, colored glassware.

Different chemical solutions produce different iridescent effects. Iron (ferric) and tin (stannous) chloride, or a combination of the two, were the most frequently used in the past—today, strontium sulfate may also be used. Sometimes the hot glass was sprayed more than once, with varying metallic solutions, giving interesting effects. The temperature of the glass when it is sprayed also has an effect. If it is very hot, the iridescent effect becomes matt or satin like. If it is not quite so hot, the effect will be shinier. A matt effect is generally known as satin iridescence, while a multicolored, mirror-like effect is often called radium. For more on this, see the section on "Iridescent Effects" below.

Note that shaping took place before the glass was iridized. Further manipulation after iridization meant that minute breaks would occur in the surface of the iridescence. This was, however, intentionally done in certain instances, as it created the effect often termed as "onion skin" iridescence that is found on stretch glass and some rare Carnival examples such as Fenton's celeste blue. The stretch effect was created by spraying hot glass with the metallic oxides that were used to give the iridescent effect, then the glass would be briefly reheated in the glory-hole, the hottest part of the furnace. The spray—being metallic—didn't expand at the same rate as the glass, causing the iridescent effect to break into the onion-skin like surface, producing a beautiful rainbow effect.

There were many variables involved in the doping process. In addition to the chemical mixture being applied and the temperature of the glass, another variable that altered the effect of the iridescence was the different thickness of the glass itself. Some Carnival patterns are quite deeply moulded, and the differences in thickness of the glass resulted in differential cooling. The metallic salts in the iridescence were affected by this, and consequently we can see different iridescent colors on the surface of the glass created by the pattern. Not all Carnival has this effect, but seen at its best, a design composed, say, of plump grapes on a background of leaves may be seen with deep purple grapes against a greenish, purple background.

Another method of enhancing the iridescent effect on the glass was to add **stippling**. Stippling gives the impression of a covering of fine dots over the surface of the glass, in what would otherwise be blank areas of pattern. The texture of stippling catches the light and increases the appearance of the iridescence. Some Carnival designs are known in both stippled and non-stippled versions—the former are usually more sought after.

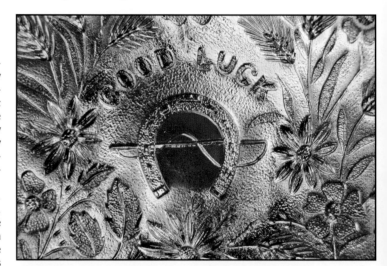

Stippling enhances iridescence. Compare this detailed view of a stippled *GOOD LUCK* bowl with the next photograph of an un-stippled *GOOD LUCK* piece.

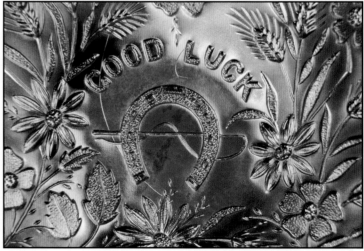

This un-stippled *GOOD LUCK* plate catches the light far less than the stippled *GOOD LUCK* piece in the previous photograph.

In close-up, the iridescent stretch effect ("onion skin") can easily be seen on this cobalt blue *GOOD LUCK* bowl from Northwood.

Some Carnival Glass items, such as pitchers and tumblers, were often sprayed only on the exterior, while most bowls and plates were usually iridized both inside and out. It was, of course, necessary to hold the item while it was being sprayed. The snap was the tool used for the job—being clamped firmly onto the marie of the glass item with jaws of the correct size and shape to hold the piece. As the snap covered the marie during spraying there was, obviously, no iridescence on the collar base of the glass. This has an interesting sideline: modern reproduction items, and indeed some fakes, may well have iridized bases as their different method of manufacture allows for the iridescent spray to be applied to the marie as well. However, note that many European Carnival items made in the 1920s and 1930s may also show traces of iridescence on the base. This is due to the fact that the method of manufacture was slightly different in that a snap was not used to hold them, but instead they were grasped by the "stuck up" method whereby the base of the item was stuck with molten glass to a punty rod. This was then broken off and the base of the item ground flat. For further explanation see Part Two, Chapter One, "Bowls," in the section on feet.

Most Classic Carnival did not have a ground base, but there were exceptions. This amethyst *PANELLED DANDELION* tumbler from Fenton clearly shows its ground base. $50-80.

An amethyst *MARY ANN* by Dugan/Diamond on the left ($200-350) and the contemporary reproduction in purple from Mosser on the right ($30-50).

Most of the Carnival from mainland Europe and Scandinavia did have a ground base. The ground base of this *ROSE GARDEN* vase from the German manufacturer, Brockwitz shows traces of iridescence—a typical effect on this glass from the 1920s and 1930s.

The uniridized base of the Classic original *MARY ANN* by Dugan/Diamond on the left and the iridized base of the contemporary reproduction from Mosser on the right.

Iridescent Effects

The incredible visual effect that iridescence has is caused by the light interference patterns produced by constantly shifting wavelengths. Certain iridescent effects have been given names by collectors. A matt effect is generally known as **satin** iridescence, while a multicolored, mirror-like effect is often called **radium** (see above for explanation of how these effects were achieved). A particularly desirable effect is **electric** iridescence. This is usually applied to blue shades (electric blue) but more and more collectors are extending the term to apply to other colors, hence: electric purple, electric green etc. An electric effect is where the iridescence has a very brilliant, multi-colored, indeed almost luminous quality. In fact, it almost gives the appearance of being connected to the power supply—it's so vibrant! The blue *GOOD LUCK* bowl illustrated in Chapter One is a good example of electric iridescence, though it really is impossible for any photograph to do full justice to the astonishing vibrancy of a true electric effect.

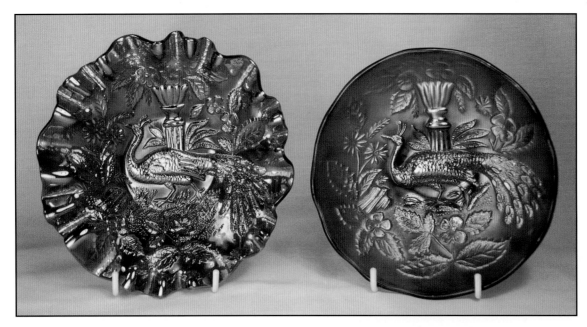

Two amethyst Millersburg *PEACOCK AND URN* small bowls. On the left, the rare 3 in 1 edge bowl has a shiny, mirror like radium iridescence. $1200-1500. On the right, the ice cream bowl has a matte satin iridescence. $150-250.

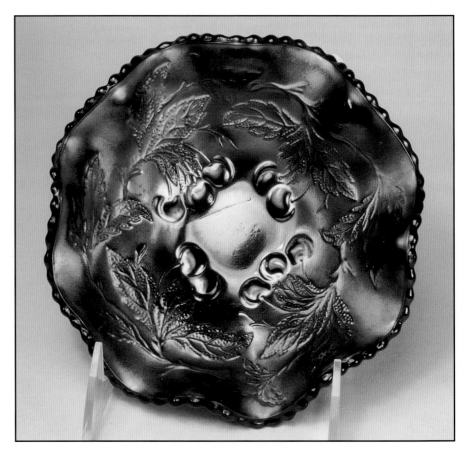

The iridescence on this Dugan/Diamond purple *CHERRIES* small bowl has wonderful electric highlights. $100-200.

[1]Thistlewood, Glen & Stephen. *A Century of Carnival Glass.* Atglen, Pennsylvania: Schiffer Publishing Limited, 2001.
[2] Cottle, Simon. *Sowerby Gateshead Glass.* Gateshead, England: Tyne and Wear Museums Service, 1986.

Chapter Four
Decorating the Glass

Enameling, staining, gilding, etching, and frosting are decorating techniques that were used by virtually all the main Classic Carnival manufacturers on glass other than Carnival. Iridizing was undoubtedly seen to be the main form of decoration in itself and thus most Carnival does not have these extra techniques applied. Furthermore, Carnival Glass is, of course, already patterned by virtue of its press moulded design. However, sometimes, extra methods of decoration have also been used. Enameling was the most frequently used form of decoration on Classic Carnival Glass (and indeed still is—see below), though other forms of painting such as staining were also used. Designs were also stenciled or applied as transfers or decals onto glass during the later Depression or Late Carnival era. Etching and frosting are further methods of decoration that were, and indeed still are, used on Carnival.

Enameled Decoration

In the Classic era of production, three Carnival manufacturers employed this method of decoration—Fenton, Northwood, and Dugan. The enamel used in this type of decoration is usually mixed with ground glass and applied by free-hand painting to the surface of the glass item. When the piece is then carefully re-heated, the mixture melts and fuses to the surface of the glass for a longer-lasting decoration. To quote from a Butler Brothers ad of 1910, the "decorations burnt in, will not wash off." Examples are mainly found on USA made glass from both the Classic Carnival era as well as well as Contemporary examples (in particular that made by Fenton Art Glass) though some painted pieces from Czechoslovakia and India are also known.

In this section, we present a selection of illustrations of Classic enameled Carnival Glass made circa 1910 to 1914. Water pitchers, tumblers, and bowls were the main shapes decorated in this way. Note that Dugan limited the shapes they enameled to bowls, whilst Northwood and Fenton concentrated on pitchers and tumblers. Rare examples of table sets and berry sets with enameled patterns were also made by both Northwood and Fenton. Fruits and flowers are the predominant motifs used and the colors are mainly white, blue, green, and yellow. Note the broad brush technique of painting. This was intended to be fast work aimed at mass production. Though it was hand done, the artist would have had a template model design to work from and copy. She (most likely the painters were women) would have worked fast, reproducing the same pattern on piece after piece. An archive photograph of the "Decorating Room at the Fenton Art Glass Works" is shown in Heacock's *Fenton the First 25 Years*[1] on page 127. The workers (all but one of the painters was female) are seated at long wooden benches, arrayed close by them are stacks of unpainted pitchers and tumblers (called "blanks") awaiting decoration. Before them are the completed items. Similar archive photos taken inside the Northwood works are shown in *Harry Northwood:*

The Wheeling Years[2] on pages 34 and 42. The foreman of the Northwood Decorating Shop was Carl Northwood, Harry's younger brother.

Northwood's enameled *APPLE BLOSSOM* water pitcher and tumbler in cobalt blue. This is one of the few enameled patterns where the flower on the tumbler is full blown, matching the one on the pitcher. On virtually all the other enameled patterns, the flower on the tumbler is in bud form. These items seldom come up for sale. SP Pitcher $1500-1750; tumbler $200-300.

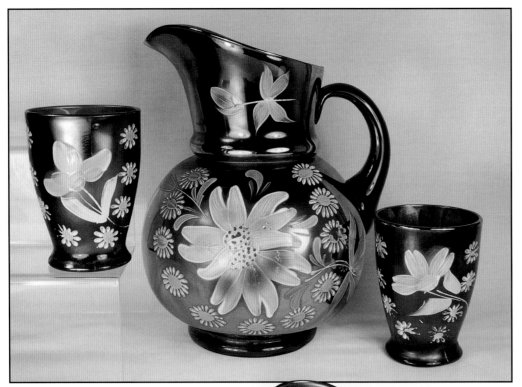

DAISY AND LITTLE FLOWERS by Northwood (cobalt blue) is not found very often. The bulbous pitcher features the wide open daisies; the tumblers feature the bud. It's impossible to value these items accurately as they are sold so rarely. SP Pitcher $300-800; tumbler $50-100.

Two elegant tankard water pitchers from Fenton, both in the enameled *FORGET ME NOT* pattern. On the left, the marigold tankard pitcher has no middle prism band—the floral decoration continues unbroken (other variations of the pitcher have a scroll motif in the center, either side of the prism band). SP $400-600. On the right, is the rare ovoid (amphora) shaped pitcher in green. This shape of pitcher usually has the *BANDED IRIS* enameled design, but this one features Fenton's *FORGET ME NOT* pattern. One sold at auction in 1998 for $6000.

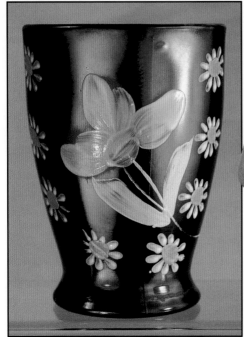

A closer view of the Northwood *DAISY AND LITTLE FLOWERS* cobalt blue tumbler. SP $50-100.

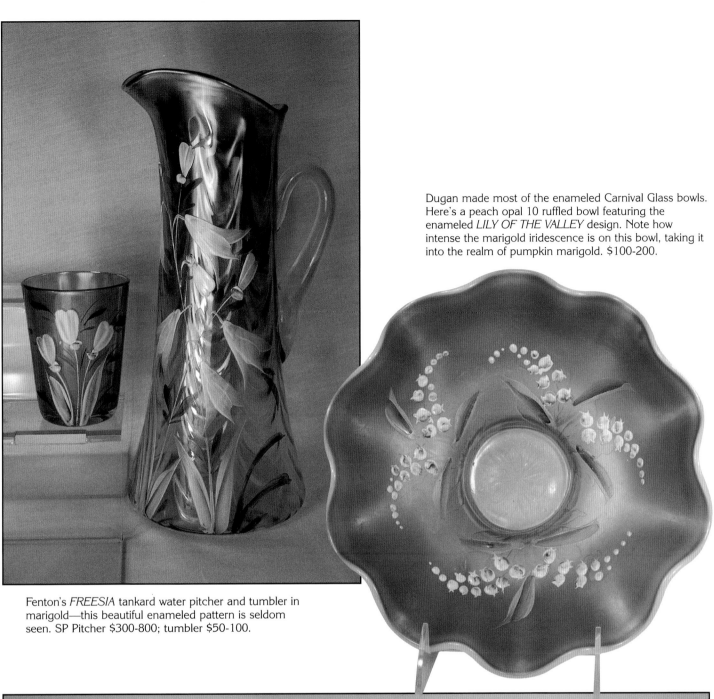

Dugan made most of the enameled Carnival Glass bowls. Here's a peach opal 10 ruffled bowl featuring the enameled *LILY OF THE VALLEY* design. Note how intense the marigold iridescence is on this bowl, taking it into the realm of pumpkin marigold. $100-200.

Fenton's *FREESIA* tankard water pitcher and tumbler in marigold—this beautiful enameled pattern is seldom seen. SP Pitcher $300-800; tumbler $50-100.

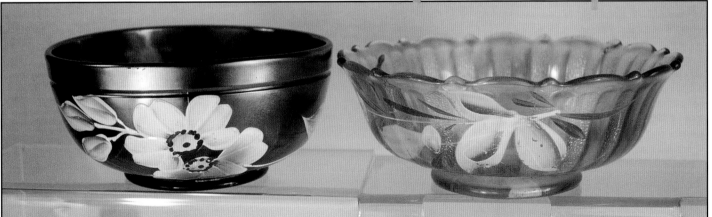

Bowls with enameled decoration are not often found; here are two very scarce ones. On the left, Northwood's *APPLE BLOSSOM* cobalt blue berry bowl. SP $100-150. On the right, Fenton's *MAGNOLIA AND DRAPE* marigold berry bowl. SP $100-150. Both these berry bowls are part of full berry sets—the master bowl is known for each.

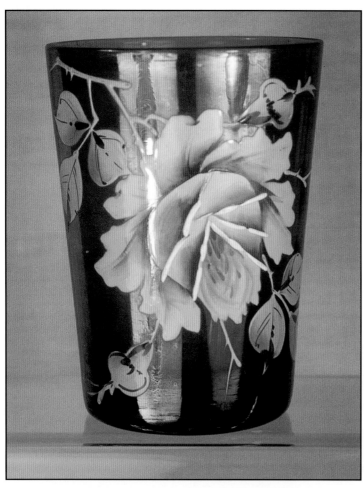

This is a green, enameled *ROSE OF PARADISE* tumbler. The paintwork is exquisite, and the glass is slightly thinner than that usually found on enameled tumblers. The manufacturer is unknown. $150-250.

It is interesting to note that Fenton's origins began with decorating glassware. Frank L. Fenton was working in the Northwood factory when he decided that (in his own words) "my particular work was in the matter of design and then I got the idea that if I could do this work for an employer, I could certainly do something for myself. So, with $284 capital, my brother John and I rented an old glass plant in Martin's Ferry and went into the glass business for ourselves." That was in 1905. The Fenton Art Glass Company was thus founded in Martin's Ferry, Ohio, by Frank L. Fenton and his elder brothers, John W. Fenton and Charles H. Fenton. Later, the other brothers, Robert C. and James E. Fenton were to join in. The first Fenton glass at the Martin's Ferry location involved the use of "blanks"—plain glass items made by other companies which the brothers then decorated themselves. Soon they moved to Williamstown, West Virginia, where they established their own glass making plant. The company is still there—quite a success story.[3]

Enameling is still carried out today by the decorating department of the Fenton Art Glass Company. In 1967 Fenton decided it wanted to use decorating techniques again on its glassware; the following year, Louise Piper was employed as chief decorator in the newly created Decorating Department. Louise had always been fascinated with glass decorating and had learnt the skills and techniques whilst employed at the Jeanette Shade and Novelty Company. She reported that "they taught me to layout designs, to mix colors and other things such as what colors could be fired over the top of another color."

In the early years of Fenton's Contemporary Carnival production, little was enameled or enhanced in any way. But during the 1980s, mainly through the production of limited edition whimsies for Carnival club souvenirs, enameled Carnival Glass produced by Fenton appeared more regularly. During the 1990s enameled items were made in Red Carnival ('95 and '96) Plum Carnival ('97 and '98), and Spruce Carnival ('99) ranges as shown in Fenton's General Catalogs. Fenton's talented designer team originated motifs such as "Buttercups and Berries" (by Martha Reynolds—used in 1995) and the "Damask Rose" motif (Frances Burton—1996), as well as further original designs from Martha Reynolds and Kim Plauche. Furthermore, the demand for limited and whimsied items for Carnival Club commemoratives has produced some unique and very beautiful examples of decorated glass.

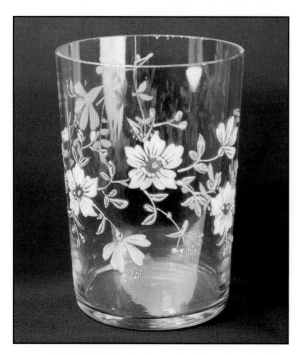

A rare *ELEGANCE* enameled tumbler in a light marigold with delicate floral decoration. The maker is unknown. NP.

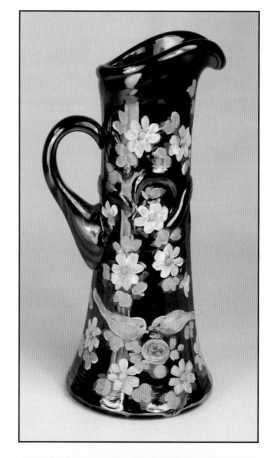

The photo may be deceptive, for this *MORNING GLORY* pitcher is a miniature and stands just a fraction over 6 inches high. Moulded on the base is the lettering "Camp Hill, PA. 1988"—this was an American Carnival Glass Association (ACGA) souvenir for that year. It was then hand painted by the renowned Fenton artist, the late Louise Piper, and is signed by her, dated Sept. 26th 1989. NP.

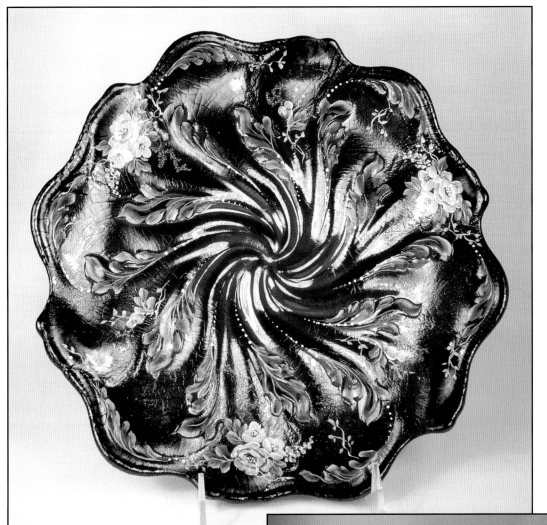

This superb commemorative *ACANTHUS* plate made by Fenton for the International Carnival Glass Association (ICGA). This black Carnival whimsy (one of only two black plates made) was painted by the renowned Fenton decorator, Martha Reynolds. SP $200-500. *Courtesy of Angie Thistlewood.*

Detail of the exquisite paintwork on the Fenton black whimsy *ACANTHUS* plate shown in the previous illustration. The floral motifs have been painted in toning pastel shades of pink, cream, white, and blue that echo the stretch iridescence on the plate—*coralene* decoration adds further delightful accents. Coralene decoration was first used in the Victorian era—the effect is of a raised, almost stippled, painted effect. Tiny glass balls were added to the fresh enamel work, and then re-heated to fuse them into the surface of the glass. *Courtesy of Angie Thistlewood.*

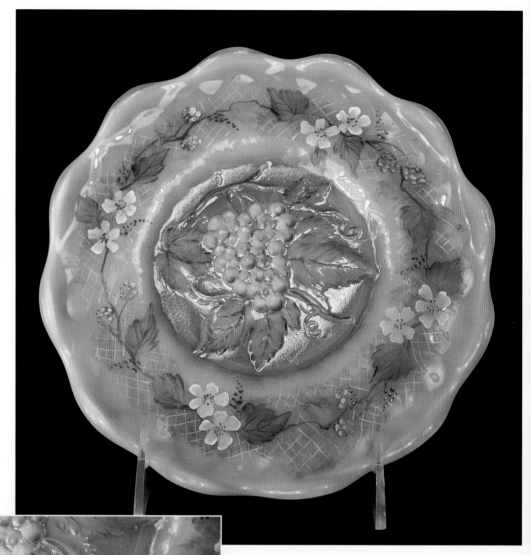

A contemporary Fenton commemorative made for the San Diego and Southern California Carnival Clubs in 1996 (Bakersfield, California). This blue opal plate is *HEAVY GRAPE*, it has been made unique by the hand decoration. SP $150-200.

Detail of the delightful paintwork on the *HEAVY GRAPE* Fenton commemorative shown in the previous illustration.

The internet Carnival Club, www.cga, has a unique commemorative (known as the *WOODSLAND PINE*) that has been made by Fenton, using the club's wholly owned, original mould and plunger. This is a cobalt blue, whimsied ruffled bowl with hand decoration painted by J. Cunningham. SP $150-200.

A black amethyst, crimped edge plate that has a unique hand decoration painted by the designer of the *WOODSLAND PINE*, Glen Thistlewood. This whimsy was sold at the www.cga convention in St. Louis, 2003, for $200.

Two enameled items from Fenton that are at opposite ends of the spectrum regarding availability. On the left, a whimsy *FROLICKING BEARS* tumbler made in 1993 for ICGA. This unique item is Crystal Velvet. The regular 1993 commemorative was made in honey marigold. The whimsy shown here is decorated with pink and yellow pansies. SP $150-350. On the right, the Crystal Velvet hand painted bell was "in the line" during the 1990s and was sold at a wide variety of retail outlets. $50-90.

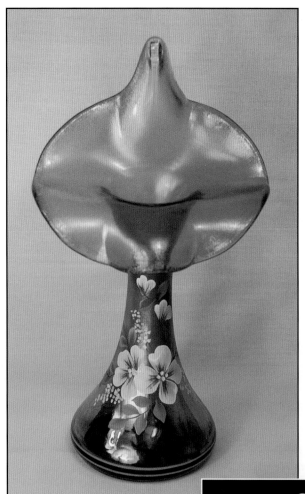

set may be found with the dahlia flowers picked out in dark ruby, blue, or green. Unlike gilding, which was fired on to make it permanent, the staining was not usually fired and consequently may show signs of wear. (On un-iridized glass, this staining is sometimes referred to as "Goofus" Glass).

Verdigris staining, applied to give a copper patina effect, can be seen on the *CLASSIC ARTS* and *EGYPTIAN QUEEN* items from the Czechoslovakian manufacturer, Josef Rindskop (dating from the 1920s). These items have a very distinctive band of dull green stain applied over the decorative, figural design. The effect was used to evoke a metallic appearance, imitative of similar, more expensive art glass items that were in vogue in Czechoslovakia at the time. Other items from Czech manufacturers such as Moser, Harrach, Palder and Walther featured similar decorated bands of dancing figures. (This entire design concept being inspired by the 1922 Egyptian archaeological discoveries of the tomb of King Tutankhamen).

An exquisite, violet satin contemporary vase from Fenton Art Glass, made in 1999. Not strictly Carnival Glass, this beautiful, hand painted item is softly iridized. The shape is known as an 11 inch tulip vase. The painting on this item was done by D. Robinson. $50-100.

Dugan/Diamond's *WREATHED CHERRY* tumbler in frosty white with transparent red, painted cherries and gilding. $200-250.

Fenton's sea green satin, 11 inch tulip vase with "Floral Interlude" decoration designed by Martha Reynolds. This vase was part of the 1998 Fenton Family Signature Series (with George W. Fenton and Nancy Fenton signatures). The painting on this item was done by S. Fisher. $125-175.

Staining and Gilding

Staining was rarely used on Carnival, though there are a few notable exceptions. A surface stain was applied to sections of the raised pattern—usually ruby, though blue and green are sometimes seen. Northwood used this technique, often in conjunction with gilding, but not on his Carnival, however, there are several examples of Dugan Carnival stained in this way, for example, the *DAHLIA* water

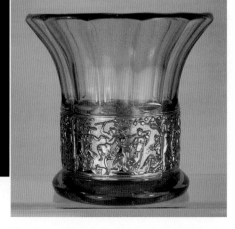

Here's a piece of glass (not Carnival) from the German manufacturer, August Walther. The pattern frieze is very reminiscent of that on the Carnival patterns *EGYPTIAN QUEEN* and *CLASSIC ARTS* from the Czech maker Rindskopf (see the following three illustrations).

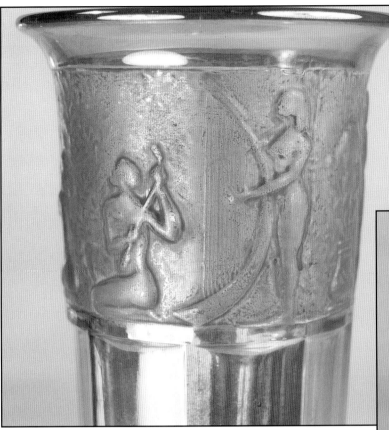

The marigold *EGYPTIAN QUEEN* vase made by Rindskopf features a verdigris (green) effect pattern band. The Egyptian figures are shown playing harps and other musical instruments. $250-500.

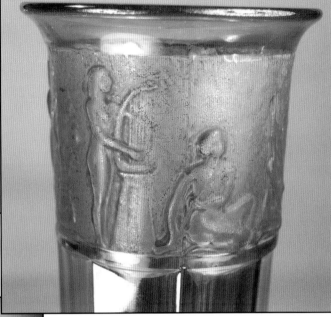

Another aspect of the pattern frieze on the marigold *EGYPTIAN QUEEN* vase.

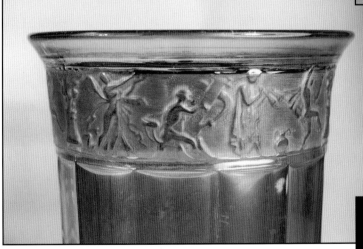

The pattern frieze on this *CLASSIC ARTS* vase has a deep green effect. The figures have a Roman look, and, as on the *EGYPTIAN QUEEN* pattern, they are playing instruments and dancing. $250-500.

Gold was very occasionally added to the edge of various Classic Carnival items. Northwood's *FOUR PILLARS* vase is known with a gilded edge, as are several scarce examples of Fenton's *(FOOTED) ORANGE TREE* berry set in white. Gold was also applied on some Carnival patterns to pick out certain features, a good example being Northwood's white *PEACH* items where the fruits are gilded.

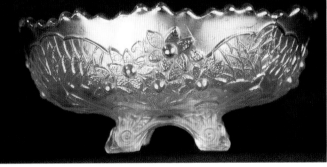

Gilding was used on this rare, frosty white *(FOOTED) ORANGE TREE* berry bowl from Fenton (part of a set with matching master berry).

Etching and Frosting

Acid treatment (usually using hydrofluoric acid) causes an ice or frosted effect on the surface of the glass that may sometimes be felt as a kind of roughness (though there are also examples that have a smooth feel). Colors with this finish are often called **ice colors**. Ice green, ice blue, celeste blue, and white are the main examples of the acid treated colors. The acid treatment was carried out prior to iridizing with a pastel iridescence that enhanced the frosty effect. The degree of frostiness may vary, those with the most intense frosty effect usually being the most sought after. In the opinion of the authors, the frosty effect is a necessary characteristic for the Carnival colors ice blue, ice green, celeste blue, and white. Without this frosty effect, white Carnival, for example, would be clear Carnival—clear crystal glass that has been iridized with a clear, pastel effect iridescence. (It should be pointed out here, for the sake of clarity, that marigold Carnival Glass is also clear, crystal glass that has been iridized. However, the iridescent spray applied in the case of marigold, also gave the glass an orange stain). Glass with a pale blue or pale green base color that has absolutely no trace of frostiness whatsoever is simply pastel blue or pastel green.

Three Northwood tumblers in the ice colors: white, ice blue, and ice green. Left to right: white *GRAPE ARBOR* $60-90; ice blue *ORIENTAL POPPY* $175-300; ice green *GRAPE ARBOR* $250-400.

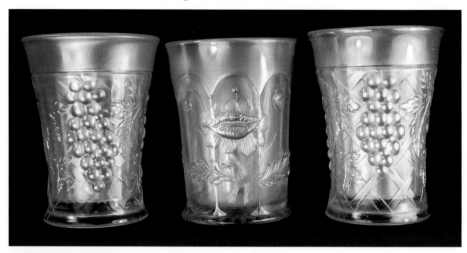

Selective frosting can also be seen on some examples of Czechoslovakian Carnival (mainly vases) dating from the 1920s—in these items elements of the pattern are picked out with the frosted effect. The Indian Carnival manufacturers, Jain and CB, produced a number of items, mainly vases and tumblers, where acid etching, combined with selective use of marigold iridescence, formed the actual design. In more recent years, Fenton Art Glass Company have used the technique of acid cut-back to enhance some of their iridized ware.

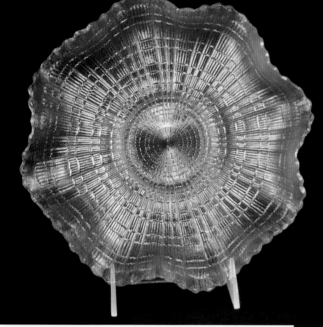

Fenton's celeste blue *PLAID* bowl with an "onion skin" frosty, stretch effect. SP $5000-6500.

Selective etching/frosting and iridizing on these two beautiful *FROSTED FISH* vases from the Indian maker, Jain. Note the differences in the pattern details of the iridized motifs on the two vases, as well as on the foot. $250-400.

This *MISTY MORN* vase probably made by Jain—the etching and iridizing form the actual pattern, giving the impression of flowers seen through the mist. $75-125.

A Favrene vase with acid cut-back floral decoration from Fenton, part of their Connoisseur Collection, 1996. The vase was made from a new mould designed by Jon Saffell, the floral decoration was designed by Martha Reynolds. $200-300.

Selective Iridescence

A range of items are known where the sides of the bowl or plate are sparklingly clear (and made from high quality crystal) while the base has an intaglio design underneath, that is richly iridized in marigold. On all the examples of this technique, the base design is exceptionally well detailed, which allows the marigold iridescence to create an effect of unusually clear relief. The manufacturer of these items remains uncertain, though several countries of origin are possible (all European): Finland, Sweden, Czechoslovakia, and Poland (an example has been found bearing a sticker "Beverley Crystal Made in Poland") are all possible contenders. *DIANA THE HUNTRESS, GOLDEN CUPID,* and the distinctive *GOLDEN CARP* are all examples of this method of decoration.

Selective iridescence was used to pick out the moulded pattern on this splendid 8 inch *DIANA THE HUNTRESS* bowl. The maker of this and the other scarce "Golden" designs has not yet been determined. SP $800-1000.

The smaller *GOLDEN CUPID* bowl is sometimes found matched with *DIANA THE HUNTRESS* as a berry set. $200-350.

One of the loveliest of the "Golden" designs is the seldom seen *GOLDEN CARP*. The rich marigold iridescence is selectively applied to the intaglio fish, leaving the rest of the bowl crystal clear. Note that the iridescence on all these "Golden" pieces is on the under side of the bowl. SP $200-350.

A most unusual ashtray in a recently discovered "Golden" design that features a dog's head. The base of the high quality crystal glass is highly polished. Catalog extracts from the Bohemian glass maker, Hoffman, show items very similar to this, suggesting a likely link. The authors have named this rare item *GOLDEN ROVER*. SP $350-400.

Stenciling, Silk Screen Printing, and Decal Application

Seen mainly on Late Carnival, the use of stencils and applied decals (transfers) speeded up the decorating process greatly. Individuality, of course, was sacrificed, as each decal or stenciled pattern was identical to the next. Water pitchers, tumblers, and souvenir items such as shot glasses and creamers were often used for such decorative purposes. Four machine methods of applying this type of decoration are explained in Weatherman's *The Decorated Tumbler*.[4] Stencilling, silk screen printing, and the "Rotary" method of banding (where the glass was turned "on a turret while wheels rolled through a paint solution and then around the glass") were the main mechanical decorating methods employed.

Engraving

Carnival Glass from China is hard to find, though there are a few examples around. Tumblers, vases, and covered cookie jars are known (the jars have been found in boxes marked with their country of origin) in thin marigold glass, with finely engraved designs of flowers or fruit. The date of manufacture is thought to be circa 1930s through to the present day. It is also possible that the Glimma glass factory in Sweden produced some engraved marigold items.

On the left, a scarce, transfer decorated Jeanette Glass Co. juice glass known as *MINUET* ($50-100); on the right, Jeanette's *SOUVENIR OF BUFFALO* juice glass ($50-90).

A cranberry Late Carnival tumbler from the 1940s by Bartlett-Collins—this is *LATE WATERLILY*. The floral motif was achieved via a screen print and lustre decorating process. $15-35.

The floral pattern is engraved on this delicate *ENGRAVED FLOWER BAND* aka *GLORIOUS* tumbler in pastel marigold. SP $30-70.

[1]Heacock, William. *Fenton the First 25 Years*, Marietta, Ohio: O-Val Advertising Corp. 1978.

[2]Heacock, William: Measell, James: Wiggins, Berry. *Harry Northwood. The Wheeling Years*. Marietta, Ohio: Antique Publications, 1991.

[3]Thistlewood, Glen & Stephen. *Carnival Glass—The Magic and the Mystery*. Atglen, Pennsylvania: Schiffer Publishing Limited, 1998.

[4]Weatherman, Hazel Marie. *The Decorated Tumbler*. Springfield, Missouri: Glassbooks Inc., 1978. London, England: Apple Press, 1990.

Chapter Five
A Closer Look at How Designs Take Shape

It is often said that there is nothing new in life, "no new thing under the sun."[1] Carnival Glass is no exception. The number of different patterns is well over a thousand, possibly now even approaching two thousand, with recent advances in research and discoveries being made in Scandinavia, Europe, South America, and India. Undoubtedly, many patterns and shapes were inspired or influenced by the styles and trends of the time (see Chapter Part One, Chapter One, "Inspirations"); but other forms of glass, other patterns, and other manufacturer's ideas, all played their part. In this chapter, we take a look at some specific examples of intriguing design links and influences, as well as outright plagiarism, on the development of Carnival Glass patterns.

A Tornado or a Peacock's Feather?

Northwood's wonderful *TORNADO* vase is a familiar Carnival Glass item with its unusual shape, tricorner mouth and sinuous, curling motifs. The vase was named *TORNADO* by Carnival Glass pioneer, Marion Hartung in the 1950s though it was given another name ("Tadpole") by the equally famous pioneer Rose Presznick. It's easy to see how both names might apply: the curling motif could represent a wriggling tadpole or could just as easily be that scourge of the midwest, the tornado. In fact—it was probably not intended to represent either. It was almost certainly a representation of a stylized peacock feather. And it was highly likely that it was based on similar high quality art glass vases that Harry Northwood had seen on one of his trips back home to England.

Northwood's home town was Kingswinford in the West Midlands of England; the area was known as Stourbridge and it was famed for its glass manufacture. John Northwood I, Harry's father, was the Artistic Director of Stevens and Williams, one of the great glass makers located there. Another well known Stourbridge firm, Thomas Webb and Son, is fully credited with using surface iridescence. The company produced free-blown, iridized luster ware in the late 1800s, making a deep green glass, iridized in shades of purple which they called "Bronze" glass and later an iridized golden effect called "Iris." Queen Victoria herself bought some of Webb's iridized "Bronze" glass and Harry Northwood was undoubtedly influenced and inspired by some of the splendid examples of iridized art glass made in the Stourbridge area.

In the early 1900s, the famous London store of Harrods issued catalogs showing glass made in Stourbridge. Illustrated in the catalog extract were vases adorned with what was termed "peacock decoration"—bold, feather like swirls that look exactly like the motifs (the "tornadoes") on the later Classic Northwood *TORNADO* vases. Further, some of them had what was called "Emeraldene" decoration—applied green trails of glass. It is very likely that this is what Harry Northwood modeled his famous *TORNADO* vases on.

The Stourbridge items that were almost certainly the inspiration for Harry, have been called *TORNADO VARIANTS*. Common to each is a pontil mark on the base, indicating that the vase has been blown and then broken off the pontil (punty) rod. Some variations are on a pedestal base while others have a flat base. All have in common the tricorner mouth, marigold coloring and the three, applied "peacock/tornado" motifs. Interestingly, a scarce variation in the *VARIANT* vase is that the applied glass "peacock/tornado" motifs are sometimes found made of green glass. Rare variations in the Northwood *TORNADO* have also been found with applied green "peacock/tornado" motifs.

The main difference between the inspirational *VARIANTS* and the Classic Carnival *TORNADO* vases is that the Northwood vases are press moulded versions of the blown art glass originals. Within each type there are further differences in moulded pattern, height and base size.

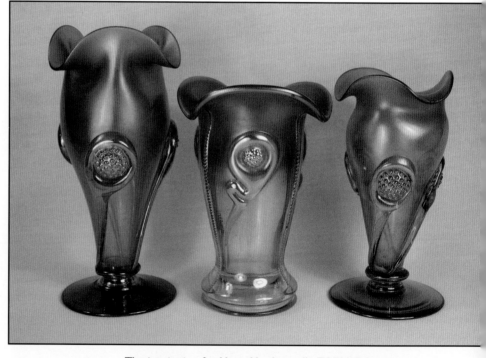

The inspiration for Harry Northwood's *TORNADO* vase was surely these rare *TORNADO VARIANTS*. In the center, Northwood's press moulded, marigold *TORNADO* vase is flanked by *VARIANTS* in differing heights. These two blow moulded vases were probably made by Thomas Webb and Sons of Stourbridge, England, just prior to the Northwood pressed production in the USA. Value for the Northwood *TORNADO* vase in marigold $650-900; *VARIANTS* $1000-2000.

TORNADO—Northwood

These come in two basic sizes, though the distinctive mouth shaping means that the height can alter slightly. The smaller of the two sizes is 5.5 inches high—while the larger, which is seen much less often, is around 6.5 inches. The base measures 2.75 inches on the smaller versions and 3 inches on the taller ones. The body of the vase is usually plain, but may also be found ribbed, imitative of "threading"—a popular style of winding fine glass filaments around glass objects as an applied, decorative technique. Harry Northwood's father, John, had used the technique in England at Stevens and Williams. Note that on the Northwood versions, there are two rows of vertical lines between each of the "peacock/tornado" motifs. Ribbed examples are harder to find than the plain versions.

> Shape: collar based vase, rare examples found without collar base and also with a flat pedestal base
> Colors: marigold, marigold with applied green tornadoes, amethyst, green, white, lavender, cobalt blue, ice blue, sapphire blue, and ice green

TORNADO VARIANT—probably Thomas Webb, Stourbridge.

As with the Northwood *TORNADO*, the sizes differ, ranging from 6.25 inches right up to 8.25 inches. The base may be either pedestal or flat: pedestals are 3.25 inches in diameter while the flat version is 3.5 inches. Unlike the Northwood versions, the *VARIANTS* are blown and have pontil (punty) marks on the base. The "peacock/tornado" motifs are applied, yet are very similar in appearance to the press moulded Northwood ones.

> Shape: pedestal footed vase and flat base vase
> Colors: marigold and marigold with both green and vaseline applied "peacock" feather decoration (the "tornadoes"). These green "tornadoes" were what was called "Emeraldene Decoration" in the Harrods ad. mentioned above.

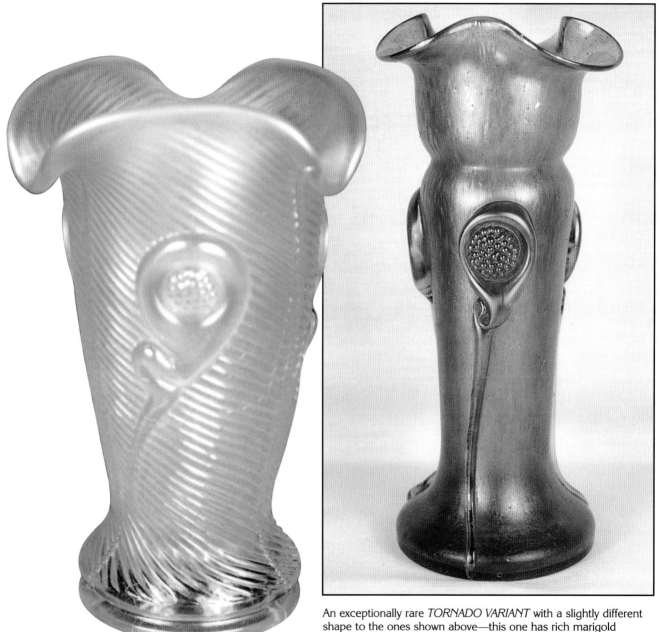

An exceptionally rare *TORNADO VARIANT* with a slightly different shape to the ones shown above—this one has rich marigold iridescence and applied ("Emeraldene") vaseline green tornadoes. SP $2000-2200.

This is the only known ribbed *TORNADO* vase in ice green. A fabulous Northwood rarity that we are delighted to showcase here. *Courtesy of Trudy and Stephen Auty.* NP.

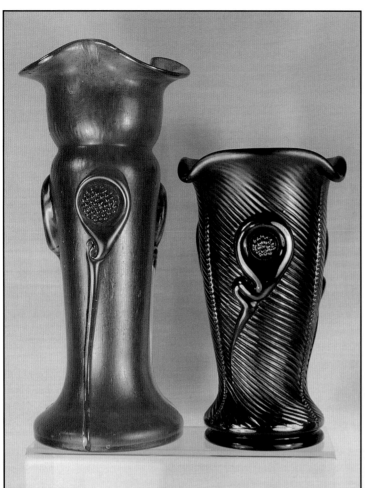

Mould Makers and Designers

A fascinating discovery in crystal (flint) pattern glass may be the source of several Classic Carnival patterns: Imperial's *WINDMILL* (plus the related *DOUBLE DUTCH* and *Nu Art HOMESTEAD*) and Millersburg's *SEACOAST* pin tray. The little crystal sugar dish and tiny creamer (maker unknown—but almost certainly English and dating from the late 1800s) both have three medallion shaped panels—over the rest of the piece there is a textured, stippled effect. The panels feature different detailed landscapes, all typically English in character. On the sugar, the three panels feature a lighthouse and rocks, a stone bridge and trees, and a boat on water with trees in the foreground. On the creamer, the three panels feature a wooden bridge with trees, a farm or homestead with trees, and a smaller version of the boat on water with trees in the foreground. The similarity between the Carnival patterns and the designs seen on the crystal items is remarkable, as a study of the series of photographs will illustrate.

SEACOAST PIN TRAY—Millersburg

The main features on the *SEACOAST PIN TRAY* are a lighthouse surrounded by rocks and choppy seas with a yacht in the background and the sinuous body of a fish in the foreground. Compare the illustrations: the shape and detail of the lighthouse, the angular rocks, the portrayal of the angry sea. Compare the pattern on the pin tray with the pattern on the sugar. Almost identical! There are even tiny birds in the sky and a boat in the background on each. The fish, of course, is an addition, as is the sun—but the rest of the design reveals its obvious link with the crystal pieces shown here.

Shape: pin tray
Colors: green, marigold, and amethyst

Compare the size of the *TORNADO VARIANT* (left) with a small sized, ribbed, Northwood *TORNADO* vase in amethyst on the right. $600-1000 for the Northwood vase.

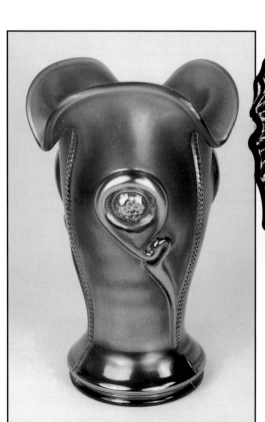

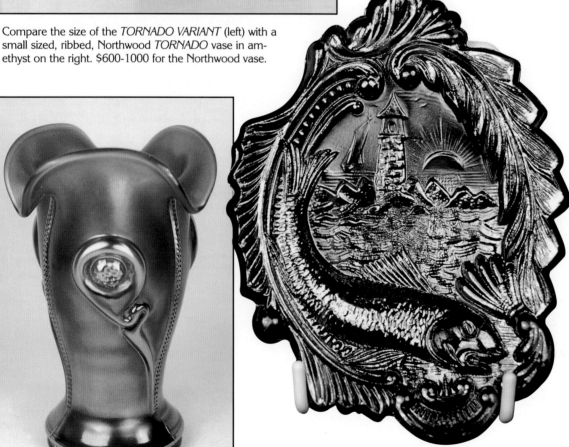

Millersburg's superb *SEACOAST* pin tray in green. $600-1300.

The large size Northwood *TORNADO* in green. $400-900.

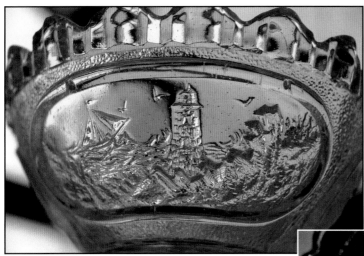

Compare the pattern on this Victorian crystal sugar to the later *SEACOAST* pin tray seen in the previous photograph. The similarity is astonishing.

WINDMILL and related patterns *DOUBLE DUTCH* and *Nu Art HOMESTEAD*—Imperial

The pattern on all these three items is essentially a landscape that has a European feel to it—almost certainly the same designer or mould maker conceived all three. Common to each is a river or pond, a bridge (sometimes more than one), and framing trees—the style of all three is distinctive and very similar to that on the crystal items. For further details of these items please refer to *Carnival Glass—The Magic and the Mystery*.[2]

So how could this have come about? Why might a tiny crystal glass sugar and creamer made in England be similar to several Classic Carnival patterns that were probably made a decade or so later? The creamer and sugar are unlisted and undoubtedly rather rare items—and it is unlikely that the actual items would have been shipped from England to the United States and subsequently copied by mould makers there. Perhaps there is another, far more plausible explanation. The thing that connects all the items is their distinctive style coupled with the use of certain common pattern elements. Could the mould maker/designer have been an Englishman who emigrated to the United States in the early 1900s? The Imperial Glass Company were known for having European artisans amongst their workforce—perhaps the immigrant mould maker designed new patterns in his own inimitable style, illustrating the landscapes of his earlier days back in England. For the scenes on *WINDMILL* and its related patterns are strongly characteristic of the English countryside—windmills were common in parts of England, the streams, the trees—all of it so typical.

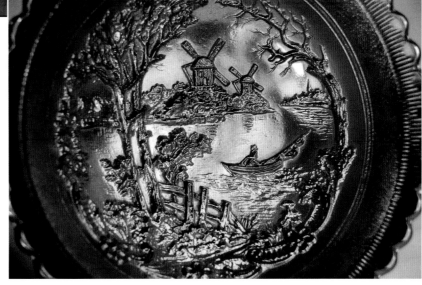

A close-up view for comparison of Imperial's *DOUBLE DUTCH* bowl in rich purple—note the two windmills.

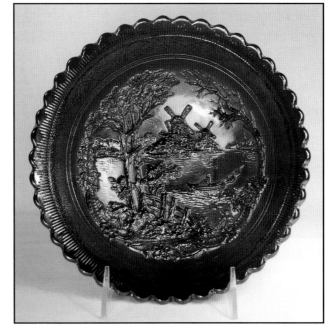

Imperial's *DOUBLE DUTCH* bowl in rich purple. $200-300.

67

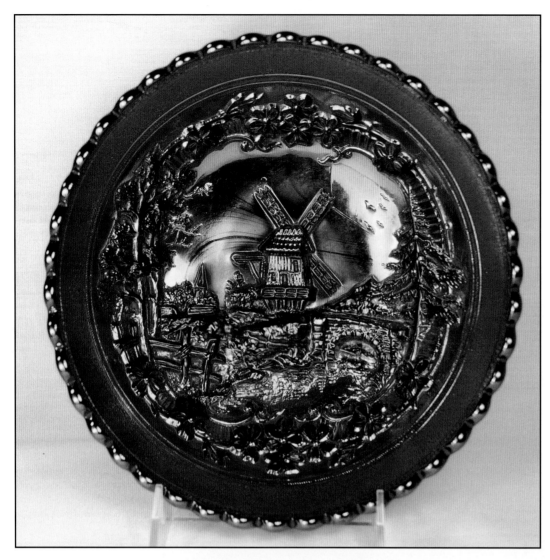

Imperial's *WINDMILL* bowl in smoke. $75-100.

A close-up view for comparison of Imperial's *WINDMILL* bowl in smoke—note the single windmill.

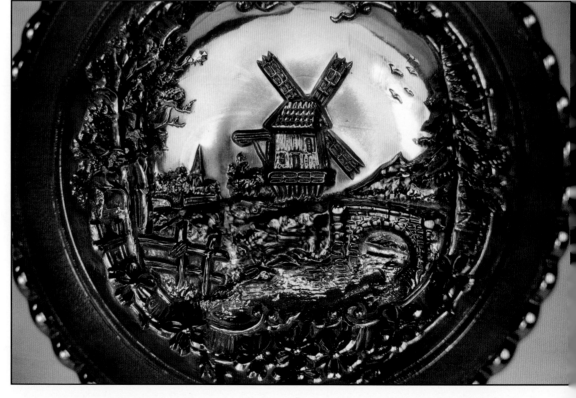

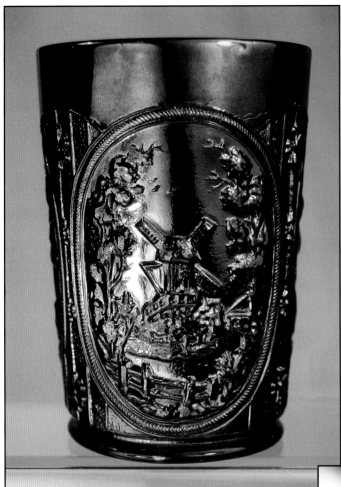

This Victorian crystal creamer features a series of designs on its panels that appear to have influenced various Carnival Glass patterns.

Imperial's *WINDMILL* tumbler in purple. $75-150.

Detail from the pressed glass sugar bowl showing the seascape.

Fenton's *CHRYSANTHEMUM* bowl features windmills and sailing boats, as well as large floral motifs. $150-250.

Detail from the pressed glass sugar bowl showing the stone bridge and trees.

Detail from the pressed glass creamer showing the wooden bridge scene.

Summit's reproduction of the original Imperial *Nu Art HOME-STEAD* plate. Note the similarity of features in the design to the Victorian glass in the previous photographs. $50-70.

Detail from the pressed glass creamer showing the farmhouse scene

Victorian Style

A fascinating trail of evidence exists to link Sowerby's *DIVING DOLPHINS* design with life in Victorian England. The original mould for that pattern was made in 1882, in the days of Queen Victoria. Style at that time was something of a battleground: the Rococo Revival, neo-Classicism, and High Victorian Gothic all vied with each other for center stage. In 1851, the Great Exhibition—the world's first international exhibition of Industry—was opened at the Crystal Palace by Queen Victoria. Here "arguably the first real style wars were fought" and "the very concept of design became a matter of public debate."[3]

Fossil collecting was a new and very popular science at the time and the craftsmen of the era frequently used marine and fossil motifs within their designs. Throughout the 1800s and into the early 1900s, they appeared on glassware, ceramics, furniture, and more. In the Great Exhibition such motifs were frequently found and even in the cityscape, one would see them—carved on doorways, on buildings and in civic spaces. In fact, one such civic space (in the fashionable south coast resort of Brighton, England) a fountain was constructed to honor Queen Victoria that is a life size twin to the *DIVING DOLPHINS* bowl. A giant bowl that catches the fountain's water sits on top of three twisting dolphins—the similarity is astonishing. It's quite likely that when Sowerby originally made the *DIVING DOLPHINS* mould in 1882, they were reflecting the fashion of the era —the designer may even have styled it after the Victoria Fountain.

DIVING DOLPHINS—Sowerby

The *DIVING DOLPHINS* bowl stands on three feet, each styled to form the shape of a dolphin's head. Their bodies curve up and round, onto the main part of the bowl. Around the sides of the bowl are stylized flowers and leaves, the combination of elements forming a most attractive, overall design. Note that this pattern is cameo (raised up off the surface of the glass). In the 1920s, when Sowerby began to make iridized glass, *DIVING DOLPHINS* (Sowerby's pattern number 1544) was one of the moulds that they revived, but one change was made. The interior of the original bowls had no pattern, but Sowerby decided to update the old mould by adding their version of Imperial's *SCROLL EMBOSSED* pattern. This is an undoubted copy and one that Sowerby subsequently also utilized on several other small Carnival items.

Shapes: ruffled or smoothly flared bowl, as well as rare square and tricorn bowl and rose bowl, all shaped from the same mould
Colors: marigold, amethyst, amber and aqua/teal blue shades

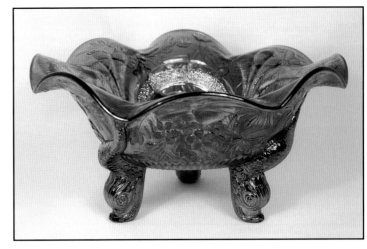

A rare example of Sowerby's *DIVING DOLPHINS*, this eight ruffled bowl is in aqua-teal. *Courtesy of Phyllis and the late Don Atkinson.* NP.

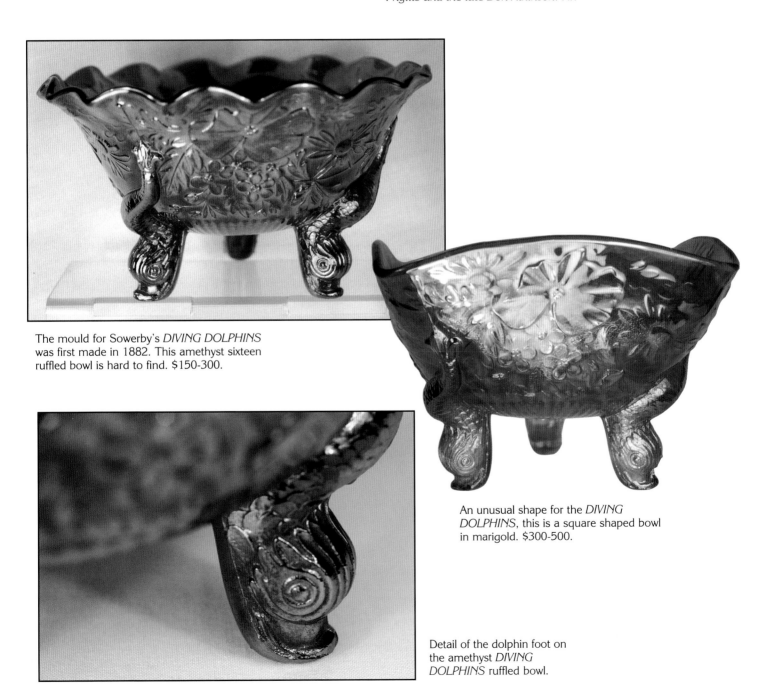

The mould for Sowerby's *DIVING DOLPHINS* was first made in 1882. This amethyst sixteen ruffled bowl is hard to find. $150-300.

An unusual shape for the *DIVING DOLPHINS*, this is a square shaped bowl in marigold. $300-500.

Detail of the dolphin foot on the amethyst *DIVING DOLPHINS* ruffled bowl.

Another perfect example of the marine motif translated into glass is Northwood's (and later Dugan's) *NAUTILUS* (aka *ARGONAUT SHELL*). But the story behind this is even more complex and very intriguing. The *NAUTILUS* was modeled on a Royal Worcester porcelain vase, made in 1888, that looks almost identical to Northwood's version—the features of the large shell, the tiny shells adorning the base—all the details are there. The late Miss Elizabeth Robb, Harry Northwood's granddaughter, remembered her grandmother "relating that Harry Northwood returned from England with the Royal Worcester vase, vowing that he would recreate it in glass."[4] The Royal Worcester china vase still remains with the Northwood family (see the photograph below). In 1900, Northwood made the *NAUTILUS* in ivory glass, imitative of the porcelain original. It was later to be made in Carnival Glass by Dugan, who took over the Northwood moulds.

NAUTILUS (ARGONAUT SHELL)—Dugan/Diamond

Very similar to the Royal Worcester porcelain item, the *NAUTILUS* comprises a blend of maritime motifs. Some Carnival examples are found bearing the Northwood script signature which led collectors in the past to believe they were indeed Northwood items. In fact the moulds had been left behind by Northwood at his Indiana, Pennsylvania plant when he moved on to Wheeling, West Virginia. His cousin, Thomas Dugan, used the moulds for Carnival production though Northwood himself never did.

The most distinctive features of the *NAUTILUS* pattern are the roughly parallel sets of wavy lines running down the items, giving the appearance of the ridges of a shell. Harry Northwood's original glass items were made in ivory glass, imitating the Worcester porcelain examples, and giving the effect of actual shells.

Only three of Northwood's original moulds are known to have been used by Dugan for Carnival production. The spooner, the large berry dish, and the tumbler. However, the Carnival shapes that were produced from these moulds are known respectively as: gravy boat/candy dish/sugar/creamer whimsy (all from the original spooner mould); master berry/giant compote (from the large berry dish mould) and swung vase (from the tumbler mould).

Shapes: see above for detail
Colors: peach opal and purple

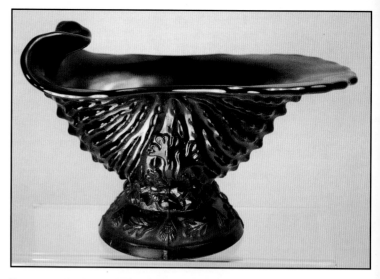

Dugan made this *NAUTILUS* item using a mould that originally belonged to Harry Northwood (some examples still bear the Northwood script logo). This is the "creamer" shape in purple. $150-200. More for Northwood marked examples.

From Continent to Continent

Plagiarism—the copying of ideas or designs—was not unusual in Carnival Glass circles. A manufacturer's main aim was to produce goods that would sell, and so if another company was making a particular pattern or style that seemed to be a good seller, then it surely made sense to produce something similar. Not only were designs copied, but moulds were also sometimes sold to other companies. In Classic Carnival Glass production, there was a plethora of grape patterns and designs featuring peacocks. Virtually every United States Carnival manufacturer in the Classic era of production made at least one design featuring the grape!

But it didn't stop there. When the European manufacturers began to make Carnival Glass in the 1920s, they looked to the United States for some of their inspirations. Often, the initial impression of Carnival patterns from Europe is that geometrics and intaglio designs are all that was produced. The following selection of "inspired" patterns may serve to counter that view.

Before embarking on descriptions of a selection of the imitative patterns, it is important to explain some recent research regarding Riihimaki's Carnival production. The authors visited the Finnish Glass Museum in 2002 and were aided by curator Kaisa Koivisto in viewing some recently acquired catalogs. The date of the catalogs is considered to be around 1927—the year that Riihimaki took over the Kauklahti glass factory. The items depicted in the catalog are fascinating, and there are some exciting discoveries, such as the first illustrations of the *FIR CONES* items. It is most interesting to note that virtually all the items shown in the catalog are reported in Carnival Glass. Furthermore, the list of patterns identified in the Riihimaki/Kauklahti catalog account for a massive three quarters of forty or so currently recognized Riihimaki Carnival patterns.

What could be the rationale behind this? Our theory is that Kauklahti were possibly the impetus behind the introduction of Carnival in Finland. Several of the patterns, for example *TIGER LILY* and *GRAPE MEDALLION*, were clearly inspired by United States Carnival designs. Indeed, their *TIGER LILY* design is a pretty faithful copy of the Imperial pattern of the same name and *GRAPE MEDALLION* was undoubtedly inspired by designs such as Fenton's *PEACOCK AND GRAPE* and other medallion style patterns. So, as Kauklahti were taken over by Riihimaki in 1927, their patterns and possibly their development ideas, were absorbed by Riihimaki. In terms of dates, it is known that Riihimaki were producing Carnival in 1929 (as the *TURKU ASHTRAY* known in marigold, has the date moulded into the design). It seems likely to assume therefore, that Carnival production began shortly after the Kauklahti acquisition. In the patterns below, where a

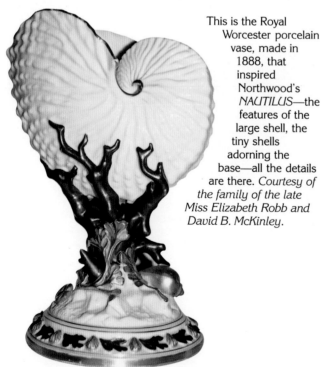

This is the Royal Worcester porcelain vase, made in 1888, that inspired Northwood's *NAUTILUS*—the features of the large shell, the tiny shells adorning the base—all the details are there. *Courtesy of the family of the late Miss Elizabeth Robb and David B. McKinley.*

design was one of the Riihimaki acquired Kauklahti examples, we have indicated accordingly by assigning the manufacturer as Riihimaki/Kauklahti.

A number of Riihimaki/Kauklahti patterns appear to have also been made by the German firm of Brockwitz. It is possible that Kauklahti and Riihimaki actually bought moulds from the German manufacturer, as similar patterns appear in each manufacturer's catalogs over the same period of time (1920s-1930s).

SCROLL EMBOSSED—Sowerby

First produced by Imperial in the United States, this simple yet effective design was also used by the English glass maker, Sowerby. It is seen on the interior of Sowerby's *DIVING DOLPHINS* bowls and also on several small sweet or bonbon dishes (sometimes called ash-trays) where *SCROLL EMBOSSED* is seen in conjunction with *JEW-ELLED PEACOCK* (an intricate geometric design that features the Sowerby peacock head trademark in the center of the base). The sweet dish was also used with two other exterior patterns: *PRISM AND CANE* and *PINEAPPLE*.

Shapes: bowl and small sweet dish (bonbon)
Colors: for *DIVING DOLPHINS*, marigold, amethyst, amber and aqua/teal blue. For *JEWELLED PEACOCK* and other exteriors, marigold and amethyst.

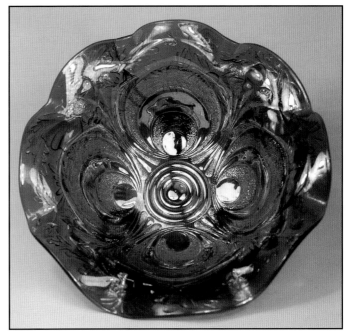

The interior of the aqua-teal *DIVING DOLPHINS* bowl shown above displays the *SCROLL EMBOSSED* design that Sowerby's copied from Imperial. *Courtesy of Phyllis and the late Don Atkinson.* NP.

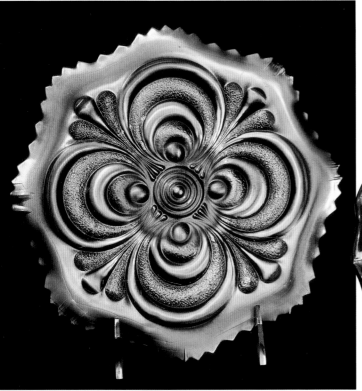

Imperial's *SCROLL EMBOSSED* plate in electric purple. Imperial did it first! $250-600.

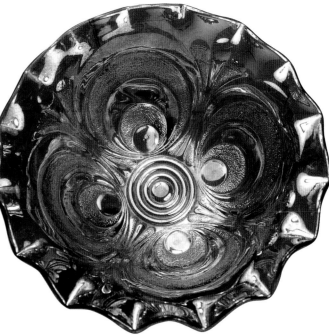

The interior of the sixteen ruffle, amethyst *DIVING DOLPHINS* bowl shown above also displays the plagiarized *SCROLL EMBOSSED* design. $150-300.

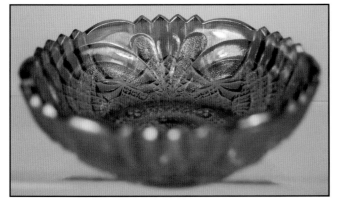

An unusual item from Sowerby, this is their *PINEAPPLE* pattern on the exterior, coupled with the plagiarized *SCROLL EMBOSSED* design on the interior. In amethyst, this little sweet dish is SP $40-75.

FOUR FLOWERS—Eda Glasbruks and Riihimaki

First produced by Dugan/Diamond in the United States, an exact copy of this pattern was later shown in the catalogs of both the Swedish company Eda Glasbruks and the Finnish company, Riihimaki. Both companies are believed to have produced the item in Carnival Glass, in the form of a large ruffled bowl. The edge ruffling is very distinctive (shown clearly on the photographs) and distinguishes the Scandinavian version from the slightly earlier American made original. Note that the pattern featured on the upper/inside of the item is cameo—quite unusual for Scandinavian designs. The base of the Scandinavian versions is distinct in that it is ground.

A variation of the *FOUR FLOWERS* (*FOUR FLOWERS VARIANT*) distinguished by the interlocking pods between the flower motifs, has still not been conclusively traced to its manufacturer. Sowerby is a possible contender for the manufacturer, but evidence remains circumstantial (see *A Century of Carnival Glass*[5] for detailed discussion of this pattern).

Shape: bowl

Colors: marigold and blue (both Eda and Riihimaki), lilac (Eda)

An extract from the 1925 Farrglas Fran Eda Glabruk (Colored Glass from the Eda Glass Works) used color printing to give the effect of iridescent glassware. On this page Eda's *OHLSON* bowl can be seen—it is of course the pattern we know as *FOUR FLOWERS*. The *SUNK DAISY* bowl (see below for details) can also be seen.

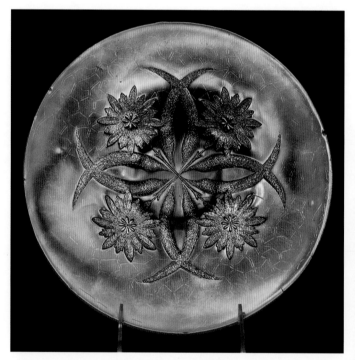

Dugan/Diamond's original *FOUR FLOWERS* pattern, shown here in a peach opal chop plate. $300-1000.

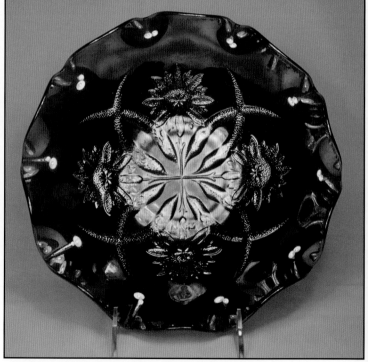

A blue *OHLSON* aka *FOUR FLOWERS* bowl from Scandinavia. As both Eda and Riihimaki made this pattern in the bowl shape in blue and marigold, it is impossible to be certain which manufacturer produced this item. $200-400.

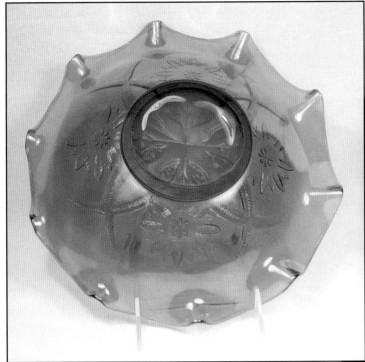

This *OHLSON* aka *FOUR FLOWERS* is easy to attribute to a manufacturer because of its base color—pale lilac. Eda Glasbruks made various shades of lilac/purple Carnival, although it should be considered rare. This photo shows the back view of the bowl to illustrate the ground base. NP.

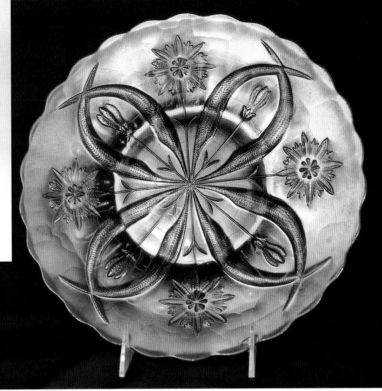

The *FOUR FLOWERS VARIANT* is shown here in the form of a rare (just two or three currently reported) emerald green chop plate. The maker is unconfirmed, but the authors believe it could be a Sowerby product. NP.

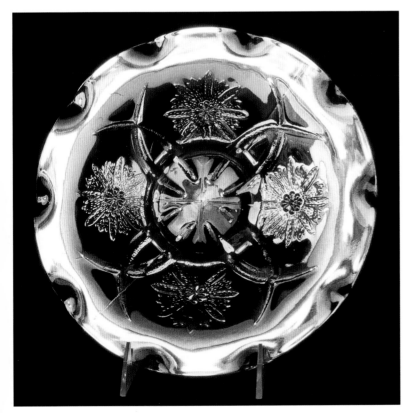

TIGER LILY VARIANT—Riihimaki/Kauklahti

At first glance you would believe this intaglio, floral pattern to be the Imperial version of the *TIGER LILY* pattern, so alike is this Riihimaki/Kauklahti copy. Only found in pitcher and tumbler shapes, the Finnish items can be easily distinguished by the complex hobstar on their ground bases. (The Imperial tumbler has a twenty-four point star on its base while their water pitcher has a pattern of four stylized flower heads and leaf fronds on its base). There are also many more small differences. The Riihimaki/Kauklahti tumbler is smaller than the Imperial version. The more frequently found Riihimaki/Kauklahti pitcher has a larger diameter and bells out more around its middle, while their rare, small sized pitcher has a different profile altogether. There are also several subtle pattern differences. Two slightly different shapes of tumbler are known—one straight sided and one slightly flared—these were shown in the Finnish catalogs.

 Shapes: water pitcher in two sizes and tumbler
 Colors: marigold, blue and amber

Here's an unusual shape for the Scandinavian *FOUR FLOWERS*—it's a very low, marigold plate that is flat across the top surface with ten tight pinched crimps around the edge. As this item is marigold, it's not possible to state if it was made by Eda or Riihimaki—it could be either. SP $200-400.

The original version of the *TIGER LILY* was made by Imperial. This is a water pitcher in aqua-teal. $250-500.

SUNK DAISY (AMERIKA)—Eda Glasbruks and Riihimaki/Kaukhlati

This intaglio, floral pattern was originally made in the United States by the Cambridge Glass Company and was their pattern number 2760. It first appeared in the Butler Brothers catalogs from around 1910. The distinctive squared foot was patented by Cambridge Glass and most items were marked "NEAR-CUT." A few years after its appearance in Butler Brothers, the pattern (in the shape of a footed bowl) was depicted in the Riihimaki 1915 crystal glass catalog where it was given the pattern name "Onerva." At that time, it was no doubt only produced in crystal and not in iridized glass. In 1925 the same item was featured in an Eda catalog where it was called *AMERIKA*, which strongly suggests its origins (see catalog illustration above). The subsequent Eda catalog of 1929 depicted *AMERIKA* again, its catalog number being 2400-03 indicating that it was made in four sizes of bowl. At roughly the same time (1927) the footed bowl was illustrated in the Riihimaki/Kaukhlati catalog. Twelve years later, the same pattern, but in a wider range of shapes that included jugs and bowls, appeared again in the 1939 Riihimaki catalog. No name appears to have been given to the design in the Finnish catalogs at that time, but collectors today refer to it as *SUNK DAISY*. Note that the underside of the distinctive square feet is ground flat.

Shapes: bowls, plates and a jardinière in varying sizes. The bowls may be cupped in, upright, or flared out to varying degrees. Bowls and plates are footed and range from tiny diminutive examples right up to large, heavy items. A scarce footed creamer is also now known in the pattern.
Colors: marigold, blue, pearl (Eda only), pink and purple (Eda only)

SUNK DAISY aka *AMERIKA* blue rose bowl—this could be either from Eda Glasbruks or Riihimaki/Kaukhlati. $150-250.

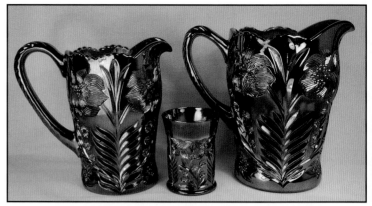

The Riihimaki/Kauklahti version of *TIGER LILY* is almost indistinguishable from the Imperial one. Here are two pitchers in varying sizes flanking a *TIGER LILY* tumbler—the larger pitcher on the right is seen more often than the small one to the left. SP $400-700.

The base of the *TIGER LILY* tumblers clearly differentiates the manufacturers. On the left, the blue Finnish tumbler has a ground base and a complex star. SP $125-250. On the right, the purple Imperial tumbler has a 24 point star. SP $75-125.

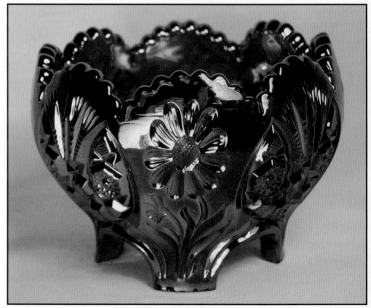

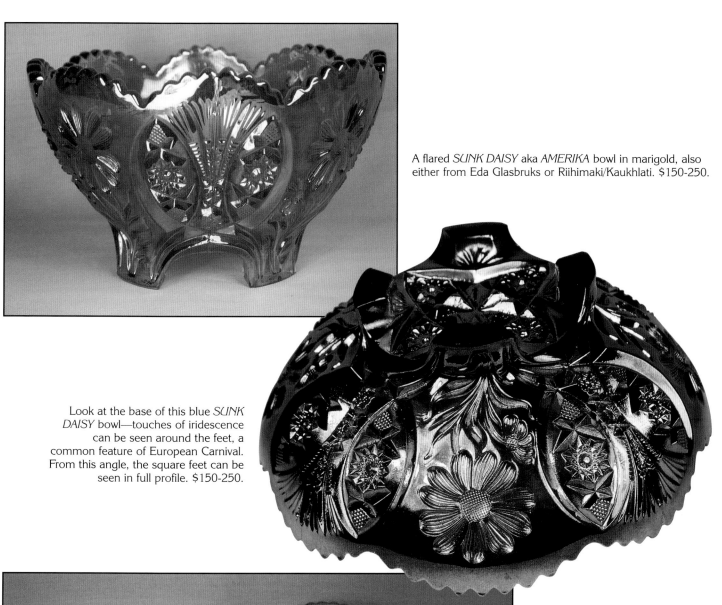

A flared *SUNK DAISY* aka *AMERIKA* bowl in marigold, also either from Eda Glasbruks or Riihimaki/Kaukhlati. $150-250.

Look at the base of this blue *SUNK DAISY* bowl—touches of iridescence can be seen around the feet, a common feature of European Carnival. From this angle, the square feet can be seen in full profile. $150-250.

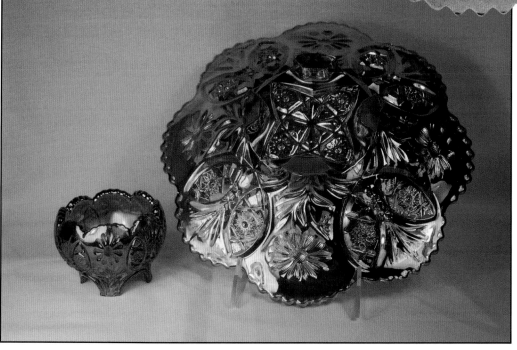

A wide range of shapes and sizes can be found in the *SUNK DAISY* pattern, from diminutive rose bowls to large flat plates. Note the pattern is exterior. The value of these marigold items would be in a range from approximately $150 to $400.

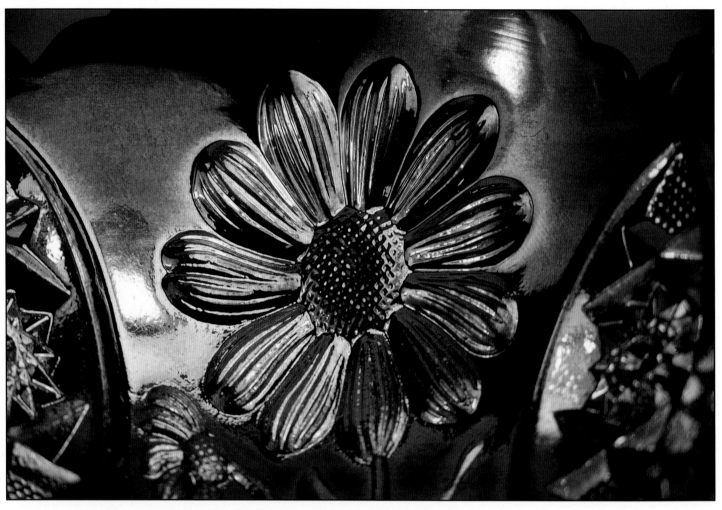

Close-up detail of the *SUNK DAISY* pattern showing the intricate intaglio mould work.

RIIHIMAKI GRAPE—Riihimaki

The deeply moulded grape pattern is raised up from the surface on this impressive bowl. The grape design is all on the exterior and the interior is plain. The base (marie) is typically ground. At first sight, the pattern looks like a Classic American product, with its plump grapes and irregular leaves. But this item is undoubtedly from Finland and is clearly shown in the Riihimaki catalog. Undoubtedly inspired by the many grape patterns of Classic Carnival.

 Shape: bowl
 Colors: marigold and blue

Grapes were one of the most popular motifs on Classic Carnival Glass. Here they can be seen on a Northwood *GRAPE AND CABLE* banana boat in purple. $200-500.

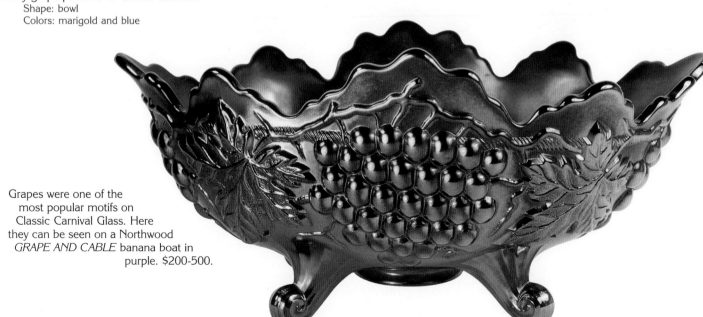

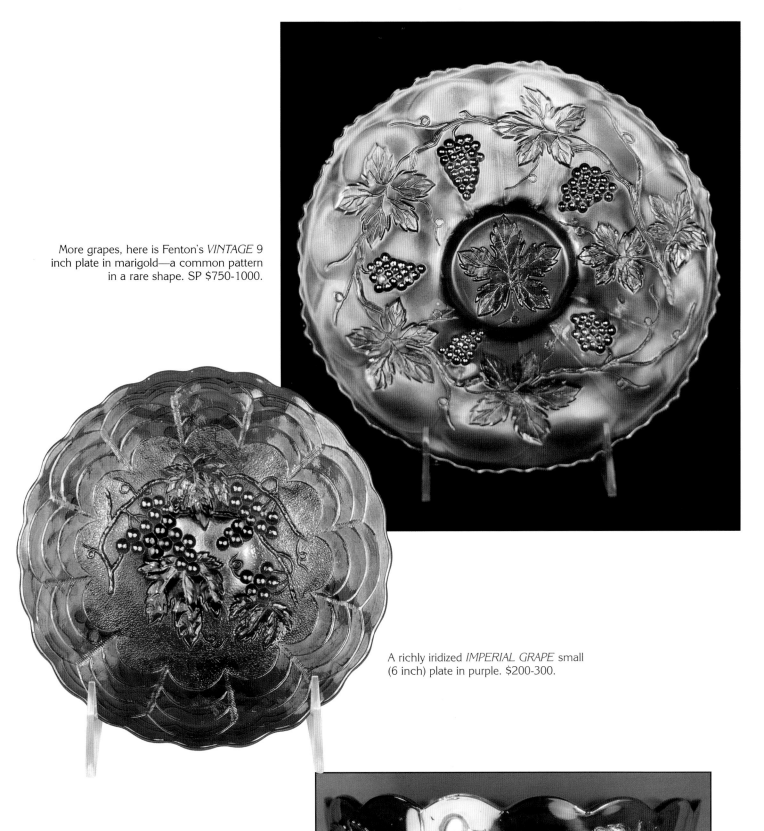

More grapes, here is Fenton's *VINTAGE* 9 inch plate in marigold—a common pattern in a rare shape. SP $750-1000.

A richly iridized *IMPERIAL GRAPE* small (6 inch) plate in purple. $200-300.

Hard to tell at first glance that this bowl, with its proudly moulded grapes, is actually from Finland. This is a marigold bowl in the *RIIHIMAKI GRAPE* design. SP $150-250.

GRAPE MEDALLION—Riihimaki/Kauklahti

At a brief first glance, this cameo pattern could be taken for a look-alike to Fenton's *PEACOCK AND GRAPE*. Further scrutiny reveals that the motifs in the medallions are, in fact, single large grape leaves alternately featured with bunches of grapes. The overall effect is of a very regular and ordered design. It is found with one of two exterior designs: one is plain panels separated by a small three line motif—the other is *DOUBLE STARFLOWER*, a copy of the daisy motif that is part of the exterior pattern on Imperial's *OPEN ROSE* bowls. *DOUBLE STARFLOWER* is also known in a rare handled sugar and creamer set. The base is ground.

Shapes: bowls in two sizes: miniature, flat plates in two sizes (4 inches and 5 inches diameter)
Colors: marigold, pink, amber and blue

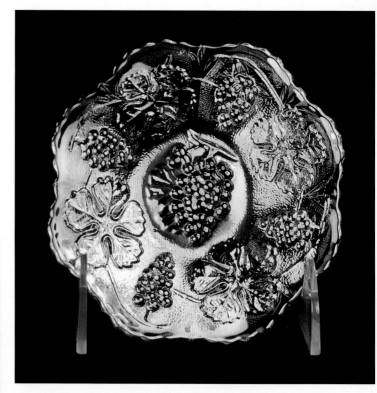

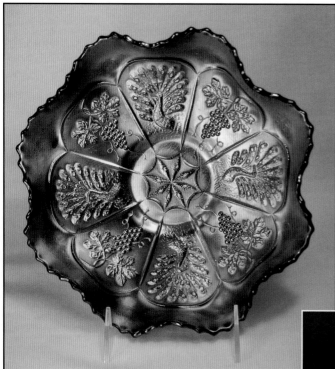

A miniature (3.75 inches in diameter) plate in Riihimaki/Kauklahti's *GRAPE MEDALLION* pattern. The design is cameo and stands proudly on this pretty item—something of a departure from the norm for the Finns, as the majority of their Carnival patterns are intaglio. In fact *GRAPE MEDALLION* has more of the characteristics of the Classic Carnival designs and was surely made in imitation of them. NP—this is the first example reported.

Fenton's *PEACOCK AND GRAPE* ruffled bowl. The base color is a deep red slag. SP $500-1000.

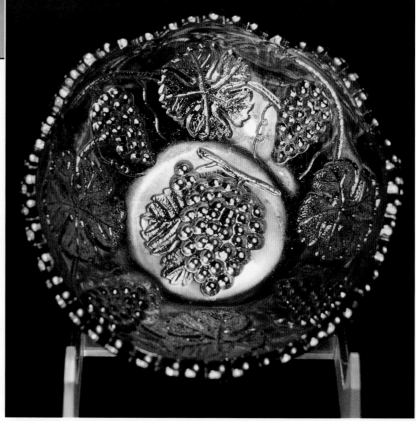

A small 5 inch amber bowl in Riihimaki/Kauklahti's *GRAPE MEDALLION* design. SP $100-200.

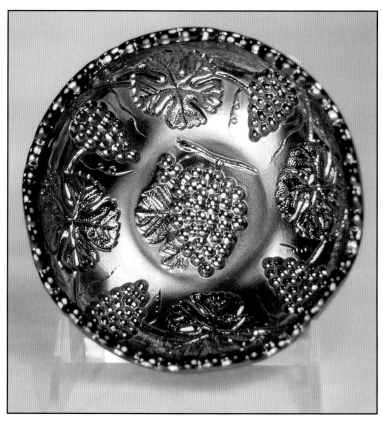

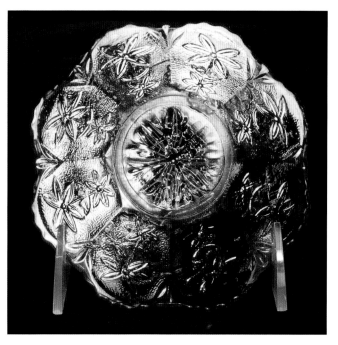

DOUBLE STARFLOWER is the exterior paneled pattern that is coupled with GRAPE MEDALLION on the little plate seen in the above photograph. It is also cameo and is very similar to the exterior design on Imperial's OPEN ROSE/LUSTRE ROSE items. NP—this is the first example reported.

A blue 5 inch bowl in Riihimaki/Kauklahti's GRAPE MEDALLION. SP $100-200.

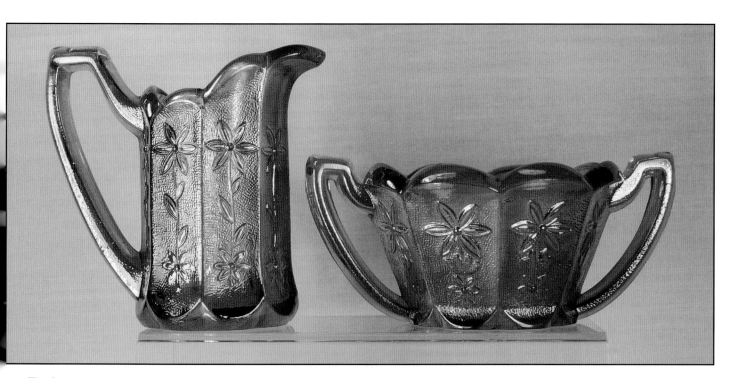

The first reported sugar and creamer in the Finnish DOUBLE STARFLOWER design. The shape and style of the items bears a resemblance to Chippendale pieces. NP.

WREATH OF FRUITS—Karhula

Only a single example (a 7" blue bowl) of this intriguing item is currently reported. Its proudly raised (cameo) fruit pattern features an encircling wreath of cherries, plums, pears, and apples—the leaves of all four fruits are identical. There are eight tapering panels, each topped off with a banded scallop. The base is ground and features a deeply incised multi pointed star. The pattern is illustrated in the Karhula 1934 catalog and has the pattern number 4371. Shapes shown are regular bowl, low bowl, and plate. Only the ground and polished base on this item is a clue to its origin, for at first sight, this pattern could easily be mistaken for a Classic Carnival Glass item.

Shape: only the 7 inch bowl is currently known in Carnival
Color: blue

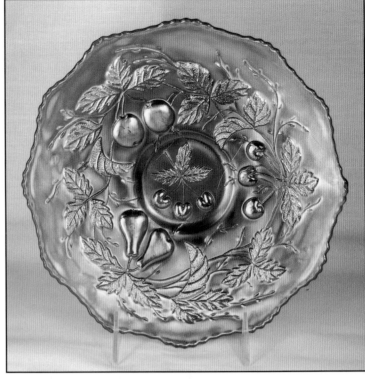

Fenton's 12 sided *THREE FRUITS* plate in green. $150-300.

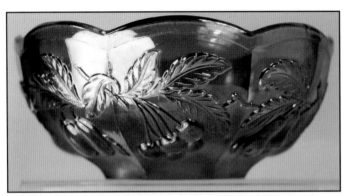

Karhula's *WREATH OF FRUITS* 7 inch blue bowl—currently the only example reported. The fruits are cameo (raised up off the surface of the glass)—the overall appearance of the design echoes the Classic patterns such as the Fenton example shown above. NP.

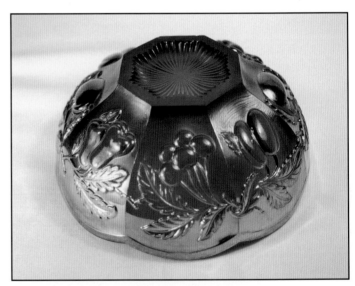

The Karhula *WREATH OF FRUITS* bowl turned upside down, better to see the paneled design and the 8 sided ground and polished base. NP.

BALTIC FRUITS—unconfirmed, possibly Karhula

Just two examples of this pattern, in the form of an oval jardinière and a small bowl, are currently known. The pattern bears many similarities to *WREATH OF FRUITS* (see above) with one major exception—*BALTIC FRUITS* is intaglio where *WREATH OF FRUITS* is cameo. Both items have eight panels and a similar incised star base. The pattern of fruits and leaves is very similar too, though in *BALTIC FRUITS* there are just two fruits (apples and pears).

Shapes: 8.5 inch long jardinière and small round bowl
Colors: marigold and pink

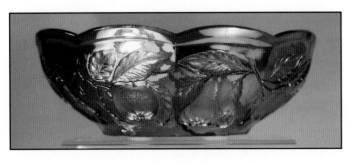

BALTIC FRUITS (maker unconfirmed but possibly Karhula). In many ways, this is familiar to the *WREATH OF FRUITS* pattern above, but note that the design is intaglio (cut in). Only two examples are reported so far. NP.

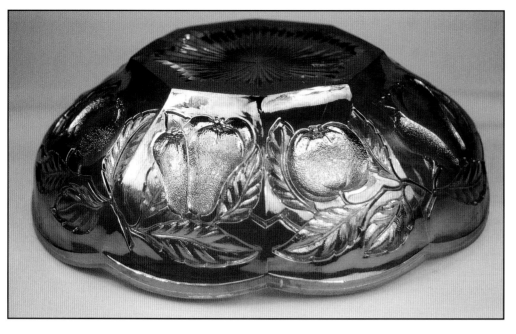

The *BALTIC FRUITS* bowl turned upside down, showing the paneled design and ground base. NP.

MAUD—Eda Glasbruks

The theme of the pattern on this splendid little bowl is grapes and vine leaves—but the execution is outstandingly different. The bunches of grapes and leaves are very deeply incised (intaglio) on the glass. The pattern is cleverly designed as an entity over the entire exterior surface of the glass. The grape vine forms a pattern motif around the base of the glass, while the grape and leaf motif continues over onto the ground base itself. A very clever and skillfully crafted piece of mould work. The pattern is illustrated in the Eda Glasbruks 1929 catalog.

 Shape: small bowl
 Colors: blue and purple

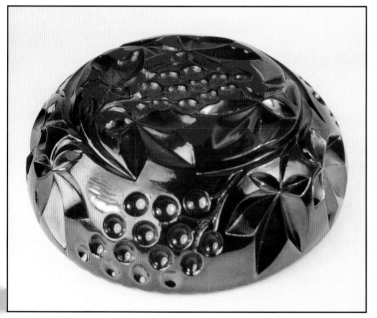

A seldom seen item from Eda Glasbruks featuring grapes—this is a 6 inch *MAUD* bowl in rich purple. The pattern is all intaglio and deeply "cut" into the glass—note, the bowl is shown upturned to illustrate the exterior and base. SP $300-500.

Imperial's *OPEN ROSE* small berry bowl in smoke. $50-70.

RIIHIMAKI OPEN ROSE—Riihimaki

When the authors saw a 6 inch plate in this pattern on an antique stall in southern Finland they thought at first that it was an Imperial item. But stop! Imperial didn't make a small plate in the pattern—only small bowls. Pick it up and examine it! Amazingly enough, there is a collar base, just like the Imperial example, but wait—the actual base is ground. This was a Riihimaki copy of the Imperial *OPEN ROSE* pattern.

So how are the Imperial and Riihimaki items similar? And how do they differ? The rose pattern on the interior or top side, is identical in concept, although there are many small differences in execution. The exterior pattern, however, is very different. On the original Imperial version, there are three panels featuring a rose with buds, alternating with three smaller panels that feature a daisy motif. On the Riihimaki copy, there are just four large panels, each featuring a rose and buds. Another give-away is the ground base on the Riihimaki version. Of course, the shape (a 6 inch plate) is not known to have been made by Imperial either, so that too, helps to differentiate between the two manufacturers. A bowl in the Riihimaki *OPEN ROSE* pattern is very likely to have been made—however, two examples of the plate are currently the only reported items in this pattern. The final determining factor is the color of the base glass on the Riihimaki example—it's pale pink!

 Shape: 6 inch plate
 Color: pink

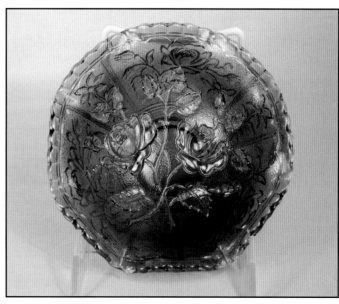

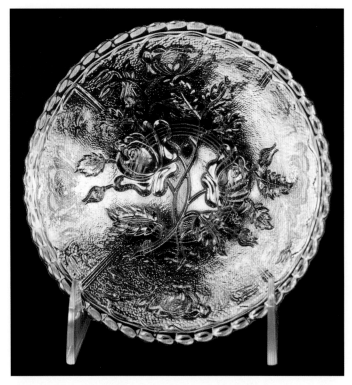

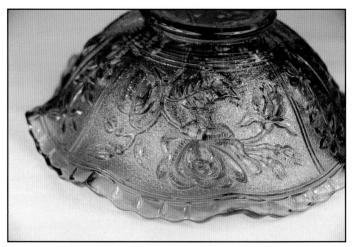

The exterior design on Imperial's *OPEN ROSE* small berry bowl in smoke.

This is Riihimaki's *RIIHIMAKI OPEN ROSE* small 6 inch plate. It has a pale pink base glass and a marigold iridescence. At first glance it is almost indistinguishable from the original Imperial version of the pattern. NP (Only two examples currently known, neither have yet sold).

The exterior design on the *RIIHIMAKI OPEN ROSE* plate. Close study will show the similarity between this and the original Imperial *OPEN ROSE* exterior, shown above.

A close-up of the *RIIHIMAKI OPEN ROSE* plate. A comparison of this pattern with Imperial's *OPEN ROSE* will show them to be almost identical.

Cultural and Ethnic Diversity

Patterns in Carnival Glass reflect many aspects of society. Fashions and design trends of the era (for example the taste for all things Oriental, which helped to bring about the multitude of peacock designs and associated inspired motifs) were certainly among the main influences on the patterns used. However, there are certain patterns found in Carnival, that were very specific to the country of origin, and reflect the society and culture that gave birth to them.

In Classic Carnival, promotional patterns featuring advertising as well as those depicting buildings and other structures, reflect the proud development of the United States in the early 1900s. The *MILLERSBURG COURTHOUSE* bowl is possibly the most well known example of this genre, depicting as it does, the courthouse building in the little town of Millersburg where John Fenton established his famous factory in 1909. Indeed, tales abound that John Fenton brought a number of peacocks with him to the town—and it seems they caused much nuisance there. They were often seen strutting across the Courthouse lawn, frightening passers-by and horses alike, with their raucous screams. One belligerent old peacock used to position itself at the top of the Courthouse steps as if to challenge those wishing to enter the building. The story goes that a scoop shovel was placed near the top of the steps for those who wished to defend themselves!

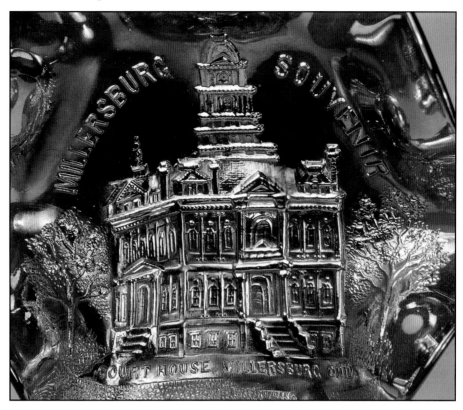

This close-up of the *MILLERSBURG COURTHOUSE* bowl allows an examination of the fine detail shown on the building façade.

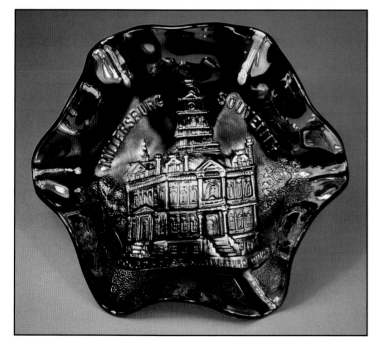

The *MILLERSBURG COURTHOUSE* bowl features the historic courthouse building that stands to this day. The ruffled bowl in amethyst, $1000-1500.

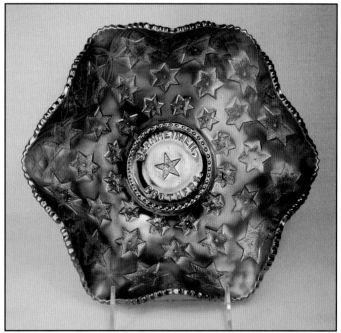

The Millersburg *BERNHEIMER (BROTHERS)* bowl is only known in blue, (a color that is actually rather rare for Millersburg in most other patterns). This was a special order bowl made as an advertising piece. $3000-5000.

Most Australian Carnival patterns are unique to their country of origin. The shapes (mainly bowls and compotes) and colors (mainly purple and marigold) were no different to those made by other countries—but the patterns are another story entirely! Kangaroos, emus, kookaburras. Waratah flowers, wattle blossoms, and flannel flowers. The flora and fauna of Australia are beautifully portrayed on the splendidly exuberant designs that were produced by the Crown Crystal Glass Company of Sydney, Australia. In recent years, the Australian collector clubs have issued commemorative souvenirs that continue this theme of native flora and fauna.

A BPOE (Benevolent Protective Order of the Elks) 1911 Atlantic City *ELKS* bowl made by Fenton. According to John Resnik in his *Encyclopedia of Carnival Glass Lettered Pieces* (self published in 1989) in conversation with Frank M. Fenton, it emerged that "these pieces were commissioned by jobbers to be sold as souvenirs at the various Elk's functions." $1000-2000.

Indigenous flora and fauna are frequently depicted on Carnival from the Australian manufacturer, Crown Crystal. This magnificent *KOOKABURRA* master bowl in the rare ice cream shape features wattle sprigs, waratahs, and flannel flowers around the little bird. In black amethyst, this item sold for $1950 in 1999.

A rare item indeed, this is the *CLEVELAND MEMORIAL ASHTRAY* made by Millersburg. Five scenes from the town of Cleveland in the early 1900s are depicted here: the Garfield Statue, the Soldiers and Sailors Monument, Superior Viaduct, the Cleveland Chamber of Commerce and Garfield's Tomb. *Photo courtesy David Doty*. In amethyst, $4,500-6000.

Another *KOOKABURRA* bowl from Crown Crystal—this is the hard-to-find float bowl, in marigold, with a "bullet" edge. $800-1000.

Indian Carnival is very distinctive. Not only are some of the shapes very striking (such as the *FISH* and *ELEPHANT* vases (see Part Two, Chapter Three, "Vases," for illustrations of many of these distinctive designs) but also the patterns are very recognizable, reflecting as they do, the culture, religion, and art of the Indian subcontinent. The influence of folk art and crafts such as wall painting and embroidery (chikankari) can be seen in the rich designs. One of the national symbols of India is the peacock, and a stylized representation of the bird can be seen on several items of that country's Carnival Glass.

A small 5 inch berry bowl in Crown Crystal's scarce *KIWI* pattern. $250-300.

This splendid group of Indian Carnival includes both vases and tumblers. At the top is a rare Jain blue *DIAMANTE STARS* vase SP $100-200. The remainder from the left: *BEADED SPEARS VARIANT* in rare Jain blue SP $100-150; marigold *BEADED SPEARS* tumbler SP $50-100; small *HAND* vase (*LEFT HAND STOLEN WATCH* version) SP $50-150; *ELEPHANT* vase (small size) SP $50-150; *FROSTED FISH* vase—one sold at auction in the USA in 1999 for $500; a group of three tumblers—at the back *BRIDE'S BOUQUET* (SP $100-150); front *SHALIMAR* ($100-150) and *GRAPEVINE AND SPIKES* (SP $75-100).

The peacock is a national symbol in India and can be seen on this *MAYURI* aka *PEACOCK TREE* vase. SP $100-150.

European Carnival, though having many distinguishing signature characteristics, does not generally have patterns that reflect the individual countries of origin. However, there is at least one notable and rare exception to this rule—a Riihimaki/Kauklahti pattern that was discovered in Finland in April 2002. Named by the authors as *HARE AND HOUNDS* it depicts a rural scene, typical of its country of origin, showing a large hare being pursued at top speed by a pair of lithe hounds. The background scene to this detailed pattern is of coniferous trees, typical of the beautiful, forested Lake District in southern Finland. A similar pattern band concept to *HARE AND HOUNDS* is the more familiar *FIR CONES* design, known in the shapes of water pitcher, tumbler, sugar, and creamer.

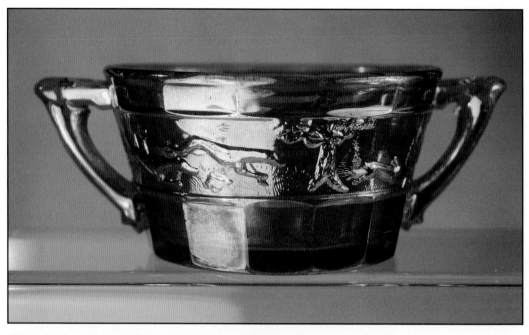

This is the first known example of Riihimaki/Kauklahti's *HARE AND HOUNDS* handled sugar bowl in marigold. The pattern is illustrated in Riihimaki catalogs from 1927 to 1939 and it was very possibly a Kauklahti original. NP.

Seen close-up, the pattern on Riihimaki's *HARE AND HOUNDS* is fascinating and quite detailed in its execution.

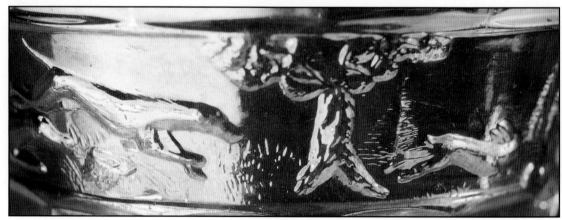

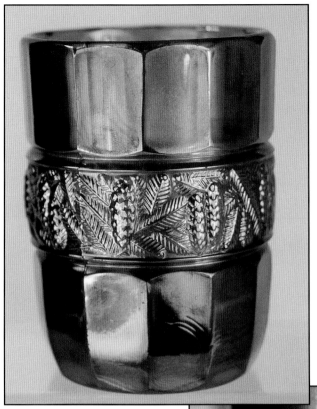

Similar in concept to the paneled *HARE AND HOUNDS* is the Riihimaki/Kauklahti *FIR CONES* pattern. Blue tumbler. SP $350-450.

The pattern band on the *FIR CONES* tumbler features typical Scandinavian conifer cones. The finely detailed design is raised up off the surface of the glass.

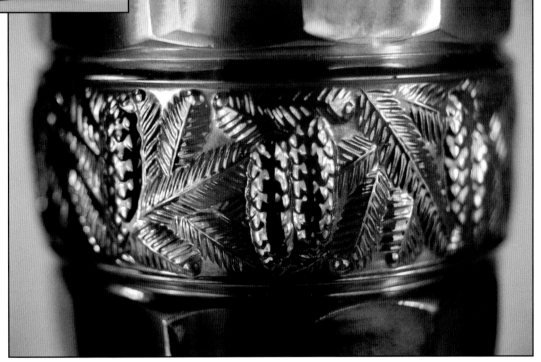

[1] Ecclesiastes 1:7-9.

[2] Thistlewood, Glen & Stephen. *Carnival Glass—The Magic and the Mystery*. Atglen, Pennsylvania: Schiffer Publishing Limited, 1998.

[3] Crowley, David. *Introduction to Victorian Style*. London, England: Apple Press, 1990.

[4] Heacock, William: Measell, James: Wiggins, Berry. *Harry Northwood. The Early Years*. Marietta, Ohio: Antique Publications, 1990.

[5] Thistlewood, Glen & Stephen. *A Century of Carnival Glass*. Atglen, Pennsylvania: Schiffer Publishing Limited, 2001.

Part Two
The Shapes

Naturally, one of the prime motives behind the production of Carnival Glass was to sell it. Of course, the way in which this was achieved went hand-in-glove with the manufacturers' aims of making attractive and appealing glass in fashionable, popular designs. The outcome of it all was that Carnival Glass was a best-seller when it was originally made—and still is today. The mixture of color, iridescence, pattern, and wide variety of shape was a winning combination.

On the face of it, the shapes were functional—tableware items, vases, a wide variety of bowls and plates, items for personal use, lighting and much more. In reality, many of them were so beautiful that they were no doubt often used as ornaments within the home. Northwood's *GRAPE AND CABLE* had probably the widest range of shapes made in one pattern, whereas other patterns such as Northwood's *TREE TRUNK* were only ever made in one basic shape (the vase).

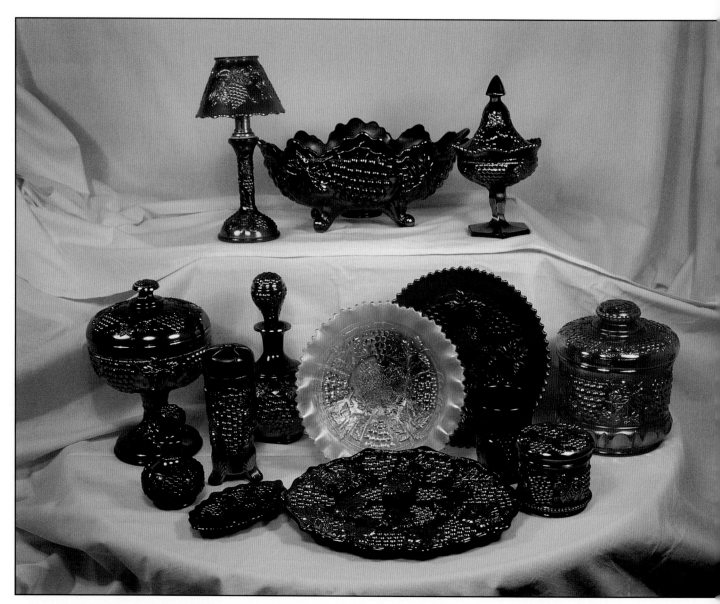

The prize for the greatest variety of shapes in one, single pattern in Classic (Unites States made) Carnival Glass would surely go to Northwood's *GRAPE AND CABLE*. This illustration features just a selection of the different shapes and colors available in the pattern. Back row, left to right: green candle lamp $800-1200; purple banana boat $150-500; purple sweetmeat compote $200-300. Bottom row: purple covered compote $300-500; this pretty little perfume bottle is not Northwood, it's Dugan/Diamond's—$500-800; purple pin tray $100-200; purple hatpin holder $200-500; cologne bottle $200-500; dresser tray $200-350; aqua opal, pie crust edge, stippled bowl $2500-4000; purple plate $100-150; powder jar $100-150; marigold humidor $300-400.

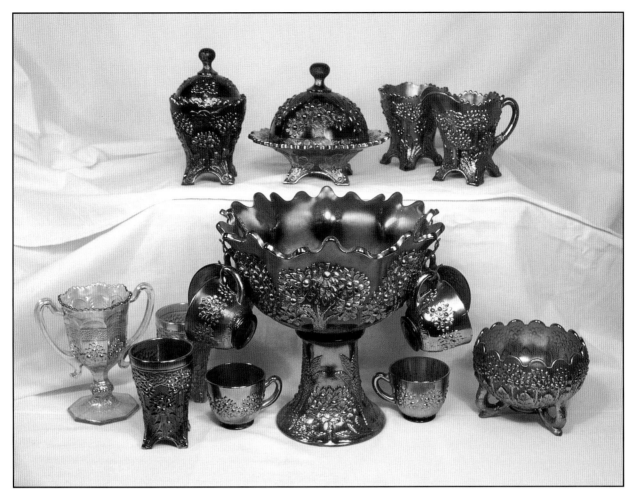

Fenton's *ORANGE TREE* pattern was also made in a wide variety of shapes. Across the top, all four items in the full table set (covered sugar, butter, open spooner, and creamer) $400-700 for the full set in blue. Bottom row, left to right: smoky marigold loving cup NP; blue footed tumbler $50-100; marigold footed tumbler $50-100; punch set and cups $400-600; green rose bowl (aka *FENTON'S FLOWERS*) $150-250. This pattern was surely inspired by the William Morris' orange tree design on his "Orchard" wallpaper—the large leaves seen on the punch bowl base and on the feet of the footed pieces are a representation of the acanthus leaves that form part of the Morris' design.

Two of the European manufacturers, Riihimaki (Finland) and Brockwitz (Germany) are known for producing a range of shapes in a pattern suite. This is the popular Brockwitz pattern *CURVED STAR* in a variety of shapes. Back row, left to right: blue bowl $150-250; marigold epergne NP; blue *SUPERSTAR* jardinière (part of the *CURVED STAR* pattern suite) $350-450. Front row, left to right: blue creamer $75-100; miniature blue bowl $150-300; at back, 9 inch blue cylinder vase $700-1100; 7 inch marigold cylinder vase $400-600; blue celery $175-300; rare centerpiece in blue NP; in foreground, marigold plate NP; blue open, stemmed sugar or compote $100-150; blue, miniature stemmed sugar or compote NP; blue pitcher $2000-3000.

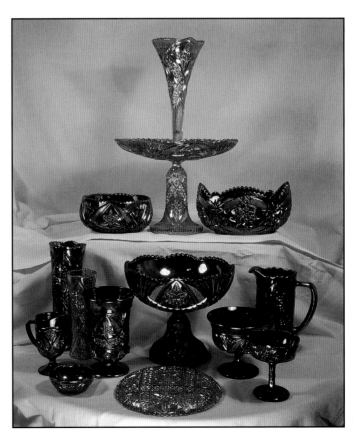

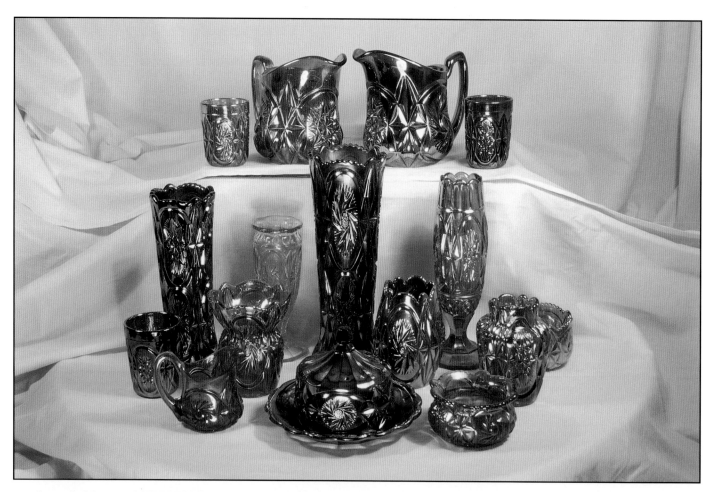

A wonderful array of *STARBURST* items from Riihimaki. Back row, left to right: marigold iridescence on a pink base glass tumbler SP $150-300; amber pitcher SP $800-1400; blue pitcher SP $800-1400; blue tumbler SP$300-500. Front row, left to right; rare green tumbler SP $400-800; 9.5 inch high blue *STARBURST* cylinder vase SP$700-1000; amber creamer SP $100-150; amber vase SP$300-600; small, pale marigold, pedestal footed *STARBURST* vase NP; foreground, blue butter dish SP $500-600; 11.5 inch massive blue cylinder vase NP; blue vase $400-650; *STARBURST AND DIAMONDS* vase (part of *STARBURST* pattern suite) SP $300-600; spittoon shaped (waisted) sugar in amber SP $500-1000 (note, one sold at auction in Kansas City, April, 2003 for $1350); marigold vase SP $300-600; amber sugar SP $150-250.

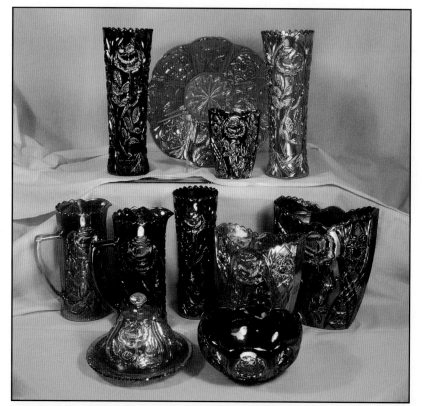

Brockwitz *ROSE GARDEN* items in different shapes and sizes. Back row, left to right: rare 11 inch high cylinder vase in blue, one of two currently reported (NP); marigold chop plate, only one currently reported NP; 5 inch oval, blue vase SP $1500-2000; rare, marigold 11 inch high cylinder vase SP $750-1000. Front, left to right: marigold pitcher SP $500-1000; blue pitcher SP $1000-2000; blue 9 inch cylinder vase NP; mid size, marigold oval vase SP $1000-1500; large size, blue oval vase SP $4000-5000. Foreground: marigold butter dish SP $200-400; mid size blue bowl SP $200-500. Note that oval *ROSE GARDEN* vases were also made by Eda Glasbruks of Sweden.

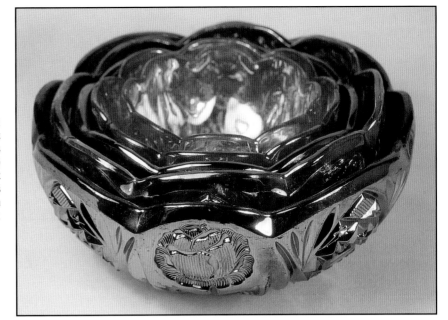

ROSE GARDEN bowls were illustrated in five different sizes in the Brockwitz catalogs through the 1920s. Two sizes (the next to smallest and next to largest) are the easiest to find—however, diligent searching has finally revealed all five sizes (ranging from 9 inches to 4.5 inches in diameter), shown here nested together.

All five sizes of *ROSE GARDEN* bowls set out. Values range from around $100 up to $500 for these items, in blue or marigold.

Only the vase shape was made in Northwood's *TREETRUNK* pattern. This is the standard size that has an (approx.) 3.5 inch base. Other sizes of the vase are known. $80-150.

In order to achieve high sales, the marketing thrust was to give a multi-purpose appeal to the glass. An item may have several different possible uses ascribed to it. Why sell a bowl as a simple "salad bowl" when you can also encourage buyers to think of it as a fruit bowl, a berry bowl, an orange bowl, or simply a "fancy bowl." More names and descriptions: celery, olive, bonbon, sweetmeat, jelly, nappy, sauce—and on and on. The more uses that an item could be put to, the better it would sell.

To add further variety (and "sale-ability") many shapes exhibited further hand finishing. Edges were crimped and shaped and vases were swung and ruffled. The astonishing range of shapes and decorative finishes on Carnival Glass truly illustrates the artistry and skills of the glassmakers. In Part Two, we explore the Art of Carnival Glass through a consideration of function and form, as we study the amazing range of Carnival Glass shapes.

Chapter One
Bowls

When Carnival Glass was first introduced to the buying public, at the start of the last century, it was with one aim—to sell. And the most practical shape of all that could be used for so many purposes, was the bowl. Bowls in every shape and size imaginable can be found in Carnival Glass. Large, small, footed, stemmed, flat, frilled, ruffled and plain. Patterned outside, patterned inside, or patterned both sides. The trade ads suggested a multitude of uses covering just about every culinary purpose: berry bowls, salad bowls, fruit bowls, olive dishes, celery trays, sweetmeats, jelly dishes, bonbons, and more. Of course, they weren't only designed for use—these bowls were beautiful and would often have simply been put on display and admired.

Round, square, oval or tri-corner—these are the main shapes that Carnival bowls were made in. Round bowls are the most readily found shape, with oval coming second (though not too close a "second" as there really aren't too many oval shaped bowls around). Tri-corner and square shaped bowls were usually fashioned from regular round bowls whilst the glass was hot and malleable.

Sixteen years after Carnival was first introduced into the United States, it was still being sold through mail order catalogs. This illustration is taken from a Perry G. Mason Co. "Premium House" mail order catalog dated 1924. A variety of Carnival was offered both for sale and as premiums (gifts) to agents. This *HOLLY* bowl with a (removable) silvered wire handle was offered as a "Cake or Fruit Basket" for 85 cents.

Bowls range from truly massive to diminutive and dainty. This is a tiny, blue, Brockwitz *CURVED STAR* bowl that nestles snugly into the palm of one's hand—you can see the size by comparing the inch rule pictured alongside it. This miniature bowl stands around 1.5 inches high and measures around 3.5 inches across at its widest point. SP $150-300.

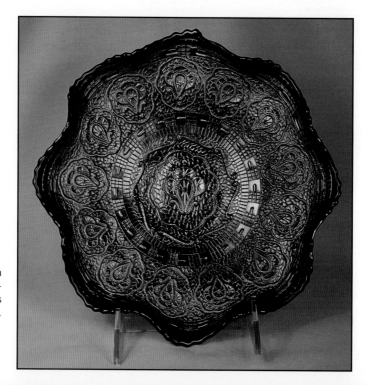

An eight ruffled, round bowl in Fenton's *PERSIAN MEDALLION* pattern. This example is in rare red. $1000-2500.

An oval shaped *STARBURST MEDALLIONS* bowl from the Finnish manufacturer, Karhula. Note also the traces of iridescence on the ground base of this blue bowl. *Courtesy Ann and David Brown.* SP $150-400.

A square shaped, ruffled bowl from Dugan/Diamond in the scarce *GRAPE ARBOR* pattern. This purple bowl is seldom offered for sale, SP $100-300.

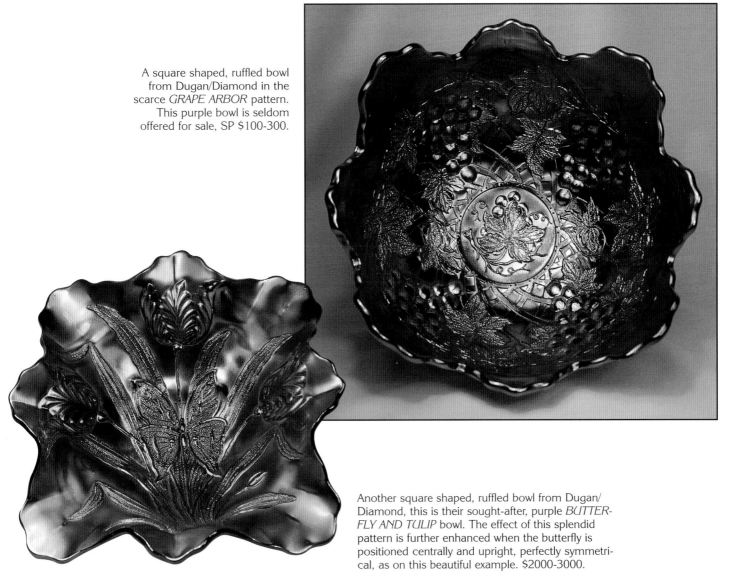

Another square shaped, ruffled bowl from Dugan/ Diamond, this is their sought-after, purple *BUTTER-FLY AND TULIP* bowl. The effect of this splendid pattern is further enhanced when the butterfly is positioned centrally and upright, perfectly symmetrical, as on this beautiful example. $2000-3000.

This marigold Brockwitz *CURVED STAR* bowl is both square and unruffled—rather an unusual shape for this pattern. *Courtesy Carol and Derek Sumpter*. SP. $100-200.

An unusual shape, this peach opal *SKI STAR* bowl (Dugan/Diamond) has first been pulled into an elongated banana bowl shape, then pulled again. $100-200.

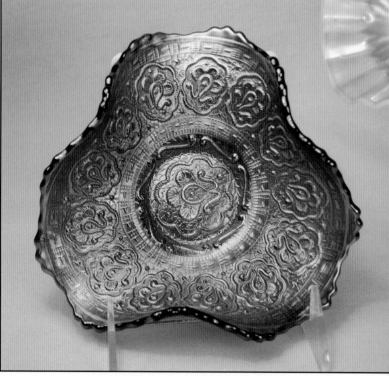

An unusual tri-corner bowl pulled in three ways—this is Fenton's *PERSIAN MEDALLION* pattern in amethyst. SP $100-200.

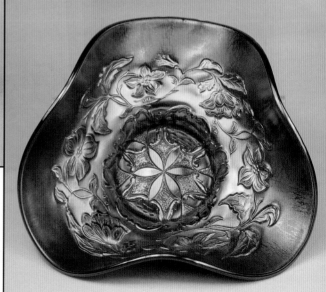

A tri-corner bowl from Dugan/Diamond, this is a purple *SIX PETALS* bowl. $200-300.

Many of the terms given in the early Butler Brothers ads from around 1909-10 appear to be interchangeable. One ad quotes a berry set comprising a "deep bowl and six nappies." Similar bowls are shown in other ads where the large bowls are called "salad bowl," "flared berry bowl," and "sauce or fruit bowl." To further complicate the terminology, one ad for Fenton's glass depicts two items: a 6 inch *SAIL-BOATS* "crimped nappy," and a 5 inch *PANTHER* "footed berry." Another ad for the same two items, also in a Butler Brothers catalog, calls the *SAILBOATS* item a "sauce dish" and the *PAN-THER* a "bonbon."

Size

Size is arguably the main element that determines the category the bowl falls into. To determine the size measure the diameter across the top of the item. The majority of bowls fall into the 8 to 9 inch diameter category—these would have been sold as salad or berry bowls. Some bowls are much larger though, and can run to around 11 inches or so across. They include master berry bowls, centerpiece bowls and fruit bowls intended for oranges or bananas.

• **Regular bowl**—around 8 to 9 inches across, but can be larger. Pattern usually on the interior surface, possibly for display potential (often both interior and exterior are patterned). Multipurpose use intended.

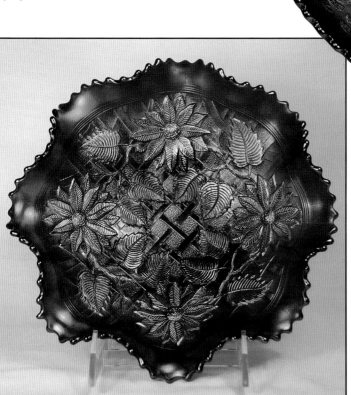

Here's a regular bowl with eight, gentle ruffles. It's Northwood's *POINSETTIA AND LATTICE* in cobalt blue. $300-800.

A splendid and rare, centerpiece bowl from Fenton in the *PANTHER* design. The shape (opened wide and unruffled) is what differentiates this from the regular *PANTHER* bowls. A similar bowl sold in 2002 for $2300.

• **Master berry bowl**—often (not always) this would have deep sides and an exterior pattern only, for practicality. By definition, the "master" would be part of a set, and would have six matching smaller berries. Note these bowls are usually round, but oval shaped bowls are also known. Dugan/Diamond's oval shaped *WREATHED CHERRY* was made in a berry set—the large oval master berry is sometimes thought to be a banana boat (see below).
• **Centerpiece bowl**—many collectors give this type of bowl a separate category. The centerpiece bowl should be large (around 10 inches or more in diameter), unruffled and with the edge slightly cupped in or straight up. It is this straight un-ruffled edge that distinguishes the centerpiece bowl from similar large items, such as orange bowls. An extension is the centerpiece set, complete with candlesticks. In his *Collectors Encyclopedia of Carnival Glass*,[1] (long out of print) Sherman Hand described the *GRAPE AND CABLE* centerpiece set, comprising a large, footed, cupped in bowl flanked by two matching candlesticks. Such a set may also be termed a *console set*. In European Carnival, centerpiece bowls were also made on stands or pedestals, to rise above the rest of the dishes set out on the dining table. The Brockwitz Glass Works in Germany produced several massive and impressive centerpieces, such as the *CURVED STAR* example illustrated.

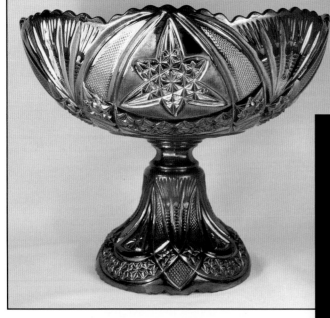

Also a centerpiece bowl, but a very different shape, this is Brockwitz' *CURVED STAR* centerpiece. The bowl and stand is one entire item (fused together). Currently two examples are reported in blue. NP.

- **Ice cream bowl**—like the berry bowls, these usually came in matching sets of one large ice cream bowl and six matching, small bowls. The defining characteristic of the ice cream bowl is that it is low and completely round with no edge shaping or ruffling whatsoever—the pattern will be on the interior or upper side. The edge should cup in slightly. (These bowls would most likely have been used for ice cream, which would, of course, not be contained well if the edges were flared or ruffled). It is worth noting that the term *ice cream shape* is used to denote a round, unruffled bowl that has a slight cup inwards. Such a bowl would not be part of a full set. The abbreviation ICS is used to denote the ice cream shape.

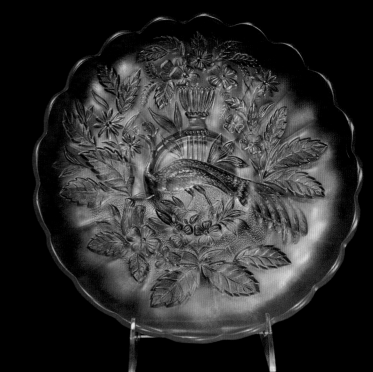

Northwood's *PEACOCK AND URN* master ice cream bowl in ice blue. $800-1500.

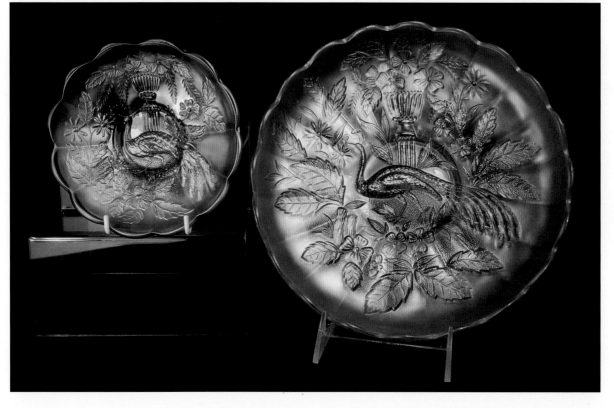

Northwood's ice cream bowls in the *PEACOCK AND URN* pattern. On the right is an ice green master ice cream bowl measuring almost 10 inches across; on the left is a small, individual ice cream bowl in green. Ice green master ice cream bowl. $1000-2200. Individual ice cream bowl in green. $500-800.

• **Fruit bowl, Orange bowl, and Banana boat**—generally these are larger (again around 9 inches to 10 inches across) and more showy than the regular bowls. They may have feet or even comprise a bowl and separate base. Such fruit bowls were often termed *orange bowls* when they were originally made, according to contemporary Butler Brothers ads. Note that these bowls may be ruffled, a characteristic that distinguishes them from the scarcer, straight edged centerpiece bowl. Footed, oval shaped *banana boats/bowls* also come into this category. Many European fruit bowls were intended as two part sets. An upturned stemmed sugar (or a compote) was used as the matching base and would fit into a circular groove on the base of the large fruit bowl.

A Fenton banana boat in rich cobalt blue with two patterns: *WATERLILY AND CATTAILS* on the exterior, *THISTLE* on the interior. This bowl measures 10.5 inches from side to side, and stands on four feet. $200-400.

This European bowl is shaped just like the Classic Carnival banana boat, but its intended purpose (according to information in catalogs) was not for fruit, instead it was to hold potted plants and flowers on a narrow window ledge. This is a blue *HAMBURG* jardinière and it was made by the Swedish manufacturer Eda Glasbruks. SP $400-700.

An amethyst, two piece fruit bowl by Dugan/Diamond in the *PERSIAN GARDEN* pattern. $500-800.

- **Float bowl**—a large and impressive low bowl with a shallow profile intended to be filled with water on which would be floated flower heads. Examples are mainly from Australian and European makers.

Large, blue float bowl in the *CHARLIE* pattern from Eda Glasbruks. Eda gave the design this name in their 1920's catalogs. SP $200-400.

The smaller bowls are around 4 inches in diameter and are often termed sauces, nappies, bonbons, or berry bowls (berries). Even tinier bowls are known. Though original contemporary advertising seemed to use the terms indiscriminately, today's collectors have (more or less) agreed on the following terminology:

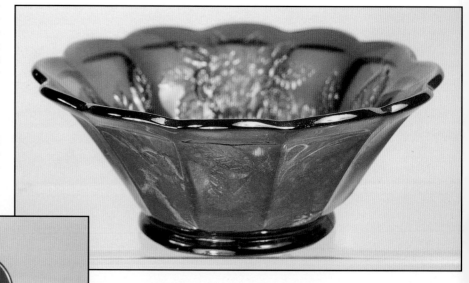

A small and unusually deep, sauce bowl in amethyst by Millersburg in the *PEACOCK AND URN* pattern. The unruffled form characterizes this shape. $100-200.

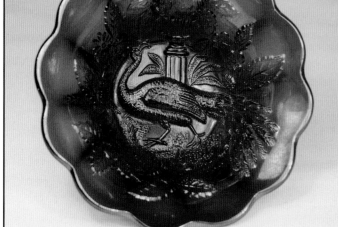

- **Sauce**—a small bowl that is not ruffled (or the sauce would simply flow out).
- **Individual ice cream**—shallow in depth, unruffled and cupped in slightly (refer to previous illustration of the master ice cream bowl to also see the individual ice cream).
- **Berry**—may have a matching master berry bowl, also may be ruffled.

The same Millersburg *PEACOCK AND URN* bowl is illustrated here from above, to show the interior pattern better.

A small berry bowl in the *EMU* pattern from Crown Crystal. $100-200.

• **Nappy**—small dish, usually one handled (may be collar based or pedestal based).

Dugan/Diamond's *LEAF RAYS* one handled, spade shaped (tri-corner) nappy in pale lime green with a strong marigold iridescence. The glass does not glow under UV light. This color was part of Diamond's "After Glow" assortment that was produced in the late 1920s and early 1930s. SP $50-80. Cleo and Jerry Kudlac have researched this range of Carnival and a visit to their website is advised. http://home.ionet.net/~jckok/afterglow.html.

A 1924 catalog extract from Lee Manufacturing showing a range of shapes in Imperial's *OPEN* (or *LUSTRE*) *ROSE* pattern. The set of bowls shown bottom left is the berry set, comprising a master berry bowl and six small, matching berries. It's interesting to note that the set was described as a "7 pc. Golden iridescent berry or salad set"—multi purpose use always meant better sales. Other shapes illustrated in the ad are: water set, table set, and goblets. These other shapes will be discussed in later chapters.

101

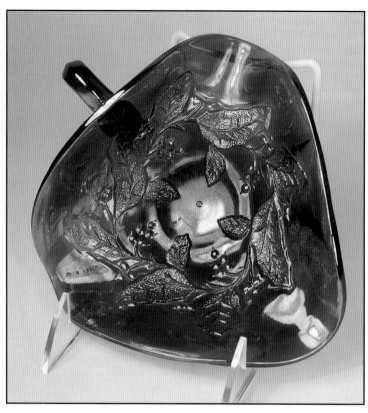

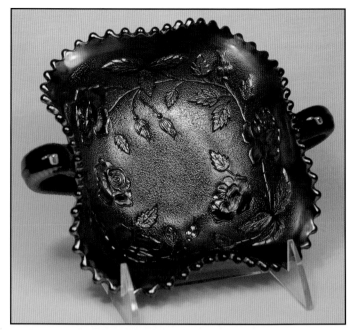

Another two handled bonbon, this is rather a rare one— Northwood's *BASKET OF ROSES* in purple, which has the Northwood *BASKETWEAVE* exterior. $200-400.

An amethyst, tri-corner, one handled nappy in Millersburg's *HOLLY SPRIG* pattern with a radium iridescence. $80-125.

• **Bonbon**—small dish, usually two handled; ruffled, un-ruffled, or two sides pulled up (also may be collar based or pedestal based).

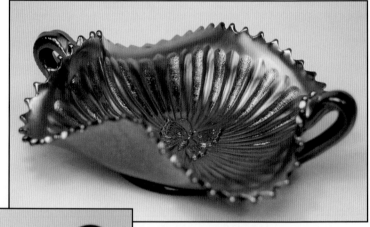

Northwood's collar based *BUTTERFLY* bonbon in purple. The two sides are pulled up between the handles. $100-140.

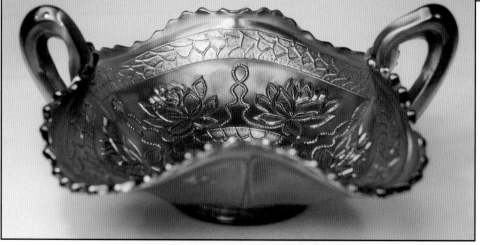

Fenton's *POND LILY* handled bonbon in cobalt blue. $50-80.

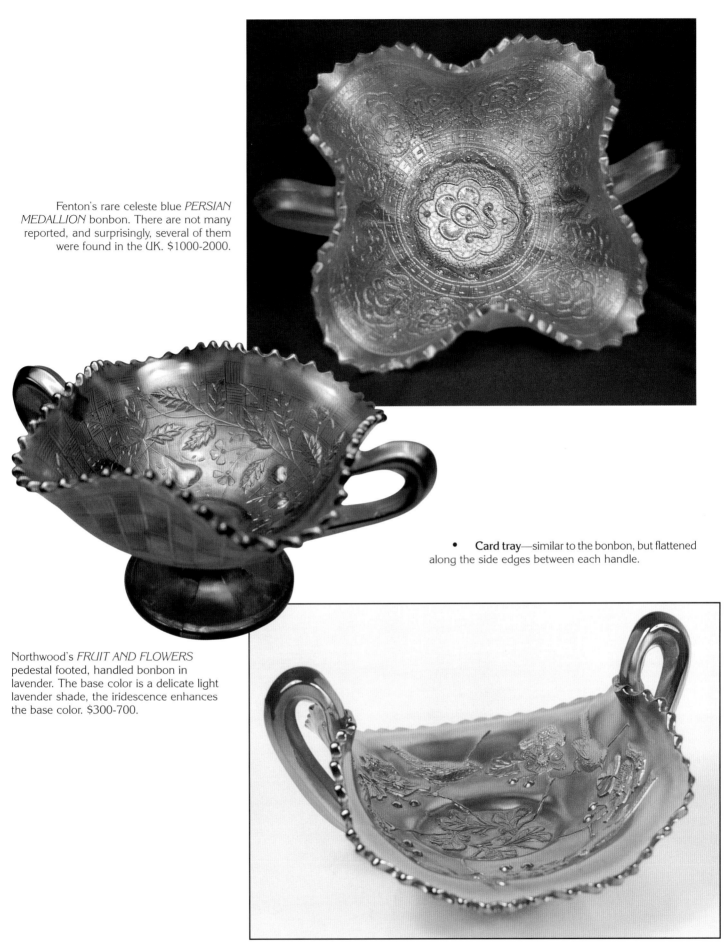

Fenton's rare celeste blue *PERSIAN MEDALLION* bonbon. There are not many reported, and surprisingly, several of them were found in the UK. $1000-2000.

• **Card tray**—similar to the bonbon, but flattened along the side edges between each handle.

Northwood's *FRUIT AND FLOWERS* pedestal footed, handled bonbon in lavender. The base color is a delicate light lavender shade, the iridescence enhances the base color. $300-700.

This is a card tray—note how it is flattened along the side edges between each handle. The pattern is Fenton's *BIRDS AND CHERRIES* in cobalt blue. $80-150.

Footed or Collar Based

Bowls may sit flat on their bases or they may be footed, having one of a variety of different types of feet. Flat based items (often called collar based) usually have no iridescence on the base. However, some flat based items (including a few scarce Classic examples, some Australian items, and a large amount of those produced in Europe) are ground flat and may exhibit traces of iridescence on the base. These differences are caused by the manner in which the items were manufactured—whether they were stuck-up or snapped-up.

Stuck-up and **Snapped-up**. The glass items that have a ground base were attached to a hot metal punty rod after being extracted from the mould. The punty had been heated so that the glass would stick fast to it. After being finished (shaped) and iridized, the piece had to be broken from the punty, and this left a rough base which had to be ground flat. The factory term for this was stuck-up. Items which had a collar base could be gripped in a tool with clamp-like spring loaded jaws called a "snap" whilst being finished off. This process was termed snapped-up. These pieces had no need to be ground and they have smooth, as-moulded bases.

- **Spatula feet**—spade shaped feet (usually three).

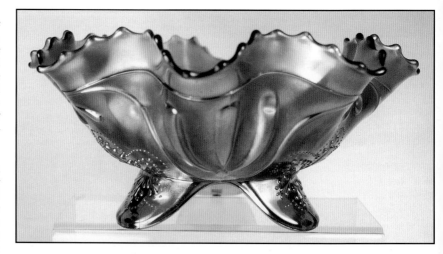

The exterior of Northwood's green *SUNFLOWER* bowl gives a clear view of its typical, spade shaped, spatula feet. The exterior pattern is called *MEANDER*. $100-200.

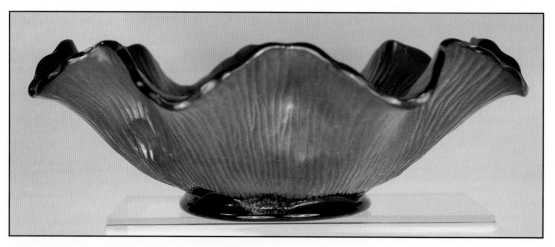

Looking at a bowl in profile enables the collar base (marie) to be seen. This Classic Carnival bowl was made by the "snapped up" method (see text for explanation). This is a purple ruffled bowl in Northwood's *POPPY SHOW* pattern (hidden in this shot). $700-1000.

- **Collar base**—a flat, circular base; the marie is the name for the center of the base within the collar.
- **Ground base**—ground flat, sometimes with a mirror-like sheen. Often the grinding caused small chips and flakes on the stuck-up base. Such chips are caused by the method of manufacture and are very common on ground bases. Unless the chipping is extensive or excessively large it should not be considered as damage for it is simply a feature of the manufacturing method. (An illustration of a ground base can be seen on the oval bowl at the start of Part Two, Chapter One).

Compare the collar base on the *POPPY SHOW* bowl in the previous illustration with the ground, flat base on this blue *TOKIO* bowl from the Swedish maker, Eda Glasbruks. This item was made by the "stuck up" method (see text for explanation). SP $400-600.

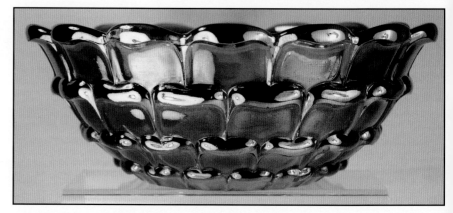

A different aspect of the spatula feet on this upturned *SUNFLOWER* bowl.

- **Scroll or Ball feet**—round shaped feet that may sometimes actually be fashioned like claws, rather like the ball and claw feet on furniture.

Fenton's large, footed *CHRYSANTHEMUM* ruffled bowl has three scroll feet. This green bowl, $150-250.

A typical ball and claw style foot seen on this upturned Fenton *PANTHER* bowl in olive green. The exterior pattern that can be seen is *BUTTER-FLY AND BERRY*. $200-400.

- **Pedestal or Domed foot**—a single, circular domed up pedestal, often used by Dugan/Diamond.

This Northwood *THREE FRUITS* ruffled, green bowl has a distinctive domed foot. $80-150.

- **Square shaped feet**—rather unusual and exactly as their name suggests. Such feet are seen on the Scandinavian *SUNK DAISY* items as well as the rarely seen *FOUR CROWNS* items from Karhula. Fenton's *LEAF TIERS* and some *(FOOTED) ORANGE TREE* items have similar, angular feet.

The exterior pattern on this upturned, domed footed *THREE FRUITS* bowl is unusual in that it has two patterns. The *VINTAGE* (aka *VINTAGE GRAPE*) design shows through the *BASKETWEAVE* pattern. This was an old Jefferson mould that was purchased by Northwood—the *BASKETWEAVE* pattern was over cut onto the *VINTAGE* design.

The Scandinavian *SUNK DAISY* aka *AMERIKA* design has very distinctive squared feet. The *SUNK DAISY* design first appeared in the Butler Brothers catalogs from around 1910. It had the Cambridge pattern #2760 and was named "Red Sunflower" by Minnie Watson Kamm (in her 1950's self published *A Second Two Hundred Pattern Glass Book*) as the items were finished in ruby glaze and gilt. The distinctive squared foot was actually patented by Cambridge Glass and most items were marked "NEAR-CUT." Cambridge did not make the item in Carnival Glass—it was left to Eda Glasbruks and Riihimaki to do that. This purple bowl is from Eda and is rare in this color. NP.

• **Hexagonal feet**—short, rather stubby looking hexagonal feet such as those found on Imperial's *DOUBLE DUTCH* bowls.

Imperial's *DOUBLE DUTCH* bowls have three stubby hexagonal feet. Note this is a purple example of the pattern. $200-300.

A good view of the square feet on this upturned blue *SUNK DAISY* aka *AMERIKA* bowl. $250-450.

A seldom seen pattern, (indeed this blue bowl is the only example the authors have ever seen) this is *FOUR CROWNS* by the Finnish maker, Karhula. Note the squared feet. NP.

Edge Shaping

This is where individuality and beauty really come to the fore. Edge shaping was introduced on press moulded glass during the 1800s. The technique was similar for most methods in that the glass item was taken up in the snap in order to be removed from the mould—then, whilst still hot and malleable, was pushed down onto a crimping tool. This piece of apparatus was essentially a circular metal device that shaped the still warm glass—there were several variations of tool that produced a range of decoratively shaped effects on the edge of the glass item. Frank M. Fenton gave us some specific information as to how and when these types of apparatus are used.

"The Fenton Art Glass Company still uses an apparatus known as the crimp to produce the Fine Crimped Edge. The bowl is removed from the mould and placed in the snap to be reheated in the 'glory hole' (to a temperature of around 2500 degrees Fahrenheit). Then, whilst still hot and malleable, it is pushed down onto the open bottom section of the shaped apparatus called the crimp. The top part of the crimp which is hinged in two sections, then closes down onto the piece to form the fine crimped edge. The crimp was operated by a foot pedal when Carnival was first made, but later a means of utilizing pneumatic power to operate the apparatus was employed, but the foot was still used to activate it. Crimping was and still is a skilled job. Not only does the finisher have to know how to center the bowl onto the apparatus, he also has to know how far out to flare the piece before it goes on the apparatus. It takes delicate timing to make it work properly, and if the bowl is placed off-center, the result is not very pleasing."

"The Fine Crimped Edge uses the Fine Crimp tool described above with anywhere from 16 to 32 points, depending on the size of the piece. The ruffled edge may use a Drop Crimp tool (8 point, 10 point, etc.) or a crimp made like the fine crimp with the foot pedal, but with 6 or 8 points instead of multiple points. Sometimes we use both the Fine Crimp tool and the Drop Crimp. Or we may use the Fine Crimp tool with a foot-operated crimp and from this we get many items that we call double crimped. The three-in-one edge uses the Fruit Crimp tool that operates with a foot pedal."

Various companies used edge shapings that were specific to them only—Northwood's pie crust edge shaping is a good example of this. Other simple decorative edge shapings, such as ruffling and scalloping, were used by most manufacturers.

Some unusual edge effects were formed by the *ring* which fitted around the top of the mould. This ring served three purposes: it held the body of the mould tightly closed, it created the shape of the top of the piece being pressed, and it allowed a plunger to be held exactly in position and pressed down into the center of the mould so that the molten glass evenly filled up the space between the mould and the plunger. Shapings on the ring produce scallop edges, flutes, flames, bracket edge, bullet edge, castellated edge, and similar regular shapings.

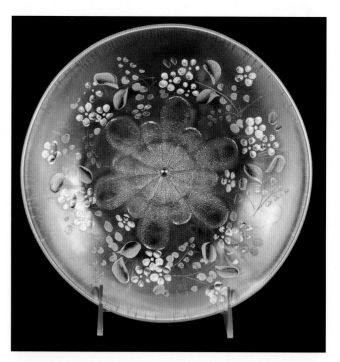

A completely smooth edged bowl with no shaping whatsoever—this is Dugan/Diamond's peach opal *STIPPLED PETALS* bowl with the enameled *FORGET ME NOTS* design. $175-225.

Types of Edge Shaping

* **Smooth**—a simple, unshaped edge.
* **Flutes and Flames**—flutes are the small gently pointed shapes on the outer edge of the piece. When they are very sharp and jagged the edge is referred to as a *saw tooth* edge. When they are much bigger projections, as seen on punch sets and some large vases, they are called *flames*. Flutes are formed by the ring (see above).

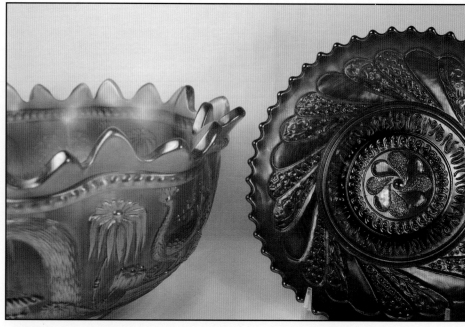

Flutes and flames are different in size. On the left, a Northwood *PEACOCK AT THE FOUNTAIN* punch bowl showing the large flames around the top edge of the bowl (full punch set in marigold, $700-1300). On the right, a Dugan/Diamond *ROUNDUP* piece with a fluted edge. $600-1000.

A jagged saw tooth edge, seen on Imperial's *SCROLL EMBOSSED* purple plate.

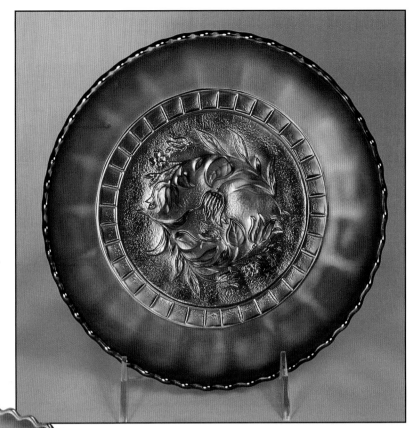

An amethyst Dugan/Diamond *WIND-FLOWER* bowl with a fluted edge. $60-90.

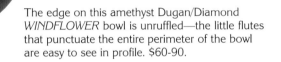

The edge on this amethyst Dugan/Diamond *WINDFLOWER* bowl is unruffled—the little flutes that punctuate the entire perimeter of the bowl are easy to see in profile. $60-90.

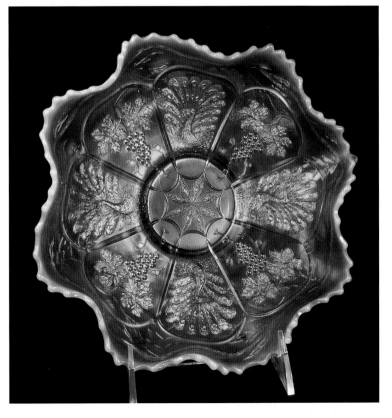

Fenton's *PEACOCK AND GRAPE* bowl in peach opal. The contrast of the white opal glass against the black background shows the fluted edge very clearly. The marigold iridescence has a very rich pumpkin effect. A similar bowl with pumpkin iridescence sold for $1000 in 2000. Lower values would be reached where the iridescence was not pumpkin.

- **Scallops**—these are the semi circular humps that curve around the edge of the piece. Again, this shaping is formed by the ring. The scallops may also have little flutes on them, all along their length.

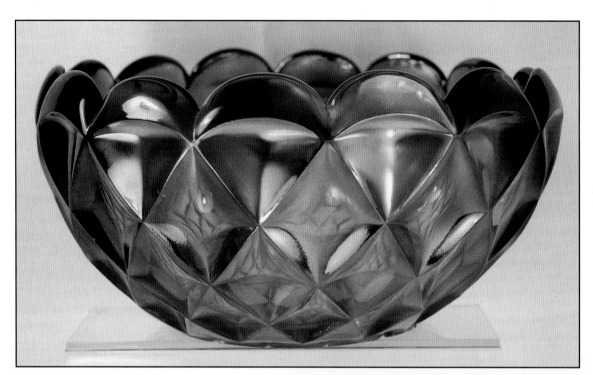

A scalloped edge on this purple *SVEA* bowl from Eda Glasbruks. Purple is a rare color for Eda, so SP $300-500.

A most unusual edge on this rare, marigold *GRANKVIST* bowl made by Eda Glasbruks. The edge was scalloped, then a further feature added—an inner edging of tiny V shapes moulded into the glass. NP.

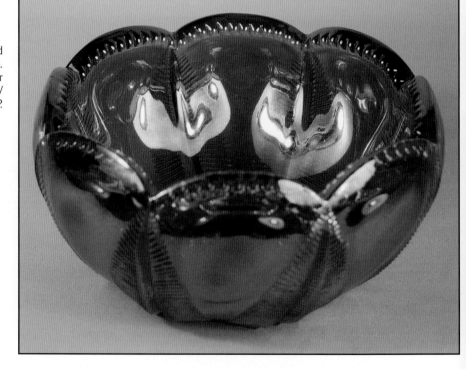

- **Ruffles**—gentle, soft crimping or ruffling was used by all the manufacturers of Classic Carnival as well as the Australian and some of the European producers. The number of ruffles varies—though most Classic Carnival bowls in the 8 to 9 inch size will have 8 ruffles—more unusual is 6 ruffles. Frank M. Fenton notes that Dugan bowls may have 10 crimps, but Fenton did not use a Drop Crimp tool that produced that number. Thus, any Classic 10 ruffled bowls will probably therefore be Dugan. Sometimes these will be flat topped ruffles—a very distinctive edge treatment that is characteristic of Dugan. The Scandinavian *FOUR FLOWERS* bowls also have 10 ruffles, but they are very distinctive, pinched ruffles, unlike the Classic American shaping. Even more ruffles can be seen on the edge of some *DIVING DOLPHINS* bowls from Sowerby in England and some of the Australian bowls from Crown Crystal—as these may have 12 or even 16 ruffles!

Note that ruffled edges may have further shaping, and for example may be smooth or fluted.

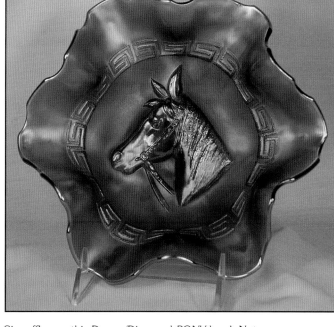

Six ruffles on this Dugan/Diamond *PONY* bowl. Note the interesting flat top effect on the edge—a typical Dugan/Diamond feature. Easily found in marigold, this amethyst bowl sells for around $150-450.

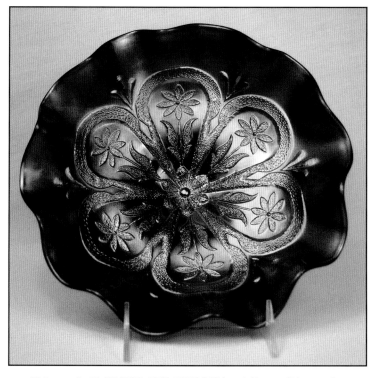

This purple *FLOWERS AND FRAMES* bowl (Dugan/Diamond) has a smooth, ten ruffled edge. $300-650.

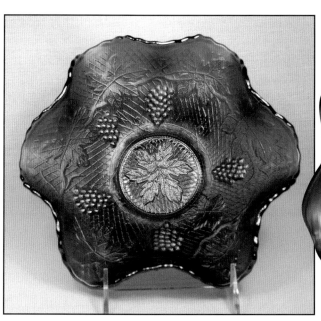

Six ruffles are not seen too often on Classic bowls— eight ruffles are more usual. Here we see six ruffles on this fluted, ruffled edge, green *CONCORD* bowl from Fenton. $300-1000 (highest prices would be paid for an emerald blue-green iridescence).

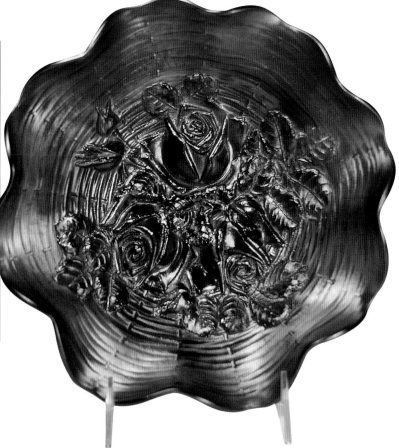

This Northwood *ROSE SHOW* bowl in purple has eight ruffles. Note the edge is also gently scalloped. $700-1000.

111

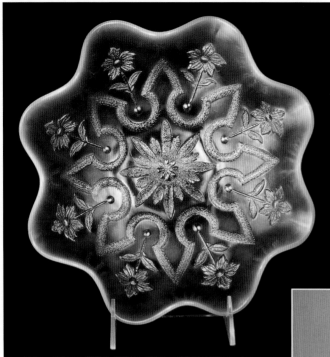

This rare *FLOWERS AND SPADES* Dugan/Diamond bowl in peach opal has eight ruffles and a smooth edge. SP $400-600.

There are sixteen, smooth edged ruffles on this black amethyst, Crown Crystal *SWAN* bowl. $200-400.

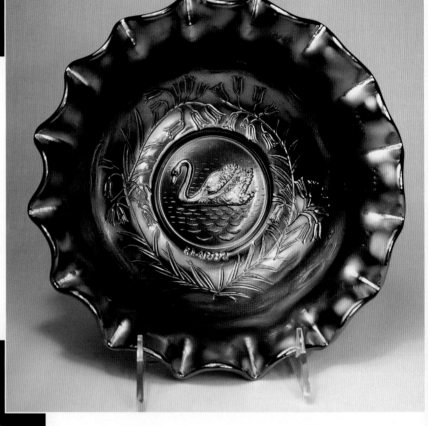

Rather hard to find, this is Dugan/Diamond's *WEEPING CHERRIES* bowl. (The exterior pattern on this particular example is *WESTERN DAISY*—an unusual combination). Note that this bowl has the distinctive Dugan/Diamond ten ruffles. SP $100-150.

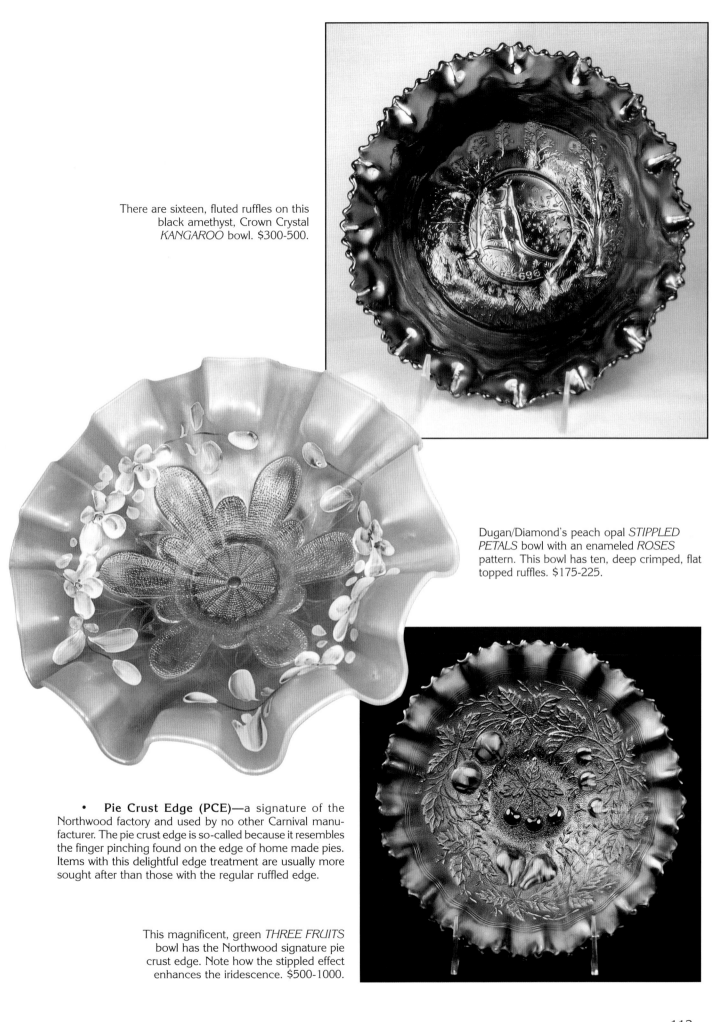

There are sixteen, fluted ruffles on this black amethyst, Crown Crystal *KANGAROO* bowl. $300-500.

Dugan/Diamond's peach opal *STIPPLED PETALS* bowl with an enameled *ROSES* pattern. This bowl has ten, deep crimped, flat topped ruffles. $175-225.

• **Pie Crust Edge (PCE)**—a signature of the Northwood factory and used by no other Carnival manufacturer. The pie crust edge is so-called because it resembles the finger pinching found on the edge of home made pies. Items with this delightful edge treatment are usually more sought after than those with the regular ruffled edge.

This magnificent, green *THREE FRUITS* bowl has the Northwood signature pie crust edge. Note how the stippled effect enhances the iridescence. $500-1000.

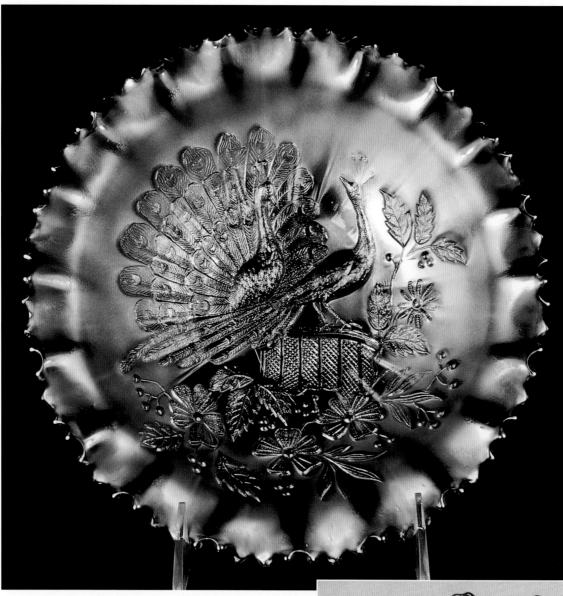

It's hard to find a prettier green *PEACOCKS (ON THE FENCE)* bowl than this. Northwood's characteristic pie crust edging is the "icing on the cake." $1000-2000.

• **Three in One (3 in 1)**—two small dips or ruffles and then one larger dip characterize the fancy edge often called Three in One or Three and One. Frank M. Fenton informed the authors that he prefers to call this edge Two and One—as that is more descriptive and accurate. When the edge shaping was first introduced, Fenton actually referred to the shaping as the Fruit Crimp. Dugan, Fenton, and Millersburg used this distinctive edge shaping—the Dugan version tends to have much deeper dips. There are some scarce examples of Northwood 3 in 1 edges. It seems most likely that these were early Northwood items and carried over from the pre-Carnival era. Northwood appears to have abandoned this edge technique in favor of their pie crust edge.

A 3 in 1 edge on a Fenton *CAPTIVE ROSE* bowl in amethyst. $80-150.

114

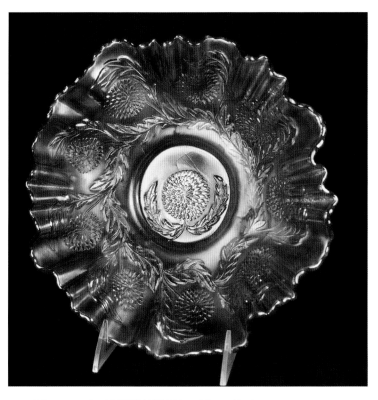

A large marigold *TEN MUMS* bowl from Fenton
with a pretty 3 in 1 edge. $100-400.

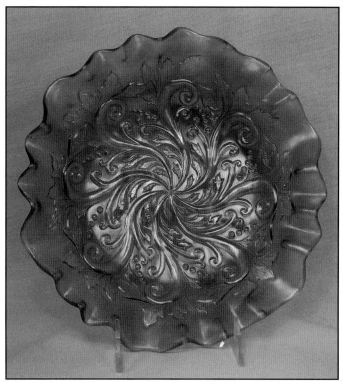

Millersburg's marigold *SEAWEED* bowl with a
gentle 3 in 1 edge. $250-400.

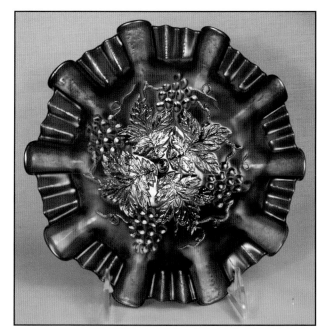

A seldom seen edge treatment for Northwood was
the 3 in 1 seen here on this *GRAPE LEAVES* bowl in
purple. Northwood used this type of edging in the
years leading up to his Carnival production. Only a
few early Carnival examples of Northwood's 3 in 1
edge treatment are reported. $100-150.

• **Fine Crimped Edge**—also called Candy Ribbon Edge (CRE),
Tight Crimped Edge (TCE), and Continuous Crimping. A splendid
edge where the tight sinuous curves belie the fragile brittleness of the
glass. Examples may be further ruffled to give a complex effect. 32
tight regular crimps appear to be the standard number on 8 inch
bowls. Only a handful of patterns can be found with this edge shap-
ing—Fenton and Dugan made possibly the greater number of ex-
amples in this unusual treatment, but Millersburg pieces are also known

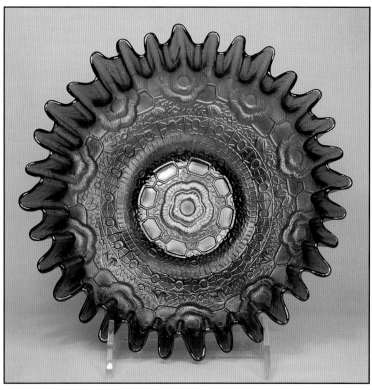

Fenton's green *CAPTIVE ROSE* bowl is shown here
with a fine crimp or candy ribbon edge. $80-150.

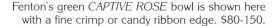

(although they usually exhibit a looser, less tight crimp). Bowls shaped in this way are usually found in regular round shapes, but rare examples are known squared and tricorner. The Fenton Art Glass Company still use an apparatus known as the crimp to produce the Fine Crimped Edge—a detailed account by Frank M. Fenton of how this edge is produced can be read above.

A modern commemorative whimsy made by Fenton for www.cga (the Internet Carnival Glass club). This is a unique piece, a tight crimped edge rose bowl in red. It was sold at the club's Las Vegas convention in 2001 for $250 after fierce bidding.

This triangular shaping to the entire bowl gives this amethyst, Millersburg ZIGZAG bowl an attractive extra. The edge treatment is the fine crimp or candy ribbon edge. $700-1000.

- **Scallop and Flute Edge**—a sequential combination of a scallop followed by a flute, formed by the ring. Fenton and Crown Crystal made examples of this edge. Dugan produced scarce examples of a large scale version of it, occasionally seen on SOUTACHE and WESTERN DAISY bowls. There are other variations of the Scallop and Flute where, for example, two small flutes occur between the scalloping. An elongated variation of the scallop and fluted edge can be seen on Imperial's ACANTHUS items (see Part Two, Chapter Two, "Plates" for a photograph of the ACANTHUS plate).

A form of scallop and flute edging is seen here on a large (10 inches in diameter) European Carnival bowl that was probably made by the German manufacturer, August Walther. The pattern was named CHEVRON back in 1984 when it was first reported in the UK. Note that the sequence is two small flutes followed by one scallop. NP.

A close-up of the scallop and flute edge on the *CHEVRON* bowl.

• **Bracket Edge**—a most unusual and seldom seen shaping that looks exactly like the curved form of a bracket. Formed by the ring, scarce Carnival examples from Eda Glasbruks are known.

• **Pierced or Open Edge**—such as seen on Northwood's *WILD ROSE* items, and Fenton's *OPEN EDGED BASKET* pieces.

A most unusual bracket edge on this marigold *DESSIN* bowl from Eda Glasbruks. SP $150-300.

A pierced, open edge on Northwood's *WILD ROSE* rose bowl in blue. $200-300.

• **Bullet Edge**—seldom seen, this edge is reminiscent of a row of bullets. Examples from Crown Crystal are known; this edge is formed by the top ring.

• **Castellated Edge**—unusual tight edge in a squared pattern formed by the ring—found on Imperial's *FILE* items (exterior pattern).

This is a bullet edge, seen on Crown Crystal's large float bowl in the *KOOKABURRA* pattern.

A castellated edge (squared) on Imperial's *SCROLL EMBOSSED* berry with a *FILE* exterior. $75-150.

117

• **Furrowed Edge**—a seldom seen edge, found on some scarce examples of Carnival possibly from the German maker August Walther and Sons. The furrowed edge is characterized by a flat edge section alternated with a dipped furrow. Recent research by the authors and Siegmar Gieselberger has shown that Walther made a small range of Carnival Glass. In 1932 they merged with Sächsische Glasfabrik Radeberg—the new name was Sächsische Glasfabrik August Walther & Söhne Aktiengesellschaft, Ottendorf-Okrilla and Radeberg. After the war the glassworks was nationalized and had the name VEB Sachsenglas, Ottendorf-Okrilla.

• **Rolled, Cupped or Turned Edge**—a rim treatment in which hand-tooling or hand-finishing caused the edge to be turned up or under. May be slightly curved (rolled edge) or much more obvious in nature (cupped edge).

[1]Hand, Sherman. *The Collector's Encyclopedia of Carnival Glass*. Paducah, Kentucky: Collector Books, 1978.

A furrowed edge is most unusual—two slightly different versions are shown here. On the right is a European *PLUMS WITH FROSTING* bowl possibly from the German maker August Walther. Note the curved shape of the furrow. The bowl on the left has a much sharper V shaped furrow. It is a Karhula item and is the first reported example of this pattern: it has been named *SCANDIC STARS* by the authors. NP for either bowl.

A rolled edge on a smoke *SODA GOLD* bowl from Imperial. *Courtesy of Carol and Derek Sumpter*. $60-80.

118

Chapter Two
Plates

Take a bowl from the mould whilst still red hot, attach it by its base to a snap (or a metal punty rod) and spin it flat—that's how most Carnival Glass plates were formed. Centrifugal force simply caused the hot glass to flatten and assume the profile of a plate. So why was it that plates were made from bowls and not vice versa? The explanation for this was provided by Frank M. Fenton (courtesy of Howard Seufer): "the reason is the need for a cutting joint to accommodate a variation in the volume of glass deposited in the mould. Fenton made some plates in recent years, but pressed them up-side-down in order to get a cutting surface (in the round shape, similar to a shallow marie) on the underside surface of the plate. In the older pieces this cutting surface was at the top edge of the bowl." Dr. James Measell, Fenton historian, further observed that "it is possible to observe a slight curving at the outside edge of some plates" on the radial mould seams. This would have been caused by the distortion caused by spinning the plate out from the bowl shape. Other plates (especially those made by machine during the Depression or Late Carnival era) were pressed flat.

In Classic Carnival, plates were made by most manufacturers, though surprisingly, Millersburg actually made very few. Classic Carnival plates are found in three, very broad size categories: chop plate, regular plates, and small plates. There are slight variations in the size of each broad category (and in fact one or two patterns are known in four discrete sizes, see below for details).

The generally accepted definition of a plate in Carnival Glass terminology is that given by the late Marion Hartung and often referred to as the *two inch rule*.

"Place the piece in question on a flat, bare surface such as a wooden table...the distance from the surface of the table to the top edge of the plate should not be more than 2 inches at the very most...a plate is round or square. If it is oblong, one has a platter or tray." [1]

According to Marion Hartung, a plate should stand two inches or less (for more explanation please see text). This wooden inch rule shows that the Northwood plate (left) stands a little taller and has a steeper profile than the flat Fenton plate on the right.

A superb plate from Fenton—this is *CONCORD* in amethyst. The flatness of the plate shows the pattern off to great advantage, while the "netting" effect enhances the iridescence. $1000-3000 and upwards.

Another way to determine whether a piece is truly a plate is to turn it upside down onto a flat table. Virtually all parts of the edge should touch the table without any ruffling or crimping. A further proviso is that the angle of the sides of the item should be nearly straight —with no curve on the outer edge. Some plates are very flat, others (typically those by Northwood) tend to have more steeply sloped sides.

Size

There are three broad sizes of plate. Small plates run from just under 4 inches to 7 inches or so, in diameter. Regular plates are around 9 inches in diameter and the large, impressive, showy chop plates measure around 10 or 11 inches or more. "Cake Plate" sets were sold that comprised an 11inch dish (actually, what we now call a chop plate) plus six small serving plates. Fenton's *PEACOCK TAIL* for example, and the *WIDE PANEL* (from various makers) are known in these three sizes of plate.

The small plate size may actually be further split, as some patterns in this group have distinct differences. Fenton's *PERSIAN MEDALLION* is a good example as plates in this pattern are known in (approximately) 6 inches, 7.25 inches, 9 inches, and chop plate size. Carl Booker reports a 6.5 inch plate that has 13 medallions on the pattern and a plain exterior. He also has a 7.25 inch plate that has 12 medallions on the front and a *WIDE PANEL* exterior. Undoubtedly these were intended as two distinctly different sizes.

Dugan/Diamond's *PERSIAN GARDEN* plates are found in a 6 inch size, a 7.25 inch size, and a chop plate. Northwood's *GRAPE AND CABLE* is a little different too, as it is found in the 6 inch plate, 7.25 inch, 9 inch, and also a chop plate that is whimsied from a large bowl. Fenton's *VINTAGE* is found in a 6 inch, 7 inch, and rare 9 inch plate. Imperial's *HEAVY GRAPE* comes in the 6.25 inch plate, 7 inch, 8.75 inch, and a chop plate.

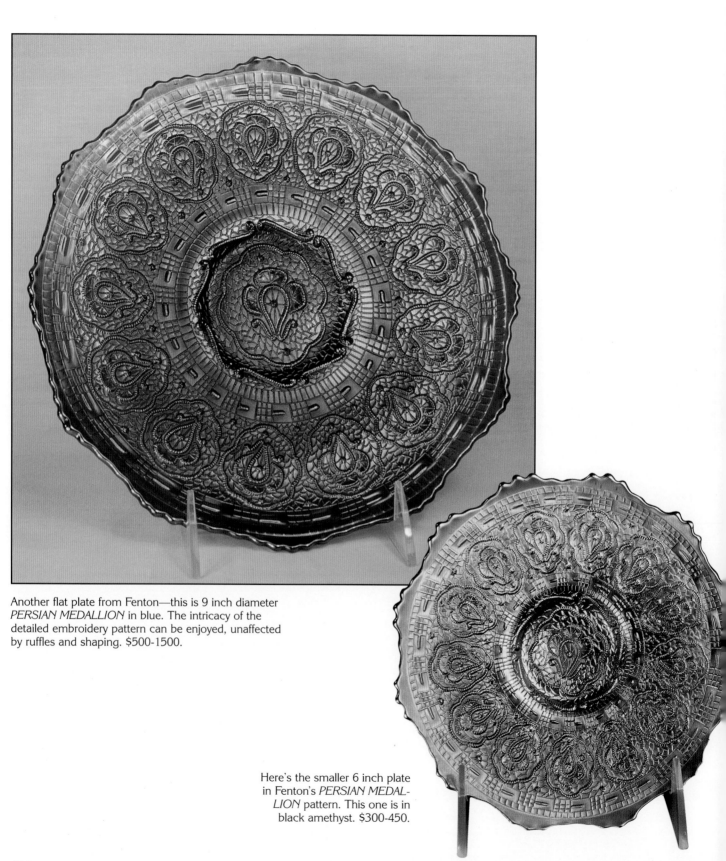

Another flat plate from Fenton—this is 9 inch diameter *PERSIAN MEDALLION* in blue. The intricacy of the detailed embroidery pattern can be enjoyed, unaffected by ruffles and shaping. $500-1500.

Here's the smaller 6 inch plate in Fenton's *PERSIAN MEDALLION* pattern. This one is in black amethyst. $300-450.

120

European plates are also known in a wide range of sizes. The smallest reported is the dainty *GRAPE MEDALLION* by Riihimaki: two small sizes are known—3.75 inches and 5 inches. Large chop plates measuring just over 12 inches in diameter are known in the *FLEUR DE LIS* pattern by Josef Inwald. Other large plates are also known, for example, in the *ROSE GARDEN* pattern (Brockwitz) and *GRAND THISTLE* (Riihimaki).

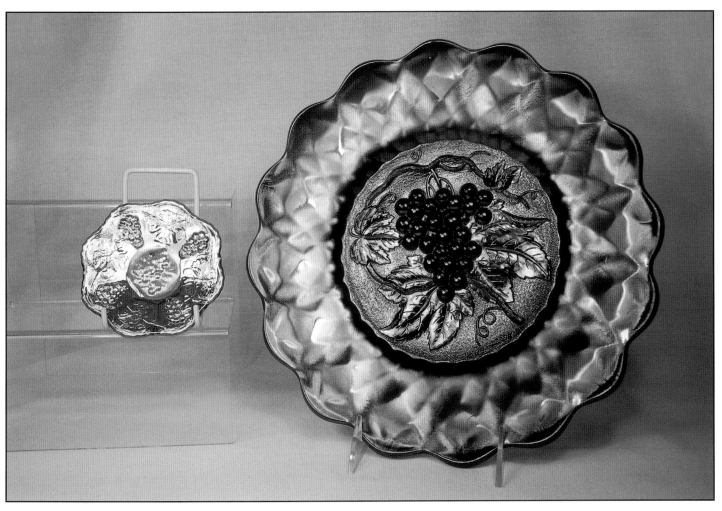

An astonishing contrast in size. On the left is one of the tiniest plates known—Riihimaki's *GRAPE MEDALLION*, measuring just 3.75 inches in diameter (NP). On the right is Imperial's *HEAVY GRAPE* chop plate, measuring 11 inches across. $400-1000.

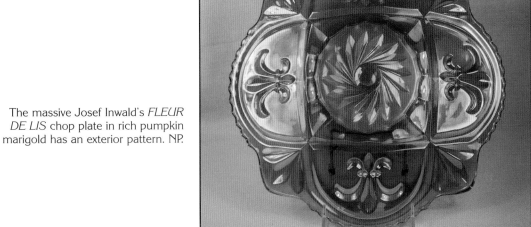

The massive Josef Inwald's *FLEUR DE LIS* chop plate in rich pumpkin marigold has an exterior pattern. NP.

Footed or Collar based

Plates may be collar based or footed, in a variety of different ways. Collar based plates can be very flat indeed, but sometimes the sides slope rather steeply—in fact the height of the plate may even go a little over the "magic" 2 inches, owing to the sharply inclined sides. Northwood plates typically exhibit this feature, while Fenton and Imperial plates are usually very flat. Dugan/Diamond plates vary and sometimes may even have a slight curvature to the sides. (This may challenge the purist to call such an item an ice cream shaped bowl instead. In such circumstances, perhaps the question should be asked—"was the item meant to be used as a plate?")

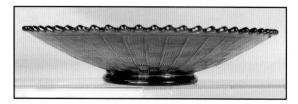

A collar based Northwood plate in profile.

The feet on plates may be spatula shaped, scroll footed or even dome footed (see previous chapter on bowls for details)—generally the 2 inch rule will be overlooked if the plate is footed. Some patterns may be found in plates that were made with either a collar base or feet (for example, Fenton's *DRAGON AND LOTUS* and *PEACOCK AND GRAPE*).

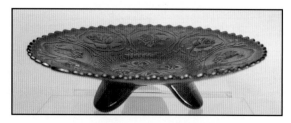

A footed Fenton plate in profile. This is an exceptionally rare, amethyst *DRAGON AND LOTUS* plate. NP.

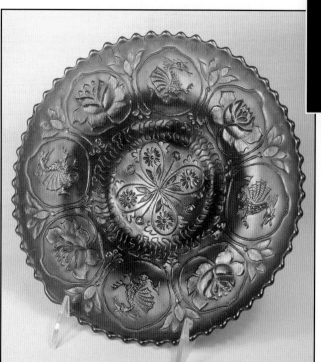

Cake stands or salvers are included within this section as defined by their purpose and use, their shape however (a flat plate on a pedestal base) obviously does not fit Hartung's "two inch rule." Most cake stands are European in origin and were often part of a matching set of items. Brockwitz' *TARTAN* pattern, for example, was made in a wide range of tableware shapes including a cake stand, celery vase, tumbler, pitcher, oval tray, bowls, and a magnificent feature epergne—that would certainly have taken center stage on the table.

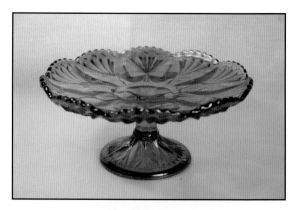

A cake stand or cake plate (also known as a salver) from the Swedish manufacturer, Elme Glasbruk. This is a *QUATTRO* cake stand with Elme's typical taffy-like iridescence. *Courtesy Ann and David Brown.* SP $80-150.

This two part marigold *WICKERWORK* cake stand from Sowerby comprises a flat plate and an unusual foot. $300-500 for the complete item in marigold.

The pattern on the Fenton *DRAGON AND LOTUS* plate in the previous photograph can be seen more easily in this illustration. NP.

Plate Variations

Sometimes the sides of the plate may be pulled up. If one side only is pulled up, the item is termed a hand grip plate—the curved up edge designed so as to make it easier to grasp the plate. Two sides of the plate may be pulled up—this may be called a double handgrip. If the sides are pulled up more deeply, it produces a shape that is sometimes called a banana boat shape. Rarely, three sides are pulled up, the item then becomes known as a tri-corner plate.

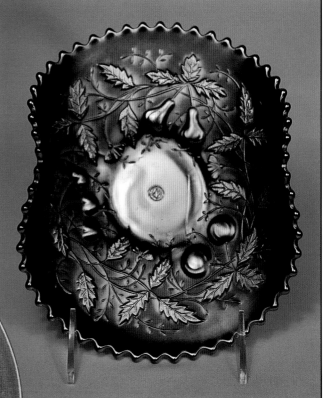

Two sides up (sometimes called a double handgrip) on this *FRUITS AND FLOWERS* plate in amethyst from Northwood. $100-200.

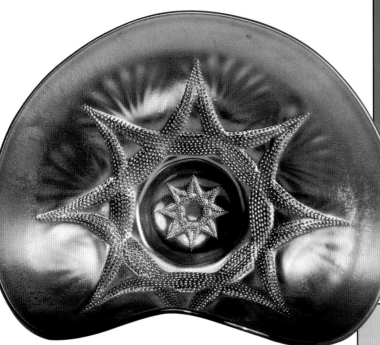

A handgrip plate with one side up from Dugan/Diamond, this is *SKI STAR* in electric purple. SP $400-800.

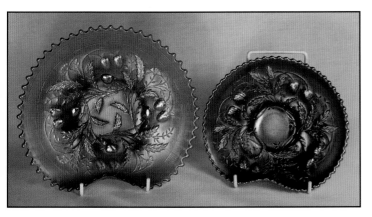

Two sizes of Northwood *WILD STRAWBERRY* handgrip plates. The small purple handgrip plate on the right is quite unusual in this 6 inch size. Most handgrip plates reported in the *WILD STRAWBERRY* pattern are the 7-8 inch size, like the green one on the left of the photograph. $150-250 for the larger green plate on the right. It is not possible to give a value range for the small 6 inch plate, as none are reported sold at auction.

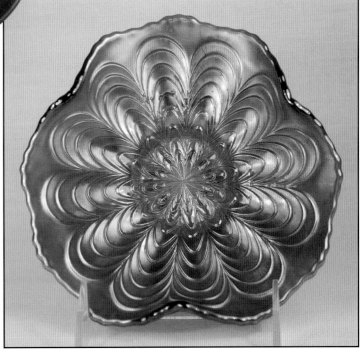

Three sides up on this flat *PEACOCK TAIL* item in green from Fenton. $100-200.

Is there such a thing as a ruffled plate? Strictly speaking, no—for by its very definition, if a plate is turned upside down onto a flat table all parts of its edge should touch the table without any ruffling or crimping. Some ruffled bowls, however, are very low indeed and easily fulfill Hartung's two inch rule (see above). Early Imperial catalogs illustrate low ruffled bowls that they termed "Grape plates"—presumably to serve bunches of grapes in.

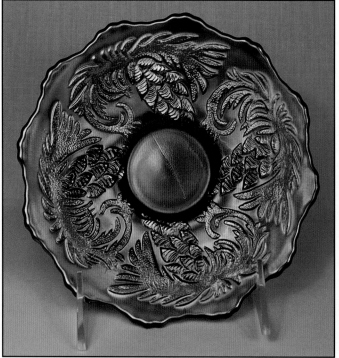

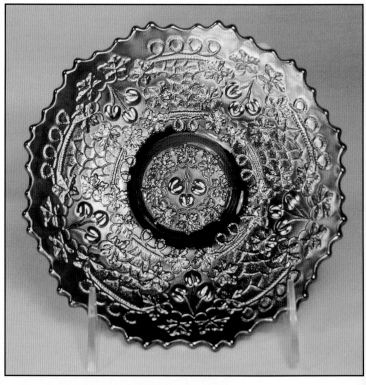

A pretty, little *CHERRY CHAIN* blue plate, from Fenton, 6 inches in diameter. $100-200.

A small, 6 inch *PINE CONE* plate in blue from Fenton. Note the shear mark across the center. (A shear mark is a chilled rough surface caused by cutting—it has the appearance of a line across the face of the glass. Shears were used to cut off the gob of hot glass as it was being dropped into the mould where it would be pressed. The shears cooled slightly the part of the hot glass being cut, causing it to harden a little. This formed a mark on the surface of the piece as it was being pressed. Usually, with skill on the part of the presser, this mark could be hidden by the pattern on the main face of the glass, but if there were large plain areas, the shear mark may be clearly seen, as here.) $100-300.

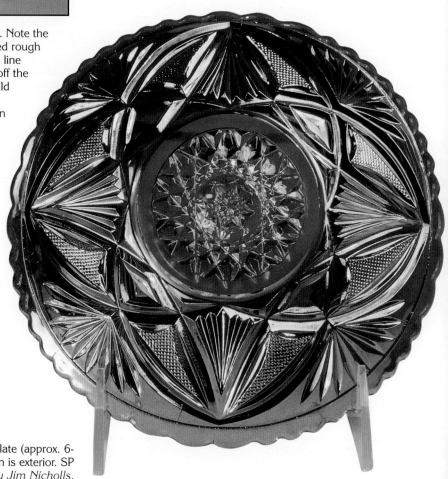

Eda Glasbruk's blue *EDSTROM* plate (approx. 6-7 inches diameter)—the pattern is exterior. SP $100-250. *Courtesy Jim Nicholls.*

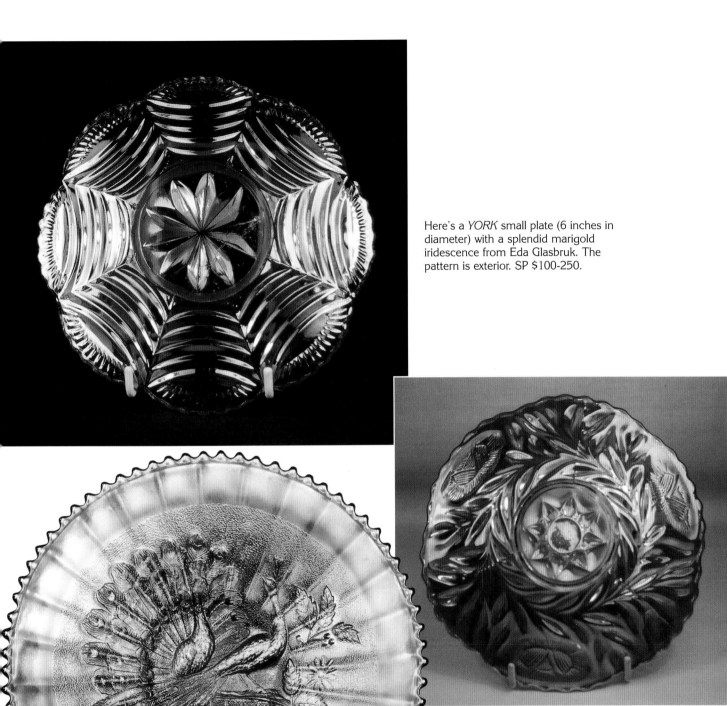

Here's a *YORK* small plate (6 inches in diameter) with a splendid marigold iridescence from Eda Glasbruk. The pattern is exterior. SP $100-250.

An unusual, small 6 inch plate from Riihimaki, this is the *GRAND THISTLE* in rich, pumpkin marigold. The pattern is exterior. SP $100-250.

Northwood's stippled *PEACOCKS* (*ON THE FENCE*) in scintillating pastel marigold. The effect of this beautiful color is seen to its best advantage against a dark background. Turquoise, green, fuchsia, purple, and blue highlights shimmer over the face of this splendid plate. SP $2000-4000.

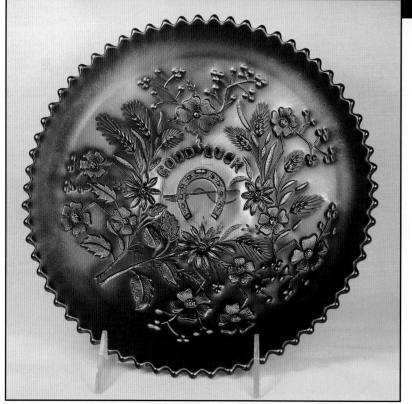

A green *HEARTS AND FLOWERS* plate from Northwood. $2500-3500.

GOOD LUCK is a favorite from Northwood, but it is not seen in the plate form as often as the bowl. Here's an amethyst plate with a blue iridescence. $500-1000.

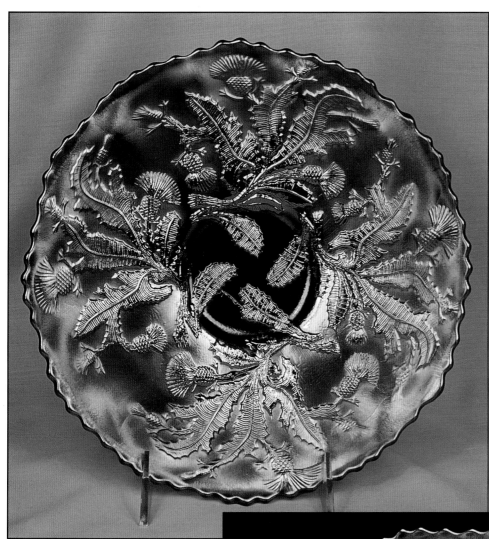

Seldom seen, this is Fenton's *THISTLE* plate in amethyst. *Courtesy Carol and Derek Sumpter*. A rare item, SP $3000-4000.

Very few of these plates are known—Fenton's *LEAF CHAIN* in amethyst. *Courtesy Les and Rita Glennon*. SP $4000-6000.

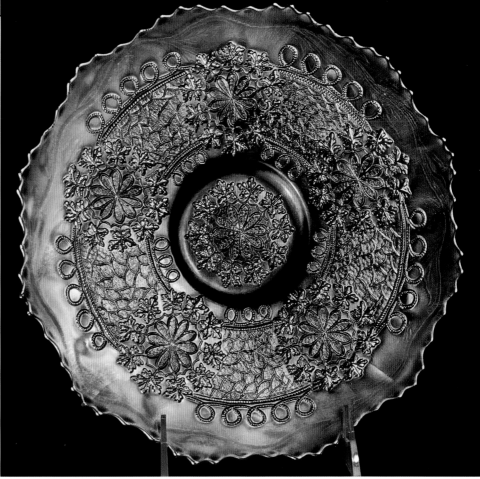

Imperial's *ACANTHUS* 10 inch chop plate in smoke usually sells between $200 and $500. Note the unusual elongated scallop and flute edge.

This *HATTIE* chop plate in helios green from Imperial has the typical, silver-gold effect of that iridescent shade. $200-350.

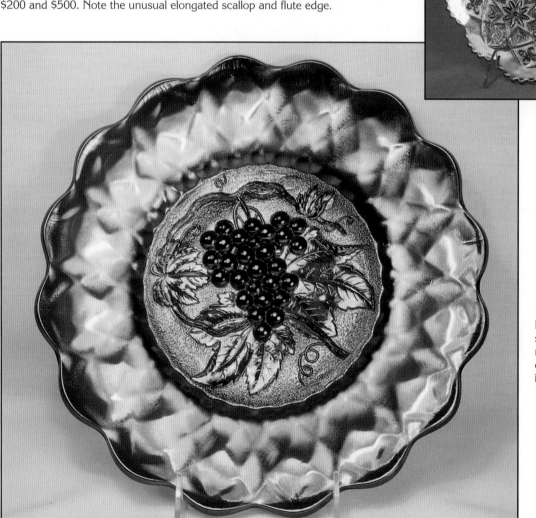

Imperial's *HEAVY GRAPE* scalloped edge, chop plate in rich purple. The grapes stand out massively on this splendid item. $400-1000.

L. G. Wright's splendid, contemporary *PEACOCKS* 12 inch chop plate in rich purple, the exterior pattern is known as *GRAPE*. John Valentine, the Contemporary Carnival Glass expert, suggests a value of $125-175 for this unusual item. John Valentine's subscription website on Contemporary Carnival can be found at http://www.carnivalglass.net/.

A chop plate from Europe, this is Brockwitz' *ROSE GARDEN* chop plate in rich, pumpkin marigold. Note, the design is on the exterior. A rare plate, NP.

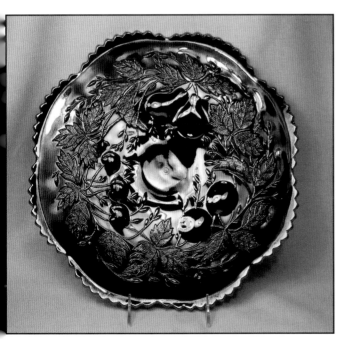

L. G. Wright's contemporary *GRAPE AND FRUIT* aka *THREE FRUITS* pattern (seen here on a purple 14 inch chop plate) is very similar to Northwood's *THREE FRUITS* pattern. The exterior is *INTAGLIO BUTTER-FLIES*. John Valentine, the Contemporary Carnival Glass expert, suggests a value of $150-225 for this massive and impressive item. See the previous photograph for the link to the Contemporary Carnival website.

A splendid, limited edition plate (5000 were made) from L.E. Smith that was produced in 1972. Known as the *MORGAN DOLLAR* plate, this lovely, amethyst item has a characteristic, decorative open edge. $50-80.

[1]Hartung, Marion T. *Seventh Book of Carnival Glass.* Emporia, Kansas: author, 1966.

Chapter Three
Vases
(including rose bowls, hats, baskets, ferneries, epergnes, and jardinières)

Vases, perhaps more than any other Carnival shape, personify the Art of Carnival Glass. With so many variations in form and finish, there is a vase shape to please every eye. Tall and slender or massive and bold: delicate, frivolous, exuberant, diminutive, or immensely grand—there is a shape and a size to suit all tastes and to fulfill every function required. Vases are, of course, primarily functional, their purpose being to hold cut flowers. However, their decorative appeal extends far beyond their function, as vases may also be beautiful objects in their own right. Other flower containers such as rose bowls, baskets, and jardinières will also be considered in this chapter.

The decorative appeal of vases extends far beyond their function, as they are often beautiful objects in their own right. The opalescent effect, coupled with the unique pattern on this slightly swung, peach opal Dugan/Diamond *LINED LATTICE* vase, combine to produce an exquisitely beautiful vase. $250-500.

Once the Cinderella of Carnival shapes, vases have come to be a collector's favorite. The reason is clear: though essentially functional, Carnival Glass vases are not only found in an astonishingly wide and fascinating variety of shapes and sizes, they are also known in a huge range of different patterns and colors. Vases can be broadly divided into two basic categories according to the way in which the vase is made—swung and "as moulded"—the form and pattern of the vase depends on this categorization.

Swung Vases

Method of Manufacture
The majority of vases made in the Classic era of production by the United States Carnival makers are swung vases; in fact over 60 different patterns are known. Indeed, the only United States manufacturer that did not produce swung vases was Cambridge. The method of manufacture was described by Joan Doty in NetworK #6 (1995)[1] and is the most eloquent and descriptive explanation of the process currently in print.

"In the creation process of a swung vase, the pieces were extracted individually from their moulds, clamped on the end of a snap, reheated in a glory hole, then literally swung by the glassmaker whilst the glass was still elastic in texture, to achieve their finished length. It is this individual reheating—each vase being reheated to slightly different temperatures and in different places—combined with the direction of, and the energy expounded on, the "swing" that makes each vase unique. Just as the camera freezes the dancer in motion, the swung vase captures glass in motion. This is the fascination of swung vases. All Carnival shapes have variation in pattern, in color, and in iridescence; swung vases have a further dimension—that is variation in form."

"It is this tremendous variety of form and shape and the way these shapes relate to each other and with flowers, that continually delights and enchants. Several ordinary vases, grouped together, can create a total

sculptural shape that is much greater than the sum of its parts. Even commonplace flowers in the right vase can be breathtakingly dramatic."

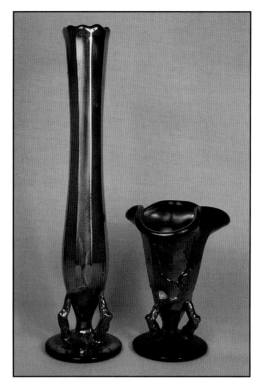

Two vases that have many similarities, yet are inches and dollars apart! On the left, Dugan/Diamond's amethyst *BEAUTY BUD* vase with twig feet has been swung to around 9 inches in height ($40-100). On the right, Dugan/Diamond's rare purple *TWIG* (aka *TINY TWIGS*) vase is only 4 inches high ($500-800).

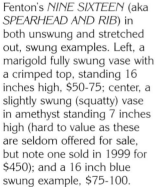

Fenton's *NINE SIXTEEN* (aka *SPEARHEAD AND RIB*) in both unswung and stretched out, swung examples. Left, a marigold fully swung vase with a crimped top, standing 16 inches high, $50-75; center, a slightly swung (squatty) vase in amethyst standing 7 inches high (hard to value as these are seldom offered for sale, but note one sold in 1999 for $450); and a 16 inch blue swung example, $75-100.

Although vases are categorized by their base width and not their height, it's interesting to look at a group ranged in height, to see what a wide variety is available. From the left, this immense, blue *RUSTIC* funeral vase from Fenton stands almost 20 inches high and has a 5.25 inch diameter base ($700-1000); Imperial's purple *MORNING GLORY* funeral vase has a base diameter a little under 5 inches ($500-800); green mid size Northwood *THIN RIB* vase standing 13 inches high with a 4.75 inch diameter base ($300-400); green mid size Northwood *TREETRUNK* vase with a 4.75 inch diameter base ($300-600); blue *KNOTTED BEADS* standard sized vase from Fenton standing 10 inches high, with a 3.5 inch diameter base ($50-100); Dugan/Diamond's *TARGET* vase—rare in blue 10 inches high, base 3.25 inches (SP $150-300); Imperial's mini *RIPPLE* vase in purple has a base size of just 2.5 inches. This example stands around 8.5 inches high ($125-150). On the far right, Dugan/Diamond's purple *TWIG* (aka *TINY TWIGS*) vase is only 4 inches high ($500-800).

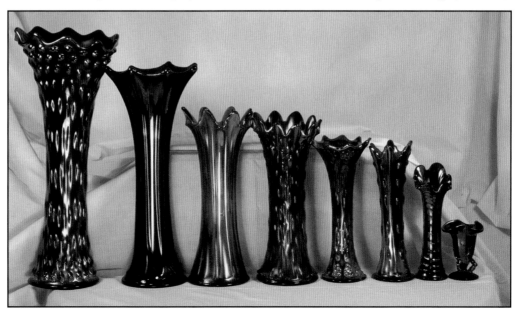

Classification of Swung Vases

Because height is dependent on how much a vase has been swung or stretched, the size of a swung vase is determined by the diameter of its base, irrespective of its actual height. There are four broad groups of swung vases according to size. Note that it is the diameter of the base, not the height that determines the size of a swung vase.

- Mini (or miniature)—has a base diameter of approximately 2.5 inches.
- Standard—has a base diameter from approximately 3 to around 3.75 inches.
- Mid size—has a base diameter ranging from around 3.75 to 4.75 inches.
- Funeral—Northwood and Fenton funeral vases have a base diameter of approximately 5.25 inches. Imperial funeral vases run slightly smaller at 4.75 to 5 inches.

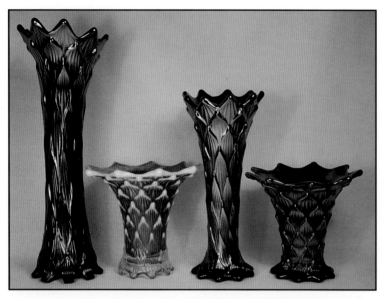

Dugan/Diamond's *LINED LATTICE* vase in several heights, and with different foot detail. From the left: 13 inch, square toed version in purple, $150-400; the triangular toed, peach opal slightly swung, 5 inch (squatty) version shown earlier, $250-500; 9 inch high, triangular toed version in purple, $150-300; slightly swung, 5 inch (squatty) version in purple, $250-500.

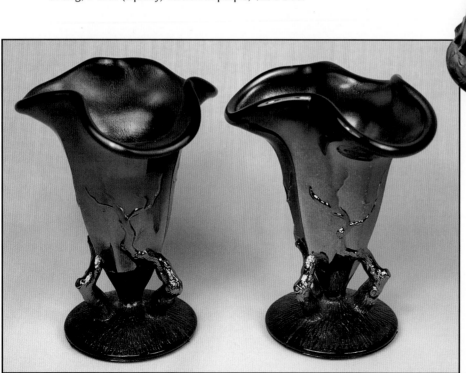

A massive, blue *RUSTIC* funeral vase by Fenton—this magnificent item stands almost 20 inches high and has a base diameter of approximately 5.25 inches. $700-1000.

A pair of Dugan/Diamond *TINY TWIGS* vases in purple. $500-800.

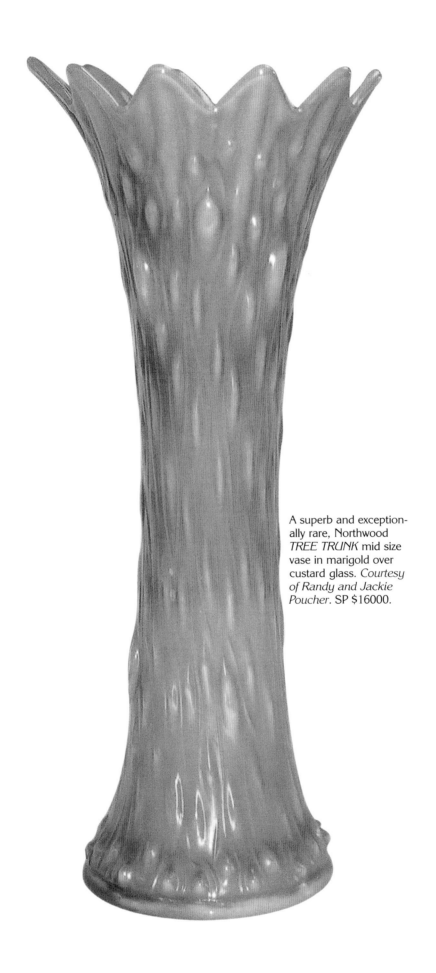

A superb and exceptionally rare, Northwood *TREE TRUNK* mid size vase in marigold over custard glass. *Courtesy of Randy and Jackie Poucher.* SP $16000.

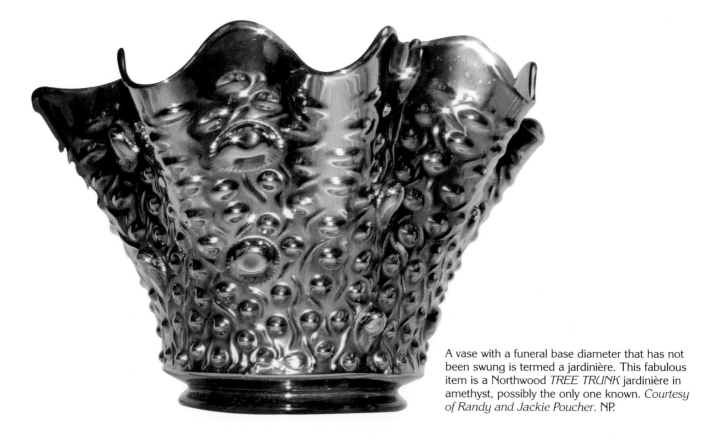

A vase with a funeral base diameter that has not been swung is termed a jardinière. This fabulous item is a Northwood *TREE TRUNK* jardinière in amethyst, possibly the only one known. *Courtesy of Randy and Jackie Poucher.* NP.

It is worth noting that there are some swung vases that—visually—appear to fall between the two categories of mini and standard. They don't look miniature enough to be classed as mini vases, and yet their base diameter is less than that of the standard sized vases. Examples of these are Northwood's small *FOUR PILLARS* vase, Imperial's *RIPPLE* in the 2.9 inch diameter base, *PANELLED DIAMOND & BOWS* and virtually all the vases that were swung from the tumbler moulds (for example, *BUTTERFLY & BERRY*).

There is a tremendous range of height in swung vases. The small vases can be as tiny as 3 inches while the largest size, the impressive and truly magnificent funeral vase, can achieve the majestic height of 22 inches or even more, weighing 4 to 5 pounds. The standard sized vases generally are around 9 to 11 inches high, with unswung "squatty" versions measuring a fair bit less. Mid size vases can be swung up to almost 20 inches, giving a tall, thin shape—yet they, too, may be unswung and end up around 7 inches high!

Some funeral vases have a further classification relating to height. A funeral vase that has not been swung is termed a **jardinière**. It is of course, still a funeral vase, a jardinière being a rare type of funeral. Northwood *TREE TRUNK* funerals have an additional unique height classification. A *TREE TRUNK* funeral which was swung, but only to a height of 15 inches or less is called an **elephant foot**. Thus, an elephant foot vase is a *TREE TRUNK* funeral between 8 and 15 inches high.

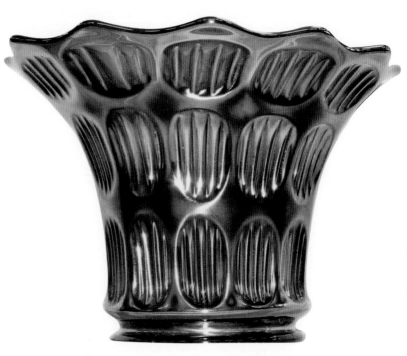

It is easy to see the pattern on this splendid, amethyst *DIAMOND AND RIB* jardinière from Fenton because it has been only slightly swung. *Courtesy of Randy and Jackie Poucher.* NP.

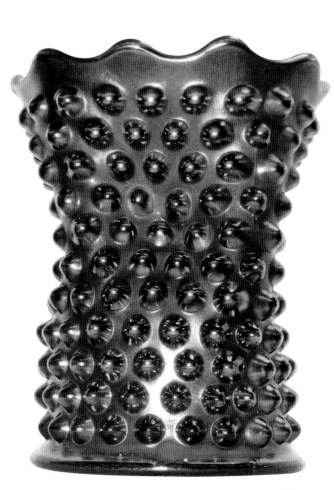

Possibly the only one known, this is a blue, Fenton *RUSTIC* pinched-in jardinière. *Courtesy of Randy and Jackie Poucher.* NP.

Many vases were given further shaping after they had been swung. One of the most attractive is the **Jack in the Pulpit** (JIP) shaping which is imitative of earlier art glass examples from Tiffany and Quezal. (Quite possibly the JIP style was first developed at Harry Northwood's original workplace—Stevens and Williams in Stourbridge, England). A JIP is pulled up at the back, and down and open at the front. Other vases were opened out and flared wide at the mouth—in some instances to a width even greater than the height of the vase. Other vases were crimped or ruffled around the rim. Some vases had more than one type of finishing, having both crimping and JIP shaping. Joan Doty writes that "the **Jester's Cap** is an interesting shaping identified by Mrs. Hartung. She had seen the treatment applied only to Northwood's *THIN RIB*, but recently several examples of Northwood's *TREE TRUNK* have turned up with the identical treatment. It is identified by one rib pointing up and eight ribs pointing down."[2]

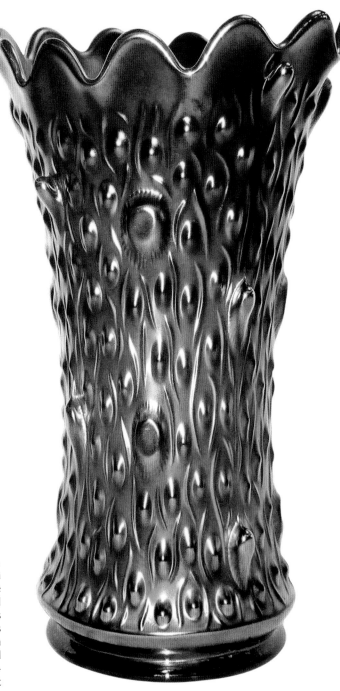

A magnificent, Northwood *TREE TRUNK* elephant foot vase in purple with a scintillating, electric iridescence. *Courtesy of Randy and Jackie Poucher.* Sold at auction for $11,000 in 1995.

Three vases from different manufacturers: on the left, Westmoreland's *CORINTH* in amethyst with a Jack-in-the-Pulpit top ($75-150); Millersburg's 9 inch high marigold *HOBNAIL SWIRL* aka *SWIRLED HOBNAIL* vase ($150-250); Northwood's green *THIN RIB* vase with a jester's cap mouth shape ($150-250).

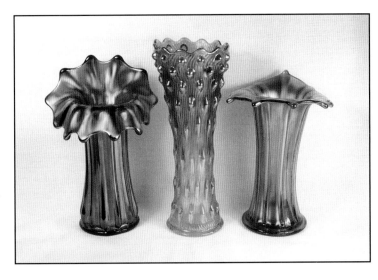

Mould Permutations

The majority of swung vases were made from moulds designed specifically for that shape. Patterns such as Northwood's *TREE TRUNK* and *THIN RIB*, Fenton's *RUSTIC, APRIL SHOWERS, DIAMOND AND RIB* and *FINE RIB*, Imperial's *RIPPLE* and *MORNING GLORY*, and Dugan Diamond's *TARGET* and *PULLED LOOP* are all familiar patterns found only in the swung vase shape.

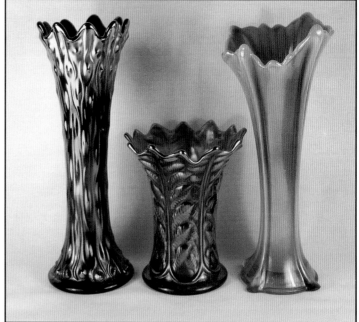

Three very different Northwood vases: on the left, a standard sized, blue *TREETRUNK* with a vivid multicolored iridescence ($150-200, but substantially higher amounts for electric blue examples); an unusual, unswung (squatty), green *LEAF COLUMNS* vase ($150-350); an aqua opal *FOUR PILLARS* vase ($250-350).

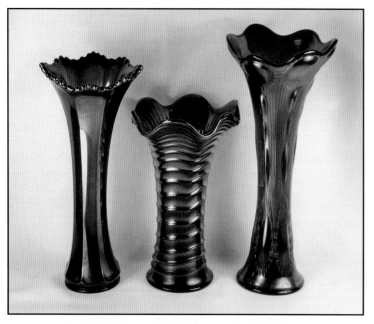

Three splendid Imperial vases in rich purple, with the wonderful electric iridescence that typifies Imperial's production of this color. The three items shown range from 8 inches in height to 12 inches. From the left: the seldom seen *IMPERIAL FLUTE* ($100-350); *RIPPLE* ($100-250) and *BEADED BULLSEYE* ($150-300).

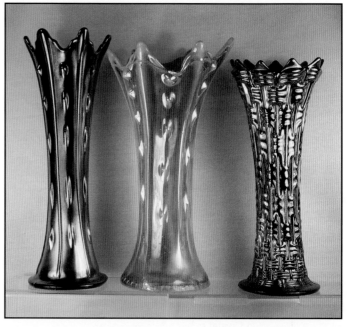

A trio of vases from Dugan/Diamond—the two outer vases are both blue, an unusual color from this manufacturer. From the left: blue *TARGET* (SP $150-300); center, same pattern, but it looks so different in peach opal, note that this color is much more easily found than the previous blue example—*TARGET* ($60-120) and right, a blue *BIG BASKETWEAVE* (SP $150-300).

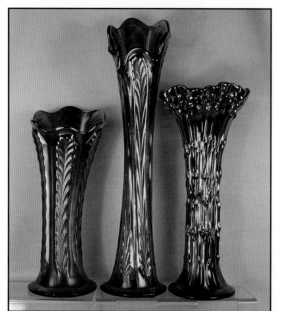

Three green vases from Fenton: on the left, a slightly swung *PLUME PANELS* vase that shows the pattern very well owing to the lack of distortion through swinging ($80-150); center, a tall, green *PLUME PANELS* that is swung to 14 inches ($80-150); and right, an *APRIL SHOWERS* with a tightly crimped top ($80-150).

Other moulds were also used to make swung vases. Tumbler moulds such as Dugan Diamond's *CIRCLE SCROLL* and Fenton's *BUTTERFLY AND BERRY* were brought into use for vases. The tumbler shape was swung and thus stretched out into a vase. On the *BUTTERFLY AND BERRY* examples, it is sometimes stretched so much, that it is very hard to distinguish the butterfly motif. Spooner moulds were used too: United States Glass *PALM BEACH* and *FIELD THISTLE* vases were both made this way. A scarce and sought after vase is Fenton's *BLACKBERRY OPEN EDGE* swung from the bowl (sometimes called a basket) shape, while a punchbowl base was used to fashion the rare Fenton *ORANGE TREE* whimsy vase. Millersburg used the rose bowl mould to produce rare *HOBSTAR AND FEATHER* vases.

The usual press moulding technique relies upon the vertical motion of the plunger within the mould. For this to work, the sides of the mould have to be either vertical, or wider at the top than the bottom, to facilitate the removal of the plunger. There are Carnival Glass vases that could not have been made this way—bulbous shapes, vases with wide, curvaceous shapes, or vases with deeply sculptured patterns—such as Imperial's *POPPY SHOW*, and the *SEAGULLS, PEBBLE AND FAN,* and similar vases which were made in Czechoslovakia. These vases were made by a technique called blow moulding, whereby the hot metal was forced into the mould with the assistance of pressurized air.

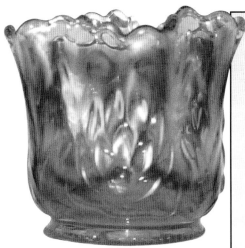

This marigold *WATERLILY AND CATTAILS* whimsy vase (Fenton) was swung from a sauce. *Courtesy of Randy and Jackie Poucher*. NP.

Some all-purpose moulds were used to fashion several different shapes including swung vases. Millersburg's *SWIRLED HOBNAIL* utilized the same mould to produce the swung vase, rose bowl, and cuspidor. Westmoreland had two patterns that were put to this multi-functional use: *CONCAVE FLUTE* and *CORINTH*. Vases, rose bowls (*CONCAVE FLUTE*), bowls (*CORINTH*), and plates were made in these two patterns. Dugan Diamond too, used one mould to produce vases, hats, bowls, and plates in their *LATTICE AND POINTS* pattern.

Note: it is worth mentioning the vase production of Australia. Crown Crystal produced several superb swung vases, for example, the *GUM TIPS* vase.

As Moulded Vases

Method of Manufacture

Many Carnival vases were not swung when they left the mould, but were intended to be just as they came out of the mould with little or no further finishing or shaping. It is difficult to categorize these vases as they vary considerably in size and form, with no governing order to base size or height. A convenient classification for our purposes, however, is by country of origin.

Northwood's *DAISY AND DRAPE* vase with its three distinct feet, is just as it came out of the mould with no further finishing or shaping. This delightful example is in aqua opalescent with a butterscotch iridescence. $400-800.

Imperial's *LOGANBERRY* vases have a sculptural quality that never fails to impress. On the left, a purple example ($2000-3000)—on the right, an amber example ($300-800).

USA Classic Output

In this group of vases are some of the most sought-after examples of Classic Carnival Glass. Millersburg dominates the scene with a fabulous range: *PEOPLE'S VASE, WOODPECKER AND IVY, BUTTERFLY AND CORN, ACORN, ROSE COLUMNS, MITERED OVALS,* and *OHIO STAR* vases. Other sought-after vases are Imperial's *POPPY SHOW, THREE ROW,* and *LOGANBERRY* vases. Further examples are Northwood's *PULLED HUSK* vase, Fenton's *DANCE OF THE VEILS* and Dugan Diamond's *TWIGS*.

In some examples, there has been an element of secondary hand finishing. The tops might be flared and (or) ruffled to lend individuality to the vase. Millersburg's *PEOPLE'S VASE* (a top rarity) for example is known with a ruffled top as well as a plain, upright top. The *MITERED OVALS* vase (also Millersburg) has an intricate top that is deeply ruffled and tightly crimped, while the *ROSE COLUMNS* vase has a ruffled edge. Jack in the Pulpit shaping (see above for definition) was also used on some vases that weren't swung, for example Dugan Diamond's *FORMAL*.

The size of Classic Carnival vases varies tremendously (despite the fact that they were not swung), from diminutive examples standing a shade over 4 inches high, such as Imperial's *ROCOCO* and Dugan Diamond's *TWIG* vase—to large stately specimens like Imperial's *POPPY SHOW* that rise to 12 inches in height.

Dugan/Diamond's delightful *FORMAL* vase in purple with a jack-in-the-pulpit top. The same item, but with a different mouth shaping that is pulled up and flattened off, is usually referred to as a hat pin holder. $600-900 for the JIP vase in purple (note, examples with spectacular iridescence have sold for more).

Imperial's memorable *POPPY SHOW* vase in marigold stands around 12 inches high and is a heavy, impressive item. $500-800 in marigold. Note that this vase was reproduced by Imperial and currently by Fenton for Singleton Bailey. The reproductions are splendid, sought-after items and can be identified by their ruffled tops (some Fenton examples have whimsied jack-in-the-pulpit tops), moulded trademarks and unusual colors. The original, Classic examples were only made in marigold, purple, and smoke.

Northwood's *TOWN PUMP* was probably intended as a novelty vase. Always sought after, the delightful, all-over ivy design combined with the unique shape, makes this a collectors' favorite. In purple (as here) the *TOWN PUMP* usually sells for around $700-1000.

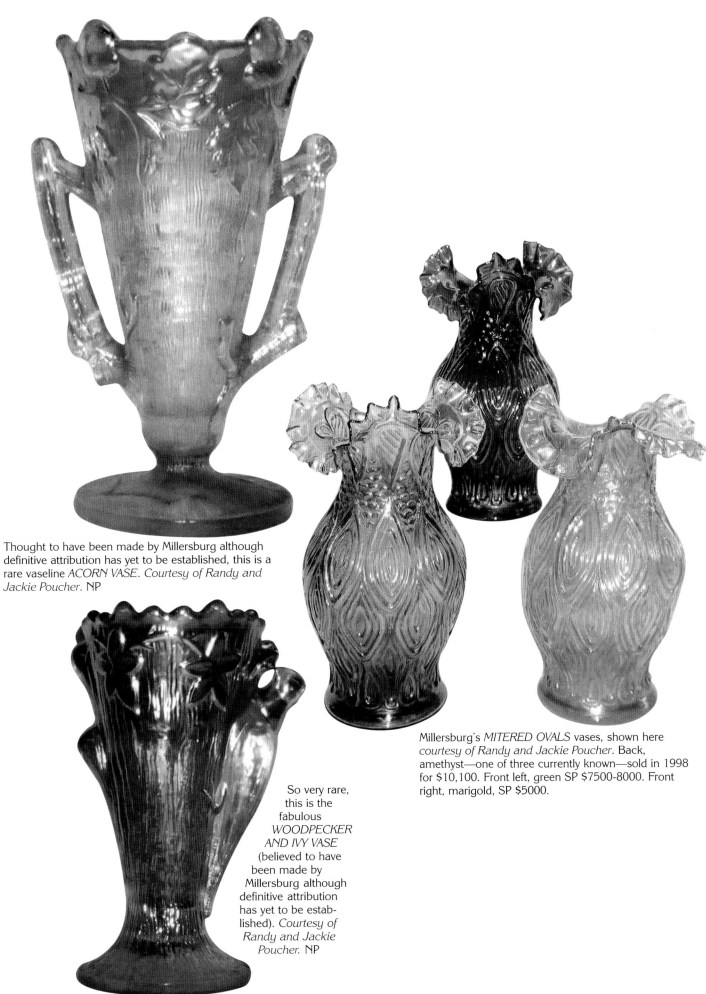

Thought to have been made by Millersburg although definitive attribution has yet to be established, this is a rare vaseline *ACORN VASE. Courtesy of Randy and Jackie Poucher.* NP

Millersburg's *MITERED OVALS* vases, shown here *courtesy of Randy and Jackie Poucher.* Back, amethyst—one of three currently known—sold in 1998 for $10,100. Front left, green SP $7500-8000. Front right, marigold, SP $5000.

So very rare, this is the fabulous *WOODPECKER AND IVY VASE* (believed to have been made by Millersburg although definitive attribution has yet to be estab-lished). *Courtesy of Randy and Jackie Poucher.* NP

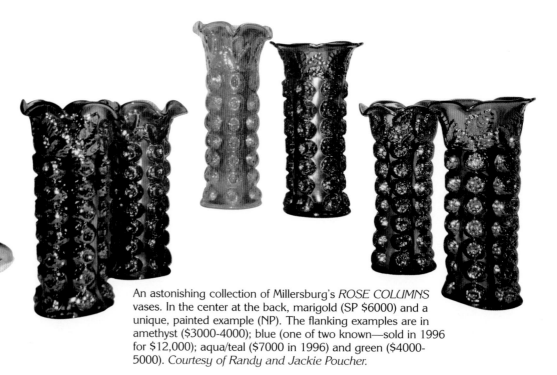

An astonishing collection of Millersburg's *ROSE COLUMNS* vases. In the center at the back, marigold (SP $6000) and a unique, painted example (NP). The flanking examples are in amethyst ($3000-4000); blue (one of two known—sold in 1996 for $12,000); aqua/teal ($7000 in 1996) and green ($4000-5000). *Courtesy of Randy and Jackie Poucher.*

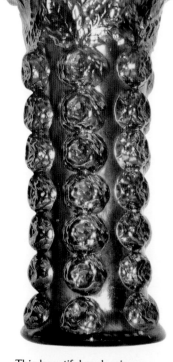

This beautiful and unique amethyst Millersburg *ROSE COLUMNS* vase with painted flowers (in red and yellow) is the only one of its kind known. NP. *Courtesy of Randy and Jackie Poucher.*

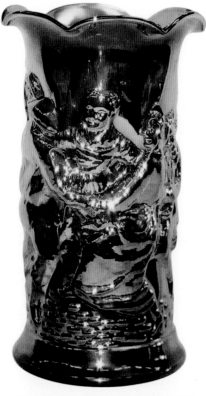

The fabulous Millersburg *PEOPLE'S VASE* in amethyst is shown here *courtesy of Randy and Jackie Poucher.* The pattern features people dancing and is thought to have been produced as a tribute to the people of Millersburg. Only a handful of these vases are known. SP $50,000.

Imperial's *COLONIAL LADY* vase seen here in purple stands a little over 6 inches high. The electric iridescence is typical of Imperial's purple Carnival. $750-1400. *Courtesy of Randy and Jackie Poucher.*

One of two known, this is Fenton's *PANELED DANDELION* whimsy vase in cobalt blue made from the water pitcher. This splendid rarity is illustrated here *courtesy of Randy and Jackie Poucher.* NP.

European vases were often produced in a range of sizes in the same pattern. Here are three amethyst *DERBY* aka *PINWHEEL* vases from Sowerby: on the left, this vase stands 10.5 inches, middle 8 inches and on the right, the small 6.5 inch size. Prices range from around $300 to $500 for each.

European Output

Vases were a favorite of the European Carnival Glass manufacturers. Every one of the Carnival Glass producers on the European mainland (Scandinavia in particular) made a wide range of vases, from the fairly commonplace to the superb and truly magnificent. Brockwitz, Riihimaki, and Eda as well as the Czech manufacturers Josef Inwald and Josef Rindskopf produced some superb examples. Recent research by the authors has also added the name of Sächsische Glasfabrik August Walther & Sons to the list of makers. For example, the massive *CIRCLES AND GROOVES* vase (previously thought by the authors to have been made by Josef Rindskopf) is shown in their catalog from the 1930s. Other vases (and items such as *REISLING*) are now known to have been made by Walther and the later Sächsische-Walther firm. Research into this continues.

• **Size**. Various sizes of the same vase were often made. Brockwitz' *CURVED STAR* vase is a good example of this, found in 3 sizes corresponding to approximately 7 inches, 9 inches and 11 inches high.

• **Pattern**. Manufacturers often made a variety of shapes within a pattern range, one or two of which may well be different shapes of vases, but all in the same pattern. An example from Brockwitz again will help to illustrate this point: in the *ASTERS* pattern, Brockwitz made bowls in several sizes, a footed salver or cake stand, a stemmed sugar (compote), plates and two very different looking vases. They called this range their *MARGUERITE* pattern. Of the two vases, one is an oval shape (also called a letter vase) and the other is a tall cylindrical shape. Though both are clearly shown to be part of the same Brockwitz pattern range in their catalogs, the major contrast in both shape and interpretation of the pattern, has caused the two vases to be classed under quite different names. The oval vase is rare and is known as *ASTERS*, while the cylindrical vase is fairly easily found (in marigold) and is called *SUNFLOWER AND DIAMOND*.

The Scandinavian Carnival manufacturers also made slight variations to vases in the same pattern. Karhula's *SPINNING STAR* and its "sister" pattern *SPINNING STARLET* are good examples of this, as the illustrations show.

The *RISING COMET* vase is almost certainly a Czechoslovakian item (it has all the characteristics of Rindskopf's output). Three sizes are known—all very hard to find indeed. From the left: the small vase is just 6 inches high; the mid size is 8.5 and the tallest 11 inches. SP $200-400.

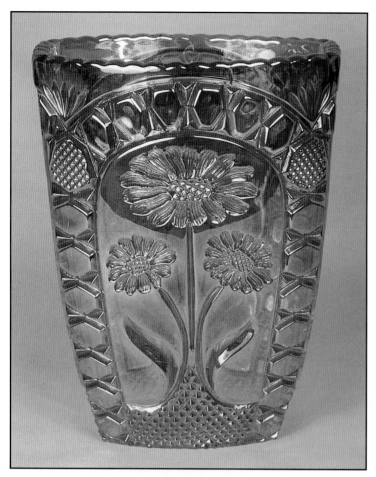

Brockwitz exquisite little ASTERS vase in the oval or "letter" shape is seldom seen. Only known, so far, in marigold. *Courtesy of Phyllis and the late Don Atkinson.* NP.

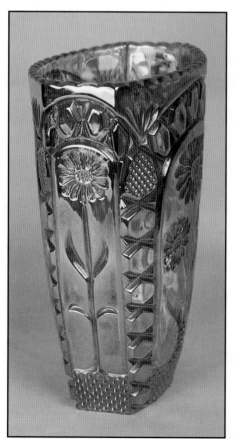

SUNFLOWER AND DIAMOND vases from two different makers. On the left is a marigold Brockwitz version, on the right, a blue Eda Glasbruks example (*courtesy of Ann and David Brown*). As well as the size difference, there's also a different number of petals on the floral motifs. The Eda version has 20 petals while the Brockwitz one has 36 petals. Marigold Brockwitz vase, $100-200. Blue Eda example, SP $400-700. Note, a rare purple example of the Eda version of this vase was reported in 2003.

Another view of the ASTERS vase to illustrate the side panel. *Courtesy of Phyllis and the late Don Atkinson.* NP.

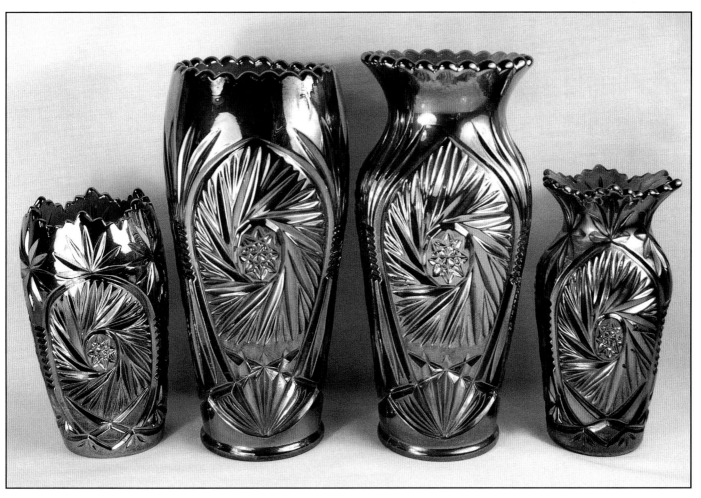

Two similar vase designs from Karhula in Finland, probably made during the 1920s. In the center are two magnificent 9 inch high *SPINNING STAR* vases in blue, with different neck shapes. Flanking these vases are two smaller (6 inch), blue *SPINNING STARLET* vases, also with different neck shapes—very similar in design to *SPINNING STAR*, but they have an additional intaglio motif just under the neck. The iridescence on all four vases is superb and vivid. SP $500-1000 for the *SPINNING STARS*. SP $400-700 for the *SPINNING STARLETS*.

• **Shape**. European vases were not swung but are found in a wide variety of shapes. The most frequently found shape is the cylindrical vase, usually flat based but sometimes footed. Oval vases (letter vases) and bulbous vases are also known. Rare square vases were made by Brockwitz and Riihimaki/Kauklahti—the *SQUARE DIAMOND* aka *COLUMN FLOWER* vase appears in the catalogs of both companies. Other square vases are *REGINA'S STAR* (Brockwitz, named and reported by Dick and Sherry Betker) and *SCHMALZIE* (Riihimaki, named and reported by Jeri Sue Lucas). Some are found in unique shapes that are only seen on one specific vase. An unusual shape variation typical of Riihimaki/Kauklahti was where the vase was belled out around its middle, the massive *ELEKTRA* vase illustrated is a perfect example.

The Finnish Carnival manufacturer, Riihimaki made a variety of different vase shapes in the same pattern. The *STARBURST* design, for example, proved to be most versatile—the illustrations show some of the range of different shapes that were produced. Many of these fascinating shapes were depicted in the Riihimaki/Kauklahti catalog of 1927.

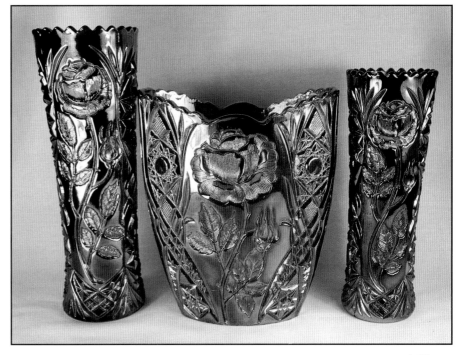

Two shapes of *ROSE GARDEN* vase: left, a rare 11 inch high cylinder vase in blue, one of two currently reported (NP); center, the oval vase (a little under 9 inches high) SP $4000-5000; and right, a rare 9 inch cylinder vase in blue (NP).

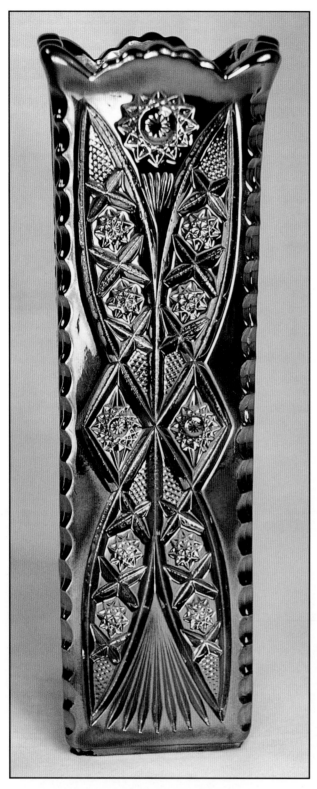

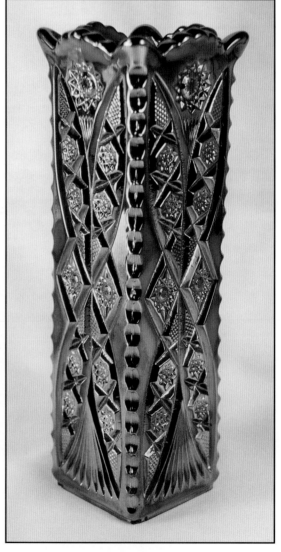

The astonishingly lovely *SQUARE DIAMOND* aka *COLUMN FLOWER* vase in cobalt blue. The mould work is intricate and superbly executed. This rare beauty appears in the catalogs of both Brockwitz (Germany) and Riihimaki/Kauklahti (Finland). SP $700-1200.

Another view of the *SQUARE DIAMOND* aka *COLUMN FLOWER* vase.

Josef Inwald's statuesque *FLEUR DE LIS* vase in rich, pumpkin marigold, very typical of that factory's high quality output. This fabulous item stands some 10 inches high and is very heavy. SP $300-500.

This is the splendid square shaped *REGINA'S STAR* vase in blue, made by Brockwitz. This rare item is currently the only example reported. *Courtesy of Dick and Sherry Betker*. NP.

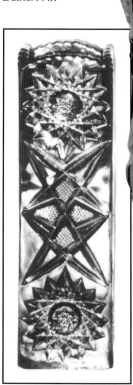

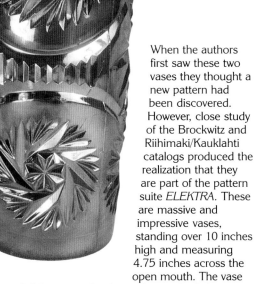

When the authors first saw these two vases they thought a new pattern had been discovered. However, close study of the Brockwitz and Riihimaki/Kauklahti catalogs produced the realization that they are part of the pattern suite *ELEKTRA*. These are massive and impressive vases, standing over 10 inches high and measuring 4.75 inches across the open mouth. The vase shown left has an amber base glass and a light marigold iridescence (Riihimaki pattern number 5952; Brockwitz pattern number 33141). The vase on the right has a clear base glass, with a rich marigold iridescence that shows much pink and green (Riihimaki pattern number 5954; Brockwitz pattern number 33141). SP $600-1000 for either vase.

From Riihimaki in Finland, this is currently the only reported example of the wonderful, rare *SCHMALZIE* vase. Shown here in blue, *courtesy of Jeri Sue Lucas*. NP.

- **Finishing**. Often European Carnival Glass vases were given no secondary shaping to the neck of the vase, though there are several notable exceptions, for example, the *SOWERBY DRAPE* vase and Eda Glasbruk's *FLORAL SUNBURST* (aka *TUSENSKONA* aka *DAISY SPRAY*) as well as the diminutive and rare (only three examples are currently known) *LITTLE LEAVES* vase from Riihimaki/Kauklahti. The *WESTERN THISTLE* and *STARBURST* patterns (both from Riihimaki/Kauklahti) also exhibit excellent secondary shaping.

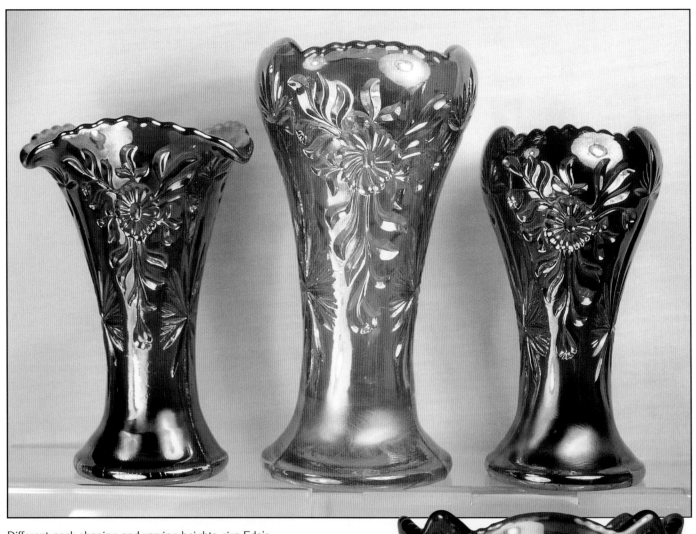

Different neck shaping and varying heights give Eda's *FLORAL SUNBURST* aka *TUSENSKONA* vases variety. On the left, the triangular shaped top in blue stands 6.5 inches high. In the middle, the curved-in top vase stands 8 inches high and is a rich marigold. On the right, a blue, curved-in top example. These vases usually sell in the range between $700 and $1200, though some examples have been a little lower, while one flat topped example sold for $1900 in 2001.

A fabulous amber *STARBURST* vase from Riihimaki/Kauklahti with most unusual hand shaping to the neck. Hand shaping such as this is typical of the Finnish makers, Riihimaki and Karhula. SP $300-600.

146

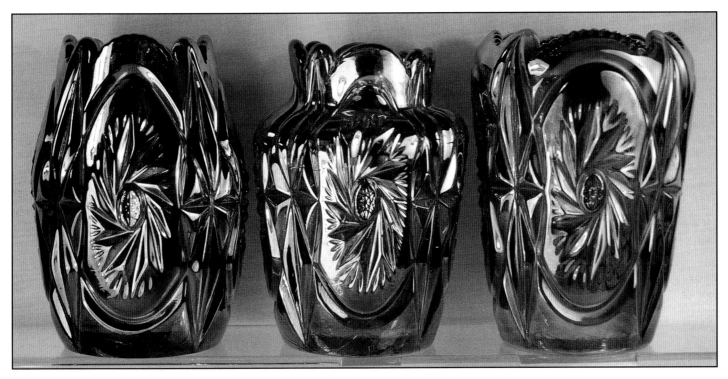

These three *STARBURST* vases are all from the same mould as the previous one, but the shaping is very different indeed. $300-600 for any of the three.

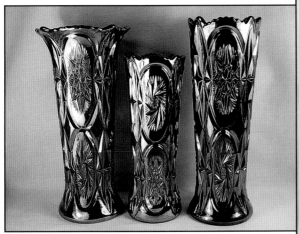

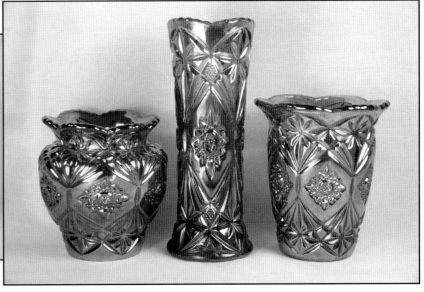

Would you recognize these three vases as *STARBURST* too? They are in the same pattern suite as the previous *STARBURST* vases. The design motifs are the same, but on these tall vases it is doubled up, one above the other (maybe the name *DOUBLE STARBURST* would fit better). These vases, and all the other shapes in the *STARBURST* pattern were shown in the Riihimaki/Kauklahti 1927 catalog (discussed in Part One, Chapter Five). The Finns gave this pattern suite a name—*KERO*. In practical terms, the *STARBURST* name is too entrenched in collectors' terminology to revert to the correct original name now. On the left is an 11 inch high example in rich amber with a flared mouth. Center, a smaller 9.5 inch vase in blue and right, the massive 11.5 inch example. SP $700-1000 for the 9.5 inch size in blue. NP for the larger versions.

Three different shapes of Riihimaki/Kauklahti's *TENNESSEE STAR* vase. All these three examples are on amber base glass. The pattern's almost inappropriate name arose because the first reported example (in blue) was found in Tennessee by collector Mike Cain, in the 1990s. SP $500-700.

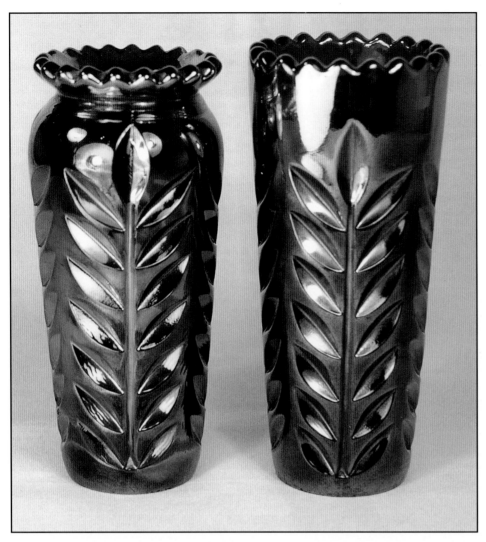

Here are two examples of this scarce, diminutive vase that the authors have named *LITTLE LEAVES*. The base color is blue and the taller of the two vases (seen on the right) stands just five inches high, while the base measures 1.5 inches in diameter. Note the different neck shaping on these exquisite vases: one is pinched and flared (Riihimaki pattern number 5977) while the other is as it came from the mould (Riihimaki pattern number 5973). Illustrated in the 1927 Riihimaki/Kauklahti catalog. NP.

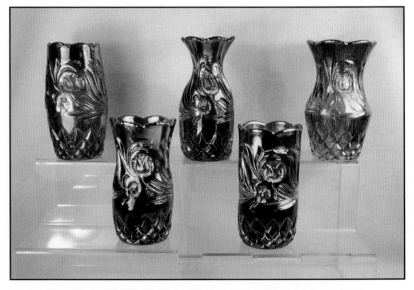

The *WESTERN THISTLE* vase is fairly often seen in the regular, waisted shape shown in marigold (top right). However, a wide range of vase shapes was also made in the pattern—most of these are very rare indeed. Blue vases are known and are also very rare. The pattern was shown in the 1927 Riihimaki/Kauklahti catalog where it was named *KUKKA* (which means flower or blossom). The regular marigold vase (seen top right) sells in the range $150-300. NP for the other shapes. NP for blue. (No recorded sales have yet been made of these rare items to base a value on).

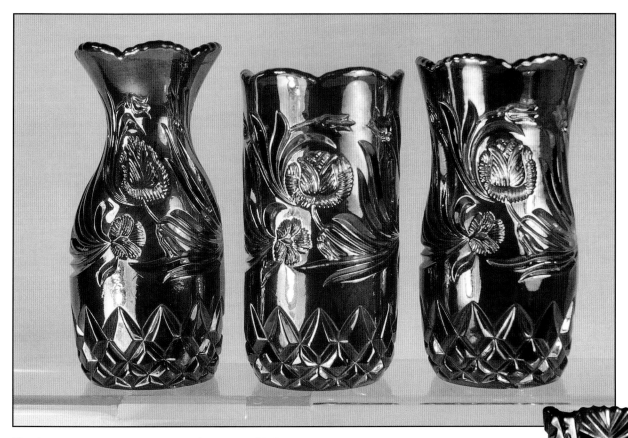

The three rare and unusual, blue *WESTERN THISTLE* vases seen in the previous photograph are shown here in closer detail—note they stand around 5 inches high. (From left to right they have the Riihimaki pattern numbers 5969, 5961, and 5970). NP.

Found in Finland, this delightful miniature bud vase stands just 5.25 inches high, and has a 1.75 inch diameter base. Named *KARELIA SWEET* by the authors (it was found near the town of Hameenlinna, made famous by Sibelius who composed the Karelia Suite) it has a deep cobalt blue base glass. The vase is shown in the 1939 Riihimaki catalog (pattern number 5906) but was probably made at an earlier date. NP.

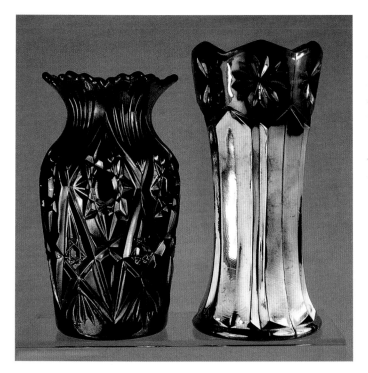

Two vases from Finland with very different interpretations of the "star" theme. On the left, Karhula's unusual *STARLIGHT* vase (pattern number 4883 in the Karhula 1934 catalog) has an intricate and complex geometric design. This example in blue stands just 5 inches high. SP $500-700. On the right, Riihimaki's blue *JULIANA* vase (illustrated in Riihimaki/Kauklahti 1927 catalog) has a much simpler interpretation of the "star" theme. This example of *JULIANA* is unusual in that the iridescence is selectively applied on the exterior so as to avoid the star band at the top. A corresponding layer of iridescence has been applied on the vase interior around the star band, thus giving an unusual contrast and a rather lovely optical effect, as the iridescence shines through the vase where the stars are incised SP $500-700.

At last. A pattern from Riihimaki/Kauklahti that can keep its original name—*JUPITER*. These items were only recently reported in Finland, and thus collectors have not previously established a pattern name. A full range of shapes was illustrated in the 1927 catalog. The three vases shown here are: blue, on the left, in an upright shape (Riihimaki pattern number 5914) and amber, on the right, in a high waisted, flat top shape (Riihimaki pattern number 5917). Each has a superb iridescence. SP $500-800. In the center is a miniature vase (Riihimaki pattern number 5929) with a pinched in flat top. This is the first reported example of the miniature 3 inch high vase— the maker's name (RIIHIMAKI) is moulded on the base. The authors were astonished to realize that its pattern is entirely cameo (raised up), whereas the pattern on all the other *JUPITER* items is intaglio (cut in). A fascinating and intriguing observation. The base glass color of the tiny vase is amber-pink, verging on light amethyst. Most unusual. NP.

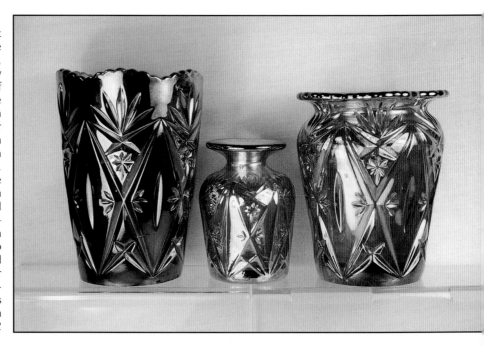

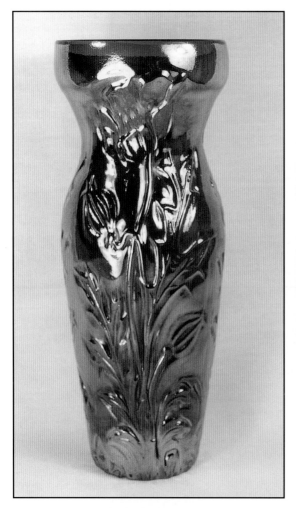

The maker of this beautiful *POPPY SPRAY* vase is currently a mystery, though it seems very likely to be from a Scandinavian manufacturer. The base color is a rich amethyst, another example is known in green. *Courtesy Jim Nicholls.* NP.

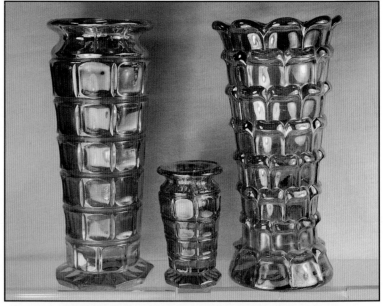

Some unusual vases in marigold from the Swedish manufacturer, Eda Glasbruks. Left is the *REX* vase and right is the lovely *TOKIO* vase with its waterfall effect. Both stand around 8 inches high. SP $300-600 for the *REX* in marigold in this 8 inch size, and $500-1000 *TOKIO* in marigold. A single example of a miniature version of the marigold *REX* is known and is shown here (center). It stands a shade over 3 inches high and measures just 1.5 inches across the base. NP.

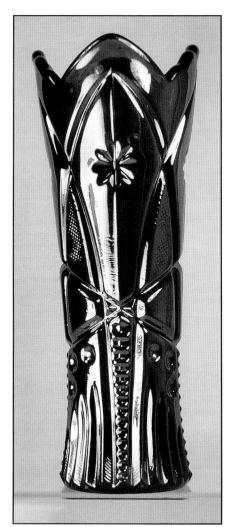

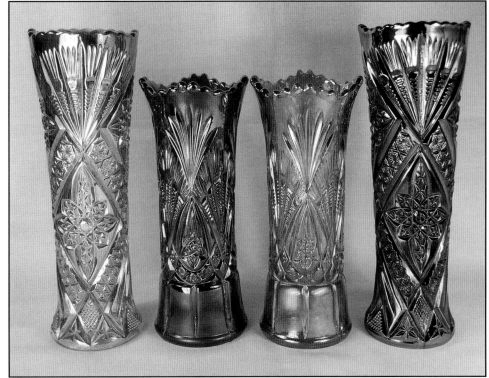

The *CURVED STAR* design is seen here in two different interpretations of the same theme. The two (taller) outside vases are from Brockwitz, the two smaller vases in the middle are from Eda Glasbruks (the Eda version is known as *LASSE*). Values range from $400-600 for a marigold vase (either maker, but note that the Eda examples are harder to find than the Brockwitz ones) to $700-1100 for the blue examples (again, either maker, with Eda versions being harder to find). Note also that the *CURVED STAR* cylinder vases from Brockwitz are known in three sizes—the 9 inch mid size is shown here. Also known are 7 inch and 11 inch examples.

A most unusual vase, *BISHOP'S MITRE*, from Riihimaki. This one, however, is very different indeed, as it is in green! Green is a rare color for Riihimaki, and this is the first vase that the authors are aware of in the color. Several Riihimaki tumblers and tableware items in green are also reported, in other patterns. NP in this rare color.

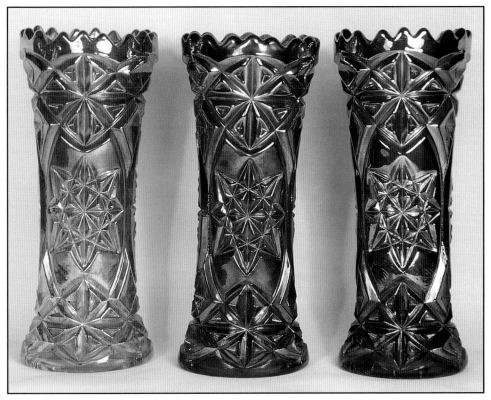

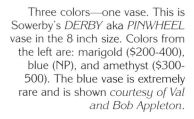

Three colors—one vase. This is Sowerby's *DERBY* aka *PINWHEEL* vase in the 8 inch size. Colors from the left are: marigold ($200-400), blue (NP), and amethyst ($300-500). The blue vase is extremely rare and is shown *courtesy of Val and Bob Appleton*.

151

Indian Output

Vases were a very popular shape in India and all manner of un-usual shapes and patterns are known. The *FISH, ELEPHANT, HAND,* and *GODDESS* vases are most distinctive in that the entire form of the vase is also the pattern. Within these basic shapes, further varia-tions are found, especially in the *HAND* vases. Research by Angela Thistlewood has found three broad categorizations of these *HAND* vases: those with encircling bead motifs, those with encircling beads and arches motifs, and those with flower motifs. Within these three broad categories can be found a wide variety of height, watch detail, and variations in mouth shaping.

Detail of the pedestal base of the *RIGHT HAND VASE* shown in the center of the previous illustration. Note the fine detail of the wrist band on the watch. This vase is marked "Jain." $50-150.

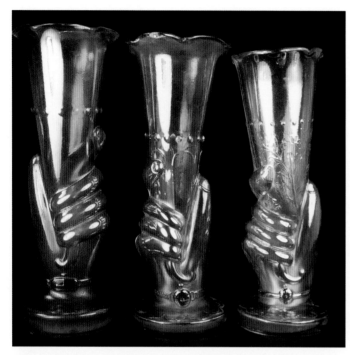

Three *HAND* vases (both left and right) from the Jain factory in India that represent the three basic categories (shown left to right): those with encircling bead motifs, those with encircling beads and arches motifs and those with flower motifs. Note the watch detail also differs on each. $50-150.

Detail of the pedestal base of the *LEFT HAND VASE* shown on the left of the previous illustration. $50-150.

Detail of the floral motif on the *LEFT HAND VASE (FLOWER VARIANT).* $50-150.

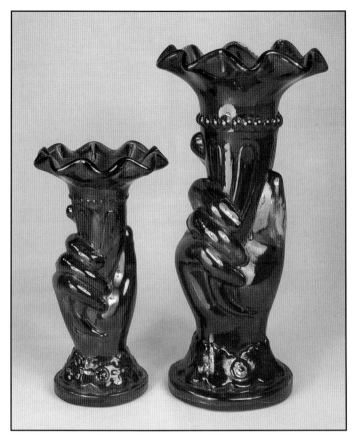

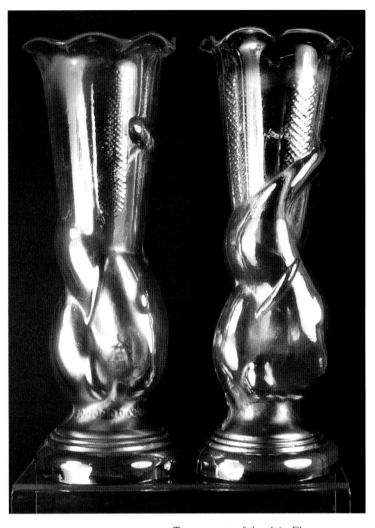

Two cranberry stained *HAND* vases (the base glass is clear) in differing sizes; 5.75 inches and 8 inches. The cranberry iridescence on each is soft and highlighted with pink and gold. The maker is unknown, but it is believed that these are certainly not Indian examples. SP $100-200 for either one.

Two aspects of the Jain *EL-EPHANT* vase. All examples of the *ELEPHANT* vase known to the authors have a swastika motif moulded on the back of the vase. As with the *HAND* and *FISH* vases, there are variations on the theme—the trunk may wind to the left or the right, some vases have the letters JAIN, some have a jewel design, and others bear the letters CB. Two sizes are known: 7 inches and almost 9 inches (as shown here). Either vase $50-150. Note that prices have been diluted in recent years owing to an influx of imported goods—a few years ago these vases were selling in the $500-800 range.

A group of *FISH* vases in a wide range of variations—most were probably made by Jain. From the left: *FROSTED FISH* vase (marked "Jain"); *FISH VASE* (marked "Jain"); *SER-PENT VASE; FISH VASE VARIANT* (so called, because it winds the opposite way to the regular *FISH VASE*); *FROSTED FISH* vase with a marigold design that has not been reported before. Prices range from around $250-400 for the *FROSTED FISH* and the *SERPENT*, prices for the *FISH* vase and *VARIANT* are a little lower, around $150-250.

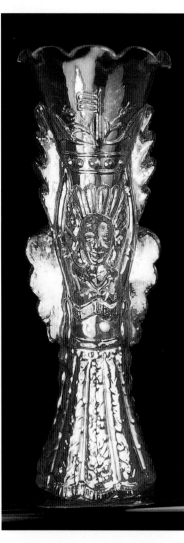

Three further basic shapes of Indian vase can be recognized:

• Bulbous (*DIAMANTE STARS* style)—known in at least four different heights: 6 inches, 6.5 inches, 7 inches, and 8.5 inches. Typically, the glass is very thick and the patterns are thickly moulded and stylized. Usually these vases have four mould seams.

• High Waisted (*GOA* style)—only one basic height (6 inches) is currently known. Typically the glass is very thin and the patterns are in light relief. Usually these vases have two mould seams.

• Etched—typically these bell out toward the bottom of the vase and are around 6.5 inches in height. The pattern is created through a mixture of acid etching and marigold iridescence (see illustration in Part One, Chapter Four: "Decorating the Glass"). Usually there are no mould seams.

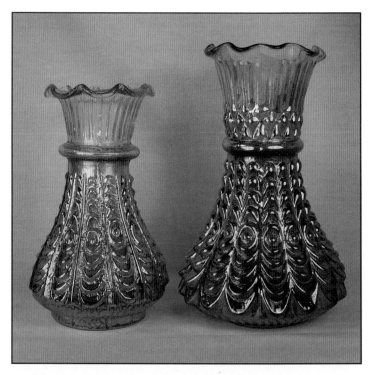

The bulbous *PANAJI PEACOCK EYE* vase in marigold and the taller *PANAJI PEACOCK EYE VARIANT* in Jain blue, both from India. NP. *Courtesy of Pam and Mike Mills.*

The exotic and mysterious *GODDESS* vase is thought to be a Jain item. Two variations on the theme are known, this is the more elaborate version. SP $500-800.

Variations on a theme in the bulbous *DIAMANTE STARS* style of Indian vase. From the left: *DIAMANTE STARS, DIAMANTE STARS VARIANT, DIAMANTES,* and *DIAMANTE RAIN.* All shown stand around 6 inches high. $50-125.

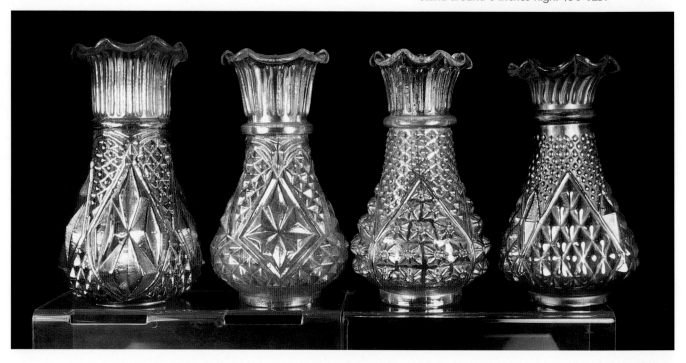

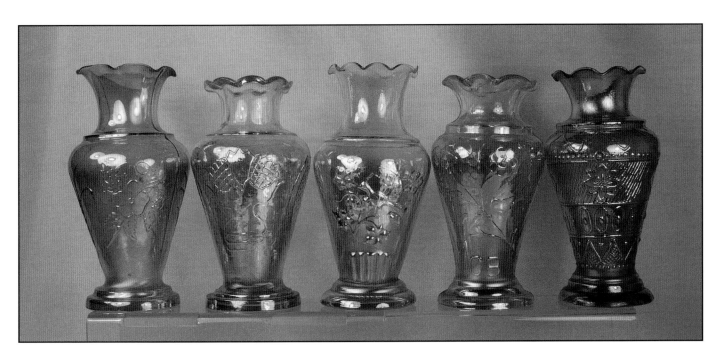

Rose bowls and Flower bowls

Rose bowls were originally used for dried rose petals or potpourri to fragrance homes in the late 1800s (a popular idea during a time of limited personal hygiene). They can also be used to float rose blooms or as vases for short stemmed flowers, though in fact many were purely decorative.

The definition of a **rose bowl** for the Carnival collector is any bowl which turns in at the top, whether it is footed or collar based. The purist rose bowl collector will also insist that the bowl is as wide as it is tall. (Nut bowls are similar in overall shape and size to rose bowls, but they are straight or flare slightly out at the top instead of cupping in). Rose bowls may be flat based or footed and the pattern may be exterior, interior or both. Their edges may be ruffled and crimped or may simply be smooth. Generally rose bowls are fairly small, but scarce, large examples are known, usually going by the name giant rose bowls.

Two *DIAMOND HEART* vases from India. A close study of the two examples in the illustration will reveal many variations in the interpretation of the design concept. $50-125.

More variations on a theme—these are the *GOA* vases from India, each featuring a different pattern. From the left: *HERBAL MEDICINE, GOA, MAYURI* (aka *PEACOCK TREE*), the *CB* vase, and *TRIBAL*. Prices range from $50-125.

This exact same cupped-in shape was also used in Europe for sugar bowls. Often these items were multi purpose and may be listed in some of the European catalogs for both purposes (not at the same time, of course).

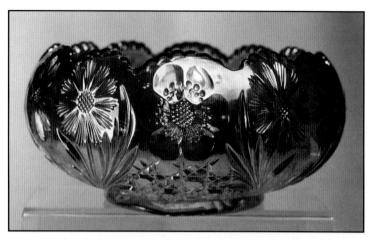

The United States Glass Company made this beautiful *COSMOS AND CANE* large rose bowl (measuring 7 inches diameter) in honey amber. $400-500. *Courtesy Jim Nicholls.*

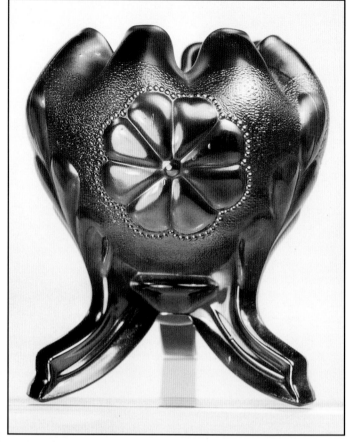

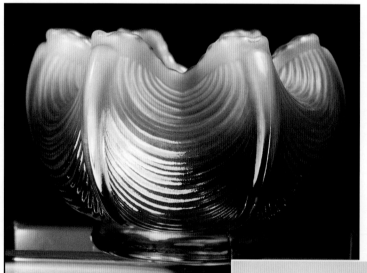

A strangely shaped foot seen on this purple, three-footed *DAISY AND PLUME* rose bowl by Northwood. The interior on this piece is *RASPBERRY*. $80-125.

Northwood's *DRAPERY* rose bowl in aqua opalescent Carnival. $250-400.

Rustic twig like feet are seen here on two Fenton items: left is the *LEAF TIERS* tumbler in marigold ($100-150); right is a green *ORANGE TREE* rose bowl, also called *FENTON'S FLOWERS* ($150-250).

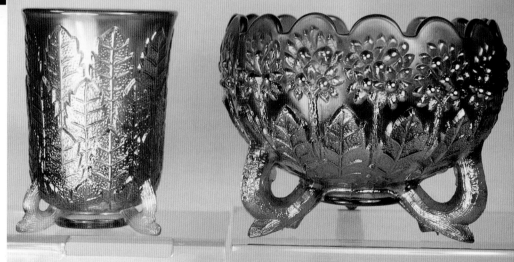

The European **flowerbowl** (blumenbowl) was usually shaped rather like a squat, wide vase with a cupped in, rimmed neck and came complete with a metal grille or glass frog, to hold the flower blooms in place. However, other shapes of flower bowl could also be found, for example, the *TARTAN* flower bowl (so-called in the Brockwitz catalog) that is identical in shape to a Classic Carnival cuspidor (spittoon). Other similar shaped flower bowls were also made by Riihimaki.

The term "rose bowl shaped top" may be applied to stemmed compotes or vases—the implication being that the top or mouth of the item is cupped in, like a rose bowl. Another term used to describe this shaped top is "tulip top."

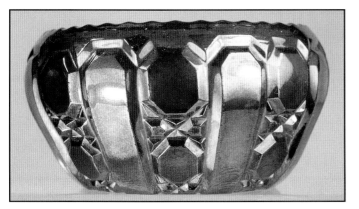

Although its shape is that of a cuspidor, Brockwitz described this item in the *TARTAN* pattern as a flowerbowl in their catalogs. Brockwitz' own name for this pattern was actually "Kopenhagen" but the *TARTAN* name is too entrenched in collectors' terminology to be changed now. This rare blue example is currently the only one reported and is shown here *courtesy of Carol and Derek Sumpter*. NP.

A previously unreported pattern, this is a rose bowl (or sugar bowl) from Karhula in rich blue. The authors have named it *BALTIC BUTTONS*. NP.

From Brockwitz, these marigold *CURVED STAR* flower bowls with a fitted metal grille (to hold blooms in place) were termed *blumenbowl* in the Brockwitz catalogs. The diminutive example on the right is the only example in this size that the authors have seen. $100-150 for the larger bowl. SP $300-400 for the small bowl.

Here's a blue *ROSE GARDEN* flower bowl from Brockwitz without its metal grille. It was illustrated in the Brockwitz catalogs complete *mit versilbertem gitter* (with silvered lattice). *Courtesy Ann and David Brown*. NP.

Epergnes

Epergnes were fashionable in the early 1900s. The bowl would have contained a fruit display while the epergne lily (or lilies) would have held specimen blooms; the whole thing becoming a delightful table centerpiece. In Classic Carnival, epergnes range from the large and impressive *WIDE PANEL* examples made by Northwood, to the diminutive *VINTAGE* epergne from Fenton. In Europe, large statuesque epergnes were made primarily by Brockwitz in Germany. The tall *CURVED STAR* epergne is probably the most well known example (see the introduction to Part Two, Shapes, for a photograph of the Brockwitz *CURVED STAR* epergne).

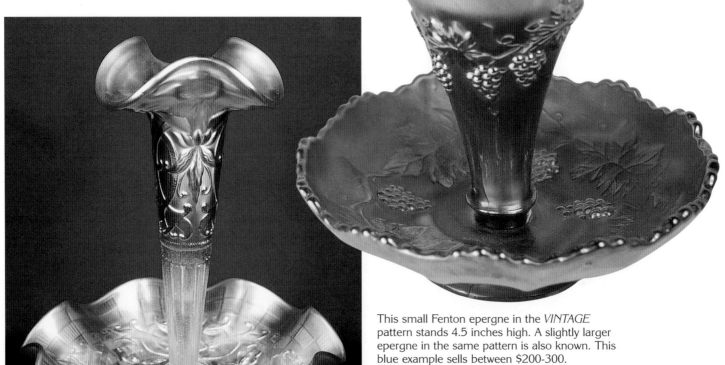

This small Fenton epergne in the *VINTAGE* pattern stands 4.5 inches high. A slightly larger epergne in the same pattern is also known. This blue example sells between $200-300.

Northwood's *WISHBONE* epergne in marigold. $350-500.

Known to collectors as *Sowerby's CHUNKY* or *ENGLISH HOB AND BUTTON*, some of the shapes were amazingly exotic. Here is a two-part, marigold epergne, the upper level supported by a chrome figure in the Art Deco style. One with a metal lily on the top sold at auction in the USA in 1995 for $450. Simple marigold bowls in this pattern will sell for much less.

158

Other shapes: baskets, hats, ferneries, jardinières, and wall vases

And still more shapes for flowers! **Baskets** in all sorts of shapes and sizes—high handled, double handled, tall sided, shallow, and open. Classic Carnival makers included Northwood, with the popular *BUSHEL BASKET*, Dugan/Diamond, with their *BEADED BASKET*, and Imperial, with their *DAISY BASKET* and others. European manufacturers also produced baskets, though they are not easily found.

Northwood's blue *BUSHEL BASKET* sells for $80-180.

A most unusual item, a marigold *GALACTIC BEAUTY* handled flower basket from Brockwitz. NP.

The **hat** shape is so called because of its similarity to an upside-down, ruffled brim hat for a very small person. Joan Doty, the vase expert, writes that **hat** is "a recent term—original ads referred to them as nut bowls, bonbons, violet vases, anything to capture the buyer's fancy. Fenton seems to have made most of the hats. For them the shape was a production line item, with "hat" moulds, and even some patterns found exclusively in the hat shape—*FLOWERING DILL, FRENCH KNOTS, BRIAR PATCH* for example. On Fenton hats the pattern is on the interior, where it can be displayed to advantage. In contrast, most Northwood and Dugan hats seem to be afterthoughts—flared and ruffled tumblers or vases."[3] A good example is the *CIRCLE SCROLL* hat illustrated that was whimsied from the tumbler. An interesting recent find is that of the first reported whimsy hat in Imperial's *FASHION* pattern that was also probably shaped from the tumbler. Note that the original Butler Brother's ads named hats, bonbons, or nut dishes.

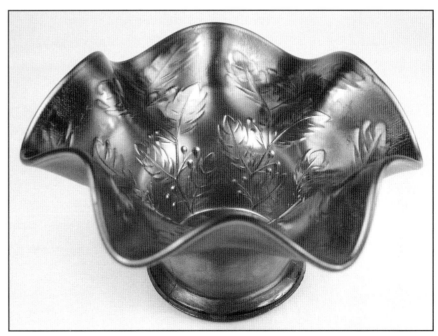

Fenton *HOLLY* ruffled hat in red. $300-500.

159

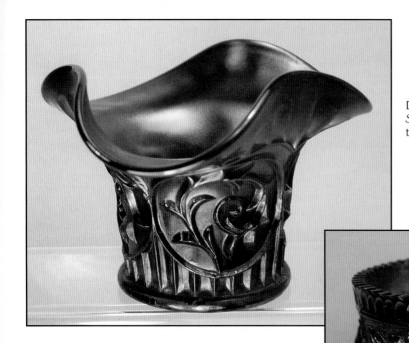

Dugan/Diamond's seldom seen *CIRCLE SCROLL* hat in purple was whimsied from the tumbler shape. $100-200.

Imperial's fernery in *LUSTRE ROSE* aka *IMPERIAL ROSE*. Note this is blue. Generally blue is considered to be an unusual color for Imperial, but not in this particular shape, as (by no means common) they are not too hard to find. $100-200.

Ferneries are a footed, deep cupped in shape, and were often sold with a removable glass or tin liner. Carnival examples are primarily Classic American—the European shape most similar is the **jardinière**—a large oval flower bowl that was intended to be placed on a window ledge filled with small potted plants. Usually jardinières are approximately twice as wide as they are deep, being around 7 to 13 inches in width, but only some 3 to 7 inches from back to front.

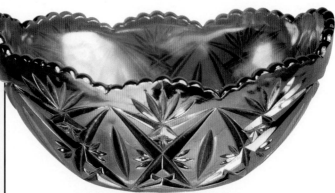

Previously unreported, this is a jardinière from Riihimaki/Kauklahti in their *JUPITER* design. This pretty blue example is SP $400-500.

Punch set bases can, on occasion, double up as small vases, provided they are not badly balanced. The base to Dugan/Diamond's *STORK AND RUSHES* punch set is used as a vase and is also known as the *SUMMERS DAY* vase.

[1]Thistlewood, Glen and Stephen. *Network 6.* Alton, Hampshire, England: authors, 1995.

[2] Doty, Joan. "Topping off Vases" May 1995 Lincoln-Land Carnival Glass Club newsletter.

[3]Private correspondence between the authors and Joan Doty.

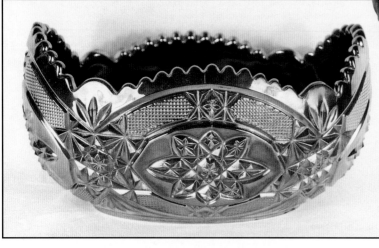

A European jardinière in Brockwitz *SUPERSTAR* pattern (actually a variation on their *CURVED STAR* design). Known in blue and marigold—this blue example SP $350-450.

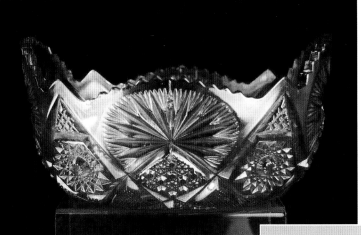

Posy vases in novelty shapes are also known. In the 1920s, Sowerby re-used a mould that they had originally introduced in 1882, to make the *ROYAL SWANS* posy holder. The exceptionally rare (less than ten are currently known) Carnival versions are splendid examples of Victorian design.

A jardinière from South America, perhaps? This is the United States Glass Company's *U.S. REGAL* pattern in the jardinière shape. It is possible that the mould was purchased by an Argentinean company and made in Carnival by them. In marigold (as shown here) SP $125-200.

Wall vases are glass pockets with moulded attachments that can be fixed to the wall to hold small floral displays. Similar vases were also made for automobiles, to adorn the inside of the cab. Apparently some funeral hearses were equipped with such vases mounted on holders, for floral displays. Interestingly, the pointed wall vases also doubled up for use in cemeteries! Their V shaped base could either be popped into the holder fixed inside the car, or could be driven into the earth at the graveside.

Sowerby's extremely rare *ROYAL SWANS* posy holder is a particularly lovely item. The center section is an oval, boat shaped container, either side of which is a swan with outstretched wings. A water lily and cattail type of pattern covers the side of the boat shape. This rare item had the pattern #1328 and was first shown in the Sowerby 1882 catalog when it was produced in a range of unusual glass (see following illustration). It is thought that it was made in Carnival in the early 1920s. Westmoreland's "Swan" sugar and creamer set are very possibly modeled on this Sowerby original. The *ROYAL SWANS* is shown here in amethyst. SP $1500-2500.

The *BIRD WITH GRAPES* aka *COCKATOO* wall pocket is considered by many to be a Dugan/Diamond product. In marigold, $75-150.

Sowerby's *ROYAL SWANS* in four different glass colors. Top left, amethyst Carnival; top right, jet black glass with gilded decoration. Bottom left, light blue milk glass; bottom right, Sowerby's patent "Queen's Ivory Ware" (a delicate ivory glass imitative of finest porcelain).

The most frequently found type of drinking vessel in Carnival Glass is undoubtedly the tumbler. Usually forming part of a water set—six tumblers and one water pitcher represent a full set in practical terms, though for collectors today, one tumbler alongside its matching pitcher is generally accepted as a "water set." Other drinking vessels in Carnival include the impressive punch sets, individual cup and saucer sets, decanters and matching wines, goblets, and dainty little shot glasses. A tremendous range of practical items was produced and undoubtedly many of them were used—and no doubt many were also broken during use and in cleaning.

Water Sets or Lemonade Sets

Made by almost every single Carnival manufacturer, from the early years of Classic production right up to today, water sets (and tumblers in particular) attract avid collectors. (The only manufacturers who are currently not known to have made tumblers or pitchers are Sowerby in England, Leerdam in the Netherlands, and Eda Glasbruks in Sweden). The range of shapes, sizes, colors, and patterns that were produced is vast.

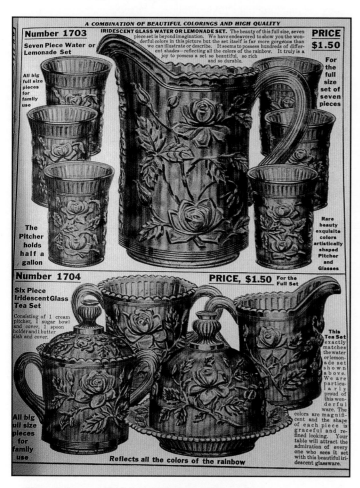

This ad from a 1915 Lee Manufacturing catalog shows an Imperial water set (top) and table set in *IMPERIAL ROSE* aka *LUSTRE ROSE*.

Another Lee Manufacturing catalog ad, this time from 1916, shows an enameled water set in cobalt blue in Northwood's *CHERRIES AND LITTLE FLOWERS* pattern. It was offered free as a special extra premium with an order of $10.00 or over to Lee's lady agents. Note that this is a bulbous shaped water pitcher.

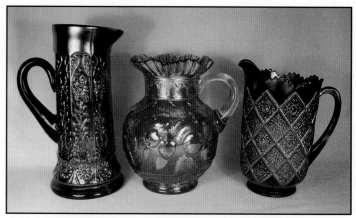

Three basic shapes in Classic water pitchers from Fenton. From the left: *MILADY* tankard shaped pitcher in blue ($500-1000); *APPLE TREE* bulbous water pitcher in marigold ($200-400) and *FENTONIA* standard shaped pitcher in blue ($800-1000).

Water Pitchers

In *The Shape of Things in Carnival Glass*[1] Don Moore classified American made water pitchers into the following broad categories of shape:

• Standard or Table size—this is the average pitcher that is most frequently seen. The sides are more or less straight.
• Tankard—usually taller and more slender than the Standard pitchers.
• Bulbous—rounder, often in a shape sometimes called "cannonball."

- Footed—usually on a pedestal or domed type of foot, but there are a few with several small feet.
- Covered—a fitted lid goes on top of the pitcher.

Northwood's *GRAPE AND CABLE* standard (table) size water pitcher in frosty ice green. A beautiful item, this is a top rarity which brought $8000 at auction in 1999. *Courtesy of Randy and Jackie Poucher.*

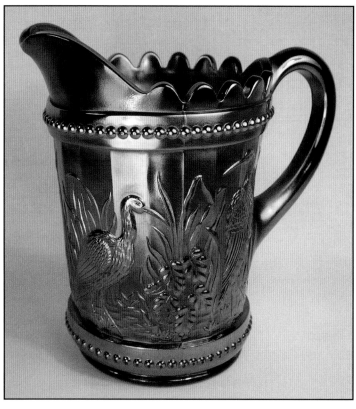

Dugan/Diamond's *STORK AND RUSHES* standard (table) size water pitcher in blue, $400-700.

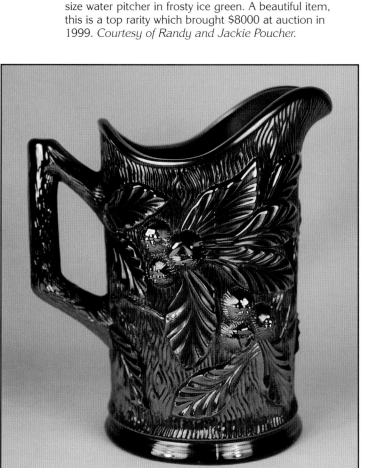

Northwood's *ACORN BURRS* standard (table) size water pitcher is a masterpiece of mould work. The design stands out proudly giving a very tactile surface. In purple, $700-900.

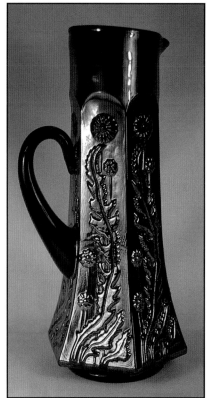

Fenton's *PANELLED DANDELION* tankard pitcher in amethyst. $350-700.

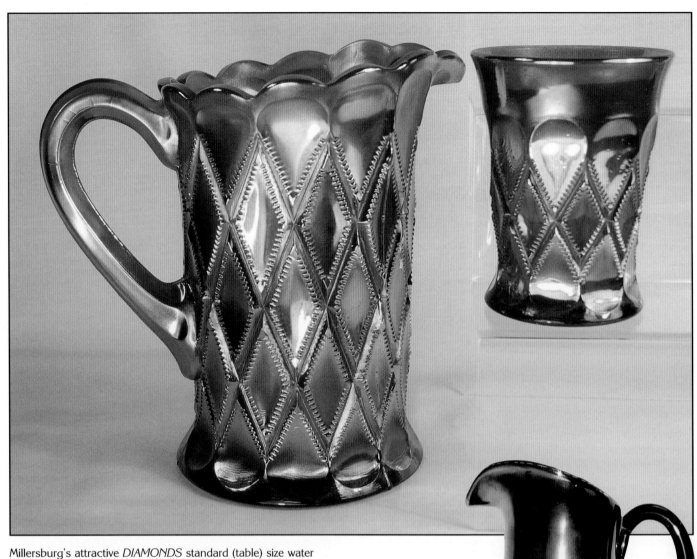

Millersburg's attractive *DIAMONDS* standard (table) size water pitcher and tumbler in green. Pitcher $250-350. Tumbler $80-100.

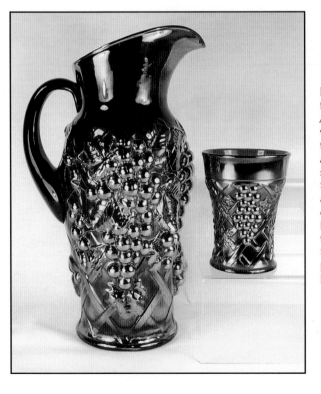

Northwood's fabulous *GRAPE ARBOR* tankard water pitcher and tumbler in purple. An average pitcher sells for around $500-750. However, an electric purple one sold for $3000 in 2002. The purple tumbler sells for $75-100. An electric purple example sold in 2002 for $225.

A similar water pitcher to this was voted as the "Favorite Pitcher" at the "One Thousand Pitcher" seminar and display during the www.cga St Louis Convention, 2003. This bulbous Millersburg *GAY NINETIES* amethyst water pitcher has a voluptuous, shapely form and an elegant pattern. *Courtesy of Randy and Jackie Poucher.* A top rarity—an amethyst six piece water set sold for $15,500 in 2002.

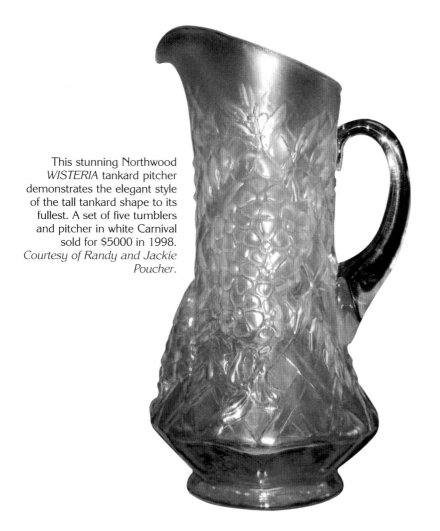

This stunning Northwood *WISTERIA* tankard pitcher demonstrates the elegant style of the tall tankard shape to its fullest. A set of five tumblers and pitcher in white Carnival sold for $5000 in 1998. *Courtesy of Randy and Jackie Poucher.*

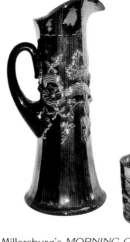
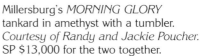

Millersburg's *MORNING GLORY* tankard in amethyst with a tumbler. *Courtesy of Randy and Jackie Poucher.* SP $13,000 for the two together.

This tall *INVERTED FEATHER* tankard water pitcher in marigold was made by Cambridge. Any water set item in this pattern is extremely rare. NP. *Courtesy of Randy and Jackie Poucher.*

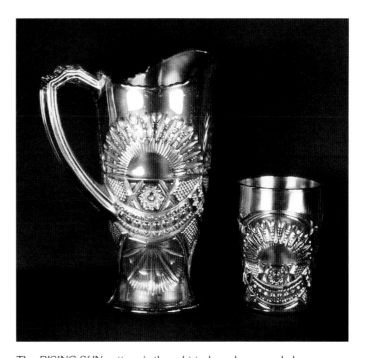

The *RISING SUN* pattern is thought to have been made by the United States Glass Company. The pattern range was illustrated in their Export catalogs, but the recent discovery of a third different shape of pitcher in Argentina further suggests the possibility that one of the South American glass factories also produced the pattern. This footed pitcher sells for around $200-400 and $75-125 for the tumbler.

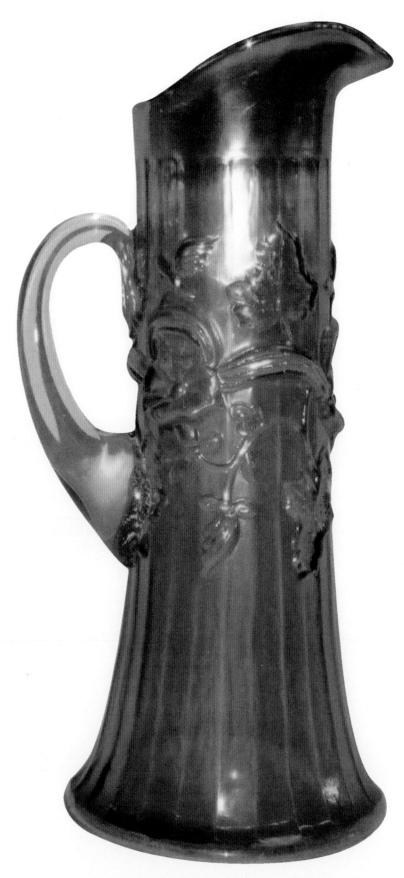

An elegant *MORNING GLORY* tankard water pitcher from Millersburg—only water set items are known in this pattern, and all are very rare indeed. This fine marigold example (one of just three known) is shown here *courtesy of Randy and Jackie Poucher*. A marigold *MORNING GLORY* tankard sold for $16,000 at auction in 2002.

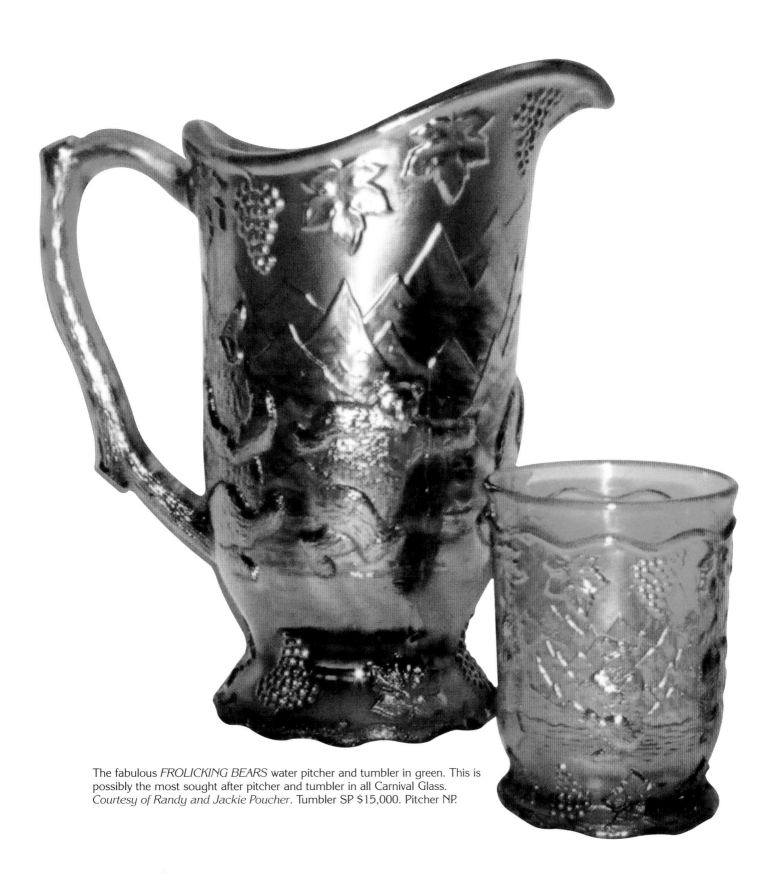

The fabulous *FROLICKING BEARS* water pitcher and tumbler in green. This is possibly the most sought after pitcher and tumbler in all Carnival Glass. *Courtesy of Randy and Jackie Poucher*. Tumbler SP $15,000. Pitcher NP.

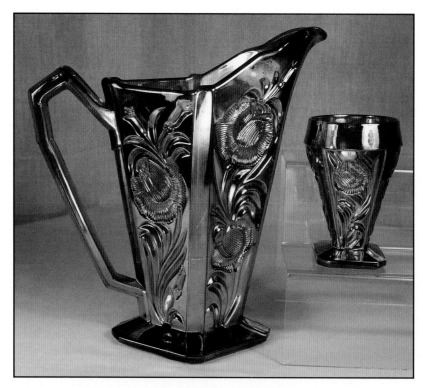

Made in Finland, this is Riihimaki's *GRAND THISTLE* aka *ALEXANDER FLORAL* art deco style, tankard pitcher and tumbler in amber. Pitcher $500-900. Tumbler, $250-350.

Most of the European, Australian, South American, and Indian water pitchers will fit loosely into the above categories, though the distinctions may be a little blurred.

The handles on standard water pitchers were usually moulded in, but those on the bulbous and tankard pitchers were generally applied ("stuck" on). Caution should be used when handling water pitchers, they are heavy items and are vulnerable to strain around the handle. Avoid picking them up by the handle—lift the whole item by the body instead.

Many Indian water pitchers (possibly made by the AVM Company) have a very distinctive D shaped handle that is moulded in.

Note that ice lips (an ice lip is a curved-in pouring lip edge to keep ice cubes from falling into the tumbler) are only found on more recently made USA Carnival pitchers. Indiana Glass' *HARVEST* water pitcher has such an ice lip—it was made in the 1970s.

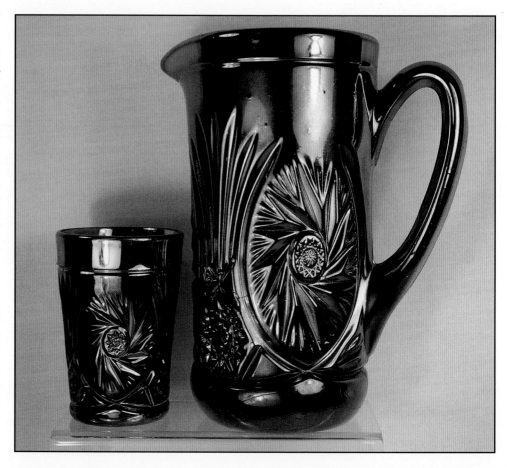

STARBURST AND CROWN was made by Riihimaki/Kauklahti of Finland (circa 1920-30). The pattern was named "Chicago" in Kauklahti literature. Scarce tumblers and water pitchers are known, but this is the first blue pitcher to surface. Note the astonishing electric iridescence on the pitcher. SP blue pitcher $800-1000; blue tumbler $150-250.

The manufacturer of this blue *LUCILE* water pitcher and tumbler is unknown, but is most likely to have been South American (based on the location of virtually all "finds" of this pattern, and the inconsistent quality of iridescence on most items studied). Pitcher SP $500-900. Tumbler $150-250.

A rare pitcher from Brockwitz is this superb, blue *CURVED STAR* example. SP $2000-3000.

The first reported *BRITT* blue water pitcher, this matches the exceptionally rare blue tumbler—both were made by the Karhula Glass company of Finland, circa 1920-30. NP.

Originally thought to have been made by the Finnish manufacturer Karhula, we can now state that the *HOBSTAR AND SHIELD* pattern was in fact made by August Walther in Germany circa 1930-1931. (The evidence was provided by a 1931 Walther catalog extract that showed a smaller version of this pitcher plus a bowl and under tray). Marigold examples of the pitcher and tumbler are known, but currently this is the only reported blue pitcher. NP.

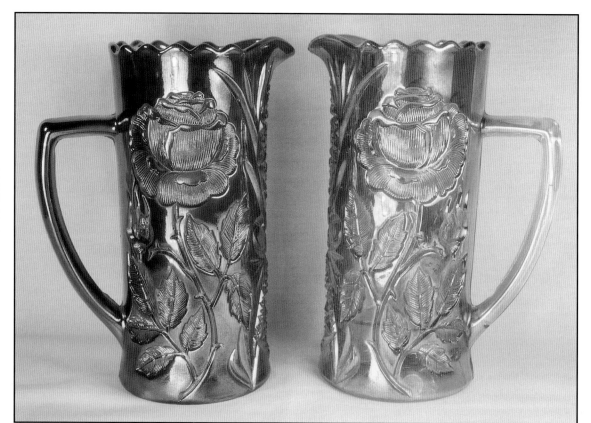

Two beautiful *ROSE GARDEN* pitchers from Brockwitz. Blue SP $1000-2000. Marigold SP $500-1000.

A bulbous water pitcher from Riihimaki that is seldom seen—this is *STARBURST* in rich blue. Pitcher SP $800-1400. Tumbler $300-500.

Brockwitz *ASTARTE* marigold water pitcher (one of three currently reported). SP $400-800.

Two unusual marigold items from Josef Inwald's Czechoslovakian factory—on the left is the pitcher in *BOHEMIAN DIAMONDS*, on the right, the decanter. SP for either item $400-600.

A truly magnificent iridescence adorns this marigold *PROVENCE* water pitcher. The only one currently known, its value is impossible to judge. The only known marigold tumbler in the pattern was sold at auction in the USA in 1998 for $800.

A most curious item, this pitcher (called the *FACE JUG*) is very heavy and blow moulded. The iridescence appears to be both within the glass as well as on the surface. *Courtesy Jim Nicholls.* NP.

THE FRIAR pitcher has a cranberry stained iridescence. It stands 9 inches tall and has much soft gold in the iridescence. The maker is unknown. SP $200-400.

The D shaped handle on this Indian pitcher is very typical of that country's output. Shown here are a pitcher and tumbler in the *SHAZAM* pattern. Prices for these items have fluctuated greatly over the past few years, as supply has increased. Pitcher SP $150-350. Tumbler SP $50-100.

Whimsied from the Fenton water pitcher mould, this is an *ORANGE TREE ORCHARD* urn or vase whimsy. The mouth is straight and unshaped (the pitchers are crimped and shaped) and there are two handles instead of one! This unique item sold at auction in 1999 for $7000. *Courtesy of Randy and Jackie Poucher.*

Tumblers

Tumblers are of course, intended to hold liquid, thus their shape doesn't veer away much from the norm. Variations in height and the slope of the sides seem to be the main departures from the regular sizing. The list below sets out the main classification by size of tumblers and related drinking vessels. Regular tumblers (as matched up with water pitchers to comprise a water set) are seen the most often, and their height averages around 4 inches. Some, like the *GRAND THISTLE* stand taller, while others are a shade under 4 inches.

- Liquor or cordial—see below in decanter sets.
- Shot—see below in decanter sets.
- Juice (sometimes considered a double shot).
- Regular.
- Lemonade.
- Ice Tea.

Tumblers may be straight up, flared or occasionally barrel shaped (or even a combination, such as barrel shaped and flared, for example, *INVERTED THISTLE* and *INTAGLIO STARS*). The majority of tumblers fall into one of these three basic forms although there are a few exceptions where the profile of the tumbler is uniquely shaped, such as the Indian tumbler *AUSTRALIAN DAISY* and the Czech tumbler *FORTY NINER*.

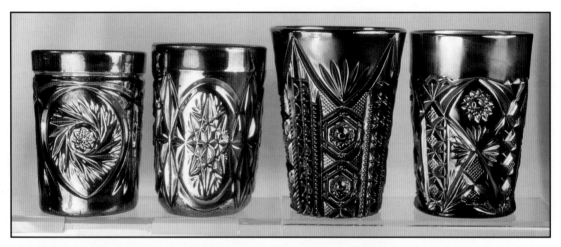

A selection of tumblers featuring geometric patterns. From the left, the seldom seen *BALTIC WHIRL* by Karhula (Finland) in blue, SP $300-500; blue *STARBURST* by Riihimaki/Kauklahti (Finland), SP $300-500; purple *CHATELAINE* by Imperial, $200-300 (outstanding examples have sold for more—in 1999 a spectacular example took $650); amethyst *MARILYN* by Millersburg, $125-175.

Three delightful, amethyst tumblers from Northwood. Left to right: *WISHBONE* ($75-125); *GREEK KEY* ($100-200); *SPRINGTIME* ($75-125). Note how the paneled form with arches is used on all three.

Three pretty Fenton tumblers, again with paneled form. The two flanking tumblers have wider panels, while the central tumbler has narrow ones. From the left: amethyst *PANELLED DANDELION* ($50-80); blue *MILADY* ($100-150); blue *BUTTERFLY AND BERRY* ($40-60).

Fenton's *ORANGE TREE* tumbler in blue, note the squared feet. $50-100.

Millersburg's *MULTI FRUITS AND FLOWERS* tumblers is a very desirable tumbler. Here it is shown in three different colors. At the top: green SP $1100-1300; left, marigold SP $1100-1300; right, amethyst SP $1200-1500. *Courtesy of Bob Smith.*

The *BIG BUTTERFLY* tumbler is a rare one indeed. Just one example in marigold is known, and there are four in olive green like the one depicted here, *courtesy of Randy and Jackie Poucher.* A green one sold in 2000 for $10,000.

Three tumblers featuring birds from three different manufacturers. Left to right: Dugan/Diamond's blue *STORK AND RUSHES* with lattice band ($70-90); Imperial's marigold *ROBIN* ($30-50); Northwood's green *SINGING BIRDS* ($75-100);

This amethyst tumbler in Cambridge's intaglio pattern *INVERTED STRAWBERRY* is both slightly barrel shaped and flared at the mouth. $200-400.

In the main, tumblers are flat based. Depending on their method (and country) of manufacture, they will either have a collar base (such as most Classic USA tumblers) or a ground base (such as those from Europe). Fenton's *FOOTED ORANGE TREE* and *LEAF TIERS* tumblers are distinctive in that they have little feet. Riihimaki/Kauklahti's *GRAND THISTLE* and Inwald's *DECORAMA* are distinctive in that they have an angular diamond shaped foot.

In recent years, some exciting discoveries in European tumblers have been made—the illustrations here depict some unusual and sought after examples. Also, a wide range of Carnival tumblers from the Indian sub-continent have recently been reported. (Photographs of the trademarks mentioned below can be seen above in Part One, Chapter Two). There seem to be three broad types of Indian tumbler:

• Those made from very thin and fine glass, the pattern tends to be rather delicate and intricately executed. These usually have four mould seams. Examples have been found bearing the trademark JAIN and the script signature Paliwal.

• Those made from thick, chunky glass, the pattern tends to be simple and geometric with many minor variations on similar themes. These usually have two mould seams. Examples have been found bearing the trademark AVM. Recent research by Bob Smith suggests that one maker of these chunky Indian tumblers is the West Glass Works of Firozabad.

• Those made from frosted glass with marigold decoration. The glass is usually fairly thick. These usually have two mould seams. Examples have been found bearing the trademark CB and the trademark JAIN.

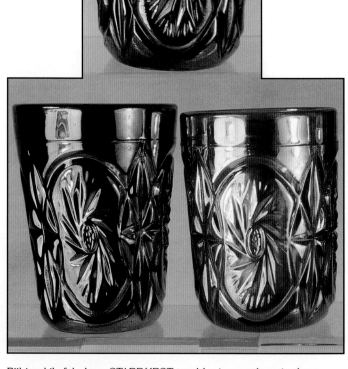

Three different shapes of *WESTERN THISTLE* tumblers from Riihimaki in Finland. From the left—blue barrel shaped; marigold flared; blue upright. All are hard to find, but the barrel shaped tumbler is probably the most difficult to source. SP for any $200-450.

Riihimaki's fabulous *STARBURST* tumbler is seen here in three colorways, all with stunning, vivid iridescence. Left, one of only two known, this green tumbler is a very rare color for Riihimaki, SP $400-800. Right, marigold iridescence on a pink base glass tumbler, $150-300. Top, just a handful of these blue tumblers are known, all have superb iridescence, SP $300-500.

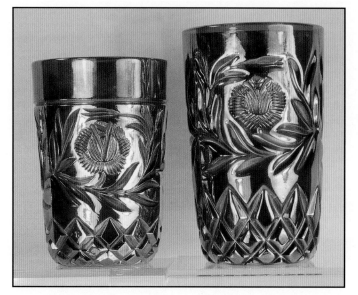

A rare variation to the *WESTERN THISTLE* tumbler is this blue *BANDED WESTERN THISTLE* seen left. The tumbler is smaller than the regular tumbler, the diamond band is different and there is a plain wide band around the top. Although the pattern concept is the same as on the *WESTERN THISTLE*, note that the execution of the design is different. SP for the blue *BANDED WESTERN THISTLE* $300-450.

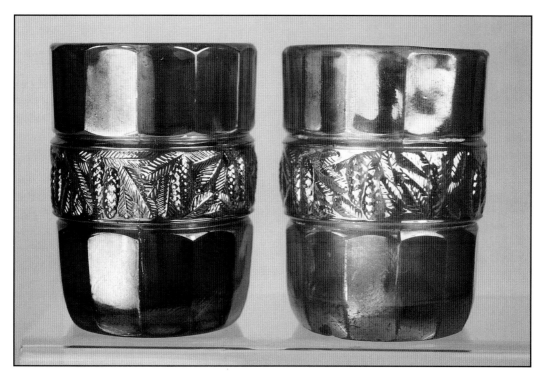

Riihimaki's *FIR CONES* tumbler in pink with a marigold iridescence is a rare item, in fact this is currently the only example known. The pink tumbler is shown here alongside a blue example (on the left). NP for the pink example, SP for the blue tumbler $350-450.

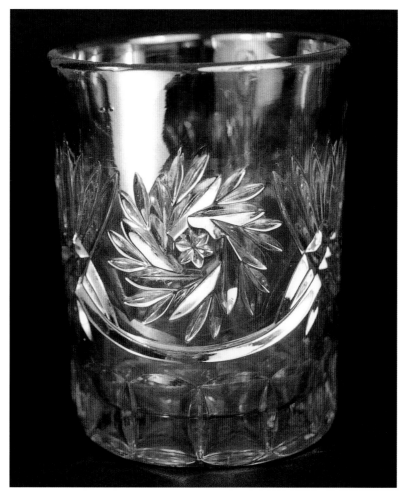

Brockwitz *ANTIGONE* tumbler in marigold is hard to find. SP $200-300.

Karhula's *BRITT* tumbler in marigold (left) is one of just a handful known. SP $400-600. Also known in blue, this is a rare one, (Karhula 1934 catalog, pattern number 4041). Shown at right is the first reported tumbler in the *KARHULA FOUNTAINS* pattern (Karhula 1934 catalog, pattern number 4022). Note the *KARHULA FOUNTAINS* pattern is shown in Part One, Chapter Three in the sub-section on Moulded Trade-marks.

Two unusual, marigold Indian tumblers: right, *FANTASY FLOWER* SP $75-150, *CIRCLED STAR AND VINE* $75-100.

More tumblers from India. On the left, a rare one—*FLOWER WEB* SP $75-150; in the center, *GRAPE-VINE AND SPIKES* $50-100; on the right, *EMBROIDERED PANELS* $75-100.

Two thick glass tumblers in marigold, their name indicates their origin. On the left, *INDIAN BRACELETS*—on the right, *INDIAN BANGLES*. Either, $30-60.

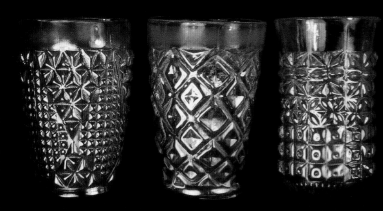

Three chunky, marigold tumblers from India, made of thick glass: from the left: *SPICE GRATER, CALCUTTA DIAMONDS, SARITA*. All sell for around $30-60.

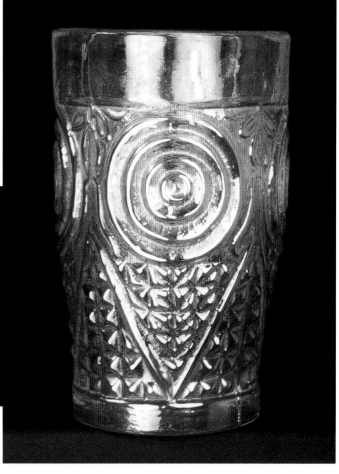

A very striking design, this is a most unusual Indian tumbler—*MONSOON*. SP $80-120.

Punch Sets

All the major Classic Carnival Glass manufacturers made punch sets in a wide range of patterns and colors. The Butler Brothers Catalogs from 1909 through to 1920 show iridized punch sets—with the heaviest concentration of advertising for them appearing in 1911. Of the major manufacturers, Imperial produced the greatest number of different patterns: surprisingly, the least number came from Fenton.

The pattern on the punch set was usually on the exterior only, as the inside was designed for use. Some punch sets, however, do exhibit patterns on both interior and exterior. Fenton's WREATH OF ROSES punch set may be found with either PERSIAN MEDALLION or VINTAGE as the interior design. Imperial's BROKEN ARCHES punch set may either have a ribbed interior with central concentric rings (called Imperial's "Persian Design") or may simply be plain. The inside of the cups matches the bowl interior.

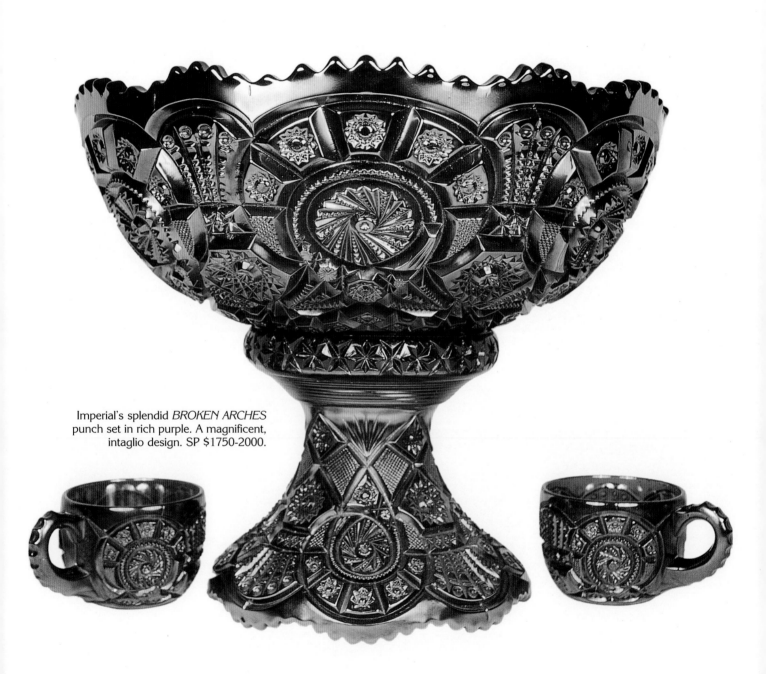

Imperial's splendid BROKEN ARCHES punch set in rich purple. A magnificent, intaglio design. SP $1750-2000.

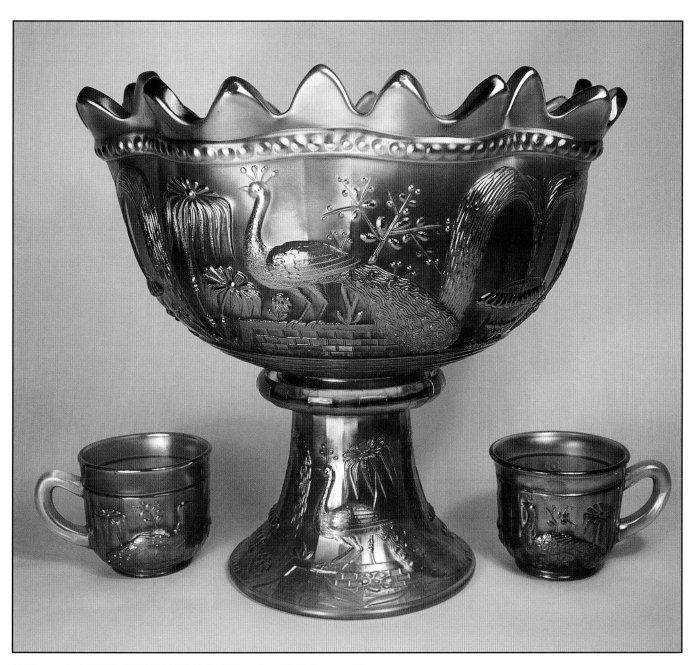

Northwood's *PEACOCK AT THE FOUNTAIN* punch set in rich, pumpkin marigold is impressive in both its color and design. $900-1400.

Classic American punch sets comprise a separate base and stand plus six or twelve cups (depending on what the pattern is and its overall size) and wire holders. Most punch sets stand between 9 to 11 inches high and measure from about 10 to 13 inches across. The largest set of all is the Northwood Banquet Size *GRAPE & CABLE* that stands 14 inches high and is 16.5 inches across. With the exception of the aforementioned *GRAPE & CABLE* (which is found in three different sizes—see below for details) punch sets only come in one basic size, though there may be differences in the final shaping and hand finishing.

The punch bowl may be ruffled or unshaped. Where the edges are ruffled, it seems natural to hook the punch cups onto the downward part of the ruffle. The edges of the punch bowl may have small flutes or large "flames" (see section on edge shaping in Part Two, Chapter One "Bowls").

Punch sets have a multi purpose facility—the base, when inverted, may be used as a compote or a vase. The inside of most punch set bases is iridized to enhance the appearance if used in this manner. Indeed, the base to Dugan Diamond's *STORK & RUSHES* punch set is sometimes called the *SUMMER DAYS* vase: while the base to Dugan Diamond's *MANY FRUITS* punch set is frequently mistaken for (and used as) a compote. Punch cups also had a multi-use as custard cups; while a punch bowl and base may have had a multi-use as an Orange bowl.

GRAPE AND CABLE punch set sizes:
• Small size (11 inches high. 12.5 inches wide) has matching small cups—six to the full set
• Mid size (13 inches high. 14.5 inches wide) has large cups—six to the full set
• Banquet size (14 inches high. 16.5 inches wide, though they are reported standing as much as 16 inches high) has large cups—twelve to the full set

There are no punch sets with matching cups to be found in non United States made Carnival. Various large centerpiece bowls on stands look very similar to punch bowls, but no matching cups are known and it is the authors' belief that they were not intended to be used for punch.

One of just two examples known, this is Millersburg's wonderful *BIG THISTLE* punch bowl and base in amethyst. The mould work is superb—the iridescence breathtaking. NP. *Courtesy of Randy and Jackie Poucher.*

This green *INVERTED FEATHER* punch set by Cambridge is seldom seen. SP $1250-1750. *Courtesy of Randy and Jackie Poucher.*

This is the fabulous aqua opal *PEACOCK AT THE FOUNTAIN* punch set by Northwood—breathtakingly lovely and exceptionally rare. SP for a full set, in the region of $95,000. *Courtesy of Randy and Jackie Poucher.*

Decanter Sets, Wine Sets, Cordial Sets, Whisky Sets, and Liquor Sets

A multitude of names, but a common concept, these sets comprise a container for wine or similar beverage and usually six small drinking glasses. The size and shape vary greatly, and some were even produced with a matching undertray. Made across the entire time-frame of Carnival production and by most of the countries that produced Carnival, there is a tremendous variety of examples. The use was surely intended to be multi-purpose—wines, cordials, liqueurs, or spirits such as schnapps could have been served in these vessels.

Here's an ad from the Perry G. Mason Co. "Premium House" mail order catalog that was issued in 1924. The items shown in the illustration were six marigold *STAR AND FILE* goblets from Imperial. The text of the ad stated that "they are large size measuring 6 1/4 in. high and 3 1/4 in. across top. There are six to the set and when not in use make a wonderful display." Despite (or maybe because of) the fact that these goblets must have been plentiful and used a lot, there are very few of them to be found today.

The example of Northwood's *GRAPE AND CABLE* whisky set will further serve to illustrate the complexity of this category. The whisky decanter in this pattern is a tall, handled bottle with a unique and distinctive shape. Six small shot glasses match the decanter and make up the set. However, in the 1980s, a set of six shots was found in the UK complete with an item known as the *GRAPE AND CABLE* cologne bottle. The general assumption was that they had been mismatched and bought separately, but Carl O. Burns' recent discovery of a hitherto unknown 1912 Butler Brother's catalog ad,[2] brought the realization that the cologne bottle was originally sold with the shot glasses as a whisky set. Completing the set was an undertray in the *HOLIDAY* pattern. A splendid example of multiple usage.

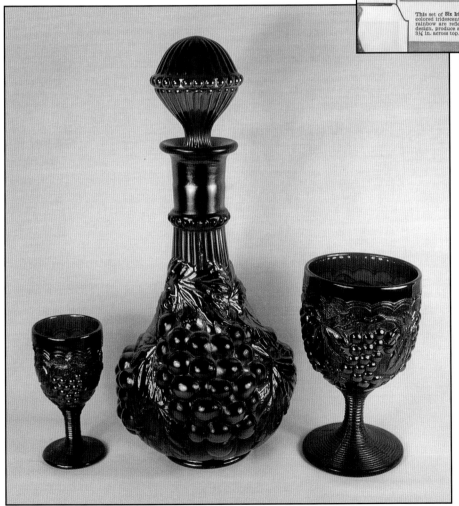

An *IMPERIAL GRAPE* decanter is seen here flanked by a large *IMPERIAL GRAPE* goblet and a tiny *IMPERIAL GRAPE* wine glass. All items shown are in purple with a vivid iridescence. $300-500 for the decanter, $40-75 for the goblet, $30-60 for the wine.

The glasses in the sets were produced in two basic shapes: flat based and stemmed. The stems however, may be the regular thin stemmed shape one associates with wine glasses or something a little more unusual, such as seen on the *MOONPRINT* cordial set illustrated below. The capacity of the wine glasses varies too. The flat based glasses may also be called shot glasses, whisky glasses, or cordials. Some wine glasses were not issued as part of a set and thus have no matching decanter. Instead they were part of a wider pattern range, for example Fenton's *SAILBOATS* and *ORANGE TREE* wines.

Standing just 2.75 inches high this *DAISY AND SCROLL* marigold cordial glass has a matching decanter and was almost certainly made in Argentina. SP $100-150.

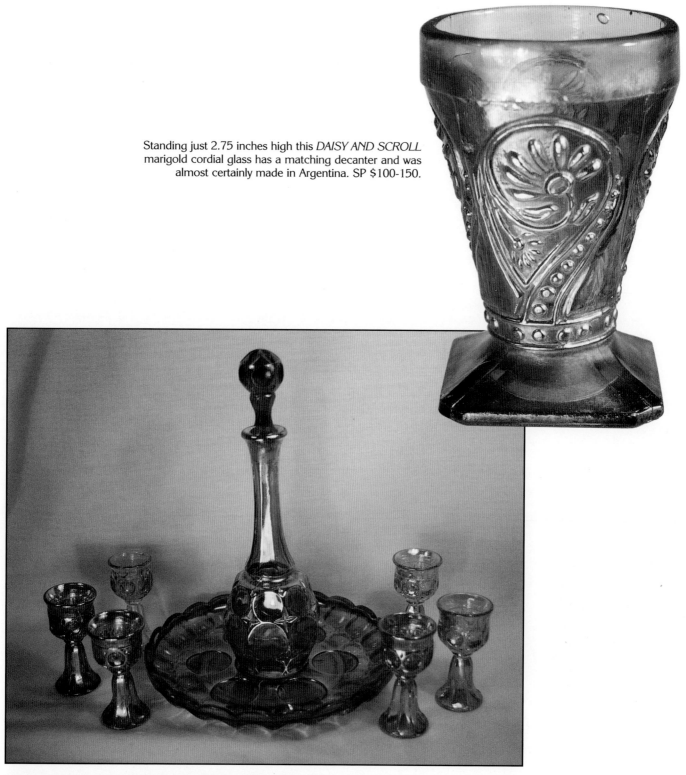

This is a seldom seen, marigold cordial set from Brockwitz in the *MOONPRINT* pattern. The six unusually shaped glasses fit into six circular depressions on the matching tray. SP $500-800.

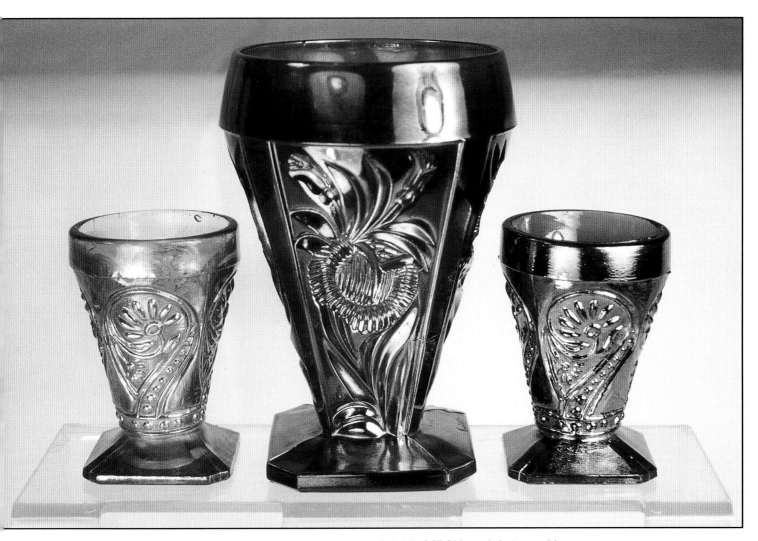

Flanking a Riihimaki *GRAND THISTLE* blue tumbler are two little *DAISY AND SCROLL* cordials (marigold on the left and blue on the right). The shape and style of the little cordials are imitative of the Finnish *GRAND THISTLE* design. A great deal of Riihimaki Carnival was exported to Argentina and it is very possible that the Argentinean items were styled to look like the Finnish article. Marigold *DAISY AND SCROLL* cordial SP $100-150; blue *GRAND THISTLE* tumbler $150-250; blue *DAISY AND SCROLL* cordial SP $200-250.

In *A Century of Carnival Glass* the authors speculated that the decanter set in *RISING COMET AND GROOVES* could well be a Rindskopf item from Czechoslovakia. The discovery of a set of four green Carnival *RISING COMET AND GROOVES* cordials in 2003 was evidence to the contrary, as green Carnival is not known to have been made in Czechoslovakia. Circumstantial evidence points to Argentina as the manufacturing origin. On the left, a marigold cordial—on the right, the green one. The green base color can clearly be seen despite the rich marigold iridescence. Each stands around 2.5 inches high. SP for the marigold cordial $80-150. SP for the green cordial $125-200.

For comparison, here are the sizes of Imperial's *OCTAGON* cordial, wine and goblet sizes according to the late John Britt;
• Cordial: 3.5 inches high. Slightly over 1.5 inches across the top. Slightly over 1.5 inches across the base.
• Wine: 4 inches high. 2 inches across the top. Slightly over 1.75 inches across the base.
• Goblet: 6.5 inches high. 3.25 inches across the top. Slightly less than 3.25 inches across the base.

Decanters were usually made with a matching glass stopper. Note that sometimes a jug was issued to match an item that appears to be a wine glass—for example, Fenton's *WINE AND ROSES* jug and stemmed wine (see below under Individual Stemware).

Tumble-Ups and Water Decanters

The tumble-up is an open necked, bottle-like, container (usually intended for water) plus an upturned small tumbler that serves as a lid to keep the water covered. Essentially a very practical item, tumble-ups (they may also be termed bedroom set, night set, or guest set) were often made as part of a dressing table set. Although some were made in the USA (probably later in the manufacturing time frame, circa 1920s) the majority were produced in Europe. India, too, made several Carnival tumble-ups, however these typically are very plain with little or no moulded pattern.

Where the pattern was already known as a regular tumbler, the matching tumble-up tumbler would often be a slightly different shape (usually smaller). Northwood's *CONCAVE DIAMONDS* for example, is known in both regular tumbler shape and also in a small, protruding base tumbler that fitted on top of the tumble-up.

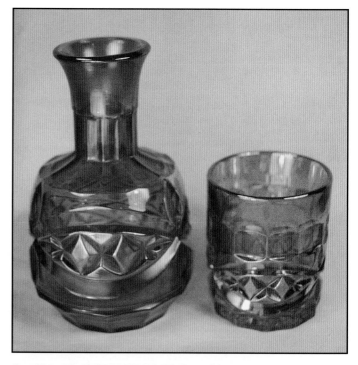

Josef Inwald's *DOUBLE DIAMOND* tumble-up in marigold is seldom seen. *Courtesy of Carol and Derek Sumpter.* SP $300-500.

Cups, Saucers, and Mugs

Cups are, of course, known as part of punch sets—however, they were also made in Classic Carnival with matching saucers. Other cup and saucer sets were intentionally made by combining punch cups with small plates (especially those with a central blank area and indentation—much like a saucer). Fenton's ads in Butler Brothers in 1911(the mid Spring edition) illustrated a *PERSIAN MEDALLION* punch cup twinned with a *PINE CONE* plate.

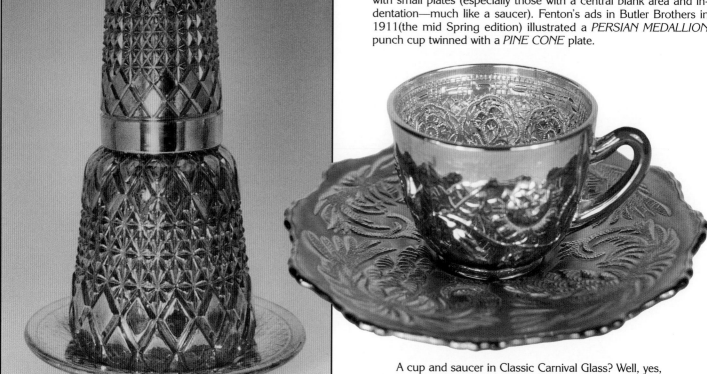

The *TRIPLE DIAMOND* tumble-up was illustrated in the catalog of the Argentinean manufacturer, Cristalerias Papini. It was called Modelo No.8. *Courtesy of Bob Smith.* SP $300-500.

A cup and saucer in Classic Carnival Glass? Well, yes, according to a 1911 Butler Brother's catalog ad that is recreated here in the actual glass. No doubt the combination would have been used for cold beverages or perhaps, for serving fancy desserts. This blue Fenton cup has a *WREATH OF ROSES* exterior, and a *PERSIAN MEDALLION* interior. $50-80. 6 inch Fenton *PINE CONE* blue plate. $150-250.

These early cup and saucer combinations were not, of course, heat proof, like the Late Carnival *FIREKING* examples produced by Anchor Hocking were. They certainly would not have been used for coffee or hot tea! Possibly they were used for cold beverages, but they were also undoubtedly used for desserts such as custards. Indeed, custard cup is the name often given to these cups—the saucer or plate would have been used to hold the spoon and protect the table.

Mugs were also multi-purpose. Tall, handled, and somewhat straight sided, they could be used for cold beverages or for personal use such as shaving. Fenton's large sized *ORANGE TREE* mug (known in two sizes) was sold as a shaving mug.

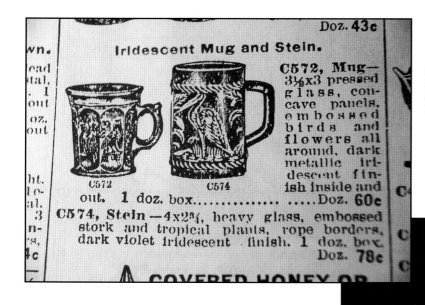

A Butler Brother's ad from 1912 for an "Iridescent Mug and Stein." The mug (left) is Northwood's *SINGING BIRDS* and the stein is the seldom seen Dugan/Diamond *HERON* mug.

Northwood's *SINGING BIRDS* mug in blue with a scintillating iridescence. $75-150.

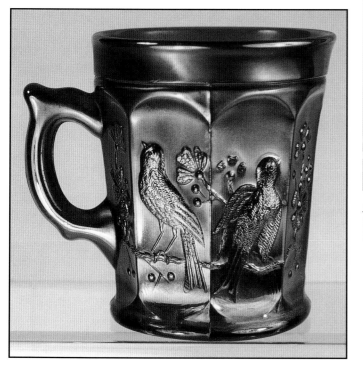

STORK AND RUSHES was also made in a mug shape by Dugan/Diamond. Note this item has the lattice band around the top. In marigold $30-50.

Dugan/Diamond's *BEADED SHELL* mug in purple. $75-150.

Possibly the smallest Carnival mug in existence standing next to one of the biggest. On the left, this tiny marigold item, standing around 2 inches high, was made by Riihimaki of Finland. Illustrated in their catalogs, it had the pattern number 5101. The authors have named the pattern *HANGING SPEARS*. NP. On the right is a tall, heavy blue mug that stands 5.5 inches high. Also made by Riihimaki, this item had the pattern number 5157. The authors have named the pattern *PANEELI*. NP.

Individual Stemware

Stemmed goblets and wines in varying sizes are known—usually with matching small pitchers or carafes, but sometimes without any matching larger container for liquids. *IMPERIAL GRAPE* goblets, for example, can be matched up with either the water pitcher or the carafe, whereas Fenton's *IRIS* pattern (classed as either a large goblet or compote) has no matching pitcher or carafe. There are also *PEACOCK AND URN* goblet/compotes that could be used for drinks and also have no matching pitcher or carafe.

Small wines without matching carafes can be found in patterns such as Fenton's *WINE AND ROSES* and *SAILBOATS* (there is also a larger goblet in the *SAILBOATS* pattern).

[1]Moore, Donald. *The Shape of Things in Carnival Glass.* Alameda, California: by author, 1987.
[2]Burns, Carl O. *Northwood Carnival Glass.* Paducah, Kentucky: Collector Books, 2001.

Chapter Five
Tableware: Table Sets and Related Items

Tableware was designed for practical purposes. A wide range of items was made in Carnival for the table—some of them, such as water sets, bowls, and plates, are considered above in their respective chapters. In this section, we will look at the many other Carnival items designed primarily for use at the table. These include cookie jars, celeries, and compotes as well as the obvious tableware sets comprising butter dish, creamer, sugar, and spooner.

Table Sets

Classic Table Sets

These were designed for an obvious practical purpose and originally comprised a covered butter dish, a covered sugar bowl, an open spooner (spoon holder), and a creamer (cream or milk jug). The sugar and spooner may have handles. Virtually all the main Carnival manufacturers made these matching sets and they are avidly collected. The patterns are exterior, often elaborate, and beautifully matched on the different shapes. Finials on the lids to both butter dish and covered sugar can be rather quixotic—the United States Glass Company's *PALM BEACH* table set, for example, has a bunch of grapes as the finial while Dugan/Diamond's *MAPLE LEAF* boasts a finial with three maple leaf stems intertwined.

United States Glass Company's splendid *PALM BEACH* butter dish in frosty white. Note the finial is shaped like a bunch of grapes. $200-350.

A full table set in rich marigold from Millersburg in the *HANGING CHERRIES* pattern $300-600. Top row, left to right: covered butter dish; handled spooner. Bottom row, left to right: creamer; covered, handled sugar.

A close-up detail of the finial on the *PALM BEACH* butter dish. The cover to the sugar dish also has the grape finial.

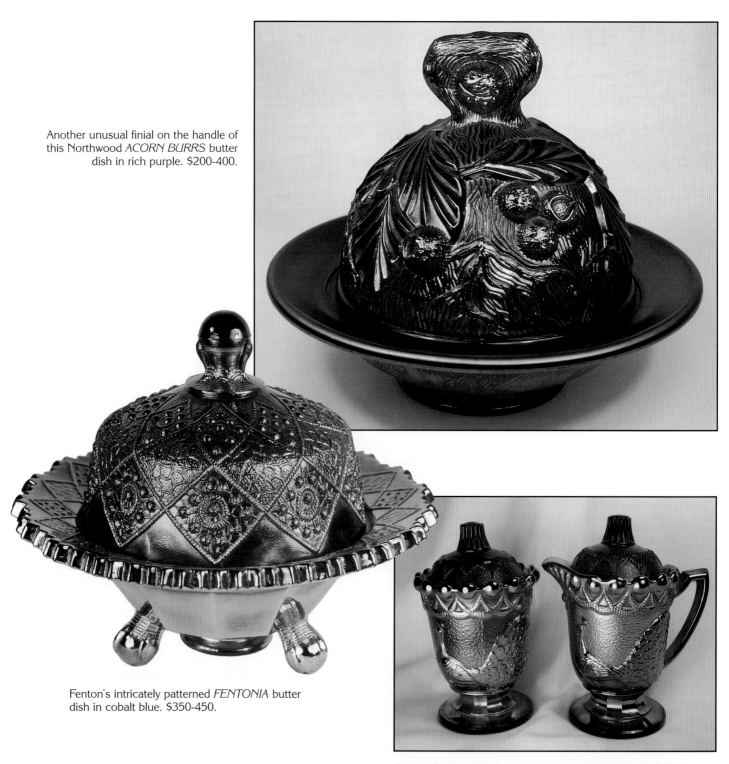

Another unusual finial on the handle of this Northwood *ACORN BURRS* butter dish in rich purple. $200-400.

Fenton's intricately patterned *FENTONIA* butter dish in cobalt blue. $350-450.

An amethyst covered sugar and covered creamer in *STRUTTING PEACOCK* by Westmoreland. These two pieces comprise the full breakfast set. Note that the lids on the original items are never found iridized (they were reproduced in the 1970s by Westmoreland). $75-125 for either item.

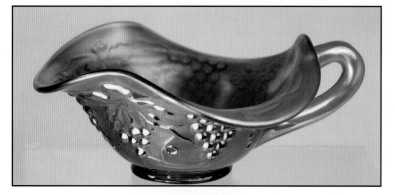

An unusual, green *GRAPE AND CABLE* punch cup whimsied into a creamer shape. NP.

Classic Breakfast Sets

Only a handful of breakfast sets are known—they differ from the full table set in that the breakfast set is comprised of just two items, an open sugar bowl and a creamer. They were intended for use on less formal occasions and are a little smaller than the full table sets.

European Table Sets

These usually consist of three items: a covered butter, sugar bowl (which may or may not be stemmed), and cream jug. A patterned surface is occasionally found on the inside of the butter dish lid, unlike the Classic examples, where the pattern is always on the outside. The reasoning for this is purely functional—it was so the outside of the lid may be easily wiped down and kept clean. Among the European makers, the German manufacturer Brockwitz, Riihimaki in Finland and Rindskopf in Czechoslovakia produced the widest range of table sets. Sowerby in England also made them, as did Crown Crystal in Australia and some of the South American Carnival producers. It is interesting to note that Riihimaki made cut crystal items that were termed *lusikkavaaseja*—vases for spoons.

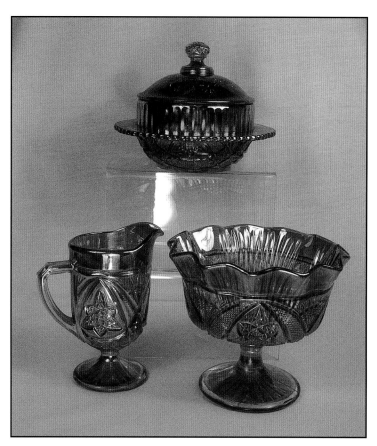

A three part, European table set, comprising a creamer, covered butter dish and stemmed, open sugar (which can double up as a compote). This marigold set is from Brockwitz and is in their *CURVED STAR* design. SP for the set $150-200.

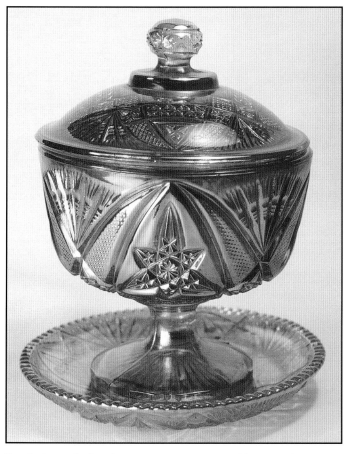

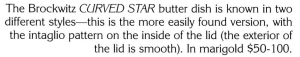

Brockwitz made this distinctive item—a marigold, covered sugar bowl with under-plate in the *CURVED STAR* pattern. SP $200-350.

The Brockwitz *CURVED STAR* butter dish is known in two different styles—this is the more easily found version, with the intaglio pattern on the inside of the lid (the exterior of the lid is smooth). In marigold $50-100.

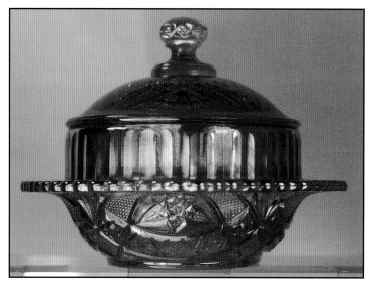

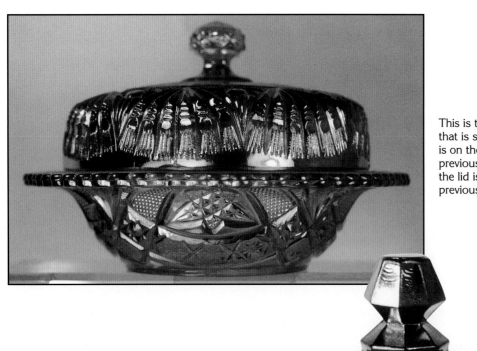

This is the version of the *CURVED STAR* butter dish that is seldom seen. The intaglio *CURVED STAR* design is on the exterior of the lid (unlike that shown in the previous illustration). Note that the shape and profile of the lid is very different from the butter dish in the previous illustration. In marigold, SP $200-300.

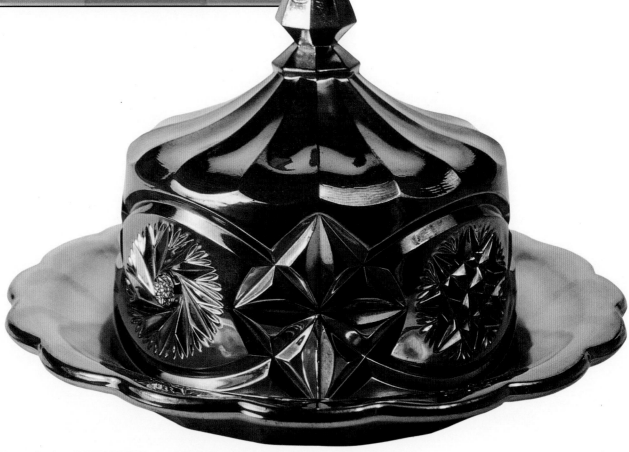

This is the first *STARBURST* butter dish to be reported—the color is a rich blue. It was discovered in Argentina in 2002, by Jorge Perri and Jorge Duhalde. A large amount of European Carnival was exported to Argentina in the 1930s. SP $500-600.

Here's an unusual, amber butter dish (named *KELPIE*). The pattern is shown in the catalogs (from the 1930s) of the German manufacturer, August Walther and Sons. It has a very distinctive deco style finial and swirl. *Courtesy of Carol and Derek Sumpter*. NP.

The first reported matching creamer and spittoon shaped sugar in Riihimaki's *WESTERN THISTLE* pattern. This splendid pair are both in pale pink glass with a marigold iridescence. NP.

The *SUNK DAISY* aka *AMERIKA* pattern (made by both Eda and Riihimaki/Kauklahti) is fairly well known in the various sizes of bowls—from dainty rose bowls right up to large salad bowls. This blue creamer, however, is the first reported example of the shape. It has the same squared feet that are found on the bowls, which frequently bear tiny chips from the grinding process used during manufacture. A marigold example is also known. SP $100-200.

The first reported *FIR CONES* creamer from Riihimaki/Kauklahti. This rare item is blue—an amber creamer and sugar are also known. NP.

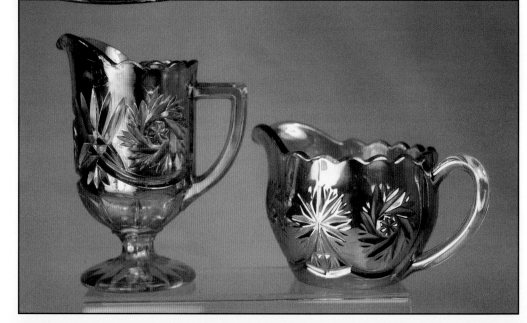

Two marigold creamers that have similar patterns. On the left, *ANTIGONE*, on the right, *ELEKTRA*. Each was made by both Brockwitz of Germany and Riihimaki of Finland. Either creamer, $50-100.

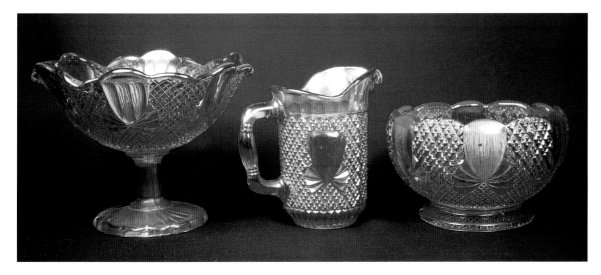

Sowerby made the *PINEAPPLE* pattern: here is a marigold creamer flanked by a ruffled, stemmed sugar (left) and a rose bowl, style sugar (right). Creamer, $40-75. Stemmed sugar (which has a dual role as a compote) $40-75. Rose bowl style sugar $75-125.

European sugar bowls were not usually covered, in the way that the Classic examples were. However, there are one or two notable exceptions, foremost of which is the scarce Brockwitz *CURVED STAR* covered sugar (see photo page 195) that was illustrated in various Brockwitz catalogs through the 1920s (clearly labeled as a sugar bowl).

Some manufacturers (in particular Rindskopf and Riihimaki) made several different shapes for both creamers and sugars. In particular, the sugar bowl might be stemmed (like a compote), collar based or whimsy shaped and "waisted" rather like a spittoon. Various popular patterns were available in a variety of different shapes.

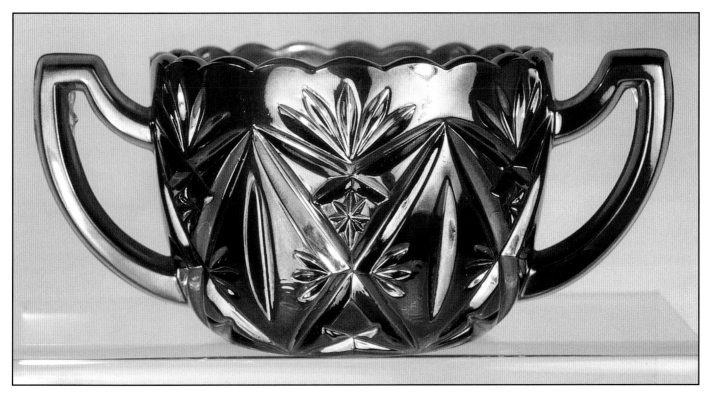

JUPITER in blue—this is the first reported, handled sugar from Riihimaki/Kauklahti in this delightful, intaglio design. The style of the handles is reminiscent of "Chippendale" designs. NP.

A rare item of tableware is the tray, intended to be used in conjunction with a sugar and creamer. The Riihimaki *JUPITER* tray (shown at the bottom of this page) is shown in the Riihimaki/Kauklahti 1927 catalog. A similar tray in the *STARBURST AND CROWN* pattern was also depicted.

A rare color from Riihimaki is green—seen here on this green *FOUNTAINS* handled sugar, the first reported item in this color, and indeed in this pattern. NP.

A blue, stemmed compote or sugar in *ANTIGONE*—both Brockwitz and Riihimaki made items in this pattern. The stemmed compote is a hard-to-find shape. SP $200-300.

Same manufacturer, same pattern, same purpose and function— but different shapes. This is Riihimaki/Kauklahti's *STARBURST* design in two different shapes of sugar and creamer. The pair at the top have simple forms—the sugar bowl is straight sided with no secondary shaping, the creamer is also straight sided and very basic. The pair at the bottom is wholly different. The sugar bowl is waisted and flared into a spittoon shape, while the creamer bells out around the bottom. Although all appear to be the same color, even that differs. The pair at the top are a marigold creamer $75-150 and a nut bowl shaped sugar $75-150. The pair at the bottom are an amber creamer $100-150 and an amber, spittoon shaped sugar $500-1000.

A seldom seen shape, this is a flat, marigold tray in Riihimaki/Kauklahti's *JUPITER* pattern. A sugar and creamer would fit perfectly on top of this item, but alas, only a single sugar in blue is currently known (see above). NP.

Individual Cream or Milk Jugs

Individual creamers and larger milk jugs are known. In some case, it is possible that they were originally matched up with other matching parts of a set, but that those other items have simply not yet been found. In others, for example, Imperial's *POINSETTIA* and *WINDMILL* patterns, milk jugs with various capacities were produced, as "stand alone" items.

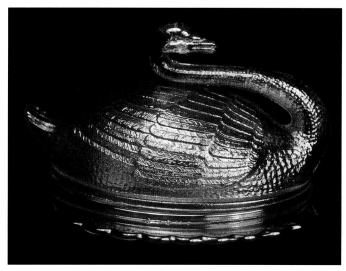

Sowerby used an old 1880s mould to make the *COVERED SWAN* butter dish in Carnival Glass during the 1920s. This is a scarce item—the delicate and elegant neck must have been exceptionally hard to remove from the mould. There are no matching table set items. In marigold, as shown here SP $100-300. Amethyst examples are much harder to find.

Imperial's *POINSETTIA* milk pitcher. The size is between a water pitcher and a creamer. There are no matching items in this pattern. In marigold, as here $50-100—note that other colors are much harder to find: purple examples have sold for several thousands!

Individual Butter Dishes

Sowerby in England issued two novelty butter dishes (also known as Covered Animal Dishes). The first, the *COVERED SWAN*, was originally introduced by Sowerby in the 1880s as an "oval butter or honey." In the 1920s when the company began their Carnival Glass lines, the *COVERED SWAN* was produced in marigold and rare amethyst Carnival. A slightly later, re-cut model was also produced in blue Carnival. A *COVERED HEN* butter was also made by Sowerby in marigold and blue. Notley[1] reports that the mould for the hen was imported from France in the 1920s. He further states that "It was in erratic production, and residual stocks were stored until well after World War Two. In the 1960s, a release of mint condition surplus production of this and various other long-packed away old and classic items caused much confusion."

In recent years, the field of Contemporary Carnival has seen the production of covered animal dishes and novelty butters. Many of these are made using old moulds that were previously not used for Carnival. In the 1960s and 1970s, Westmoreland Glass produced a variety of these items, several of which are still being made by other manufacturers (who purchased the moulds).

Compotes

A compote (also called comport and originally a comportier) is a dish with a long stem and a base (plus in some instances a lid too) that could be used to serve nuts, fruits, jellies and confections. Not only was the compote a useful and multi-purpose item, it was also very decorative, consequently a wide range of them was produced by many manufacturers—in many different sizes and finishes. At the large end of the spectrum, Fenton's *MIKADO* compote, Northwood's *GRAPE & CABLE* open or giant compote and Millersburg's *CHRISTMAS COMPOTE* are well known examples from the USA. At the opposite extreme are Imperial's diminutive *SCROLL EMBOSSED* and Millersburg's tiny *LEAF & LITTLE FLOWERS* compotes.

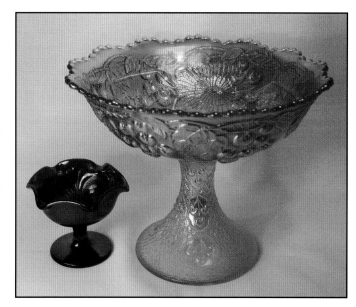

Big and small compotes: Imperial's *SCROLL EMBOSSED* miniature compote in purple stands around 3 inches high ($200-300) and Fenton's massive *MIKADO* compote in marigold stands around 7.5 inches high ($200-500).

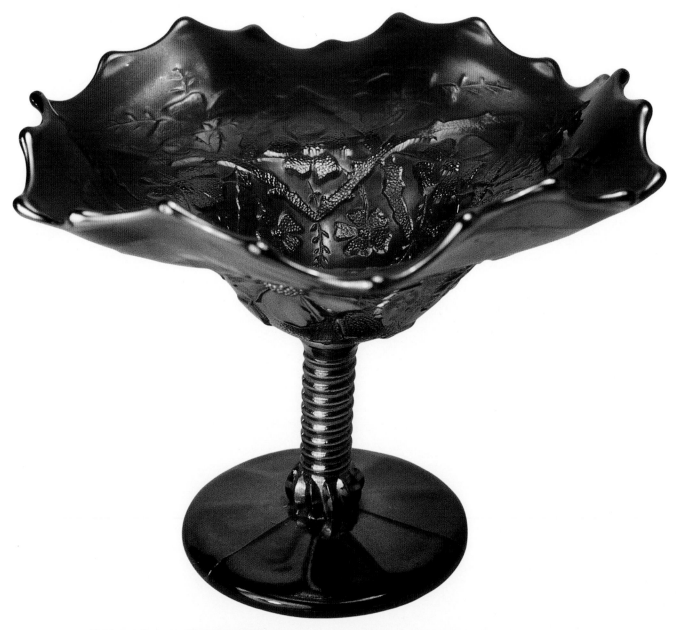

Northwood's pretty *BLOSSOMTIME* compote in amethyst has a unique characteristic—a "threaded" stem. The concentric circles are intended to look like "threading"—a popular style of winding fine glass filaments around glass objects as an applied, decorative technique. Harry Northwood's father, John, had used the technique in England (he worked at Stevens and Williams, the famous glassworks in Stourbridge, England). In 1885, John Northwood had patented a machine to improve the application of glass threads, making it easier and more uniform. True to the spirit of mass production, Harry converted the manually-applied threading into his machine press-moulded Carnival Glass. "Threading" can also be seen on the exterior of some examples of Northwood's *BUTTERFLY* bonbon. $400-600 for an amethyst *BLOSSOMTIME* compote.

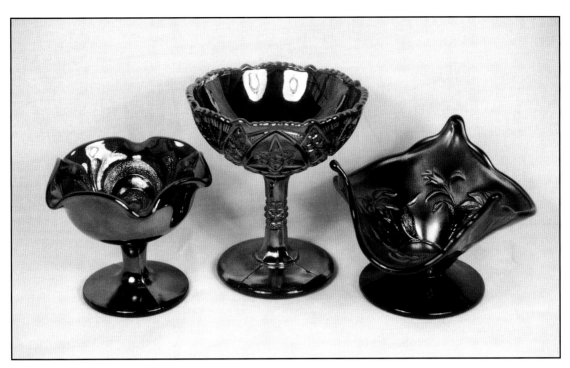

Three tiny compotes grouped together for comparison: left, Imperial's *SCROLL EMBOSSED* miniature compote in purple ($200-300); middle, Brockwitz' miniature *CURVED STAR* compote in blue (NP); Dugan/Diamond's *AMARYLLIS* compote in deep purple ($300-400)

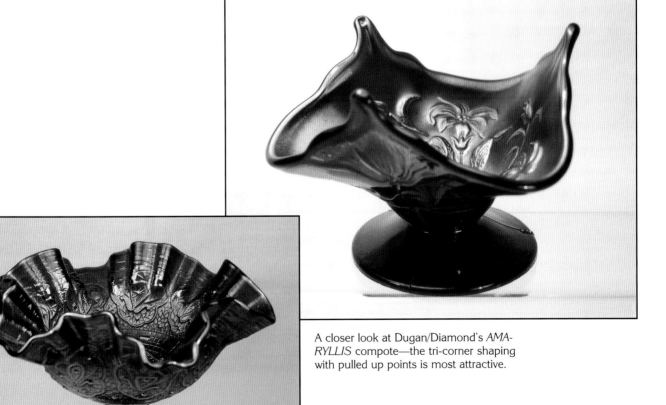

A closer look at Dugan/Diamond's *AMA-RYLLIS* compote—the tri-corner shaping with pulled up points is most attractive.

A cobalt blue *PERSIAN MEDALLION* compote from Fenton. This is an intricate pattern that imitates embroidery stitches to produce a design reflecting the popular "Persian" patterns of the late 1800s and early 1900s. The skill of the mould maker in emulating detailed stitches through the medium of an iron mould must be admired. It is the unique quality of glass—plastic when molten and able to be moulded in fine detail, that allows the intricacy of embroidery to be reproduced in such a lasting manner. $100-200.

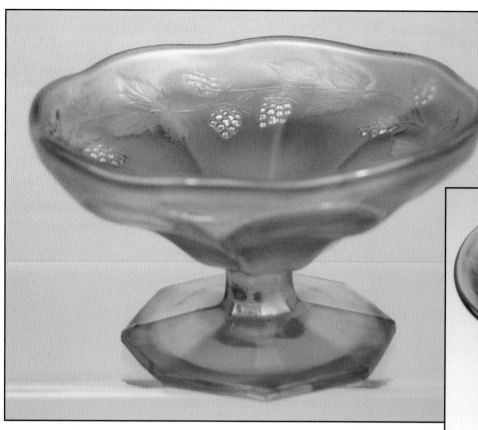

From Fenton—this is the *BLACK-BERRY (MINIATURE)* compote in marigold. A dainty item that is not easy to find. $100-150.

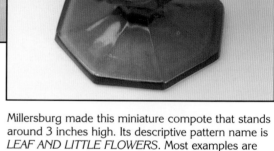

The edge shaping of the compote may also vary. Both Classic and Australian compotes are generally ruffled, but smooth edged variations are also known. Large flutes (called "flames") may also be present on the biggest of the compotes. European compotes, however, are almost always "as moulded" with little or no edge shaping.

Millersburg made this miniature compote that stands around 3 inches high. Its descriptive pattern name is *LEAF AND LITTLE FLOWERS*. Most examples are ruffled, unlike this pretty piece. In green, $300-700.

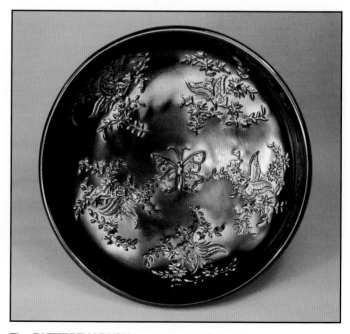

From Crown Crystal in Australia, this unruffled *BUTTERFLY BUSH* compote in deep purple (dark) may sell for around $200-500. There are other variations on this pattern theme where the central butterfly motif is replaced, for example, by a bellflower (as seen below on the *BUTTERFLY BUSH AND CHRISTMAS BELLS* compote).

The *BUTTERFLY BUSH* compote seen from above shows the pattern fully.

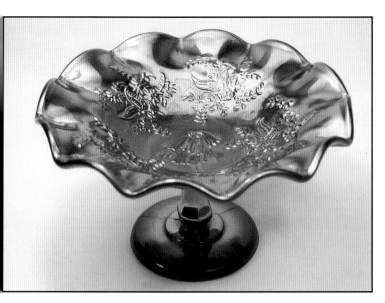

Crown Crystal's *BUTTERFLY BUSH AND CHRISTMAS BELLS* ruffled compote in deep purple (dark). $200-500.

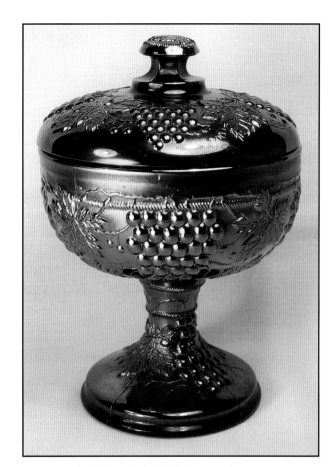

Northwood's *GRAPE AND CABLE* covered compote in purple stands around 9 inches high. $300-500.

It should be noted that European stemmed sugar bowls are more or less identical in shape to Classic made compotes. No doubt they were multi purpose and could be used for either function. Furthermore, some of them were also intended to be used upturned and fitted underneath a large bowl. Many original catalog illustrations from Brockwitz and Rindskopf show "combination" table centers that have been constructed in such a manner. The base of the bowl is generally formed and shaped with a groove into which the upturned base of the compote neatly fits.

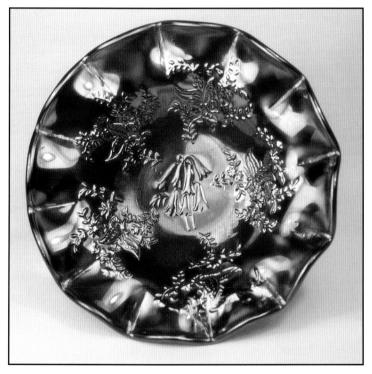

The *BUTTERFLY BUSH AND CHRISTMAS BELLS* ruffled compote seen from above shows the pattern to full advantage. The pretty floral motif in the center is the Christmas Bell flower (its botanical name is *Blandfordia*).

A further variation to the compote is the addition of a lid. Few USA-made lidded compotes are known—one notable exception being Northwood's *GRAPE & CABLE* covered compote. (The covered sweetmeat is similar to the covered compote—see below). In European Carnival production, some covered stemmed sugars are known, but are rare. (Note—these are similar in appearance to covered compotes).

Riihimaki's *GARLAND AND BOWS* marigold compote is an impressive item, standing 8 inches high. The stem is clear and has not been treated with iridescence. SP $100-150.

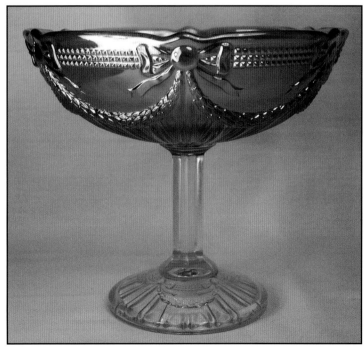

205

Brockwitz *CHAR-LOTTE* compote in cobalt blue is the only shape known in this pattern. Although described in the Brockwitz catalogs as a "sugar" no other matching table set items were illustrated and indeed, none have yet been found. SP $200-500.

Contrasting sizes in Brockwitz' *CURVED STAR* compotes. On the left, the miniature stemmed compote (or sugar)—on the right, the impressive, stemmed centerpiece (see Part Two, Chapter One) that can also be used as a giant compote. Both examples shown here are blue. NP.

Other Tableware Shapes

Sweetmeats and Covered Bonbonnieres

These are deeper than compotes and usually have a domed lid, which was no doubt intended to keep the contents clean and covered. They can be stemmed or may be flat based and jar-like. Only a handful of patterns are known from all the Carnival manufacturers, but they are distinctive and beautiful shapes that are always sought after.

Northwood's *GRAPE AND CABLE* sweetmeat compote has a wonderful pagoda-like lid. Its shape is rather exotic and this is always a popular piece among collectors. In purple, $200-300.

Seen right is the first reported *LAUREL BAND* covered bonbonnière in blue (from Riihimaki, pattern number 5653)—this shape can also be used as a covered sugar dish. NP. Water pitchers are known in both blue and marigold, but are scarce. Alongside it to the left is a *NIGHTWISH* (aka *VERTICAL STAR PANELS*, pattern number 4670) bonbonnière in blue from Karhula. NP.

LAGERKRANS was the Swedish name given to this beautiful and rare item, from Eda Glasbruks. Only known in the lidded bonbon shape illustrated here in both marigold and blue. NP.

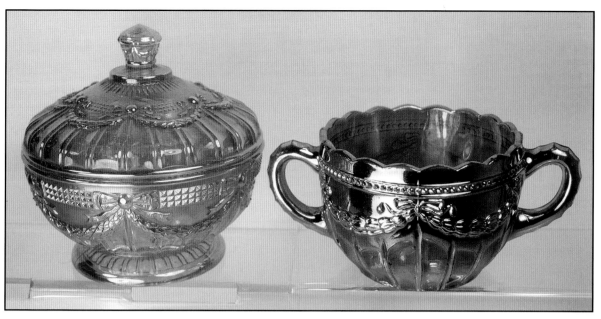

Riihimaki's *GARLAND AND BOWS* in two unusual shapes: left, a marigold, covered bonbonnière (SP $300-500); right, an unusual, blue handled sugar (SP $200-400).

A detailed view of the pattern on the *GARLAND AND BOWS* bonbonnière shown in the previous photograph. Note that this item could also be used as a covered sugar.

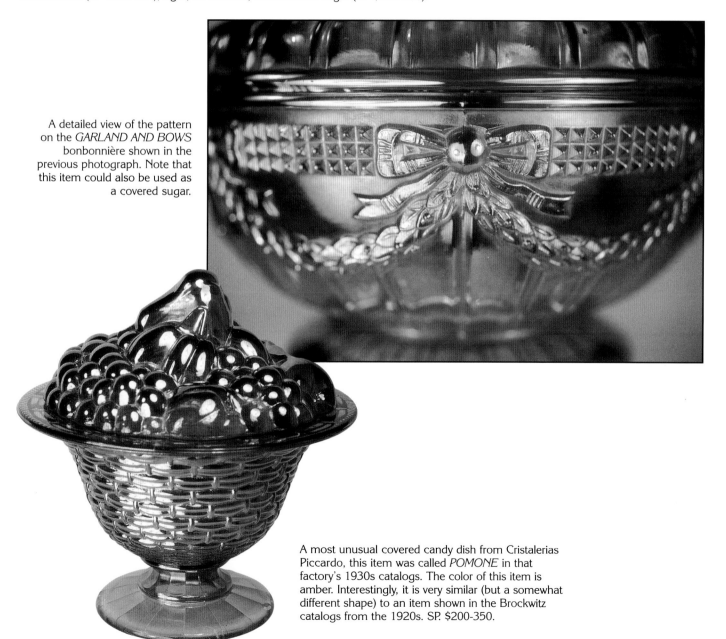

A most unusual covered candy dish from Cristalerias Piccardo, this item was called *POMONE* in that factory's 1930s catalogs. The color of this item is amber. Interestingly, it is very similar (but a somewhat different shape) to an item shown in the Brockwitz catalogs from the 1920s. SP. $200-350.

Brockwitz marigold, covered bonbonnière in the *MOONPRINT* pattern is a scarce item. SP $350-500.

Cookie Jars and Cracker Jars

Tall and often barrel shaped with a well fitting lid that may either overlap the jar or fit snugly inside it, the cookie jar (known in Europe and elsewhere as a biscuit jar) is known in both Classic and European Carnival shape. The lidded cookie jar is certainly an unusual and desirable shape and few companies produced them. Northwood's *GRAPE AND CABLE* cookie jar is possibly the most familiar one known in Classic Carnival, though there are other splendid (and rare) examples such as the *SWEETHEART* cookie jar from Cambridge. Only a few examples of biscuit jars are documented in European production. Illustrations in the Brockwitz catalogs of such items are termed *Biskuit Dosen*. The most desirable examples made by Brockwitz are *TRIPLE ALLIANCE* (possibly the most familiar example) and the seldom seen *MINIATURE HOBNAIL*. Several other European cookie jars are known with metal lids.

Sowerby's cookie jar in the *PINWHEEL* pattern is a rare item indeed. This marigold example is shown *courtesy of Phyllis and the late Don Atkinson*. SP $300-400.

This is a Brockwitz cookie jar (actually called a Biskuitdose in the manufacturer's catalog) in the *KOH-I-NOOR* aka *MINIATURE HOBNAIL* pattern. Until this item was found, the only shapes known in the pattern were the decanter, tray, and small drinking glass (cordial set). The cordial set is so far only reported in marigold—the cookie jar is blue. The hobnail pattern is also found on the inside of the lid—a most attractive item. NP.

210

Other lidded jars that may be intended for cookies, are the *ILLI-NOIS DAISY* jar and a variety of lidded marigold jars in very thin glass with etched patterns. The latter are from China and are of recent manufacture. The make of the *ILLINOIS DAISY* jar is unknown. Examples of this rather crude jar are plentiful: it rarely boasts a good iridescence, but it is a useful and serviceable item.

Cracker jars were also not produced in great quantity, and were only made by a few Classic Carnival manufacturers. Lidded like the cookie jar, but shorter, wider and usually with two handles, possibly the most familiar example of this shape is the Cambridge *INVERTED FEATHER* cracker jar.

Pickle Dishes and Pickle Jars

The Pickle dish is a low oval bowl—Imperial's *PANSY* pickle and Northwood's *POPPY* pickle are the two best known Carnival examples.

Pickle jars are mainly known in European Carnival. They are usually lidded containers and often have a hole in the lid to accommodate a spoon handle. It is interesting to note that minus its lid, the upright shape of the pickle jar has led some collectors to believe the item is a tumbler. This is especially applicable to the *MOONPRINT* pickle jar from Brockwitz.

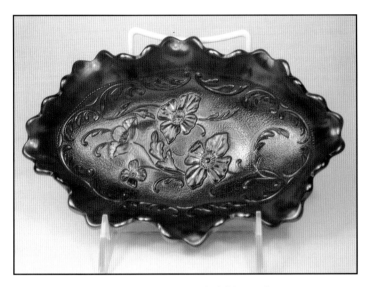

Northwood's *POPPY* pickle dish in cobalt blue with a splendid pink-purple iridescence. $200-400.

Celery Vases

A celery vase is a wide, open necked (and un-ruffled) vase used at table to stand heads of trimmed celery in. Similar shaped items were multi-purpose and were advertised for washing grapes at table (source Brockwitz catalogs—the German name for such an item is a *traubenspuler*). In Carnival, such items were only made by the European manufacturers. Possibly the best known example is Brockwitz' *CURVED STAR* celery. In the past, this item has been misidentified as a chalice, in fact owing to this confusion, the item is also known as the *CATHEDRAL CHALICE*.

This item used to be called a chalice (*CATHEDRAL*), but information gleaned in the Brockwitz catalogs reveal it to have been a celery vase. Similar Brockwitz shapes were also called *traubenspüler*—meaning that it was to be used for washing and cleaning grapes at table. In blue, this *CURVED STAR* item $175-300.

Brockwitz *MOONPRINT* lidded pickle jar is seldom seen. This marigold example is shown here *courtesy of Carol and Derek Sumpter*. SP $300-400.

211

Two shapes in Brockwitz *NORTHERN LIGHTS* pattern. On the left, a blue *traubenspüler* for washing grapes. It would also double up as a celery vase. If the item looks familiar, you may well know it under the name *TEXAS TUMBLER*. $400-500. On the right, this miniature, blue rose bowl in the *NORTHERN LIGHTS* pattern measures just 3 inches across the top. SP $400-600.

Nut Bowls

These are similar in shape and size to rose bowls—and indeed were often made from the same mould. They differ, however, in that the sides of the nut bowl are not cupped in, but are instead either flared out slightly or are straight up. Though today's collectors use the descriptive term "nut bowl" for these items, there was no such fine distinction when they were first issued. Butler Brothers catalogs show a variety of ruffled and shaped bowls that were loosely termed "nut bowls" as well as the straight sided ones described above. However, defining precisely what is understood today by the term helps to provide a common frame of reference.

Sherbets (cup and saucer)

Contemporary ads from the early 1900s show that cups were referred to as punch cups, sherbet cups, custard cups, and lemonade cups. In 1911, a Fenton ad for a "Venetian Assortment" of iridescent glass appeared in Butler Brother's catalogs. Right in the center of the ad was a *PERSIAN MEDALLION /WREATH OF ROSES* cup sat atop a *PINE CONE* plate. A cup and saucer combination! The description in the text below was: "Sherbet set, 6 1/4" plate, handled cup." It's likely that just about any plate with a plain center (and even better if it had a slight depression in the center, like the *PINE CONE* plate does) could have been teamed up with a cup. It didn't seem to matter if the pattern matched or not, as Fenton were happy to illustrate and sell mismatched patterns. The cup looks a little small, sat on top of the plate—but it would have given plenty of room to rest a spoon and the plate below would have protected the table surface from any spills. The cup and saucer combinations were almost certainly not used as tea or coffee cups for hot liquids, but were used instead for cold sweets. A photograph of this cup and saucer combination can be seen in Part Two, Chapter Four.

Footed sherbet dishes (also called sundae dish or jelly dish) were also made. These are akin to small dessert dishes, but are on a stemmed foot (rather like a small compote) and have a broad, shallow bowl atop the stem. They would have been used for cold sweets.

Condiments

Open salt holders are known in Classic Carnival, the most well known example being the *SWAN* (aka *PASTEL SWAN*) salts made by Northwood, Fenton, and Dugan/Diamond. A handful of rare examples are also known in non USA Carnival. Rindskopf in Czechoslovakia and Riihimaki in Finland produced double open salts—and one or two tiny salt dips were also made by Brockwitz, but these are very much the exception. Salt and pepper shakers were made in Contemporary Carnival (for example, Imperial's figural *SALZ AND PFEFFER* and *IMPERIAL GRAPE*).

Here's an unusual tableware item, this is a double, open salt dip in marigold—the pattern is very similar to the Czech *FORTY NINER* and *DIAMONDS* patterns. This item was sourced in Belgium. SP $150-250.

Dating from the 1960s through early 1970s, this is a set of *GRAPE* salt and pepper shakers in Imperial's rubigold (marigold). $50-100.

This marigold sherbet in Josef Inwald's *BANDED DIAMONDS AND BARS* has the typical stunning iridescence that is characteristic of Inwald's Carnival. *Courtesy of Carol and Derek Sumpter.* SP $75-125.

Harder to find, here's another salt and pepper shaker set from Imperial—
SALZ AND PFEFFER in amber—dating from the early 1970s. $100-150.

Syrup bottles are also known, but are rare—the *WILD ROSE* handled syrup (maker undetermined, possibly Westmoreland or Dugan) is an attractive and uncommon item.

Bottles for oil or vinegar (known as cruets) are also known. Cambridge made two sizes of cruet that are known as *BUZZ SAW*, though in fact the pattern is actually part of the company's *DOUBLE STAR* pattern range. Convention dictates that the smaller size would be used for oil and the larger size for vinegar.

Kitchen utensils in Carnival are also known—a *SPRY* measuring jug (calibrated in cup measures) is known in marigold and possibly was a premium with Spry shortening in the inter war years. Carnival reamers are also known, but these are mainly Contemporary Carnival items made currently using old moulds.

Indian Jars

Indian Carnival Glass jars are used as containers for water or various food stuffs, and sometimes as decorative objects for holding flowers. In traditional homes they are displayed on the shelves hung on the walls and also in the alcoves. They are usually blow moulded and have typical ground rims. The Indian jar has a distinctive bulbous shape with a flared and waisted top. Usually they are made of thick glass and are decorated with traditional Indian floral motifs in their moulded pattern.

Rose Presznick named the syrup pitcher on the left the *CZECHOSLOVAKIAN LADY*. The clothing certainly indicates a European style. On the right is a matching man—the *CZECHOSLOVAKIAN MAN*, of course! Each stands 7 inches high and is stained with cranberry iridescence that shows much soft gold and pink in the highlights. The base glass is clear. The maker is unknown. SP $200-400 for either one.

Three unusual Indian jars with a distinctive shape. The two flanking larger jars are in the *KALSHI* pattern, while in the very center is *KALSHI FLOWERS*. On some of these jars the moulded letters KP have been found indicating the maker to be K. P. Glass Industries (Firozabad). Some Indian jars may also have had matching lids. These jars have been found iridized but plain with no pattern—and with both moulded as well as etched designs. SP $50-100 for either.

[1]Notley, Raymond. *Popular Glass of the 19th and 20th Centuries.* London, England: Octopus Publishing Group Ltd. 2000.

Chapter Six
Boudoir Items and Jewelry
Dressing Table Sets and Individual Items

We know them today as dressing table sets, but the original Butler Brothers ads had them listed as bureau sets! Comprising various items for the lady's "toilette," we know these pieces today as hatpin holders, powder jars (also called puff boxes), pin trays, colognes and perfume bottles, large dressing table trays, and hair receivers. Sometimes they were issued in a matching set (as in Northwood's *GRAPE & CABLE* items), other times they were sold separately. Either way, many of these are fairly scarce items.

Hatpin Holders

Carnival Glass hatpin holders are only known in the Classic Carnival, and indeed, there are very few patterns known in the shape. Fenton's *ORANGE TREE* and *BUTTERFLY AND BERRY* hatpin holders were not part of larger, full sets of dressing table items (although there is a matching *ORANGE TREE* powder jar). Northwood's *GRAPE & CABLE* hatpin holder, however, was one part of a wide range of items made for the ladies. As a point of interest, Northwood appears to have introduced the hatpin holder (along with a covered powder jar) several years before the full dressing table set was available. The Butler Brothers catalogs show an ad in 1910 for "Metallic Iridescent Dressing Table Specials"—"for the first time in this rich attractive finish"—this was for the puff box and hatpin holder only.

Aqua opal is the most sought after color in Northwood's *GRAPE AND CABLE* pattern— here's a fine hatpin holder, shown *courtesy of Randy and Jackie Poucher*. This beauty is one of only two known. SP in the region of $19,000.

Two hatpin holders: on the left is Fenton's *ORANGE TREE* hatpin holder in green ($500-1000); on the right is Northwood's *GRAPE AND CABLE* hatpin holder in purple ($200-500).

Full Dressing Table Set

The full dressing table set is only known in one pattern in Classic Carnival Glass—Northwood's *GRAPE & CABLE*. First advertised in 1912, the Butler Brothers ad actually referred to the full set as a "Decorated Bureau Set." It comprised two large cologne bottles, a large tray for brush and comb, a tiny pin tray and the covered puff box and hatpin holder that had already been on sale for some time. The full set was packaged into a corrugated case and was sold wholesale for 75 cents. The diminutive *GRAPE & CABLE* perfume bottle is not from Northwood, but is actually Dugan/Diamond's *VINTAGE*.

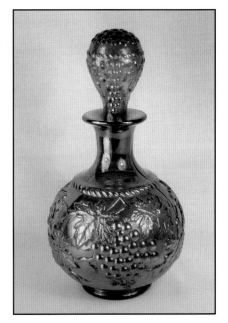

Northwood's *GRAPE AND CABLE* cologne bottle is quite hard to find in green. $300-600.

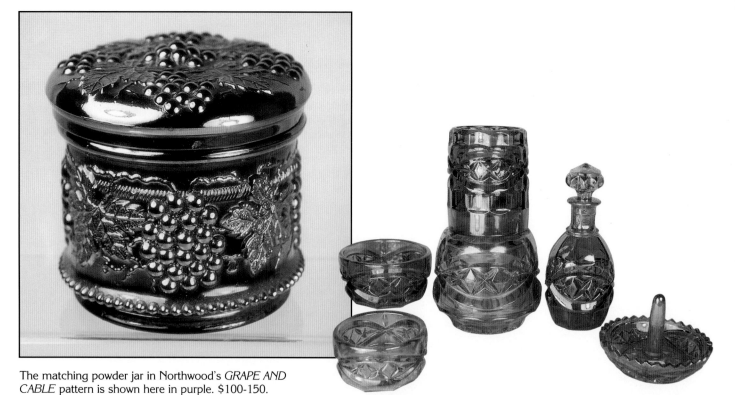

The matching powder jar in Northwood's *GRAPE AND CABLE* pattern is shown here in purple. $100-150.

A selection of dressing table items in Inwald's *DOUBLE DIAMOND* pattern is shown here *courtesy of Carol and Derek Sumpter*. NP.

Several more dressing table sets are known in European Carnival, predominantly coming from Czechoslovakia. This is not surprising, as the Czech glass makers were world famous for their dressing table sets and associated boudoir items. Josef Inwald arguably produced the finest items in this category, but Josef Rindskopf (also Czech) and August Walther and Sons in Germany, also made similar items.

The style of the European dressing table items was more in keeping with the Art Deco feel of the 1920s and 1930s, as of course, it was produced some ten to fifteen or so years later than the original Classic examples. Tall, elegant bottles with fringe embellished atomizers and perfume bottles with exotic finials were characteristic of the European boudoir items. A wider range of items was also produced in Europe: cologne bottles, perfume bottles, several sizes of covered boxes or jars, trays—plus an item that was unique to European Carnival, the ring tree. Matching tumble ups (see Part Two, Chapter Four "Drinking Vessels") were also produced as part of the dressing table set. Similar tumble ups (night sets) were of course made in the United States, but these were not specifically linked with dressing table sets.

A marigold ring holder in the Czech pattern *HEAVY VINE* aka *BALMORAL*. SP $50-100.

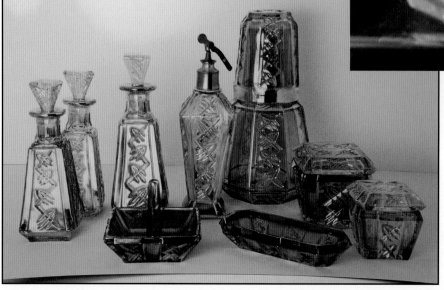

Josef Inwald's dressing table set in the *NOLA* aka *PANELLED TWIGS* in rich, pumpkin marigold. From the left: three cologne bottles, perfume atomizer, ring holder, tumble-up, trinket tray, and two covered jars. *Photo courtesy Dave Doty*. NP.

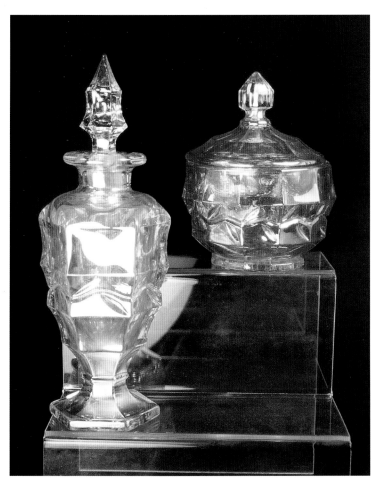

Other Individual Items

Various manufacturers made individual boudoir items that were not part of a full set. Covered jars for powder or for keeping trinkets safe were made by both the American and European Carnival manufacturers. Millersburg's splendid *HANGING CHERRIES* powder jar is a seldom seen rarity. *MY LADY'S POWDER BOWL* is one of the most well known individual covered jars. Undoubtedly European in origin, the maker has not yet been determined, though it is possible that the German manufacturer, August Walther and Sons, may have produced it.

A marigold cologne bottle (left) and powder jar (right) in *HEAVY VINE* (aka *BALMORAL*). The pattern is Czechoslovakian and most likely from the maker Josef Rindskopf. SP marigold cologne $100-150; marigold powder jar $100-150.

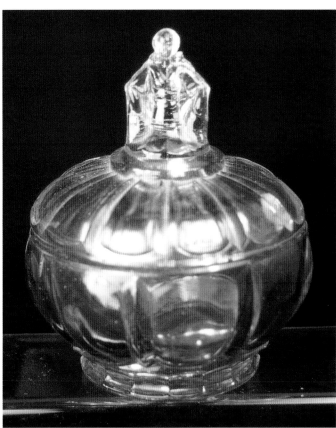

The maker of *MY LADY'S POWDER JAR* has still not been established, but it is almost certainly a European item. SP $100-200.

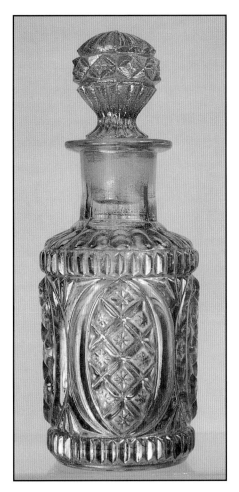

A rare *DIAMOND OVALS* perfume from Rindskopf in a delicate pink base glass with a light iridescence. SP $150-200.

217

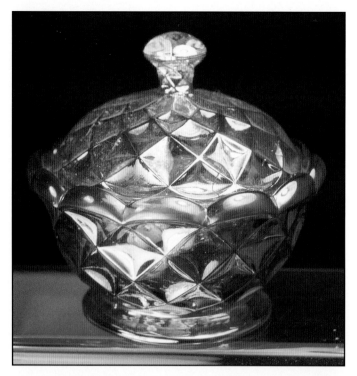

This dainty item is a powder jar from Eda Glasbruks in the *SVEA* design (illustrated in the company's 1925 catalog). SP $200-350.

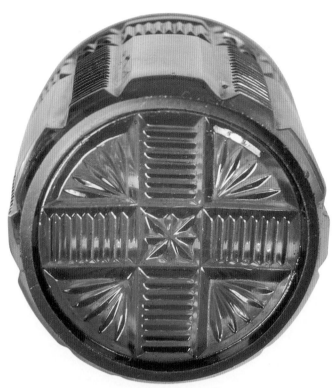

The base of the *ELSA* jar shown in the previous photograph has an intriguing pattern.

Hair Receivers were used to hold the loose strands of hair that ladies would remove from their combs and brushes. They were only made in Classic Carnival, and can only be found in one pattern—Fenton's *PERSIAN MEDALLION*. These items could easily be mistaken for the rose bowl, as they are identical except for one unique difference, they have a square opening at the top instead of a round one. Thus, Fenton got double mileage out of the mould as they used it to make both rose bowls and hair receivers!

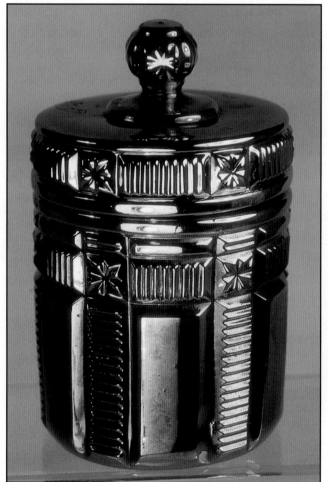

The first reported Carnival item in Eda's *ELSA* pattern is this splendid, covered, blue powder or trinket lidded jar. It is illustrated in Eda's 1925 catalog as part of a dressing table set. NP. *Courtesy Jim Nicholls.*

Fenton's *PERSIAN MEDALLION* hair receiver in blue is always a popular shape with collectors. $150-250.

Individual pin trays, as well as matching ones that are part of sets, are also known. Millersburg in particular, produced the sought after *SUNFLOWER* and *SEACOAST* pin trays (see Part One, Chapter Five for more detail on the *SEACOAST* pin tray).

Hatpins, Buttons, Jewelry etc.

Iridescent hatpins, buttons, and beads were very popular in the late 1800s and early 1900s. Butler Brothers catalogs show them clearly in the early 1920s. The costume jewelry (bijouterie) industry was—indeed still is—concentrated in and around the areas of Jablonec nad Nisou and Zelezny Brod (aka Eisenbrod) in the Czech Republic.

The hatpins, buttons, and beads were originally made mainly in iridized (usually black/deep purple) glass using innovative techniques that revolutionized the industry and ensured its success. The beads were used not only for necklaces and other adornments, but also for making pretty bags and for embroidering on clothing. Intricate patterns were impressed on the glass hatpins and buttons: flowers, animals, insects, and more. Button making in Czechoslovakia was (and indeed, is) a labor intensive operation, with many hands being involved and many stages in the process being necessary.

The bijouterie industry continues to thrive in the Czech Republic today. *National Button Bulletin* (February, 1999) reported that "the Czechoslovakian glass button makers are making buttons in the 1990s in the same manner that they did at the beginning of this century." In an article entitled "The Czech Glass Phenomenon," the *Bulletin* went on to say that button production today is being carried out by four main companies in the Jablonec nad Nisou area. "Two are factories and two are cottage based businesses." The two factories are "co-operatives with some salaried workers like managers, engravers, and mould makers. Cottage workers like pressmoulders and painters do the production of buttons for piecework wages. Beautiful finishes like auroras and other lustres are produced in a factory specializing in that work." One of the factories produces jewelry and beads as well as buttons. Production in the area is on an international scale: the Ornela factory, for example, is responsible for some 25% of the world's trade in glass beads. Some of the buttons being made today are from old Classic moulds as well as new moulds!

A wide range of hatpins, beads and other fashion accessories were produced in Czechoslovakia.

A close-up look at the intricate beadwork on a Carnival handbag.

Carnival Glass lighting reflects both social history and scientific development, for the era of Classic Carnival production came at a time when domestic lighting was a fascinating mix of both the old and the new. Candles as well as gas lamps and oil lamps were still in use in the early 1900s— however electric lighting was becoming widespread. Both Joseph Swan in the United Kingdom and Thomas Edison in the United States had produced working light bulbs within months of each other in the late 1870s, but the cost of electricity was still too high to allow electric lighting to be commonplace. In the 1920s, however, the price of generating electricity dropped steadily, electric bulbs grew more powerful, and people became accustomed to brighter lights in their offices and homes. Fewer gas and oil lamps were made, and the way was open for decorative electrical lighting fitments instead. Carnival Glass has examples of all aspects of this fascinating development.

Candlesticks and Chambersticks

A candlestick is essentially an upright stand with some sort of socket in which a wax candle stands—it is not designed for carrying around as a source of light, but is meant to be used where it is placed. Chambersticks were specifically used to light the way to one's bedroom (chamber) each night and were designed with a small handle, specifically for carrying. The timeless attraction of the glow of warm candlelight has meant that candlesticks have been produced by Carnival Glass manufacturers from the early Classic Carnival years right up to today. Northwood and Imperial produced the first Carnival examples. Northwood's *GRAPE & CABLE* candlestick, and the splendid novelty *GRAPE & CABLE* candlelamp (which combines the candlestick with a delicate, matching Carnival Glass shade) are perennial favorites with collectors. Imperial produced a wider choice of patterns, with the *CRUCIFIX* candlestick being possibly the most sought after— other candlesticks from Imperial include the splendid *SIX SIDED* and the small *SODA GOLD* examples. Cambridge also produced candlesticks in *INVERTED STRAWBERRY*—a pattern in which a wide range of shapes was made. Into the 1920s, Fenton and Dugan/ Diamond also made iridized candlesticks, but some of these owed more to Stretch Glass than true Carnival.

One of the most desirable shapes in Northwood's *GRAPE AND CABLE* is the elegant *CANDLELAMP*. This example is green. The delicate lampshades were prone to breakage, owing to the proximity of a naked flame in the candleholder. $800-1200. The base to the *CANDLELAMP* is the *GRAPE AND CABLE CANDLESTICK*.

Imperial's rare *CRUCIFIX* candlestick in marigold (the only color it is known in) stands around 9.5 inches high. $800-1200 for a single candlestick.

The European manufacturers made a wide variety of candle-sticks—from diminutive examples, such as Sowerby's *GOODNIGHT* chamberstick, to the impressively detailed *CHRIST* and *MARIA* candlesticks from Brockwitz. Riihimaki in Finland also made a variety of such items, including the fabulous *MOTH* or *FIREFLY* candlesticks and the classic *KULLERVO* examples.

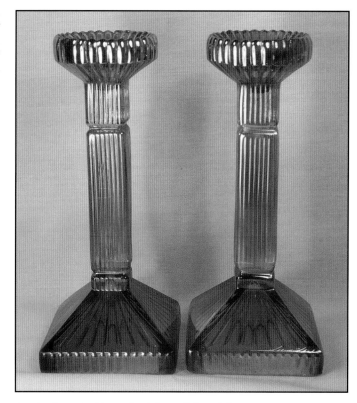

A pair of marigold candlesticks in Riihimaki's *KULLERVO* design. SP $300-500 for the pair.

The rare and magnificent, marigold *CHRIST* candlestick from Brockwitz. A partner to this piece is the *MARIA* candlestick. *Courtesy of Jim Nicholls.* NP.

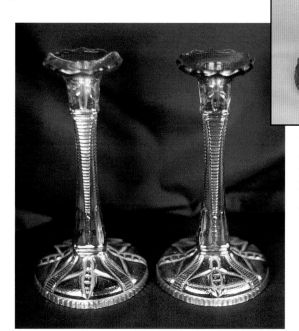

Another pair of *FIREFLY* candlesticks, this time in a pale smoky blue with a golden iridescence. SP $600-800 for the pair.

Riihimaki's *FIREFLY* aka *MOTH* candlesticks in deep blue with a vibrant iridescence. SP $600-800 for the pair. The *FIREFLY* candlestick is an old pattern for Riihimaki, as it was first shown in their 1915 catalog, then brought into production again in Carnival (lister glas) in the late 1920s and 1930s.

Oil Lamps

These range from the magnificent and showy *GONE WITH THE WIND* style lamps that were made in the USA, through several scarce lamps produced in Europe during the 1930s, right up to today, with the superb Contemporary lamps made by Fenton. Imperial Glass made the *ZIPPER LOOP* kerosene lamp in two sizes of the regular shape as well as a hand lamp (with a carrying handle). Characteristic of all this type of lamp is a bulbous lower section, which is the kerosene container or "fount." A glass chimney fits atop the fount and in the case of the *GONE WITH THE WIND* style lamps there is also a large globe.

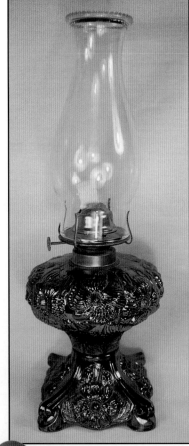

A Contemporary Carnival Glass oil lamp produced for the grandchildren of Rose Presznick by Fenton, in 1984. Less than 200 were made in red and a handful were also made in experimental colors. *PRESZNICK POPPY OIL LAMP*— SP $300-400 (according to Contemporary Carnival authority John Valentine).

Shades

Carnival Glass lamp shades were made for both gas and electric lights—the gas shades being larger and wider than those intended for use with electricity. Several shades were also used, grouped together to form chandeliers. They were made by a number of manufacturers from the Classic Carnival era as well as by some European Carnival manufacturers during the 1920s and 1930s. Predominantly, lampshades were produced in marigold, though iridized milk glass (Northwood's "Luna"), Imperial's helios green, and amber are among the colors known. Amongst the Classic Carnival makers, Imperial, Northwood and Fenton produced lampshades.

In Europe, a little known maker of Carnival is August Walther and Sons of Germany. Walther produced fine glass ware, often in designs richly evocative of the Art Deco era, which included a limited amount of Carnival made "to special order." The company produced a "Book of Patterns for Lighting" in 1937 that included a shade resembling a large candle flame that is often referred to as *FLICKER SHADE*. It is very likely that Walther also produced a number of other iridized lampshades that are currently un-identified.

A wonderful variety of enamel decorated shades featuring a variety of scenes, were also produced in Europe by the Czechoslovakian glass manufacturers (Palde is a likely contender). The finding of the remnants of an old paper label marked "Made in Czechoslovakia" on one of these lampshades confirms the country of origin (see photograph). Castles, woodland paths and streams, houses, churches, flowers, and more adorn these delightful marigold shades.

Three enameled lampshades from Czechoslovakia with a variety of painted scenes on a rich, marigold iridescence. $75-100.

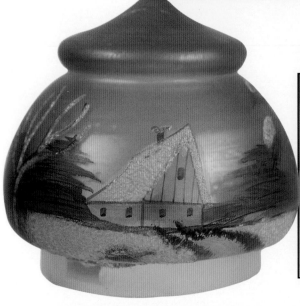

A detailed look at the label on the lampshade shown in the previous photograph.

Another enameled lampshade, but this one is rather special— it has the remnants of a paper label attached to it. The wording on the label reads: Made in Czechoslovakia. $75-100.

Even Carnival Glass light bulbs were made! The authors have seen photographs of a richly iridized, marigold screw-in lightbulb. The date of manufacture is not known. Contemporary lighting is also made in Carnival Glass. Fenton produce a range of lighting, including delightful fairy lights as well as a limited range of impressive "student" lamps and oil lamps.

A delightful fairy light in Fenton's *PERSIAN MEDALLION* pattern, in white and pink opal Carnival. $50-100.

A Contemporary Fenton fairy light in red Carnival. The pattern is in the style of Fenton's *ATLANTIS* vase (which was an old United States Glass mould). $50-80.

Chapter Eight
Tobacciana

Though the use of tobacco probably dates back to the years before Christ, it is really only generally known about since being "discovered" by Christopher Columbus. In 1492, Columbus wrote in his journal documenting his arrival in the "New World" for the first time— "the natives brought fruit, wooden spears, and certain dried leaves which gave off a distinct fragrance"—tobacco! Through the 1500s tobacco began to be smoked, often as a panacea and a "cure-all." Pipes, cigars, snuff, and even early cigarettes were in use from the 1600s. Chewing tobacco also came into use and later, cigarettes as we know them and the safety match, were both invented in the mid 1800s.

Humidors

In Carnival Glass, the tobacco humidor or tobacco jar was a covered glass jar with a close fitting lid, inside which were three glass prongs designed to hold a damp sponge to keep the tobacco moist. Few such humidors are known in Carnival and are sought after shapes. Northwood made the *GRAPE & CABLE* humidor and Millersburg produced a rare *PIPE HUMIDOR* with a rustic acorn and leaf pattern. The Millersburg item is a masterpiece of mould work, having a pipe and curving stem as the finial to the lid.

The prongs inside the lid of the humidor were used to hold a damp sponge that kept the tobacco moist.

The marigold *GRAPE AND CABLE* humidor was used to store tobacco. $300-400.

Cuspidors or Spittoons

Toward the late 1800s, chewing tobacco was more widely produced in the United States than smoking tobacco (the Census for Virginia and North Carolina in 1860 lists 348 tobacco factories, virtually all producing chewing tobacco. Only 6 stated that they made smoking tobacco as a side product). In the Ohio Valley, a popular, sweetened, chewing tobacco was produced— advertising proliferated and soon women were targeted too. Though smoking was banned in some public areas, chewing was often still allowed. When the Kansas Legislature brought in the "slobbering" bill in 1903, prohibiting spitting tobacco on floors, walls, or carpets in churches, schools, or public buildings—cuspidors (spittoons) became necessary.

It wasn't only the habit of chewing tobacco that produced a need for cuspidors, for the deadly disease tuberculosis (TB) also gave rise to a proliferation of them. In the late 1800s and early 1900s TB was considered one of the most infectious diseases around and was the leading cause of death in many areas. As there were not enough sanatoriums for everyone with TB to be cared for, the sick continued to work and socialize until the illness overtook them. Coughing up sputum was a symptom of TB and thus, ways of containing their sputum were devised. Legislation prohibited spitting in any public place—and indeed public spittoons were provided—for it was believed that infected sputum was a sure way of passing on the illness. Personal, hand-size spittoons were also marketed to the ladies of the day so they could very politely dispose of the sputum.

Types of Cuspidor

Carnival Glass cuspidors fall into two broad types: those that were in the line, that is, were specifically manufactured to be a cuspidor—and those scarce items that were not originally meant to be a cuspidor but were whimsied into the shape.

Of the regular production cuspidors, Millersburg is at the fore with their *HOBNAIL* and *HOBNAIL SWIRL* examples. The shape is typically waisted near the top, with a flat flange surrounding the mouth. Millersburg used the same mould that was also employed for the *HOBNAIL / SWIRL* rose bowl.

Although each is known in low numbers, a surprising array of spittoon whimsies were made. The selection below describes the several shapes from which they were whimsied[1]—(note the moulds used for the following whimsy shapes were regular production moulds in a shape other than a spittoon. The hot glass item would have been taken directly from the mould and hand fashioned into the whimsy item).

• Fenton's *BUTTERFLY & BERRY* spittoon whimsy was fashioned from the footed berry bowl.

• United States Glass' *COSMOS & CANE* and Fenton's *FEATHERED SERPENT* spittoon whimsies were fashioned from small sauce dishes.

• Millersburg's *COUNTRY KITCHEN* spittoon whimsy was fashioned from a spooner.

• Millersburg's *DIAMONDS* and Cambridge's *DOUBLE STAR*, Fenton's *LATTICE & GRAPE* and *WATERLILY & CATTAILS* spittoon whimsies were all fashioned from the tumbler.

• Northwood's *GRAPE & CABLE* spittoon whimsy and Fenton's *ORANGE TREE* spittoon whimsy were fashioned from powder jars.

• Northwood's *PEACOCK AT THE FOUNTAIN* spittoon whimsy was fashioned from the base of a covered sugar.

• United States Glass' *COSMOS & CANE* stemmed spittoon whimsy was fashioned from the stemmed compote.

• Northwood's *GRAPE & CABLE* humidor spittoon whimsy was fashioned from the base of the humidor.

• Dugan's *WREATH OF ROSES* spittoon whimsy shaped from the rose bowl[2].

The European manufacturers are not known to have made cuspidors at all. Yet several rare and desirable "cuspidors" are believed to exist—for example, Brockwitz' *TARTAN* and Riihimaki's *STARBURST*. These items are not, however, spittoons, even though their bulbous and waisted shape is identical. The Brockwitz catalog clearly marks this shape as a *blumenbowl*— a flower bowl. The Riihimaki items (there are other similar ones) are waisted sugar bowls.

Millersburg made this splendid *HOBNAIL SWIRL* cuspidor (spittoon). Also known in marigold and green (just two green ones known), this amethyst one is valued at around $600-1000.

Fashioned from the base of a *GRAPE AND CABLE* powder jar, this is a whimsy cuspidor in green. Only two others like this are known. SP in the region of $9000. *Courtesy of Randy and Jackie Poucher.*

Is this a cuspidor? Well, this splendid amber *FIR CONES* item from Riihimaki/Kauklahti certainly is shaped like a spittoon, though it was probably intended as a sugar bowl. It stands 2.5 inches high and is 4.25 inches in diameter across its mouth. This rare beauty is only the second reported and should be considered very unusual indeed. NP.

Spot the cuspidor? All these three are cuspidor shapes, but which one is the real spittoon and which were intended to be used for other purposes? Top row: Brockwitz' *TARTAN* cuspidor shaped flower bowl (*blumenbowl*) in marigold. SP $250-800. Bottom left: Riihimaki's *STARBURST* cuspidor shaped sugar bowl in amber SP $500-1000. (Note an example sold for $1,900 in 1996). Bottom right: Millersburg's *HOBNAIL SWIRL* cuspidor in amethyst. $600-1000.

Ashtrays

The history of ashtrays is far shorter than the history of smoking. The first examples probably date from the early 19th century, and ashtrays were in common use by the late Victorian period. By the early part of the 20th century, ashtray design had evolved to provide models of various scales for all smoking habits. These were often combined with devices for holding cigars, cigarettes or other smoking paraphernalia.

Glass was the perfect material for the ashtray, being easily cleaned, durable, and entirely resistant to the burning tip of a cigarette. Though no Classic Carnival ashtrays are known, there is, however, a wide and fascinating variety that was made by European and South American Carnival manufacturers from the mid 1920s on. A boost for smoking had come after WWI as many troops came home addicted to cigarettes. Then, in the 1920s, using testimonials from female movie stars and singers, many women were also targeted for cigarettes. Smaller, novelty ashtrays to attract the ladies were produced, as well as souvenir or promotional ashtrays, such as those made for the tire manufacturers Firestone and Dunlop. In these, the central insert was glass, bearing moulded lettering promoting the tire maker—the surround was a miniature rubber tire. One of the most sought after ashtrays is the fabulous *BEETLE* ashtray from Cristalerias Rigolleau.

The *BEETLE ASHTRAY* from Cristalerias Rigolleau is a magnificent item (seen here in amber Carnival). Eight scarabs encircle the ashtray, while the words "Cristalerias Rigolleau. Buenos Aires" surround the very center, where "Sociedad Anonima Usinas En Berazategui F.C.S." is written. (Note: the lettering translates to mean "Limited Liability Company of Berazategui"—the location of Rigolleau's factory). All the words are moulded in the design. $400-700.

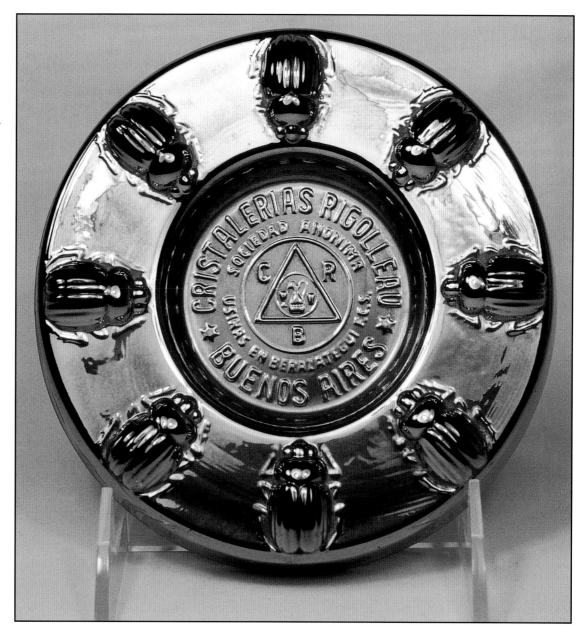

A marigold *GOOD YEAR ASHTRAY.* The center section comprises a marigold disk with the wording "INDUSTRIA ARGENTINA" encircling the words "GOOD YEAR." In between the wording is the Good Year logo, the flaming torch. Around the outside of the central disk is a miniature Good Year automobile tire. There are reports that the date 1928 is inscribed on some examples of the tire. $90-125.

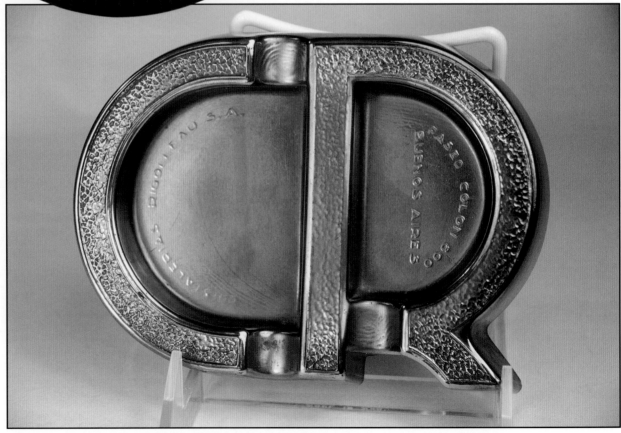

This is the only reported green Carnival *CR ASHTRAY.* On the "C" part of the ashtray the words "Cristalerias Rigolleau S. A." are moulded, while on the "R" part there is "Paseo Colon 800 Buenos Aires." Not only the company name is shown, but also its location. NP.

In Europe, Riihimaki and Brockwitz produced several different ashtray patterns. In the main, these were regular sized items, around 5" in diameter. A massive ashtray possibly intended for cigars was made by Walther (see photograph on the following page). Ashtrays were also made in Firozabad, India and later, in the 1950s and 60s, in the USA (often as advertising or promotional items).

From Riihimaki, this is a *KORONA* ashtray. Clearly shown in the factory's catalogs through the 1930s, this round, heavy ashtray features an interlocking, complex geometric design around the sides, while the ground base has a large and intricate star motif cut into it. In blue, SP $100-200.

Another item in Riihimaki's *JUPITER* pattern range was this unusual marigold ashtray. SP $150-250.

More ashtrays, this is a marigold *WILLS GOLD FLAKE* ashtray (Wills Gold Flake was a British cigarette company, based in Bristol). Maker unknown. *Courtesy of Carol and Derek Sumpter.* SP $75-125.

This massive, heavy ashtray was sourced in Germany. It measures a full 7 inches across and is a very high quality item with a mirror shiny polished base. The pattern was known as *REGINA* and was made by the German manufacturer August Walther and Sons. This is currently the only example reported. NP.

The *LBJ HAT* is a novelty ashtray that was made in the Late Carnival era (probably in the 1930s-1950s). It gained its name later, when President L. B. Johnson's headgear became well known. $15-30.

[1]Edwards, Bill and Carwile, Mike. *Standard Encyclopedia of Carnival Glass (8th Edition)*. Paducah, Kentucky: Collector Books, 2002.

[2] *The Carnival Pump*. (Color insert). Official publication of the International Carnival Glass Association Inc. June 2002.

There are many shapes that do not fit the broad categories in previous chapters, and so we have included them here in a Novelty classification. Here are the bottles, the penny banks, and the insulators. Here too is the wide range of Contemporary Carnival that defies categorization—where indeed could the Carnival Glass Greetings Cards be classified, if not under "Novelties?"

Bottles

Various examples of marigold bottles were made from the 1920s. Possibly the best known examples are the *CANADA DRY BOTTLE* and the *GOLDEN WEDDING BOTTLE*. Different shapes and sizes were known for these (and other similar bottles) but they all seemed to have had the same useful purpose—they were used to contain beverages (orangeade, whisky etc). The Argentinean manufacturer Cristalerias Rigolleau produced Carnival Glass lemonade bottles for a South American grocery store. In large script lettering, the advertising slogan on the bottle reads: Ripamonti Rafaela.

The *INCA BOTTLES*, a splendid set of Carnival bottles in a carrying case, were made by Hartinger in Peru. The company was founded in 1939, so the bottles date from after that time. Labels and moulded text found on the bottles and the case indicate that they were made for Santa Josefa Vina, probably a wine or liqueur producer. The original content of the bottles was known as "pisco" which appears to be a grape distillate (like brandy) that notches up a rather high alcohol content of 43.9 percent. The label on the front of the case states that the contents are *3 PARRAS*—which translates to mean three guys or fellows, in other words, the three *INCA BOTTLES* that were contained within the carrying case.

There are several variations of these splendidly quixotic novelties, in fact, four different versions of the *INCA BOTTLES* are currently recorded. Each has in common a grotesque appearance: three feature just a face; the other is shaped like a squat figure with a disproportionately large face and neck. Small wine glasses have also been found with one example of this bottle. *INCA BOTTLES* are scarce and unusual items in collecting circles and are known in both marigold and blue Carnival Glass.

In the Contemporary Carnival era, the Wheatoncraft Company made a range of novelty bottles (decanters) in different sizes, shapes, and colors which featured famous characters and events from the American Presidents to Marilyn Monroe and Apollo 11.

A wide range of novelty bottles were made by the Wheatoncraft Glass Company in New Jersey. This emerald green one depicts John Paul Jones, from the Great American Series. $30-60.

Here's an unusual deep blue bottle (flask) made by the Big Pine Key Glass Works for the Collector's Weekly, of Kermit, Texas. The moulded pattern on the reverse side (not shown) features former President Harry S. Truman, his initials and dates (1884-1972) and his famous saying "the buck stops here." On the base of the bottle are the moulded letters BPKGW and a triangle. A slip of paper with the bottle carries the information that the production of the flask was affected by the 1970s oil shortage, explaining that the glass works "has been forced to take a low grade of fuel oil to keep its glass furnaces going…... With this smokey fuel, it is not possible to make light colored glass, such as the planned orange for this flask. As a result, at greater expense, the enclosed flask has been carnivalized to add a new dimension to your collection." The explanation continued with an apology and an offer for refund. SP $50-75.

A Carnival Club commemorative bottle made by Wheatoncraft for ICGA (the International Carnival Glass Association) in 1969. The design on the front (illustrated) shows the club's emblem, the *TOWN PUMP*. On the reverse is written: Gateway Arch, Spirit of St Louis. St. Louis, MO. July 1969. The graphic shows the St Louis Arch and Charles Lindbergh's famous "Spirit of St Louis" airplane. SP $75-125.

Toothpick Holders

Only a few toothpick holders were produced in Classic Carnival Glass (Imperial's *FLUTE* is possibly the one seen most often)—surprising when one considers the range of toothpick holders that were available in other types of glass in the late 1800s and early 1900s. However, a large number of toothpick holders have been produced in Contemporary Carnival, often utilizing those old moulds. Unless trademarked, many of these newer toothpick holders may at first appear to be much older than they really are—the patterns and style are from an earlier age, only the type of glass and its color indicate its recent production.

Spot the Classic, old toothpick holder. On the left: *INDIAN CHIEF* toothpick in dark green, marked Joe St. Clair in script and made in the 1960s $30-60. Center: Imperial's Classic Carnival *FLUTE* toothpick in marigold $50-80. Right: a Contemporary Carnival blue *WREATHED CHERRY* toothpick marked St. Clair $25-50.

Banks

Essentially a product of the Depression era, penny banks were made in various novelty shapes. Possibly the most well known example is the *PIGGY BANK* (probably by Jeanette Glass) which was made in several sizes. The iridescence on these items is usually a light and even marigold. A similar bank in the shape of a rabbit is also known—also in several sizes. Other Carnival banks from the same era made by Anchor Hocking are the less well known *WORLD BANK*, the *WISE OWL* and the *LIBERTY BELL*.

A Late Carnival glass bank in the shape of a globe—this is the scarce *WORLD BANK*. SP $100-150. Other banks are found more easily, such as the *PIGGY BANK* and the *LIBERTY BELL*.

Carnival Club Commemoratives

Since the first days when Carnival collectors began to gather together to talk, compare glass and to learn more about Carnival, there have been Carnival Clubs. The very first Contemporary Carnival Glass souvenir was handed out at the first American Carnival Glass Association (ACGA) Convention held at Lodi, Ohio, home of the late Rose Presznick, in the 1960s. Following a trip to the Imperial plant, during the Convention, the twenty-eight members were presented with a limited edition, marigold *FASHION* compote. These were known as the "One-of-Fifty-Six" compotes, this referred to the actual number made—indeed the items were later numbered for posterity. This was to be the start of "something big," as souvenirs and club commemoratives soon became a necessary and desirable memento for all the major Carnival clubs.

Many Carnival Glass manufacturers have made souvenirs for the clubs, (in fact, the South Australian collectors' club ACE, used a Taiwanese manufacturer in 1986, to produce their club souvenir).

This cobalt blue *IRIS* picture frame was made as the ICGA commemorative in 1976 by St. Clair. Reportedly, fewer than 500 were produced. SP $100-200.

Fenton made this 1991 club souvenir for A.C.E. Victoria (Australian Carnival Enthusiasts) in rich red. The animals featured are kiwis. $25-40.

Sometimes existing old moulds were used and sometimes new moulds were cut, specifically made for the purpose—and the range of novelty shapes created has been astonishing. Indeed, it has been increased by the fact that the Fenton Art Glass Company has been involved in the production of many Club commemoratives—and one of the company's specialties is the creation of whimsy shapes.

Not all club commemoratives are novelty shapes, of course, however, amongst the novelties here we include items such as the series of delightful miniatures that the late Dorothy Taylor commissioned for her *Encore* club. In 1979, a pretty miniature, blue water set in the *GOD & HOME* pattern was made by Mosser as the *Encore* souvenir (410 sets only made.) Among the novelty shapes made for the clubs are fairy lamps, picture frames, cruets, salt and pepper shakers, bells, bottles, souvenir discs, miniature town pumps, and even miniature Christmas trees and a Santa Claus figurine. Whimsies, shaped and fashioned from the regular commemoratives, are plentiful amongst club souvenirs. Hand painting is frequently used to add individual and decorative accents and indeed the reader will have seen several examples of beautiful and rare painted commemoratives in Part One, Chapter Four, "Decorating the Glass."

Mosser made this *GOD AND HOME* miniature water set in blue for Dorothy Taylor's Encore Club in 1979.

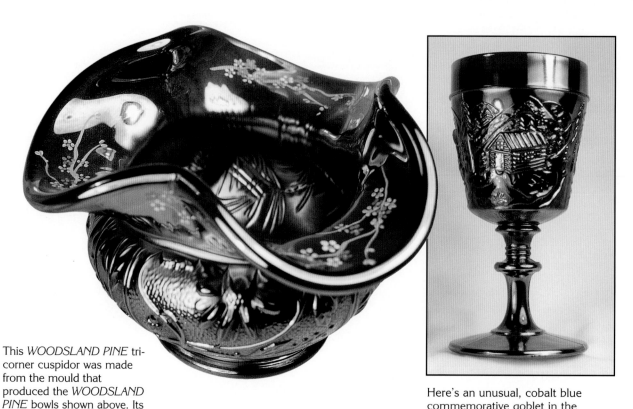

This *WOODSLAND PINE* tri-corner cuspidor was made from the mould that produced the *WOODSLAND PINE* bowls shown above. Its color is black amethyst and it was hand painted by Fenton decorator, Diane Gessel. SP $300-350.

Here's an unusual, cobalt blue commemorative goblet in the *WESTWARD HO* pattern made by Westmoreland Glass as a limited souvenir issue for the Gateway Carnival Glass Club in 1979. SP $75-125.

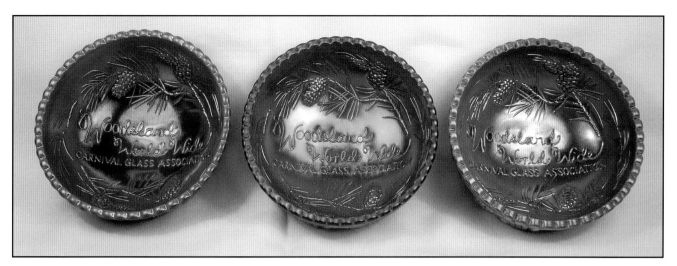

Three Favrene *WOODSLAND PINE* commemorative bowls made by Fenton for the internet Carnival Club, www.cga, St. Louis Convention in 2003. Approximately 250 of these pieces were produced. Favrene was first developed by Louis Comfort Tiffany as Blue Favrile. The formula contains pure silver which is coaxed to the surface through a series of cooling and re-heating steps. The three bowls shown here are very interesting as they illustrate different color effects on Fenton's Favrene. On the left—a "one of a kind" electric blue, the stunning color is most likely the result of the piece being cooled longer than the optimum in the step between pressing and reheating prior to spraying. It was a trial piece produced during the experimental stages of production for this commemorative. In the center, the iridescent effect shows a predominant green while on the right, purple and pink highlights predominate. The experimental bowl sold for $350 in 2003. Regular commemorative bowl, $40-60. Information courtesy Howard and Marty Seufer and Fenton Art Glass Company.

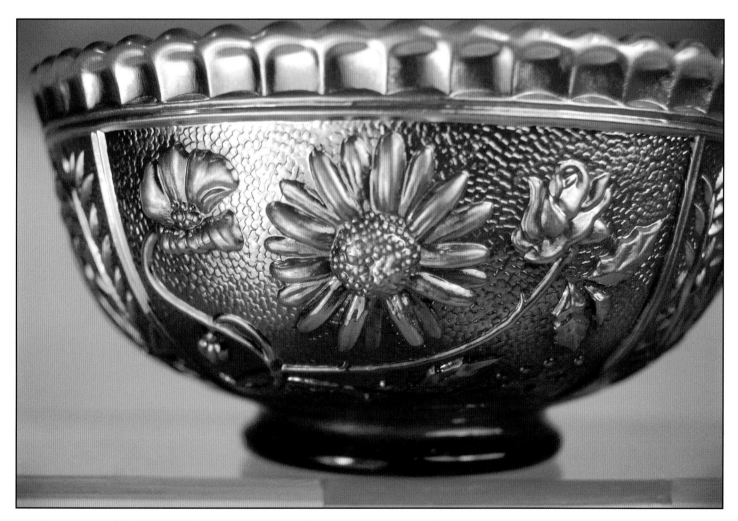

A close-up view of the *FLOWERS OF THE WORLD* floral design on the exterior of the *WOODSLAND PINE* electric blue, "one of a kind" Favrene bowl that was shown on the left of the previous illustration. The iridescence on this item is truly spectacular.

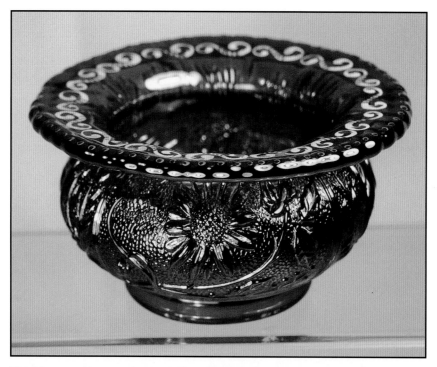

This blue cuspidor was also made from the same mould that produced the bowls shown above. Produced as a commemorative whimsy for www.cga, this item was hand painted by Fenton decorator, J. K. (Robin) Spindler. SP $200-300.

Made by Fenton for Dorothy Taylor and sold through her Encore journal on Contemporary Carnival, this is a green handled basket that features the *ELKS* design. It bears the Fenton trademark and the word TAYLOR on the exterior. SP $50-100.

This blue *TEXAS STAR* paperweight was made for the Texas Carnival Glass Club in 2000. On the base, the moulded wording reads—Texas Centennial 1836-1936. $25-50.

Figurines and Animal Novelties

The majority of items that can be classified in this section come under the umbrella heading of Contemporary Carnival Glass. The human form is known in old Classic Carnival (the *CHRIST* candlestick for example) but it was not utilized as a novelty. All manner of both human and animal novelties have been issued in recent times, however—sometimes in the form of bells (for example, Imperial's *SUZANNE BELLE*), or paperweights (for example, Wheatoncraft's *JAWS* paperweight) or simply as trinkets and ornaments.

A delightful collection of Boyd novelties shown here *courtesy of Les and Rita Glennon; Angie and Andrew Thistlewood*. Top row, left to right: *TRACTOR* (royal plum)); *VIRGIL SAD &HAPPY FACE CLOWN* (royal plum); *"J.B." SCOTTIE DOG* (cobalt). Middle row: *ARTIE PENGUIN* (cardinal red); *ZAC ELEPHANT* (cardinal red); *PATRICK BALLOON BEAR* (classic black). Bottom row: *WILLIE THE MOUSE* (cardinal red); *JEREMY FROG* (sunkiste) and *SKIPPY* (cardinal red). All $15-30.

Two figural novelties: on the left—the cobalt blue *COLONIAL MAN* is named "Stephen" on the accompanying label. Made by Boyd, $25-35. On the right—Imperial's *SUZANNE BELLE* novelty bell was made in a variety of colors—this example is in the Aurora Jewels deep, rich blue. $40-60.

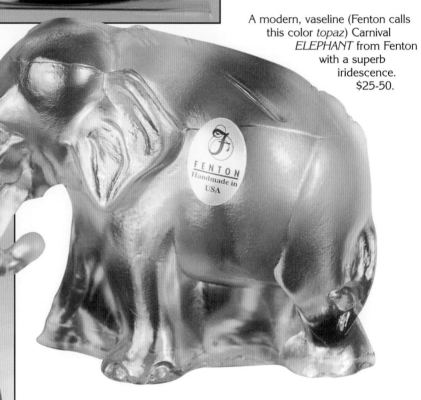

A modern, vaseline (Fenton calls this color *topaz*) Carnival *ELEPHANT* from Fenton with a superb iridescence. $25-50.

JAWS is the name given to this amazing marine blue paperweight "handmade" by the Wheatoncraft Glass Company. It stands 5 inches tall with a 5.75 inch diameter base. $50-75.

From Fenton, the mould for this delightful, contemporary, light blue *BUTTERFLY* was "sculpted" by craftsman Jon Saffell. $20-30.

OWL TREE RING (on black amethyst Carnival Glass) from Fenton. Information courtesy Howard and Marty Seufer. NP.

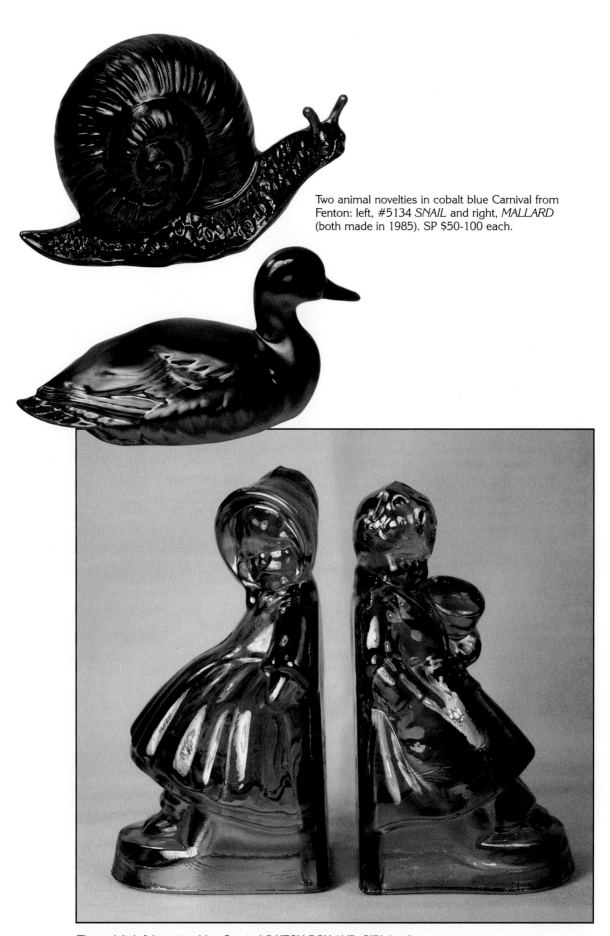

Two animal novelties in cobalt blue Carnival from Fenton: left, #5134 *SNAIL* and right, *MALLARD* (both made in 1985). SP $50-100 each.

These delightful, marine blue Carnival *DUTCH BOY AND GIRL* book-ends were made by Wheatoncraft in the early 1970s. $50-100.

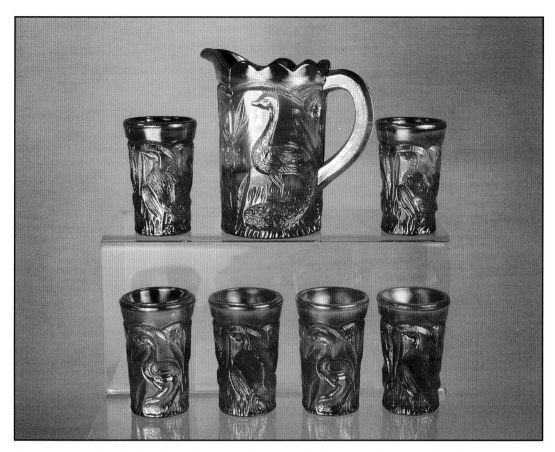

A Contemporary Carnival, miniature *INVERTED PEACOCK* water set made by Summit in Geraldine's Delight (red slag). The mould was designed by Russ Vogelsong of Summit Art Glass and was first made in green as a souvenir for Dorothy Taylor's Contemporary Carnival Glass Club, "Encore."

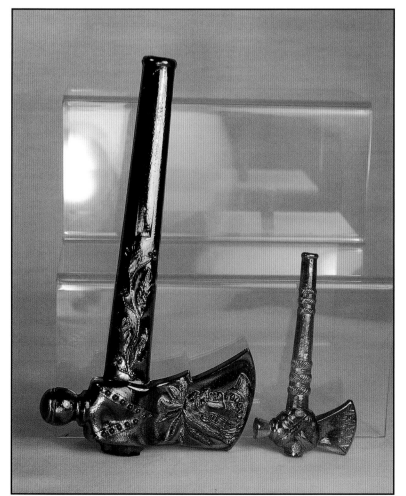

Two recent *TOMAHAWK* novelties, each bearing the Degenhardt D in a heart trademark—though both are fairly recent items and were not made for Degenhardt (the trademark has not been removed since the moulds changed hands). On the left, large blue *TOMAHAWK*. Right, small, red *TOMAHAWK*. Either, $15-50.

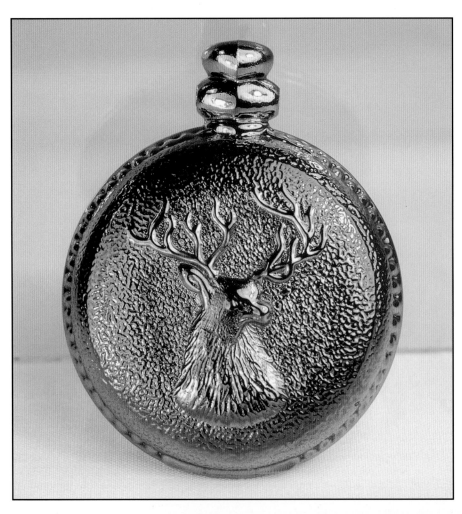

Summit Glass' *ELK POCKET WATCH* novelty in purple. $10-30.

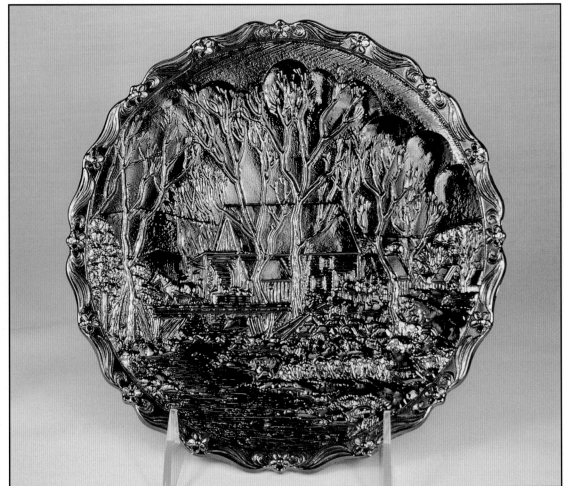

Issued in 1980 and marked "Number 1 in a series of four," this splendid purple Carnival plate from Fenton was called *THE OLD GRIST MILL* and was the first in a run of *CURRIER AND IVES* plates. Its color and iridescence are truly gorgeous. $50-75.

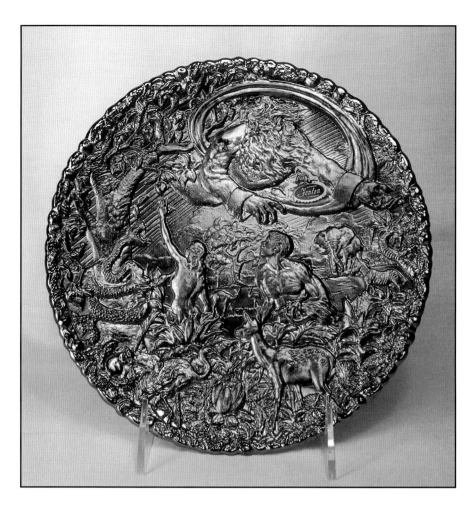

Fenton's wonderful *GARDEN OF EDEN* plate in cobalt blue ("Cobalt Marigold Carnival") was issued in 1985—the fine detail of the mould work is breathtaking. $50-75.

Insulators

Insulators were initially designed to insulate telegraph wires, later they were also used for telephone and electric lines too. The Hemingray Glass Company made possibly the largest amount of Carnival insulators in the 1940s, but the Corning Glass Company also produced them. A souvenir insulator was made by Imperial in 1971 for the 60th anniversary of the Telephone Pioneers of America.

The commemorative lettering on the front of the *HUMAN SERVICE INSULATOR* shows the logo of the Telephone Pioneers of America and marks their 60th Anniversary.

An unusual item, known as the *HUMAN SERVICE INSULATOR* was made by Imperial in 1971 to raise funds for a human service project. This example is in rubigold (marigold). SP $75-100.

Political items

Though these are essentially Contemporary Carnival novelties, they are unusual enough to warrant a mention. The connection to politics in the item made by the Imperial Glass Company is via E. Ward Russell, who was a major figure in the American Carnival Glass Association during the 1970s and 1980s as well as having very close ties to the Imperial Glass Company. John Valentine has written extensively on E. Ward Russell—in his writings, John notes that Ward Russell worked for the United States Department of the Interior in Washington for thirty years. The other intriguing political item illustrated is the Reagan Bush plate. Imperial made a *STORYBOOK MUG* using an old Heisey mould— one version of the mug in amber Carnival has the following lettering on the base: NIXON AGNEW plus the Imperial logo and the initials E.W.R. Plates (for example, featuring former President J. F. Kennedy made by L.E. Smith) and bottles (such as the *PRESIDENT* series from Wheatoncraft) were also made featuring political figures.

This novelty salt or pin dish in red Carnival made by St Clair, features former President John F. Kennedy. SP $40-75.

Two *STORYBOOK* mugs from Imperial, the amber one to the right has the NIXON AGNEW lettering, while the cobalt blue one left (the color is called "Aurora Jewels") has no such lettering. Both are marked IG for Imperial Glass. Amber, made in the early 1970s, $100-150; cobalt blue "Aurora Jewels" $30-50.

Unusual for Carnival, a political logo! This is Imperial's *STORYBOOK* mug in amber shown in the previous photograph, which was made in the early 1970s. On the base is the legend NIXON AGNEW plus the letters E.W.R. for E. Ward Russell. Note also the Imperial trademark, IG. $100-150.

244

Seldom seen, this is a small (5.25 inches across) plate from Joe St. Clair. The color is a delicate, amber Carnival and the lettering around the perimeter of the plate reads: REAGAN * BUSH. In the center is depicted the Republican Party's elephant symbol and the date, 1980, plus the letters GOP (variously believed to stand for *gallant old party* or *good old party*). NP.

Christmas Ornaments

In the 1970s, Imperial issued a set of twelve Christmas plates, each illustrating a theme of the well known song "The Twelve Days of Christmas." Strictly, these are collector plates and not Christmas ornaments—however, they also produced a limited number of miniature versions of these plates that were designed to be hung on Christmas trees. Even more unusual were the novelty "greetings cards" made by Wetzel, which included a Christmas Card—these are flat squares of iridized glass bearing seasonal scenes and greetings, issued in a presentation box. Also associated with Christmas are glass bells—these items have been issued by various glass manufacturers over the years (as club souvenirs and general trinkets too). Finally, staying with the Christmas theme, blown iridized glass tree ornaments are not uncommon, but these do not strictly classify as Carnival Glass.

A modern (1990s) Christmas novelty from Fenton, this is a frosty white *CHRISTMAS TREE* with white frit (ground glass) decorating the tops of the branches. $30-50.

A novelty Carnival Glass Christmas greeting card made by Wetzel in 1982. This whimsical item shows a rabbit and a little bird against a background of Christmas trees. Measuring 4 inches square, this item was gift boxed and "signed" with a tiny press-moulded W on the back of the glass card. SP $50-75.

Hard to find, this is a novelty Christmas tree ornament, designed to be hung on the tree with the gold cord that is threaded through the disc. Made by Lennox Imperial Glass (and marked LIG) this blue disc portrays the *PARTRIDGE IN A PEAR TREE* from the First Day of Christmas, in the style of the Imperial *CHRISTMAS PLATES*. This item was sold in a pretty gold box and came ready threaded for hanging. SP $40-75.

Here's the second in the series of the Lennox Imperial Glass novelty Christmas tree ornaments. This jade green disc portrays the *TWO TURTLE DOVES* from the Second Day of Christmas. SP $40-75.

A more recent, ice blue Christmas tree decoration from Fenton, made in the 1990s. $15-25.

Everything Else

Of course, there are many more items that defy categorization. How, for example, would you classify an inkwell? Yes, a Carnival inkwell. The first example was reported in the summer of 2003. Discovered in Argentina by Adriana Caso and Osvaldo Sulfaro from Dersu Collectibles Inc., it is a splendid item. Its shape is that of a circular, domed-up disc, with a deep central depression where the ink would be stored. A matching glass stopper fits over the central well. All over the item is a moulded pattern featuring three stylized flowers interspersed with sinuous leaves. The stopper is shaped and patterned to look like one of the stylized flower heads. Around the edge of the item, moulded into the pattern, are the words CRISTALERIAS RIGOLLEAU S. A. The maker is, of course, clear—Cristalerias Rigolleau, the Argentinean manufacturer from Buenos Aires. The base glass color is amber, the iridescence has deep, rich tones of pink and green. An amazing and unique item.

Other hard-to-classify items include some of the more unusual and whimsical Contemporary Carnival pieces. Miniature punch sets, bookends, devilled egg plates, sea shells, ewers, paperweights, angels, and even eye cups, are all available in Carnival. If it isn't being made today, then it probably will be tomorrow.

Here's a red grape patterned ewer from Gibson. Marked on the base, GIBSON 1996. $30-50.

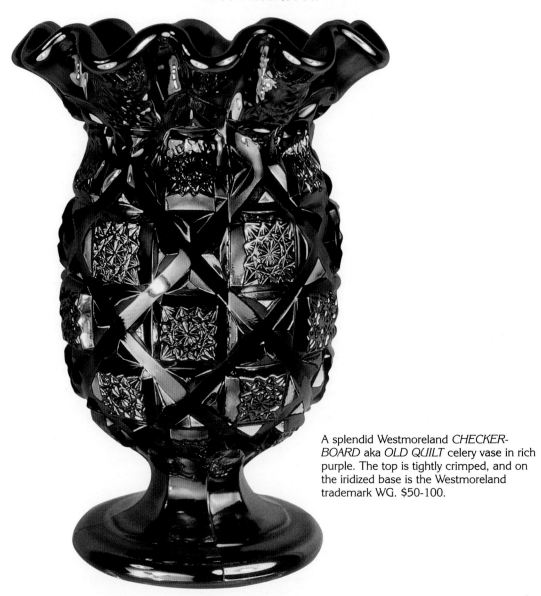

A splendid Westmoreland *CHECKER-BOARD* aka *OLD QUILT* celery vase in rich purple. The top is tightly crimped, and on the iridized base is the Westmoreland trademark WG. $50-100.

Appendix
Glass Companies that Produced Carnival Glass

Advance Glass Works—Firozabad, India. Producer of Carnival Glass water sets (including "Shalimar") and possibly vases. Paper label used saying "Advance, Firozabad." Current Chief Executive Ravindra Gupta.

AVM Glass Industries—Firozabad, India. Producer of Carnival Glass water sets and possibly vases. Moulded trademark AVM used on some items.

Bernsdorf—formerly Gebruder Hoffman: established circa 1845 in Germany. Small amount of Carnival production probably in the 1930s.

Boyd's Crystal Art Glass—1978 onwards. Cambridge, Ohio, USA. Boyd produce a wide range of glass novelties including many in unusual Carnival colors. Trademark B in a diamond (Formerly Degenhart Glass, trademark D in a heart).

B. M. Glass Works—Firozabad, India. Production of Carnival Glass tumblers, some trademarked B.M.

Brockwitz A.G.—1904 to approx.1946. Coswig, near Meissen, Germany. Wide range of Carnival Glass production through the 1920s and possibly into the early 1930s. No trademark.

CB—details uncertain, but this is possibly an Indian company that produced Carnival Glass water sets and vases. Moulded trademark CB.

Cristales Mexicanos S.A—established in 1909 at Monterrey, Mexico. Carnival Glass produced during the early 1930s, trademarked CM. Became part of Grupo Vitro in 1934

Cristalerias Papini—established 1896, Buenos Aires, Argentina. Importer of glass from Europe as well as a manufacturer in its own right. Some Carnival Glass through the 1930s. Trademark (occasionally) INDUSTRIA ARGENTINA. Today trades as Cristalux, SA.

Cristalerias Piccardo—Buenos Aires, Argentina. Wide range of Carnival Glass throughout the 1930s.

Cristalerias Rigolleau—established 1882, Buenos Aires, Argentina. Small amount of Carnival Glass (may bear the moulded name Cristalerias Rigolleau) through the 1930s.

Crown Crystal Glass Company Ltd—established 1914 in Sydney, Australia. Merged with Australian Consolidated Industries in 1963 (see Carnival Glass Collectors Association of Australian inc. for details). Produced Carnival Glass through the 1920s and early 1930s—some bear Registered Design numbers.

Dugan Glass Company and Diamond Glass Ware Company—established by Thomas Dugan and W. G. Minnemayer as the Dugan Glass Company, Indiana, Pennsylvania, USA—operated from 1904 to 1913—became the Diamond Glass-Ware Company 1913-1931. Produced a wide range of Carnival Glass from circa 1909 through 1931. No trademark was regularly used on Carnival Glass.

Eda Glasbruk—circa 1830 to 1953, Charlottenburg, Varmlands, Sweden. Carnival Glass production from around 1925 through 1929. No trademark used on Carnival Glass.

Elme Glasbruk—circa 1917 to 1970, Almhult, Smalands, Sweden. Limited production in the 1920s and 1930s. Paper label ("Elme") remains on some examples.

Fenton Art Glass Company—established in 1905 first in Martin's Ferry, Ohio, USA by Frank M. Fenton, John Fenton and Charles Fenton. The company moved shortly afterwards to Williamstown, West Virginia where they continue today. Fenton were the first to mass produce Carnival Glass in circa 1907, they continued to make it from then to the early 1930s. Carnival was re-introduced at Fenton in 1970 and is still made there today, note that most contemporary production is marked with Fenton in an oval.

Iittala and Karhula—Iittala was established 1881 at Iittala, south of Tampere, Finland. Karhula was established in 1899 at Karhula, east of Helsinki, Finland. The two merged in 1915 and more recently merged again with Nuutajarvi—glass continues to be produced today at Iittala. Carnival Glass was produced in the 1920s and 1930s. Trademarks seen are both IITTALA and KARHULA press moulded into the glass.

Imperial Glass Company—established in 1901 at Bellaire, Ohio, USA by Edward Muhleman, glass first made in 1904 through 1985. Carnival was produced from 1910 through the early 1930s and was re-introduced in the 1960s. Contemporary Carnival was marked with the IG trademark. Later ownership of the factory by Lennox and then Arthur Lorch gave the following trademarks: LIG and ALIG.

Josef Inwald—originally a Swedish firm, Inwald established a glass works at Rudolfova Hut, Czechoslovakia in 1905—the Head Office was in Vienna. Carnival Glass was made in the 1920s and 1930s. Now part of the Avirunion conglomerate—since 1993 Rudolfova Hut has sold pressed household glass under the brand "Cristal."

Jain Glass Works (Private) Ltd—established by Shri Chhadamilal Jain in 1928 in Firozabad, India. Date of cessation of production unsure, but possibly in the 1980s. Carnival Glass made from 1935, some of which was marked (JAIN).

Kauklahti—Espoo, Finland. Merged with Riihimaki Glass in 1927, probably produced Carnival Glass following this merger. Some Carnival known bearing the trademark KAUKLAHTI.

Khandelwal Glass Works—Sasni, Uttar Pradesh, India. Established in 1932; current Chief Executive is Vijay Kumar Jain. Production of Carnival tumblers, some trademarked SASNI.

K.P. Glass Industries—Firozabad, India. Production of Carnival Glass jars (possibly other items) some trademarked K P.

Leerdam Glasfabriek—established at Leerdam, Netherlands in 1879. Small amount of Carnival production in the 1920s and 1930s. Now a division of the (Dutch) United Glassworks.

Millersburg Glass Company—established in 1908 by John Fenton at Millersburg, Ohio, USA and collapsed due to bankruptcy in 1911. Re-opened as the Radium Glass Company for a short while, but finally closed in 1912. Produced Carnival Glass throughout the short life of the plant.

Mosser Glass Inc—established in the 1950s by Thomas Mosser at Cambridge, Ohio, USA. Began producing Contemporary Carnival Glass in the 1970s—still in production. Some output trademarked with a letter M or an M within the outline of the state of Ohio.

Northwood Glass Company—established in 1887 at Martin's Ferry, Ohio, USA by Harry Northwood. Moved to Indiana, Pennsylvania in 1895 and then to Wheeling, West Virginia in 1902 where Carnival Glass was produced from around 1907 through to Northwood's death in 1919 and possibly beyond until factory closure in 1925. Some (not all) Northwood Carnival Glass is marked with the underlined N in a circle.

Northwood Art Glass Company—established in 1998 by David McKinley, a descendant of Harry Northwood, at Wheeling, West Virginia. Contemporary Carnival in limited editions.

Om Glass Works—Firozabad, India. Production of Carnival Glass tumblers, some marked UMM.

Paliwal Glass Works—Shikohabad, India. Established in 1922; current Chief Executive is Raj Kumar Paliwal. Produced Carnival Glass water sets. Moulded trademark Paliwal in script or block lettering.

Riihimaki Glass (Riihimäen Lasi Oy)—established in 1910 at Riihimaki, Finland and merged with Kauklahti in 1927. Carnival Glass produced from circa 1920 through 1940, with a limited later production. Sporadic use of various moulded trademarks—RIIHIMAKI, a single letter R or the outline of a lynx—as well as a paper label. Closed in 1976.

Josef Rindskopf A.G.—established 1878 at Teplice, Czechoslovakia. Declared bankrupt in 1927 and later merged with Inwald. Carnival Glass produced during the 1920s and 1930s.

Sowerby's Ellison Glassworks—established in 1852 at Gateshead, England by John Sowerby. Carnival Glass produced in the 1920s and 1930s with some later production in the 1950s and 1960s. Glass production ceased in 1972. Some Carnival marked with the Sowerby peacock head trademark, also some items bear a paper label.

L. E. Smith Glass Co—established in the early 1900s by John Duncan at Mount Pleasant, Pennsylvania, USA. Purchased by Owens-Illinois in 1971, with Smith operating as a wholly owned subsidiary. Produced Carnival Glass from the 1970s to date. Some glass marked with a simple S, or the letter S with small letters G and C within the curves of the S.

Summit Art Glass—established in 1972 by Russel and JoAnn Vogelsong at Ravenna, Ohio, USA. Contemporary Carnival Glass production through the 1970s to date—some marked with the V trademark, but most unmarked or still bearing the trademark from original moulds (eg Imperial, Westmoreland).

United States Glass Company—conglomerate established in 1891 with headquarters in Pittsburgh, Pennsylvania, USA. Carnival Glass produced from 1911 probably through the 1920s. Bankruptcy was followed by their final demise in 1963.

August Walther and Sohne—Ottendorf, Germany. Merged in 1932 with Sächsische Glasfabrik Radeberg—the new name was Sächsische Glasfabrik August Walther & Söhne Aktiengesellschaft, Ottendorf-Okrilla and Radeberg. After WW2 the glassworks was nationalized and had the name VEB Sachsenglas, Ottendorf-Okrilla. Small amount of Carnival production from 1930s through to 1960s.

Thomas Webb and Sons—mid 1800s at Stourbridge, England. Produced iridized "luster ware" ("Iris" and "Bronze") in the late 1800s.

West Glass Works—Firozabad, India. Production of Carnival Glass water sets, some trademarked WEST.

Westmoreland Glass Co—established in 1889 as the Westmoreland Specialty Company at Grapeville, Pennsylvania, USA. Carnival Glass produced from 1908 through 1920s and then again as Contemporary Carnival in the 1970s through to the eventual demise of the company in 1984.

Wheatoncraft Glass Company—established late 1800s at Millville, New Jersey, USA. Producer of Contemporary Carnival from the 1970s.

L. G. Wright—established in 1937 by L. G. (Si) Wright at New Martinsville, West Virginia, USA. Carnival Glass produced for Wright (by Fenton and others) through the 1960s to their demise in 1999. Some trademarked with the notorious "Wonky" or "Wobbly" N that resembles a Northwood mark. Also some marked with an underlined W in a circle.

Other recent and contemporary companies that have produced some Carnival include: Jeanette, Big Pine Key Works, Viking, Gibson, and Pilgrim. Information on these and others can be found in *A Century of Carnival Glass*.

Bibliography

Burns, Carl O. *Northwood Carnival Glass*. Paducah, Kentucky: Collector Books, 2001.

Cottle, Simon. *Sowerby Gateshead Glass*. Gateshead, England: Tyne and Wear Museums Service, 1986.

Crowley, David. *Introduction to Victorian Style*. London, England: Apple Press, 1990.

Doty, David. *A Field Guide to Carnival Glass*. Marietta, Ohio: The Glass Press Inc., 1998.

Edwards, Bill and Carwile, Mike. *Standard Encyclopedia of Carnival Glass (8th Edition)*. Paducah, Kentucky: Collector Books, 2002.

Hajdamach, Charles R. *British Glass. 1800-1914*. Suffolk, England: Antique Collectors' Club Ltd., 1993.

Hand, Sherman. *The Collector's Encyclopedia of Carnival Glass*. Paducah, Kentucky: Collector Books, 1978.

Hartung, Marion T. *Seventh Book of Carnival Glass*. Emporia, Kansas: author, 1966.

Heacock, William. *Fenton the First 25 Years,* Marietta, Ohio: O-Val Advertising Corp. 1978.

Heacock, William: Measell, James: Wiggins, Berry. *Harry Northwood. The Early Years*. Marietta, Ohio: Antique Publications, 1990.

Heacock, William: Measell, James: Wiggins, Berry. *Harry Northwood. The Wheeling Years*. Marietta, Ohio: Antique Publications, 1991.

Jargstorf, Sibylle. *Baubles, Buttons and Beads. The Heritage of Bohemia*. Atglen, Pennsylvania: Schiffer Publishing Ltd., 1993.

Moore, Donald. *The Shape of Things in Carnival Glass*. Alameda, California: by author, 1987.

Mordini, Tom and Sharon. *Carnival Glass Auction Price Reports*. Freeport, Illinois: by authors, 1984-2003.

Notley, Raymond. *Popular Glass of the 19th and 20th Centuries*. London, England: Octopus Publishing Group Ltd. 2000.

Revi, Albert Christian. *Nineteenth Century Glass: Its Genesis and Development*. Atglen, Pennsylvania: Schiffer Publishing Limited, 1967.

Thistlewood, Glen and Stephen. *Network* journals. Alton, Hampshire, England: authors, 1994-2002.

Thistlewood, Glen & Stephen. *Carnival Glass—The Magic and the Mystery*. Atglen, Pennsylvania: Schiffer Publishing Limited, 1998.

Thistlewood, Glen & Stephen. *A Century of Carnival Glass*. Atglen, Pennsylvania: Schiffer Publishing Limited, 2001.

Weatherman, Hazel Marie. *The Decorated Tumbler*. Springfield, Missouri: Glassbooks Inc., 1978.

The Carnival Pump. Official publication of the International Carnival Glass Association Inc.

Further Resources

The www.cga Carnival Glass Educational Website—http://www.woodsland.com/carnivalglass—and daily mailing list on Carnival Glass is available by annual subscription to the internet Carnival Collector's Club www.cga. Contact thistlewood@woodsland.com for information

Thistlewood's Carnival Glass website can be found at http://www.carnival-glass.net

John Valentine's Contemporary Carnival Glass website—http://www.carnivalglass.net/—provides (for an annual subscription) an excellent resource on Modern Carnival Glass and is recommended.

General Index

Pattern Index

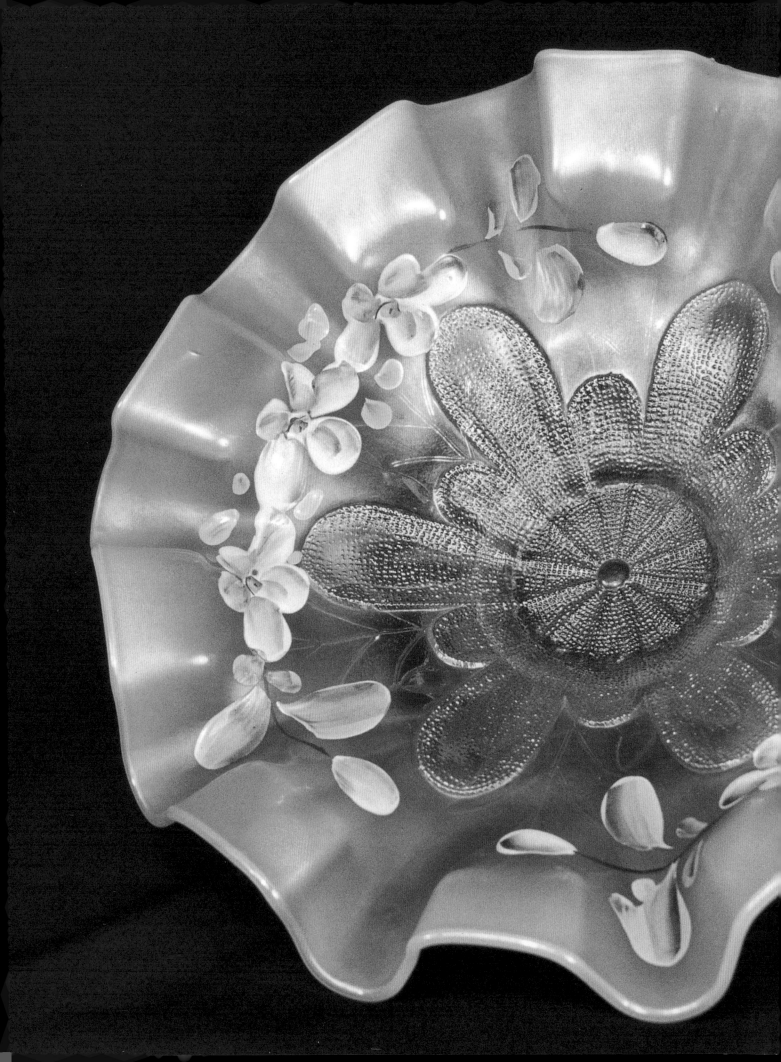